THE COMPLETE ILLUSTRATED GUIDE TO

ISLAMIC
ART AND ARCHITECTURE

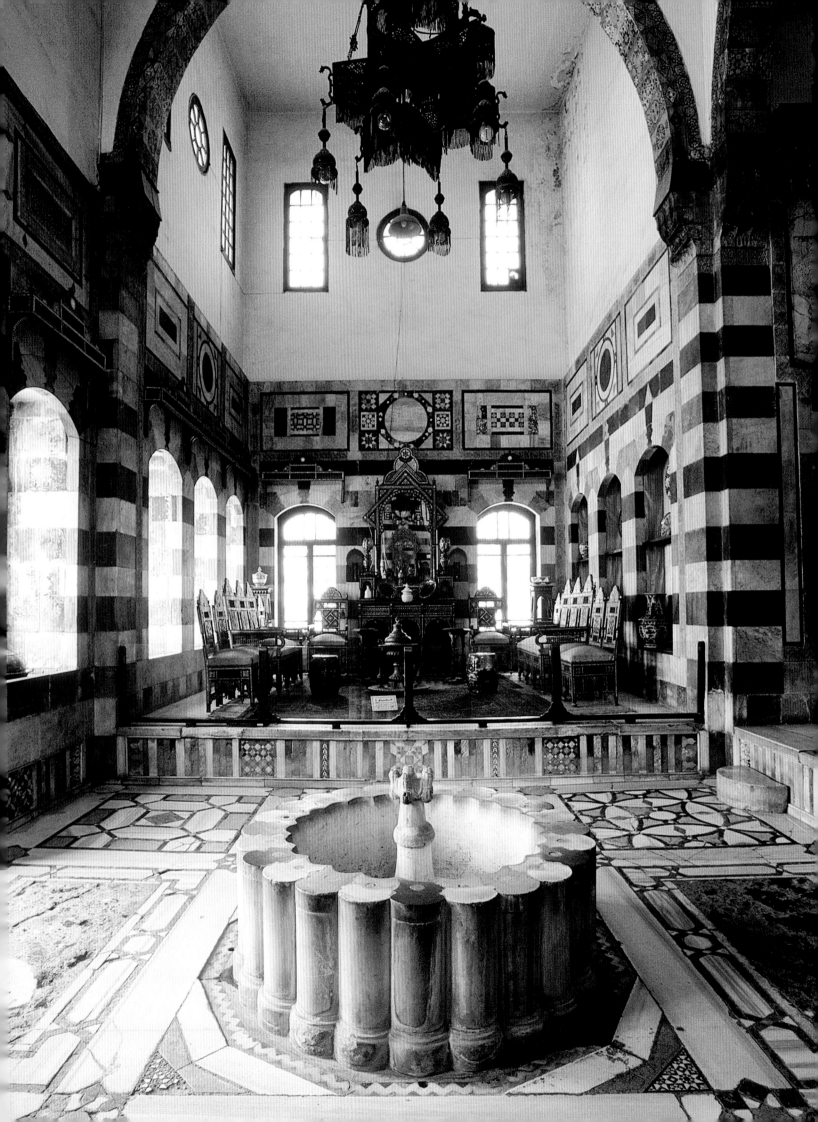

THE COMPLETE ILLUSTRATED GUIDE TO

ISLAMIC
ART AND ARCHITECTURE

A COMPREHENSIVE HISTORY OF ISLAM'S 1,400-YEAR LEGACY OF ART AND DESIGN,
WITH 500 PHOTOGRAPHS, REPRODUCTIONS AND FINE-ART PAINTINGS

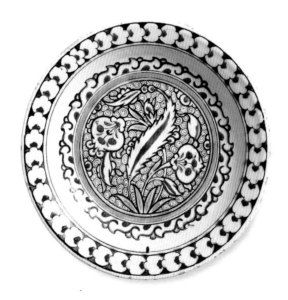

CONSULTANT: MOYA CAREY

CAROLINE CHAPMAN • MELANIE GIBSON •
GEORGE MANGINIS • ANNA McSWEENEY •
CHARLES PHILLIPS • IAIN ZACZEK

HERMES
HOUSE

CONTENTS

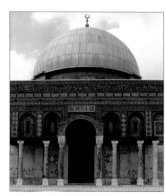

*Above Dome of the Rock,
a Muslim shrine built in
Jerusalem 691CE.*

*Above Brickwork from the
9th-century Ismail Samani
Mausoleum in Bukhara.*

*Above Muqarnas and tiles
in the Seljuks' 11th-century
Friday Mosque in Isfahan.*

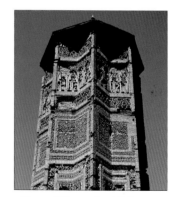

*Above The early 12th-
century Bahram Shah
minaret, in Ghazni.*

Above Detail of tiles from the Gur-e Amir Mausoleum, in Samarkand.

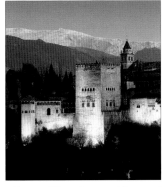

Above Alhambra, residence of Muslim rulers in Granada, built in the 14th century.

Above Detail from a mid-16th-century illustration, produced in Mughal India.

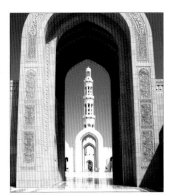

Above Sultan Qaboos Mosque, built in Oman between 1995 and 2001.

INTRODUCTION: THE PROPHET AND THE RISE OF ISLAM

THE RELIGION OF ISLAM WAS FOUNDED BY THE PROPHET MUHAMMAD (DIED 632) IN THE ARABIAN CITIES OF MAKKAH AND MADINAH. THE ARABIC WORD 'ISLAM' LITERALLY MEANS 'SUBMISSION'.

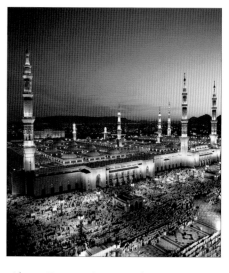

The Prophet Muhammad was born in Makkah, around 570CE. Orphaned at a young age, he was raised by his extended family, a minor clan of the powerful Quraysh tribe. Makkah was a merchant city with an important pilgrimage sanctuary at its heart. Known as the *Kaabah*, the sanctuary was dedicated to a pantheon of pagan deities. In his youth, Muhammad travelled widely beyond his hometown. He married Khadijah (died 619), a wealthy merchant widow, and they ran her business together. In 610CE, during a period of solitary reflection on Mount Hira outside Makkah, Muhammad began to receive divine revelations instructing him to preach a new, monotheistic faith, that would challenge and eventually overturn the pagan beliefs of his own community.

Below It is estimated that one million or so pilgrims visit the Kaabah in Makkah every year for the annual Hajj rituals.

Above During the annual Hajj *to Makkah, pilgrims also visit the Mosque of the Prophet in Madinah.*

THE EMERGENCE OF ISLAM
Revelations came to the Prophet periodically over the rest of his life, for the next 22 years. They were carefully remembered and retained by the Prophet and his growing community of Muslim converts,

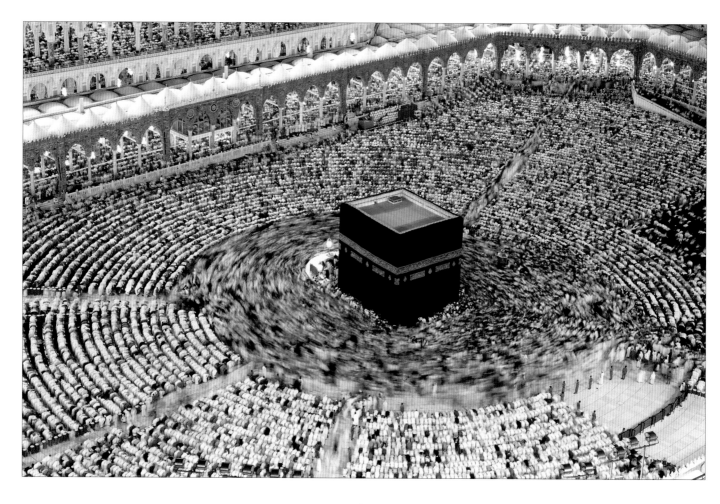

and together these revealed passages constitute the Quran, the Holy Book of Islam. As such, Muslims consider the Quran to be of divine authorship, a perfect text. The essential message of this new religion was monotheism: Muslims believe in only one God, and avoid idolatry. Islam also holds sacred a long lineage of ancient prophets including Adam, Noah, Abraham and Jesus. In these aspects, Islam shares a great deal with both Judaism and Christianity, and these fellow monotheistic faiths are described in the Quran as the 'People of the Book' because Jews and Christians also possess sacred texts (the Torah and the Bible).

THE PROPHET'S MISSION IN ARABIA

Following his first revelation, Muhammad obeyed the divine command to 'Recite!' and started to preach. He began seeking converts, first among his family and friends, and then gradually from the wider Makkah community. This soon met with hostility from the dominant Quraysh tribe, whose power in Makkah rested with their responsibility for the pagan sanctuary of the *Kaabah*. The new religion also undermined the tribal system of family loyalty, as it created a new community bound by religious commitment rather than blood relationships. After many years under threat, the Prophet and his followers were finally forced to leave Makkah in the year 622CE, and they fled to the security of a small Muslim community recently established in nearby Yathrib. There they built a house for the Prophet and his family, which became the first mosque. This migration, or *hijrah*, was an important moment for the first Muslims, and marks the beginning of Islamic history: 622CE is the first year in the Muslim calendar, 1AH ('Anno

Hegirae') – the year of the *hijrah*. In honour of this reception, Yathrib was renamed Madinat al-Nabi ('The City of the Prophet'), and is now known as Madinah.

Muslims prospered in Madinah and surrounding tribal areas, extending their political and religious influence, but hostility with Makkah remained unresolved. Eventually, in 630, the Muslim forces conquered Makkah, defeating the Quraysh, and reclaimed the *Kaabah* pilgrimage sanctuary for Islam. This had long been the

Above The first two suwar of this 16th-century Quran are richly decorated with fine illumination and colours.

Prophet's intention: he had already designated the holy *Kaabah* as the direction for Muslim prayer; now he cleared the site of its pagan idols, and it became part of Muslim tradition – and the destination for the annual *Hajj* pilgrimage, one of the five basic requirements of Islam. Following this victory, the Prophet continued to live in his house in Madinah, where he passed away in 632.

THE FIVE PILLARS OF ISLAM

Islam requires that all Muslims perform five basic duties, as follows:

1. The *shahadah*, or profession of faith, reciting the creed statement 'There is no god but God, and Muhammad is his messenger'.
2. *Salah*, or daily prayers, to be performed every day at five determined times between early dawn and evening.
3. *Zakah*, or charitable donation of alms to the poor.
4. *Sawm*, or annual fasting during the daylight hours of the month of Ramadhan every year.
5. The *Hajj*, the pilgrimage to the *Kaabah* in Makkah, which must be undertaken at least once in every Muslim's lifetime.

INTRODUCTION: PROPHET MUHAMMAD'S SUCCESSOR

FOLLOWING THE DEATH OF THE PROPHET MUHAMMAD IN 632, THE MUSLIM COMMUNITY, OR *UMMAH*, SOUGHT A MEANS OF AGREEMENT ON HIS SUCCESSOR, OR CALIPH.

Above The Kufa Mosque in Iraq was the headquarters of Ali ibn Abu Talib (died 661).

THE RIGHTEOUS CALIPHS

Until the emergence of the Umayyad dynasty in 661, leadership of the new Islamic state was determined by consensus rather than family inheritance. The initial principle was based on the Prophet's own views about his succession, which were unclear and hotly debated. When weak and close to death, the Prophet Muhammad had asked his companion and father-in-law, Abu Bakr, to lead the community's prayers on his behalf. This was considered significant, and the community chose Abu Bakr (died 634) as the first of the four Righteous Caliphs, or al-Rashidun. The following three caliphs were also close friends or family of the Prophet: Umar (died 644), Uthman (died 656) and Ali (died 661), and all were elected with the consensus of the community. The years of the Rashidun Caliphate saw the Islamic state expand with great military energy from its Arabian heartland, conquering first Syria, then Palestine, North Africa and Iraq, and then Iran. The Byzantine emperor was beaten into retreat in Anatolia, and the last Sasanian Shah Yazdagird III (died 651) was completely defeated. Both great empires were severely damaged by Muslim conquest, but both also contributed a considerable cultural heritage to the new Islamic state – in terms of government infrastructure and court ceremony, as well as art and architecture. This was particularly felt after the capital moved to Damascus in 661, and eventually to Baghdad in 750.

Left A manuscript illustration that depicts the first three Shiah Imams: Ali with his sons Hasan and Hussain.

THE EMERGENCE OF SHIAH ISLAM

The fourth caliph was Ali ibn Abu Talib (d.661), who ruled from Kufa in Iraq. He was a close friend of the Prophet Muhammad, as the first three caliphs had also been. Ali was the Prophet's younger cousin. He had been fostered by him as a child, and later married the Prophet's daughter Fatima. Ali and Fatima had two sons, Hasan and Husayn, who were therefore part of a bloodline descending directly from the Prophet – who had had no surviving sons. This lineage became ever more significant with regard to the Muslim leadership: while Ali was caliph, he was challenged by Muawiyah, the governor of Syria and eventual founder of the Umayyad dynasty (661–750). Importantly, Ali was from the same clan as the Prophet, while Muawiyah and the third caliph, Uthman, were from the Umayyad clan (another branch of the Quraysh tribe of Makkah). When Ali was murdered in 661 by members of the radical Khariji sect, Muawiyah was quick to seize

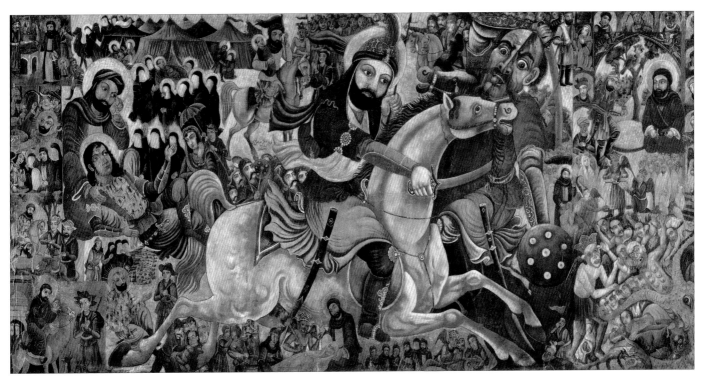

Above A painting of the Battle of Kerbala, showing Hussain's half-brother, Abbas, heroically defeating an Umayyad soldier.

the Caliphate – establishing his own dynasty, which ruled from Damascus. Ali's son Hasan (died 669) did not pursue the Caliphate, but on Muawiyah's death in 680, his brother Husayn claimed the leadership as a direct descendant of the Prophet. Husayn led his forces to Karbala in Iraq, and was greatly outnumbered by the Umayyad forces of Muawiyah's son, Yazid. Besieged, Husayn and his supporters were eventually massacred by the Umayyads (10 October 680). Ashura, the anniversary of Husayn's martyrdom, is mourned every year by Muslims, but has an especially strong significance for the sect that emerged from orthodox or Sunni Islam. Known as Shiat-Ali, or the partisans of Ali, Shiah Muslims hold that the leadership of the Islamic state should fall only to

Right Shiah pilgrims visit the holy shrine of Imam Ali in the Iraqi city of Najaf.

those descended directly from the Prophet: Ali is therefore regarded by them as the first such leader, or Imam, with Hasan and Husayn the second and third, and a succession of further Imams thereafter. The first three caliphs are therefore regarded by Shiah Muslims as invalid, while the Umayyad dynasty and its successor, the Abbasid, are considered usurpers. There are different important branches within Shiism, according to views about the succession of later

Imams: these include Twelver Shiism, the state religion of Iran since the 16th century, and Ismaili Shiism – of which the Aga Khan is the current leader. Shiah reverence for the tombs of Imams and their families is very strong, particularly for the shrine of Imam Ali in Najaf, of Imam Husayn at Kerbala (both in Iraq), and of Imam Reza in Mashhad in Iran. These and other Shiah shrines remain important pilgrimage destinations to this day.

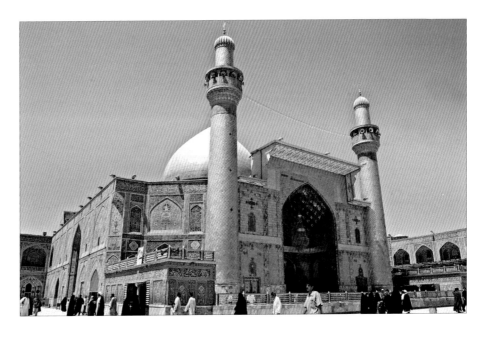

TIMELINE

The following timeline lists some of the major works in the long history of Islamic art and architecture.

- 610–32 The Prophet receives the revelations of the Quran.
- c.654 A standardized version of the Quran is issued by Rashidun Caliph Uthman ibn-Affan (reigned 644–56) and sent to the four cities of Madinah, Damascus, Kufa and Basra.
- 691 Umayyad Caliph Abd al-Malik (reigned 685–705) oversees the building of the Dome of the Rock in Jerusalem.
- 696–98 A major reform of coinage in the Umayyad Caliphate replaces figurative images with Islamic epigraphs.
- 706–15 The Great Mosque in Damascus is built under Umayyad Caliph al-Walid I (reigned 705–15). It is one of the first mosques to have minarets.
- c.712–715 The Qusayr Amra 'desert palace', or hunting lodge, is built by Caliph al-Walid I in Jordan.
- c.715 The rebuilding of the Al-Aqsa Mosque in Jerusalem is completed by al-Walid I. According to tradition the original Al-Aqsa Mosque was built in c.644.
- 724–27 Umayyad Caliph al-Hisham (reigned 724–43) builds the desert palace of Qusayr al-Hayr al-Gharbi in the Syrian desert.
- 743–44 Umayyad Caliph al-Walid II (reigned 743–44) builds the palace of Mshatta in Jordan.
- 762 Madinat al-Salam (the 'City of Peace'), later called Baghdad, is founded by Abbasid Caliph al-Mansur (reigned 754–75) beside the river Tigris in Iraq.
- c.775 The fortified palace of

Above Ruins of the Qusayr Azraq fortress in Jordan, which was expanded by the Mamluks in the 13th century.

Ukhaydir is built near Kufa, 200km (125 miles) from Baghdad.
- 775–85 Abbasid Caliph al-Mahdi (reigned 775–85) is the first Islamic ruler to put his name on official coinage.
- 784–86 Exiled Umayyad ruler Abd al-Rahman I (reigned 756–88) begins construction of the Mezquita in Córdoba, Spain.
- 805 Abbasid Caliph Harun al-Rashid (reigned 786–809) founds a public hospital in Baghdad. It is the first such institution in the Islamic world: within a few years many major cities in the Abbasid Empire have a public hospital named *bimaristan* (a Pahlavi word meaning 'place of the sick').
- 817–63 The Great Mosque at Kairouan, Tunisia, is built.
- 830 The Bayt al-Hikma ('House of Wisdom') – a library and centre for the translation of classical texts – is established in Baghdad by Abbasid Caliph al-Mamun (reigned 813–33).
- 836 Abbasid Caliph al-Mutasim (reigned 833–42) establishes a new royal capital at Samarra, like Iraq's Baghdad, on the river Tigris.
- 848–52 Abbasid Caliph al-Mutawakkil (reigned 847–61) builds the Great Mosque of Samarra, with its spiral minaret.
- c.850–70 Muhammad al-Bukhari

Above Seljuk stonework from the 1260s adorns the portal of the Ince Minareli Madrasa in Konya, Turkey.

(810–70), a scholar resident in Samanid Bukhara (now in Uzbekistan), compiles the Sahih Bukhari, a collection of *hadith*, or sayings, of the Prophet Muhammad, that is considered the most authentic of all extant books of *hadith*.
- 859 The Qarawiyyin *madrasa* is established in Fez in Morocco. Also known as the University of Qarawiyyin or Al-Karaouine, this is the oldest known *madrasa*.
- 886–940 Abbasid wazir Ibn Muqla (886–940) identifies the 'Six Pens' or classic scripts of calligraphy: *naskhi, muhaqqaq, thuluth, rayhani, riqa* and *tawqi*.
- 892 Abbasid Caliph al-Mutamid (reigned 870–92) returns the capital to Baghdad from Samarra.
- 892–943 The 'Samanid Mausoleum' is built in Bukhara (now Uzbekistan) to honour Samanid ruler Ismail Samani (reigned 892–907).
- 921 Fatimid leader Ubayd Allah al-Mahdi Billah builds the palace city of Mahdia on the coast of Tunisia.
- c.935 Iranian poet Rudaki (859–c.941) is active at the court of Samanid ruler Nasr II (reigned 914–43).
- 936–940 Exiled Umayyad Prince Abd al-Rahman III (reigned 912–61) builds the city of

Madinat al-Zahra near Córdoba in Islamic Spain.

- c.955 The superb pictorial silk banner known as the St Jossé silk is made for Samanid official Abu Mansur Bukhtegin (d.960).
- 959 A *madrasa* is set up alongside the al-Azhar Mosque in Cairo, Egypt. This eventually develops into the prestigious al-Azhar University.
- 969 The Fatimids found the city of Cairo as a royal capital in Egypt.
- 1006–7 The Gunbad-i-Qabus tomb tower is built in Gurgan, Iran, for Ziyarid ruler Qabus ibn Wushnigr (reigned 978–1012).
- 1009–10 Iranian poet Firdawsi compiles his 60,000-couplet epic, *Shahnama* (Book of Kings).
- 1012 The Mosque of al-Hakim is completed in Cairo.
- 1033 Fatimids under Caliph Ali al-Zahir (reigned 1021–36) rebuild the Al-Aqsa Mosque in Jerusalem in the form it retains today. The mosque had been damaged by an earthquake.
- 1065 The Al-Nizamiyya *madrasa* is set up in Baghdad by Seljuk administrator Nizam al-Mulk (1018–92). It is the first of a series of *madrasas* he establishes in Iran.
- 1078–79 The Ribat-i Malik *caravanserai* is built on the

road between Bukhara and Samarkand (now in Uzbekistan) by the Qarakhanid Sultan Nasr (reigned 1068–80).

- 1082 The Great Mosque of Tlemcen (in Algeria) is built by Almoravid leader Yusuf ibn Tashfin (reigned 1060–1106).
- 1086–87 Nizam al-Mulk, wazir for Seljuk Sultan Malik Shah (reigned 1072–92), builds an elegant south *iwan* (hall) at the Friday Mosque of Isfahan, Iran.
- 1088–89 Taj al-Mulk, Malik Shah's imperial chamberlain, adds the exquisite north *iwan* to Isfahan's Friday Mosque.
- c.1096 Fatimid wazir Badr al-Jamali rebuilds Cairo's city walls; he constructs the fortified gates of Bab al-Nasr and Bab al-Futuh.
- 1096 The Almoravid Great Mosque of Algiers is completed.
- 1125 Fatimid wazir Mamum al-Bataihi founds the Aqmar Mosque in Cairo.
- 1132–40 Norman King Roger II of Sicily (reigned 1130–54) builds the superb Palatine Chapel in his royal palace in Palermo. • 1135-46 The Grand Mosque in Zavareh, central Iran, is built. It is one the earliest surviving mosques built with four *iwans,* or halls, opening on to the courtyard.
- 1142 The Mosque of Taza in

Algeria is founded by Almohad leader Abd al-Mumin (reigned 1130–63).

- 1147-48 The Gunbad-i-Surkh tomb tower is built in Maragha, Iran, by architect Bakr Muhammad.
- 1154 Islamic geographer Muhammad al-Idrisi (1100–66) completes his celebrated world map, probably the most accurate made during the medieval period. It is called the 'Tabula Rogeriana' because it is made for King Roger II of Sicily at his court in Palermo.
- 1157 The square-domed building, known as the Mausoleum of Sultan Sanjar, is built at Merv (now in Turkmenistan).
- 1158–60 Another Seljuk four-*iwan* mosque is built at Ardestan, Iran.
- 1169 Turkish Zangid ruler of Syria Nur al-Din (reigned 1146–74) commissions four Aleppo craftsmen to make a beautiful new *minbar* for the Al-Aqsa Mosque, Jerusalem. It is installed in 1187 after Ayyubid general Saladin takes the city.
- 1172–98 In Seville, Spain, the Almohads build the Great Mosque, which later becomes the city's Christian cathedral.

Above Detail of 14th-century tilework on the walls of the Shah-i Zinda Mausoleum in Samarkand, Uzbekistan.

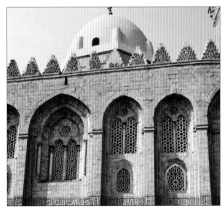

Above The Mamluk Sultan Qalawun built this mausoleum in 1285 as part of his much larger complex in Cairo, Egypt.

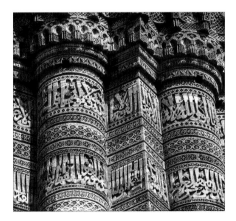

Above Inscriptions from the Quran were carved into the red sandstone of Qutb-ud-din Aybak in New Delhi, India.

Above A scene from the 1514 Battle of Chaldiran, when the Ottoman Empire defeated the Safavids.

Above Detail of one of the exquisite 16th-century Iznik tiles in the Rüstem Pasha Mosque in Istanbul, Turkey.

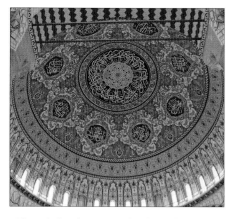

Above The dome inside the Selimiye Mosque in Edirne, Turkey, built by the architect Mimar Sinan, 1568–74.

- 1176–83 Ayyubid ruler Saladin builds the Citadel on Muqattam Hill, Cairo.
- 1190 Ghurid Sultan Ghiyath al-Din Muhammad builds the Minaret of Jam in Afghanistan. It is 60m (197ft) in height.
- 1193 Qutb-al-din Abak – Turkic Muslim general and self-styled Sultan of Delhi – begins construction of the Qutb Minar Tower in Delhi to mark the triumph of Islam in India.
- 1199 The *Kitab al-Diryaq* (Book of Antidotes) is one of many exquisite books made for the Zangid rulers of Mosul (Iraq). Zangid Mosul is also celebrated for its metalworking at this time.
- 1227–34 Abbasid Caliph al-Mustansir (reigned 1226–42) is responsible for the building of the Mustansiriya *madrasa* in Baghdad. It is designed with three *iwans* that lead on to a central courtyard.
- 1229 Anatolian Seljuk Sultan Ala al-Din Kaykubad I (reigned 1220–37) builds an imposing *han* (*caravanserai*), called a 'Sultan Han', on the road from Konya to Aksaray, Turkey. He builds a second 'Sultan Han' on the road between Kayseri and Sivas (also in Turkey) in 1232–36.
- *c.*1240 The Mosque of Djénné is built in Mali, western Africa.

- 1242–44 The *madrasa* of Ayyubid ruler Sultan al-Salih Najm al-Din Ayyub (reigned 1240–49) is built in Cairo.
- 1251 The Karatay *madrasa* in Konya, Turkey, is built by Anatolian Seljuk wazir Jelaleddin Karatay.
- 1267–69 The Mosque of Mamluk Sultan Al-Zahir Baybars (reigned 1260–77) is built in Cairo, Egypt.
- 1269 In what is now Somalia, the first Sultan of Mogadishu builds the Mosque of Fakhr al-Din. This is the oldest mosque in East Africa.
- *c.*1270 The second Ilkhanid Sultan of Iran, Abaqa Khan (reigned 1265–82), builds the summer palace of Tahkt-i Sulayman in north-western Iran.
- 1284–85 The mausoleum and *madrasa* complex of Mamluk sultan Qalawun (reigned 1279–90) is built in Cairo. In 1284, Sultan Qalawun also builds the al-Mansuri Hospital in Cairo.
- 1295–1303 The Madrasa and Mausoleum of Mamluk Sultan al-Nasir Muhammad (reigned 1293–94, 1299–1309 and 1309–41) is built in Cairo, Egypt. It is begun by Sultan al-Adil Kitbugha (reigned 1294–96) prior to his deposition in 1296. Kitbugha installs the Gothic portal, brought from a crusader church in Acre (now Israel).

- 1309 The eighth Ilkhanid sultan of Iran, Uljaytu (reigned 1304–16), adds an exquisite stucco *mihrab* to the winter *iwan,* or hall, of the Friday Mosque in Isfahan, Iran.
- *c.*1316 Ilkhanid Sultan Uljaytu builds a new capital called Sultaniyeh near Qazvin in north-western Iran. It contains his own mausoleum.
- 1322–26 The ninth Ilkhanid sultan of Iran, Abu Said (reigned 1316–35), builds a grand congregational mosque at Varamin, Iran.
- 1327 The Djinguereber Mosque is built in Timbuktu, Mali, western Africa. It is the oldest of three ancient mosque-*madrasas* in the city; the others are the Sidhi Yahya and the Sankoré mosques, and the three together form the University of Sankoré.
- 1335–36 Mamluk Sultan al-Nasir Muhammad builds the Sultan's Mosque within the Citadel, Cairo.
- 1348–91 Nasrid sultans of Granada, Yusuf I (reigned 1333–54) and Muhammad V (reigned 1354–59 and 1362–91), develop the Alhambra Palace, building the Tower of the Captives and Palace of the Lions.
- 1356 Mamluk Sultan al-Nasir Badr-al-Din Abu al-Ma'aly al-Hassan (reigned 1347–51

and 1354–61) commissions the building of the Sultan Hasan mosque and *madrasa* complex in Cairo.

- 1396–1400 Ulu Cami (the Great Mosque) is built in Bursa, north-western Turkey, by Ali Neccar on the orders of Ottoman Sultan Bayezid I (reigned 1389–1402).
- 1399–1404 Turkic warlord Timur the Lame (reigned 1370–1405) oversees the construction of the Bibi Khanum Mosque in Samarkand (now in Uzbekistan).
- 1403 Timur builds the celebrated Gur-e Amir tomb-*madrasa-khanqa* complex in Samarkand.
- 1415–20 The Mosque of Mamluk Sultan al-Muayyad Shaykh (reigned 1412–21) is built in Cairo. It is the last Mamluk congregational courtyard mosque of monumental dimensions.
- 1417–20 Timurid ruler Ulugh Beg (reigned 1411–49) builds a fine *madrasa* in Samarkand to complement the one he constructed in Bukhara in 1418.
- 1455–61 Ottoman Sultan Mehmet II 'the Conqueror' (reigned 1444–46 and 1451–81) begins construction of the Grand Bazaar, or Kapali Carsi ('Covered Market'), in Istanbul.

- 1459 Mehmet II begins building the Topkapi Palace, also in Istanbul.
- 1462–70 Mehmet II builds the Mehmet Fatih Kulliye in Istanbul. It contains a hospital, *caravanserai* and bazaar, several bathhouses and a *madrasa,* as well as a mosque.
- 1515 The Great Mosque of Agadez in Niger, western Africa, is built by Askia Muhammad I, ruler of the Songhai Empire (reigned 1492–1528).
- 1539–40 Safavid Shah Tahmasp I (reigned 1524–76) provides two beautiful and very large Persian carpets for the dynastic shrine at Ardabil, Iran. One is dated and signed by master weaver Maqsud Kashani. The 'Ardabil carpets' are probably the world's most celebrated Persian carpets.
- 1543–48 Ottoman architect Mimar Sinan (1489–1588) builds the Sehzade Mosque in Istanbul.
- 1550–57 Mimar Sinan builds the Suleymaniye Mosque in Istanbul for Sultan Suleyman I 'the Magnificent' (reigned 1520–66).
- *c.*1567–73 An illustrated manuscript of the romance *Hamzanama,* produced at the court of Akbar 'the Great' in Delhi, is one of the masterpieces of Mughal art.

- 1562 Mughal ruler Akbar 'the Great' (reigned 1556–1605) builds the Tomb of Humayan in Delhi to honour his father Humayan (reigned 1530–40 and 1555–56), second ruler of the dynasty.
- 1565–73 Akbar 'the Great' rebuilds the Red Fort of Agra, India.
- 1568–74 Ottoman architect Mimar Sinan builds the Selimiye Mosque in Edirne, Turkey.
- 1569 Akbar 'the Great' builds a new capital at Fatehpur Sikri, India.
- 1603–19 Safavid Shah Abbas I (reigned 1587–1629) builds the Lutfallah Mosque as part of his redevelopment of Isfahan, Iran. He also builds a second great establishment, the Imam's Mosque (originally called the King's Mosque), in 1611–30.
- 1612–14 The Tomb of Akbar the Great (reigned 1556–1605) is built at Sikandra near Agra, India.
- 1609–16 Ottoman Sultan Ahmet I (reigned 1603–17) builds the Blue Mosque in Istanbul.
- 1632–54 Mughal Emperor Shah Jahan (reigned 1628–58) builds the Taj Mahal as a memorial shrine for his favourite wife, Mumtaz Mahal.
- 1656 Shah Jahan completes the building of the Jama Masjid Mosque in Delhi.

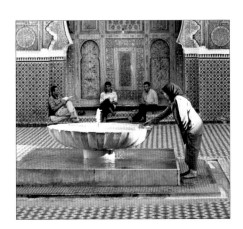

Above The University of Qarawiyyin (founded 859) is important to Muslims as one of the best centres for education.

Above Shah Jahani-style, white marble buildings grace the terraced Shalimar Gardens, built in Lahore in 1642.

Above Figures greet each other in this 19th-century tile from the Golestan Palace, a Qajar palace in Tehran.

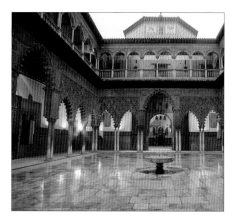

Above *A courtyard in the Alhambra, the 14th- and 15th-century residence of Muslim rulers in Granada.*

Above *Floral patterns feature on this 13th–14th-century Islamic dish, made during the Mongol period in Iran.*

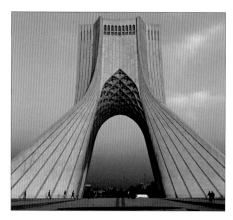

Above *The Azadi Tower, built in Tehran in 1971, marked the 2,500th anniversary of the Persian Empire.*

- 1678–82 The Ottoman Khan al-Wazir is built in Aleppo, Syria.
- 1706–15 The Shah Sultan Husayn mosque-bazaar complex is built on the Chahar Bagh in Isfahan.
- 1749 Ottoman governor Asad Pasha al-Azem builds the Azem Palace in Damascus.
- 1836 In Istanbul, Krikor Balyan completes the Nusretiye Mosque for Ottoman Sultan Mahmud II (reigned 1808–39).
- 1848 Muhammad Ali Pasha, Wali of Egypt, completes the grand Muhammad Ali Mosque in Cairo.

Below *The Islamic world extended across Africa, Europe and Asia.*

- 1855 Architects Garabet Amira Balyan and Nigogayos Balyan complete the Dolmabahçe Palace in Istanbul for Ottoman Sultan Abdulmecid I (reigned 1839–61).
- 1961 The Dhahran International Airport in Saudi Arabia is completed, designed by American architect Minoru Yamasaki.
- 1971 The Shayad Tower ('Memorial of Kings') is built in Tehran, Iran. After the Islamic Revolution (1979) it is renamed the Azadi (Freedom) Tower.
- 1973 The Great Mosque of Niono in Mali, western Africa, is completed using traditional techniques and materials.

- 1984 The Freedom Mosque in Jakarta, Indonesia, is completed by Indonesian architect Frederick Silaban.
- 1986 The King Faisal Mosque is completed in Islamabad, Pakistan. The architect, Vedat Delakoy, is Turkish.
- 1989 Architect Abdel-Wahed el-Wakil completes the King Saud Mosque in Jeddah, Saudi Arabia.
- 1990 Architect Rasem Badran completes the King Abdullah Mosque in Amman, Jordan.
- 1993 The King Hassan II Mosque in Casablanca, Morocco, is finished. It is designed by French architect Michel Pinseau. Its minaret, at 210m (689ft), is the world's tallest.
- 1999 The Kingdom Tower office and retail complex in Riyadh, Saudi Arabia, is completed. It is 311m (1,020ft) tall. A rival Riyadh tower, the Al Faisaliyah Centre, is completed in 2000.
- 1999 The Burj al-Arab ('Tower of the Arabs') hotel is completed on a man-made island off Dubai.
- 2007 The Rose Tower built in Dubai. At 333m (1,093ft) tall, it is the world's tallest hotel.

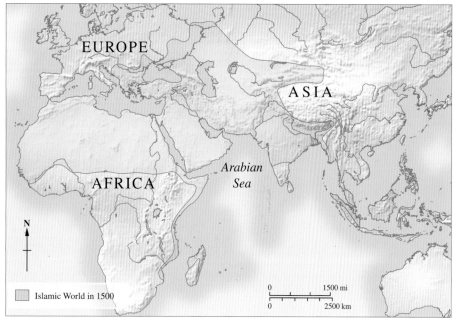

EUROPE

ASIA

Arabian Sea

AFRICA

N

Islamic World in 1500

0 1500 mi
0 2500 km

Opposite *An illustration of the city of Baghdad, showing the famous bridge of boats across the Tigris, from a 1468 anthology by Nasir Bukhari.*

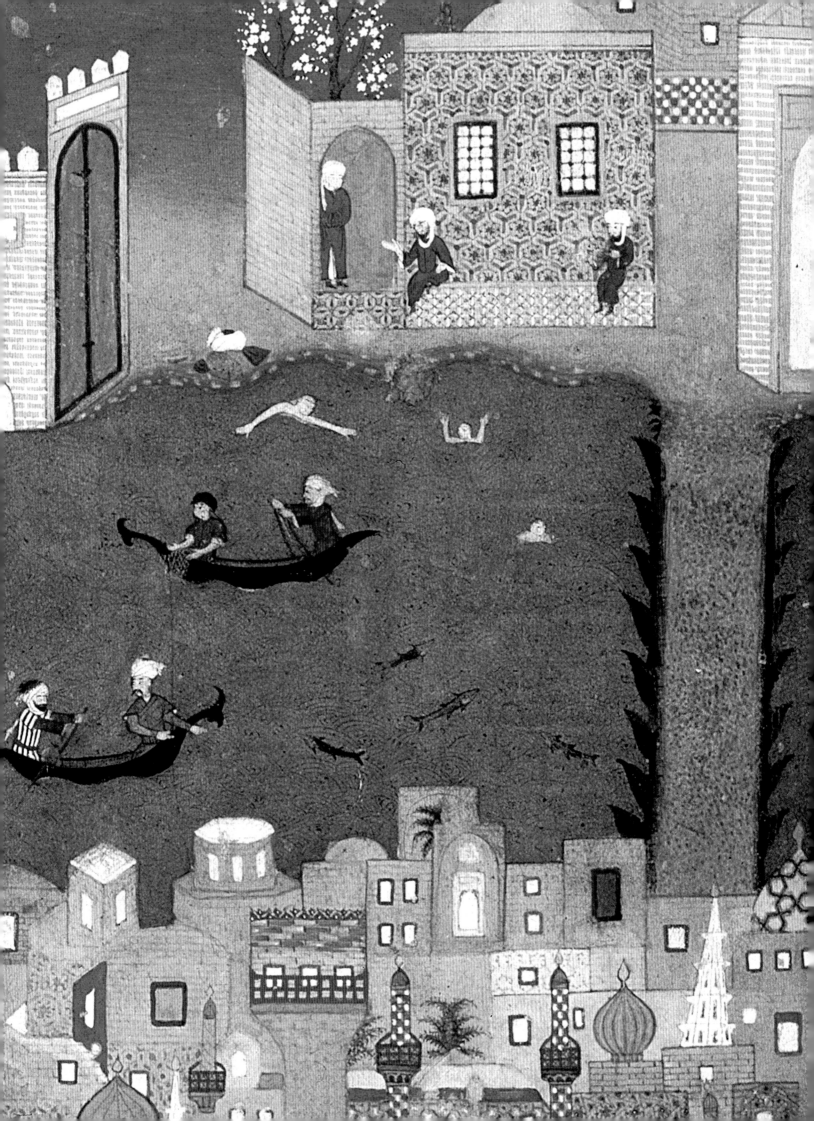

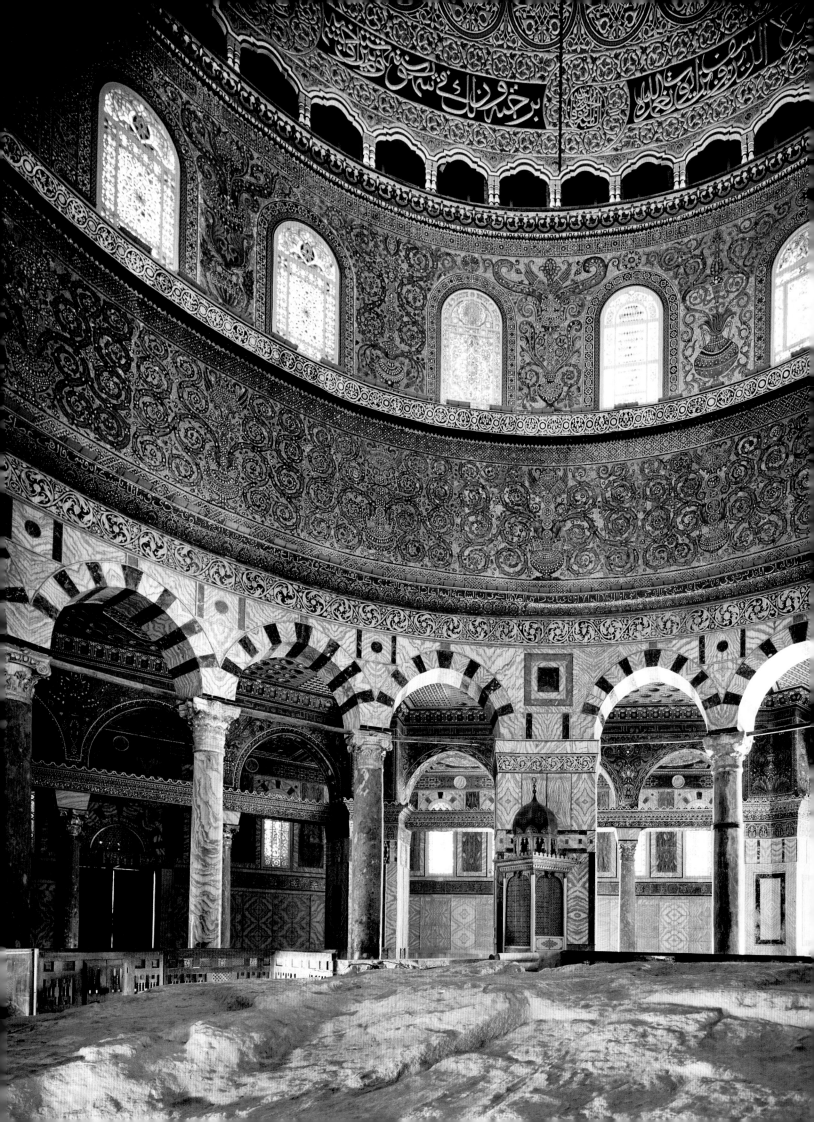

CHAPTER 1

THE ART OF THE ISLAMIC WORLD

Western art historians have long used the expression Islamic Art to describe the wide range of visual culture that has been created in the extensive regions of the world – from Spain to India, Turkey to North Africa – that have at some time come under Muslim rule. The glorious buildings, from palaces to whole cities, from mosques to bazaars; the arts of the book, such as calligraphy, painting, manuscript illumination and bookbinding; not to mention the furnishings, ceramics, luxury items made from precious metals and alloys, ivory, rock crystal, gemstones, glass and wood, and textiles and carpets, all qualify as Islamic Art. Their splendid refinement signifies a longstanding culture of taste and discernment and an educated, perhaps elite, audience. The common factor in this great output from so many different cultures is the religion of Islam, for although the civilian populations of Western Asia and other parts of the empire were never exclusively Muslim, they have long been ruled by caliphs, sultans, shahs and amirs who were.

Opposite Beautiful mosaics, including prayers and quotations from the Quran, adorn the interior walls of the Dome of the Rock in Jerusalem. Pilgrims visiting the shrine follow the ambulatory around the sacred Rock at the centre.

Above The Quran is the holy book of Islam, and is always produced with great care and respect for the text.

THE QURAN

THE HOLY QURAN, WHICH CONTAINS THE TRANSCRIBED WORDS OF ALLAH AS RECEIVED BY THE PROPHET MUHAMMAD IN 610–32, HAS BEEN A FOCUS FOR ISLAMIC ART AND CULTURE ACROSS THE CENTURIES.

Over 22 years, beginning in 610, the Prophet Muhammad received 114 divine revelations through Jibril (the angel Gabriel). The revelations are collected in the Quran, which Muslims believe to be the complete and faithful record of what Muhammad was told. The teachings he received from Jibril – who is also referred to as the 'Spirit of Holiness' (Surat al-Nahl: 102) – are understood by Muslims to be the actual words of Allah.

Muhammad did not write the Quran (he did not read or write). He passed on the words of Allah orally, repeating the revelations he had received to his early followers, who memorized them and passed them on to others.

SINGLE DOCUMENT

Scribes did write down some of the revelations using available materials, such as parchment, palm leaves, stone tablets and even animal bones. In these cases, Muhammad is believed to have had the records read back to him to check that the scribes had accurately written down his words. However, no attempt was made to gather the revelations into a comprehensive written document until shortly after Muhammad's death in 632. The situation changed when, in the Battle of Yamama (633) between Abu Bakr and followers of self-styled Prophet Musaylimah, at least 700 men who had memorized the Quran were slain. Leading Muslims saw the pressing need to make a written version for future generations before all those who had known the Prophet and his teachings at first hand had died.

A WRITTEN QURAN

One of the principal scribes, Zayd ibn Thabit (c.611–56), gathered the written revelations and wrote down all those existing in only memorized form. The results were approved by the *ashab* (Prophet's Companions) as being an accurate record of Muhammad's teachings. In c.654, during the era of Caliph Uthman ibn-Affan (reigned 644–56), a standardized version was drawn up and sent to the four cities of Kufa, Madinah, Damascus and Basra.

Some secular scholars claim that this traditional Islamic account of the collection of the Prophet's

Above Jibril transmits the words of Allah to the Prophet in this image from the Siyer-i Nebi, *an epic on the Prophet's life, by calligrapher Lutfi Abdullah.*

teachings in the Quran is incorrect and that the book was gathered from various sources over centuries. For Muslims, however, it is a binding obligation of their faith that the Quran contains the words of Allah as received by Muhammad, full, complete and unchanging.

STRUCTURE

The Quran contains 114 suwar (singular surah), or 'chapters', each containing one of the revelations received by the Prophet. They vary greatly in length: some have 3 *ayat* (singular *ayah*), or 'verses', and some as many as 286. A chapter heading will usually indicate the number of verses in the chapter, and also the location of revelation: some were received in Makkah, and others in Madinah after Muhammad and the Muhajirun made the *hijrah* (migration). The revelations received in Makkah are generally shorter and are often mystical in character; those that were received in Madinah are longer and many

HISTORICAL QURANS

According to tradition, two of the original copies of the Quran written by Zayd ibn Thabit are still in existence – one in Tashkent, Uzbekistan, where it is held in the library of the Telyashayakh Mosque, and the other in the Topkapi Palace in Istanbul. Some authorities doubt that these manuscripts genuinely date back, as claimed, to the era of Uthman. Meanwhile, fragments of the Quran found during restoration of the Great Mosque of San'a' in Yemen in 1972 have been carbon-dated to 645–90, so do certainly date back to this time. The fragments in Yemen may be remains of variant forms of the book that were in existence before the standardized version was sent out by Uthman.

This means that the longer, later revelations from Madinah appear before the earlier ones from Makkah. According to the Sunni tradition, Jibril dictated the order to Muhammad, and this gives the book an added, esoteric layer of meaning that pleases Allah but is not immediately apparent to readers. In the Shiah tradition, before the Quran was standardized under Uthman, the first Imam, Ali ibn Abu Talib, had a written version of the book made, and this was in a different order; but subsequently Ali accepted the order of the official Uthman version.

Above Muslim students study the Quran word by word. In Mali, Africa, a student copies a passage from the holy book on to a reusable wooden board.

give detailed practical guidance on ways of living that are acceptable to Allah. All the chapters, except *surah* 9, begin with the phrase of dedication known as the *basmalah*, 'In the name of Allah, most Beneficent, most Merciful'.

The material in the Quran is arranged in order of length, with the longest revelations first, with the exception of the first surat al-Fatiha.

ARABIC RECITATION

In the 7th century, many of the Prophet's contemporaries in Arabia were skilled in memorizing and declaiming poetry. Muhammad passed on his revelations to his followers, who taught them to others through public recitation. Muslims today are encouraged to memorize the Quran and believe that its words are meant to be declaimed aloud and heard by the faithful. The way the words sound is an important part of their effect on believers, which is why Muslims believe they should be recited in the language in which the revelations were given – Arabic.

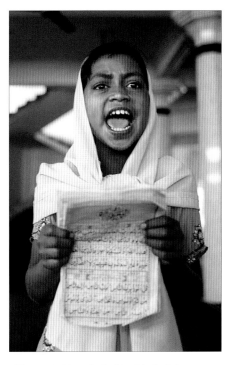

Above A Bangladeshi girl declaims a passage from the Quran in Arabic, the original language in which the revelations were given.

HOLY BOOK

The Quran is revered in book form. Some beautifully produced hand-written copies of the Quran are among the greatest of all Islamic works of art, with elegant calligraphy on the finest handmade paper between covers of skilfully worked leather. Moreover, the very fact that the holy words of Allah can be bound in a book gives Muslims a deep reverence for books in general. Indeed, the entire art form of calligraphy is derived from an earnest desire to represent the word of Allah in the most ornate way possible.

Left Hand-written copies of the Quran are the most prized of all Islamic art. This Quran was made in North Africa in 1344.

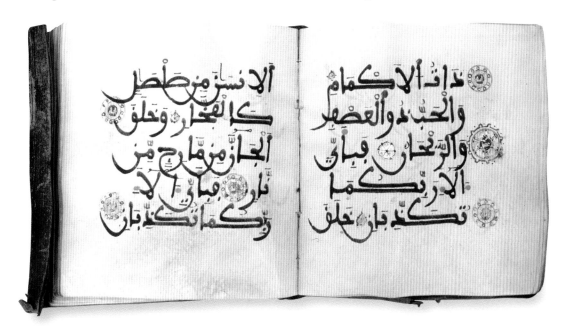

THE MOSQUE

STARTING AS A SIMPLE HALL AND COURTYARD, THE MOSQUE
DEVELOPED IN INCREASINGLY ELABORATE FORMS UNTIL IT REACHED
THE GRAND, MANY-DOMED STRUCTURE BUILT BY THE OTTOMANS.

The original use for the mosque was as a place for Muslims to gather. They meet there to pray together, and also to perform communal, social and educational activities. The word 'mosque' derives from the Arabic *masjid*, meaning a 'place of prostration', where five times a day Muslims can bow their heads to the ground, thus making the act of submission in prayer to Allah that is required by their faith.

FIRST MOSQUES

The house of the Prophet in Madinah, built in 622, was the prototype for early mosques. Worshippers gathered in large numbers in its enclosed courtyard. The early courtyard mosques were based on this pattern: a flat-roofed prayer hall led to a *sahn*, or an open courtyard, which generally had arcades at the sides. In the centre of the courtyard was often a fountain at which worshippers performed ritual ablutions. A *mihrab*, or niche,

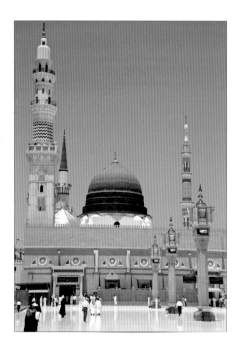

Left The Mosque of the Prophet in Madinah has changed from the simple courtyard and prayer hall that was the original prototype for mosques.

in one wall indicated the direction of the *Kaabah* shrine in Makkah, toward which Muslims must face when praying. Gates or doorways were cut in any of the three walls, other than the *qibla* wall that contained the *mihrab*.

Tall towers called minarets were added to the mosque in the late 7th century. Among the first were the four built at the Great Mosque in Damascus, built in 706–15 under the Umayyad Caliph al-Walid I. The minarets were initially watchtowers in which lighted torches were kept – 'minaret' derives from the Arabic *manara*, meaning 'lighthouse' – but they became elevated positions from which the *muezzin* sent out the five daily calls to prayers.

ARAB-STYLE MOSQUES

The mosque developed in different styles. In Syria, and afterward in Spain and North Africa, mosques were built on a rectangular plan, with an enclosed courtyard and a vast rectangular prayer hall with a flat roof divided internally by rows of columns. Architectural historians call these Arab-plan, or hypostyle, mosques. They were typically built by early Arab Muslims. A hypostyle hall is an architectural term for a large building with a flat roof supported by rows of columns.

This design was followed in 706–15 in the Umayyad Great Mosque of Damascus, which has a prayer hall 160m (525ft) long with a wooden roof supported on

***Above** An illustration shows the 8th-century Great Mosque of Damascus, with its prayer hall facing a courtyard and an early example of the minaret.*

columns and a great courtyard; the same pattern was used in 817–63 for the Great Mosque at Kairouan, Tunisia, where the prayer hall contains 8 bays and upward of 400 columns. At the Mezquita in Córdoba, Spain (begun in 784–86 under Umayyad ruler Abd al-Rahman I), builders constructed a vast prayer hall containing 850 pillars that divide the hall into 29 aisles running east–west and 19 aisles north–south. Commentators note that the rows of columns in Arab-style mosques create a sense of limitless space.

FOUR-*IWAN* MOSQUES

In Iran, a new form was developed in the 11th century. It included four domed *iwans*, or halls, one in each of the walls surrounding the courtyard. Architectural historians call this the 'four-*iwan*' or cruciform design, because it creates a ground plan in the form of a cross. The form appears to have been introduced by the Seljuk Turks from the province of Khurasan, who took power in Baghdad in 1055. The Grand Mosque in

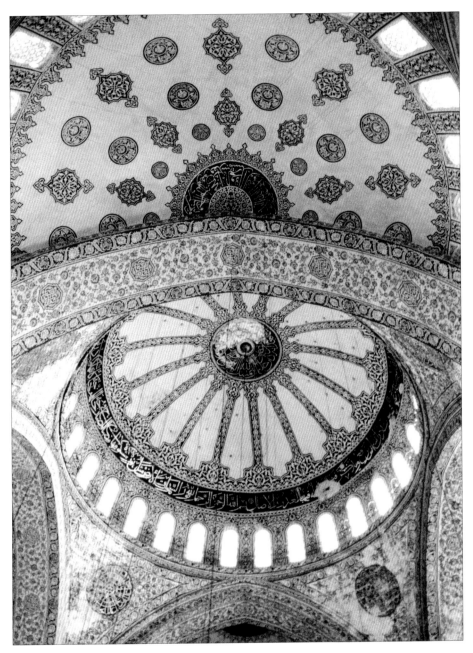

Of the three types of mosque, the first one is the daily mosque, or *masjid*, a small building used by local people for the five daily prayers. The second is the *jami*, or congregational mosque, also known as the 'Friday Mosque'. This much larger type of mosque is used by crowds of people for Friday service. It contains a *minbar*, or pulpit, used for sermons in Friday prayer. The third type is a large outdoor place for assembly and prayer containing a *qibla* wall with *mihrab* niche to indicate the correct direction for prayer, but without other facilities. These are often built near towns.

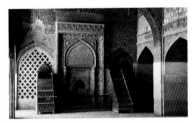

Above This delicate stucco mihrab, *commissioned by Ilkhanid ruler Uljaytu (reigned 1304–16), is in the Friday Mosque in Isfahan, Iran.*

Zavareh, Iran, built in 1135–46, followed this design and is the earliest surviving four-*iwan* mosque. Behind the *qibla iwan* (the one aligned toward Makkah) there is another domed chamber containing the *mihrab*.

CENTRAL-DOME MOSQUES

In Turkey and the cities of their empire, the Ottomans developed the vast monumental mosque with a central dome surrounded by semidomes, often called 'central-dome' mosques. They were inspired by the religious architecture of the Byzantine Empire, and in particular

Above The central dome in the Sultan Ahmet Mosque (1609–16) in Istanbul is decorated with calligraphy by Seyyid Kasim Gubari, who was the leading calligrapher of the period.

by the magnificent Hagia Sophia (Church of Holy Wisdom) in the Byzantine capital, Constantinople. Within days of Mehmet II 'the Conqueror' (reigned 1444–46, 1451–81) capturing Constantinople, he made the Church of Holy Wisdom into a mosque. Ottoman sultans and architects soon rose to the challenge of competing with the glorious Hagia Sophia.

Foremost among them was Mimar Sinan (1489–1588), chief Ottoman architect under sultans Suleyman I, Selim II and Murad III. Examples of magnificent central-dome mosques he built include the Sehzade Mosque (1543–48) and Suleymaniye Mosque (1550–57) – both in Constantinople – and the Selimiye Mosque (1568–74) in Edirne. The central-dome mosque was built at the heart of a complex of related buildings called a *kulliye*: the Selimiye Mosque, for instance, is surrounded by *caravanserais* (inns), schools, bathhouses, marketplaces, hospitals, libraries and a cemetery.

THE QIBLA

MUSLIMS ARE REQUIRED TO FACE TOWARD THE *KAABAH* SHRINE IN MAKKAH WHEN PRAYING DURING THE FIVE DAILY PRAYERS. THIS DIRECTION OF PRAYER IS CALLED THE *QIBLA*.

Above This mihrab *within the Friday Mosque in Isfahan, Iran, has a simple arch shape but is elaborately decorated with glazed ceramic tiles.*

Within a mosque the *qibla* is indicated by a *mihrab*, a niche in a wall. The wall with the *mihrab* is known as the *qibla* wall. The word *mihrab* originally meant 'a special room'. In the Prophet's lifetime, he began to use the word for the room he used for prayer in his house in Madinah. He entered the mosque established in his house through this room.

Early Muslims prayed toward Jerusalem. It was the Jewish custom to pray facing the Temple Mount, where the Jewish Temple stood (and also, subsequently, the location of the Dome of the Rock and the Al-Aqsa Mosque). One day during prayer in Madinah, the Prophet was inspired to turn toward the *Kaabah* in Makkah, a pagan sanctuary that Muslims claimed for monotheism. The revelation that he received, instructing him to change the direction of prayer, was recorded in the Quran (Surat al-Baqara: 144): 'We have seen the turning of thy face to Heaven (for guidance, O Muhammad). And now verily we shall make thee turn (in prayer) toward a *qibla*, which is dear to thee. So turn thy face toward the Inviolable Place of Worship, and ye (O Muslims), wheresoever ye may be, turn your faces (when ye pray) toward it…'

The place in which this event occurred is now called the Masjid al-Qiblatayn ('Mosque of the Two Qiblas'). It is unique in having two *mihrabs* to indicate the two directions of prayer, although at the time of the event Muslims were not yet indicating the direction of the *qibla* with a *mihrab*.

THE FIRST *MIHRAB*

The *mihrab* niche appears to have been introduced in the early 8th century. According to tradition, Caliph Uthman ibn-Affan (reigned 644–56) ordered a sign indicating the direction of the *Kaabah* in Makkah to be posted on the wall of the Mosque of the Prophet, at Madinah. When this mosque was renovated by Caliph al-Walid (reigned 705–15), a niche was made in the *qibla* wall and the sign made by Caliph Uthman placed within it.

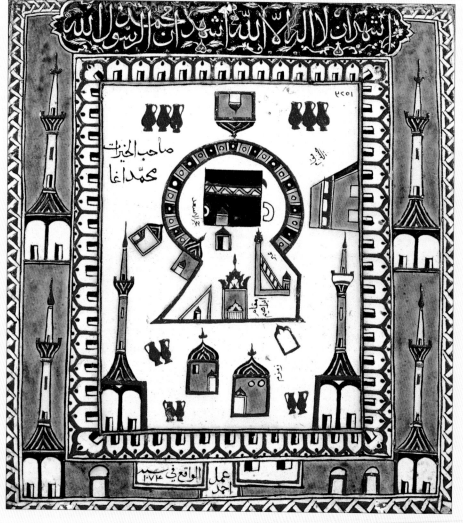

Left This 17th-century tile bears an illustration of Makkah with the black-draped Kaabah *at its centre.*

Right The mihrab *in the Mezquita, the former mosque of Córdoba in Spain, is especially notable because it is not aligned toward Makkah.*

It became traditional for the *mihrab* niche to have the shape of a doorway, possibly to indicate that the worshipper can make a journey in spirit through the *qibla* wall to the *Kaabah* at Makkah. The arched *mihrab* shape can also be found on many objects, such as prayer mats, embroideries and tiles.

NOT FACING MAKKAH

A few *qibla* walls and *mihrabs* are not aligned toward Makkah. The most celebrated is that of the Mezquita (Spanish for 'mosque') in Córdoba, Spain, where the *mihrab* faces south rather than south-east (the correct direction for Makkah). Some historians believe that this is because the mosque was built on the remains of a Visigothic cathedral; others say that when building the mosque Abd al-Rahman I aligned the *mihrab* as if he were still at home in Damascus rather than in exile in Spain.

This *mihrab* was reworked under al-Hakam II, Caliph of Córdoba in 961–76, using skilled Byzantine craftsmen. Situated beneath a breathtaking dome, it is regarded as one of the greatest masterpieces of Islamic religious building. An inscription in Arabic begins 'Allah is the knower of all things, both concealed and apparent. He is full of power, and of pity, the living one…'

DETERMINING *QIBLA*

When building a mosque or when praying, Muslims had to determine the precise direction of Makkah. Their need to be able to do this inspired Muslim scientists to develop and improve scientific instruments, such as astrolabes and compasses.

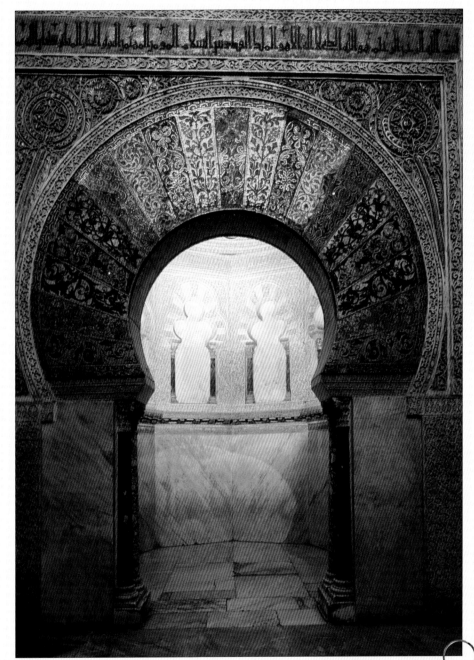

The astrolabe is an astronomical device that can be aligned with the position of the sun and other celestial bodies, such as the moon and planets, to determine latitude and local time. It was invented in the 1st or 2nd century BCE by the ancient Greeks. The first Islamic astrolabe was developed by the 8th-century CE Iranian mathematician Muhammad al-Fazari. Because they could be used to determine local time, they were also extremely valuable for setting the hours of prayer.

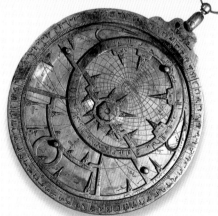

Above The astrolabe is a stereographic map of the night sky which can be set for one's exact date, time and latitude.

THE MOSQUE INTERIOR

MOSQUES VARY GREATLY IN SIZE AND FORM. SOME FEATURES, SUCH AS THE *MIHRAB*, ARE PRESENT IN ALL MOSQUES, BUT OTHERS, INCLUDING THE *MINBAR*, ARE FOUND ONLY IN LARGER MOSQUES.

The essential elements found in a mosque are the *qibla* wall (indicating the direction of the *Kaabah* in Makkah), the *mihrab* in this wall and a fountain at which the faithful perform ablutions before prayer. A congregational mosque will also contain a pulpit called a *minbar*, from which sermons, proclamations and readings are delivered as part of Friday service. The *minbar* has always stood to the right of the *mihrab*.

PURPOSE OF THE *MIHRAB*

The holiest place in the mosque is the *mihrab* archway. It is often highly decorated and is usually made of part of the mosque wall. The imam or other prayer leader leads prayers in front of the *mihrab*. Today, his voice might be broadcast using microphones and speakers, but in pre-electronic times the opening of the *mihrab* amplified the imam's voice so that all present could hear him. The *mihrab* is often decorated with lamps, symbolizing the light of Allah's wisdom. A small window is sometimes cut in the wall above the *mihrab* to give a sense of the alignment outside the mosque.

MINBAR AND *MAQSURA*

The *minbar* is usually a free-standing structure, often carved from wood, to the right of the *mihrab*. In some traditions it is decorated, in others it is plain. Steps rise to the *minbar*: the *imam khatib* (preaching imam) who delivers the sermon stands on the lower steps – the top one is reserved in perpetuity for the Prophet Muhammad himself.

The first *minbar*, used by the Prophet, had three steps and was made from tamarisk wood; the Prophet stood on the top step, but the first caliph, or successor, Abu Bakr, would go no higher than the second one as a mark of respect and then the third caliph, Umar, used only the third step. Since that time, however, the preacher has stood on the second step from the top. In the early days of Islam,

Above A cantor kneels on the kursi, *or lectern, while reciting the holy words of the Quran in the Mosque of Sultan Barquq in Cairo, Egypt.*

political and religious power were one: the Prophet and caliphs led prayers, and the governor first climbed the *minbar* to give a sermon, then descended to lead prayers in front of the *mihrab*.

In some early mosques, the *mihrab* and *minbar* were behind a carved wooden screen known as a *maqsura*. These screens were probably introduced to protect the caliph while at prayers after a rash of attacks on notables in mosques such as that on Caliph Umar, who was stabbed by a Zoroastrian slave as he led prayers in the mosque in Madinah in 644. However, over time the *maqsura*, which was often beautifully and lavishly decorated, functioned also as a statement of the ruler's power and wealth. Although the mosque belonged to the entire community of believers, the area beyond the *maqsura* was set aside for the prince or caliph as a celebration of his glory and the greatness of his rule.

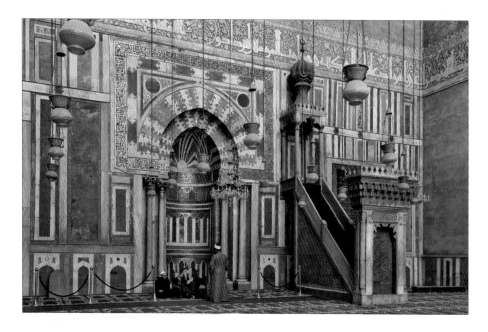

Left A grand minbar *stands to the right of the* mihrab *in the eastern* iwan *of the Sultan Hasan Mosque in Cairo, Egypt.*

Right Some early maqsuras, *as in the Ibn Tulun Mosque, Cairo, were simple raised platforms with protective screens.*

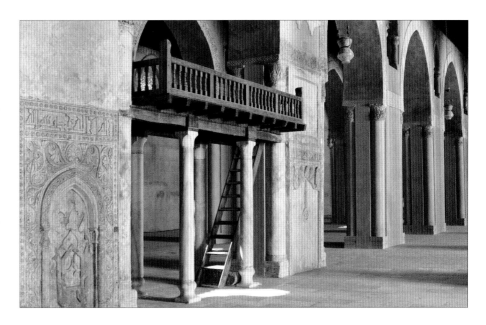

RECITING THE QURAN

Most mosques have a *kursi*, or lectern, at which a cantor recites the Quran. The recitation of the Quran is a highly regarded art. Muslims believe that the Quran has the most profound impact on a believer's mind and heart when it is heard aloud. The *kursi* is a heavy but movable piece of furniture, often with a low platform on which the cantor kneels, facing the *qibla* wall, as he recites from the Quran.

Many larger mosques contained a *dikka*, a platform for the *muezzin* to sing the responses to the prayers chanted by the imam. It was usually aligned with the *mihrab*. Today, the prayers of the imam are heard through loudspeakers, but in large mosques in the days before amplifiers the responses of the *muezzin* on the *dikka* helped those at the rear of the mosque follow the service if they were unable to hear the prayers being chanted in front of the *mihrab*. Their task was also to adopt the positions taken by the imam so that those who could not see him were able to follow this part of the service. In most mosques today, the *dikka* is not used because the *muezzin* no longer stands on the platform during worship.

PRAYER RUGS

Mosques always contain prayer rugs, because worshippers kneel and lower their foreheads to the floor during prayers. They are also usually equipped with bookrests to support copies of the Quran and keep them off the floor, as well as containers to hold the Quran when it is not in use.

Right This 18th-century Turkish prayer rug bears an image of a mihrab *with two columns and a stylized hanging lamp.*

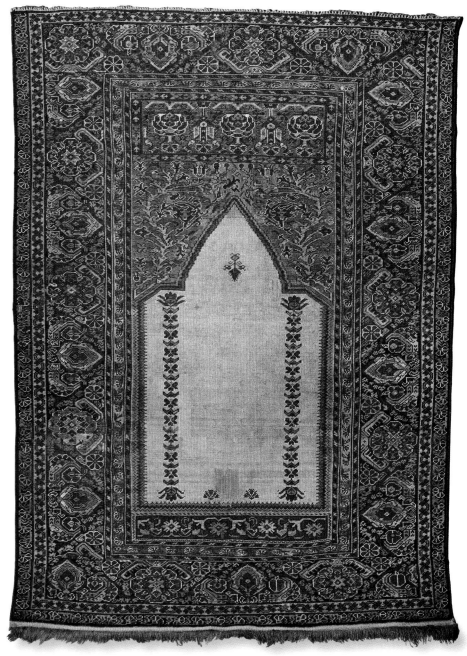

THE *MADRASA*

RELIGIOUS COLLEGES WERE OFTEN ATTACHED TO A MOSQUE, BUT THEY COULD ALSO BE AN INDEPENDENT INSTITUTION FUNDED BY HOSTELS AND MARKETS OR BY AN ENDOWMENT.

The Arabic word *madrasa* means 'a place where teaching and learning takes place', and refers to a religious school, university or college. The *madrasas* specialized in educating religious leaders and legal experts. Where they were funded by a *waqf* (religious endowment), the person who provided the endowment was usually buried in an associated mausoleum.

EARLY *MADRASAS*
In early Muslim communities, mosques were social centres in which a range of activities, such as teaching, took place. Informal teaching sessions were held by educated Muslims, who became known as shaykhs, and the *madrasa* is thought to have developed out of this custom.

The oldest known *madrasa* is in the Qarawiyyin Mosque (also known as the University of Al-Qurawiyyin or Al-Karaouine) in Fez, Morocco. It was established in 859 by Fatima al-Fihri, daughter of a wealthy merchant. Another early

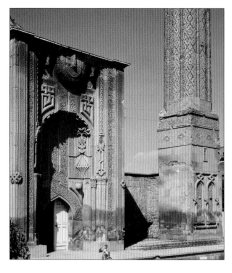

Above Built in Konya (Turkey) in 1256 by Seljuk wazir Fakhr al-Din Ali, the Ince Minareli madrasa *is celebrated for its grand gateway.*

madrasa was the one at the al-Azhar Mosque in Cairo, Egypt, in 959; this became al-Azhar University.

SELJUK *MADRASAS*
In the 11th century, the Persian scholar and Seljuk administrator Nizam al-Mulk (1018–92) set up a series of *madrasas* in cities such as Isfahan and Nishapur (both now in Iran) and Balkh and Herat (both now in Afghanistan). These were well-organized places of higher education called *nizamiyyah* after Nizam, and they had a reputation for teaching throughout the Islamic world and even in Europe.

The *nizamiyyah* became the model for later *madrasas*. The first and most celebrated of these was Al-Nizamiyya, set up in Baghdad in 1065. The widely admired Iranian Sufi mystic, philosopher and theologian al-Ghazali (1058–1111) was a teacher at Al-Nizamiyya. It became common for Seljuk rulers to build and fund a *madrasa* attached to the mausoleum in which they would be buried.

TYPES OF *MADRASA*
The *madrasa* came in a variety of forms. Some had a single large hall beneath a dome, but a typical configuration was the two-*iwan*, three-*iwan* or four-*iwan* plan, in which a central courtyard adjoins two, three or four large vaulted halls. *Madrasas* typically have grand gateways with imposing portals and towering minarets.

A splendid early example of a three-*iwan* design is the Mustansiriya *madrasa* built in Baghdad by the Abbasid caliph al-Mustansir in 1227–34. Standing beside the river Tigris, the large rectangular brick building is two storeys high and measures 106m by 48m (348ft by 157ft). Students travelled from far-flung parts of the Islamic world to this centre of learning, where they could study the Quran, theology, medicine, jurisprudence, mathematics and literature. It was the first of many *madrasas* to provide facilities for all four principal schools of Sunni Islam – the Hanbali, Shafii, Maliki

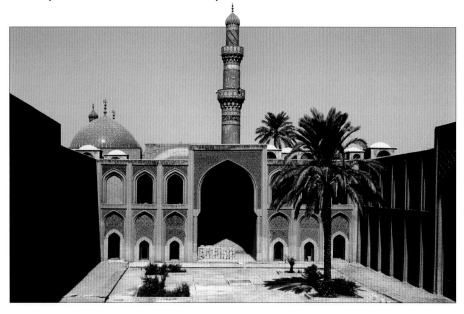

Left Three iwans *adjoin the courtyard at the Mustansiriya* madrasa. *It is one of the world's oldest centres of study.*

Right The Chahar Bagh complex in Isfahan, built by Shah Sultan Husayn in 1706–15, incorporated a bazaar and a caravanserai.

and Hanifi. Followers of each of the four schools had one corner of the *madrasa* to themselves.

Under later rulers, notably the Ottomans in Turkey and the Safavids in Iran, *madrasas* were built as part of a large complex centred on a grand mosque. In Iran, complexes often also contained a *caravanserai* (or inn) and a bazaar, and the commercial areas served to fund the educational and spiritual activities in the *madrasa*.

The Ottoman complexes were called *kulliyes*. Sultan Mehmet II built such a complex in Istanbul, the Mehmet Fatih Kulliye, in 1462–70. It had a hospital, kitchens, *caravanserai*, bazaar and several *hammams* (bathhouses), along with a *madrasa* 200m (656ft) in length for up to 1,000 students. Also in Istanbul, the Suleymaniye Mosque complex, built in 1550–57 by the great architect Sinan for Sultan Suleyman, contained, in addition to the superb mosque with its four minarets and dome, a hostel, a medical college, a school for boys, an asylum, a *hammam*, two mausolea and four *madrasas*.

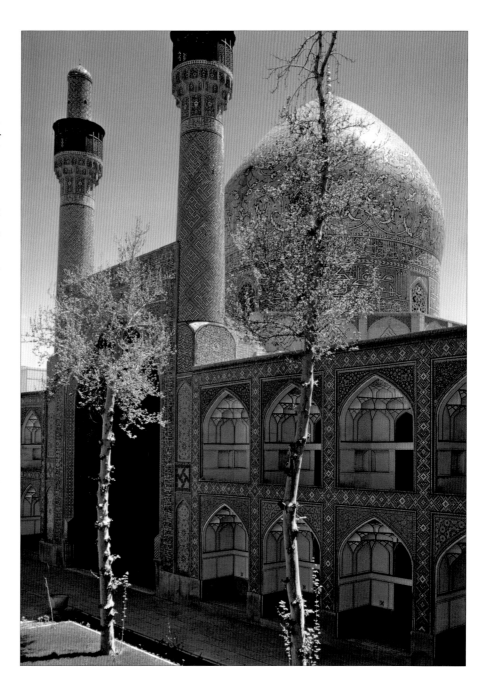

THE SULTAN HASAN COMPLEX

In Cairo, Egypt, the Mamluks built several splendid *madrasas*. Of these, the most celebrated is probably the Sultan Hasan mosque and *madrasa* complex, commissioned in 1356 by Mamluk Sultan Hasan. The sultan intended it to house teachers of all four legal schools in Sunni Islam: it has four *iwans*, one for teachers and students of each school, adjoining a large central courtyard. Its façade is extremely impressive and measures 36m (118ft) high and 76m (249ft) long. Only one of the original two minarets is still standing, but at 84m (275ft) high it is the tallest of all the minarets surviving from medieval Cairo. The other minaret collapsed during construction and killed 300 people.

Left When it was established in 1356–62, the mosque and madrasa *of Sultan Hasan was the largest structure ever built in Cairo, Egypt.*

MEMORIALS FOR THE DEAD

ORTHODOX ISLAM DISCOURAGES LAVISH FUNERARY MONUMENTS, BUT FROM THE 10TH CENTURY ONWARD MANY MUSLIM RULERS LEFT EVIDENCE OF THEIR WEALTH IN GRAND TOMBS AND MAUSOLEA.

Some of the most spectacular Islamic architecture was created in memory of the dead. The breathtakingly beautiful Taj Mahal at Agra in India – perhaps the most famous Islamic building – was built in 1632–54 by the Muslim Mughal Emperor Shah Jahan (reigned 1628–58) as a shrine for his favourite wife, Mumtaz Mahal. The mausoleum is set in gardens divided into four areas, with waterways, designed to represent the Islamic paradise.

THE *CHAHAR BAGH*

A tomb placed in a walled, four-part garden with flowing waters, as at the Taj Mahal, was called a *chahar bagh*, from the Persian words *chahar* ('four') and *bagh* ('garden'). It was originally a Persian garden scheme, first used by the emperors of the Achaemenid Empire (550–330BCE) and by Emperor Cyrus the Great (reigned 576–530BCE) in Pasargadae (now an archaeological site in Iran).

The *chahar bagh* design was pioneered in India by an earlier grand Mughal memorial structure, the Tomb of Humayan in Delhi, built to honour the second Mughal ruler Humayan (reigned 1530–40

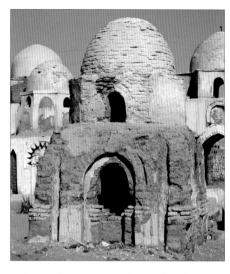

Above *The tombs in the Fatimid cemetery at Aswan are mostly modest square buildings with small domes.*

and 1555–56) by his widow Hamid Banu Begum. Other lavish Mughal mausolea with *chahar bagh* designs include Akbar the Great's tomb at Sikandra near Agra, built in 1612–14 by his son Jahangir (reigned 1605–27), and Jahangir's tomb, built c.1637 near Shahdara Bagh, Lahore, Pakistan.

Below *The Tomb of Humayan in Delhi was a forerunner of the Taj Mahal. The main chamber is beneath its dome.*

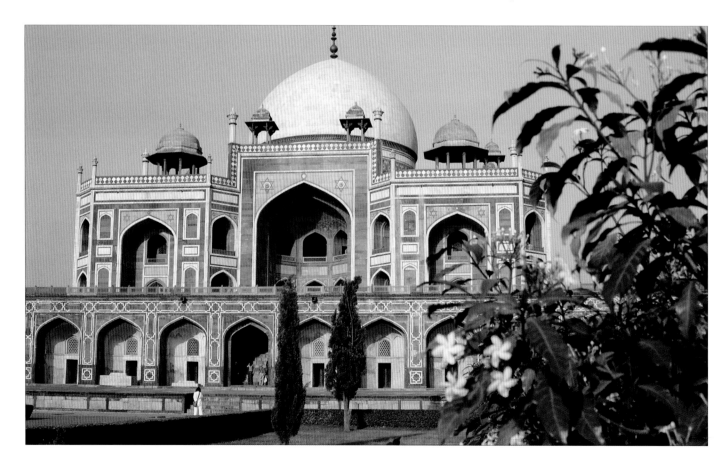

At Sasaram, an ornate mausoleum commemorates Pashtun ruler Sher Shah Suri who briefly overcame the Mughals to rule in Delhi 1540–45. His domed red sandstone memorial stands 37m (121ft) tall and – like the Taj Mahal, which it rivals in beauty – is reflected in a lake.

Farther afield, the Ilkhanid ruler of Iran, Uljaytu (reigned 1304–16), is commemorated at Sultaniyya near Qazwin, Iran, with a magnificent mausoleum dubbed 'the Taj Mahal of Iran'. With an elegant dome 53m (174ft) tall, it stood in a vast complex of buildings raised by craftsmen from all over the Ilkhanid domains.

FATIMID TOMBS

In the 11th and 12th centuries, Ismaili Fatimid rulers of Egypt and the Levant (909–1171) created the earliest surviving group of mausolea in Islamic history. At least 14 Fatimid-era mausolea survive in Cairo, Egypt, compared to just 5 Fatimid mosques. Several generations of Fatimid caliphs were buried in a tomb in the Eastern Palace in Cairo, which is now lost.

In Aswan, Egypt, an entire city of mud-brick mausolea was built under the Fatimids. In the early years of Islam, elaborate mausolea were not permitted, because the Quran teaches that tombs should be humble. One way around the religious restriction on building fine tombs was to identify them as celebrations of warriors fallen in *jihad*: the cemetery at Aswan is called 'Tombs of the Martyrs' but historians do not know whether or not it actually contained the bodies of those killed fighting for the faith.

The Aswan cemetery contains about 50 tombs in different forms and sizes. Many are compact, square buildings topped with small domes; some have adjoining courtyards. One type is known as the *mashhad* ('site of martyrdom' or pilgrimage shrine), and is a small domed

SIMPLE BURIALS

For all the exuberance exhibited in the impressive tombs and mausolea, both the Quran and Islamic law call for simple burial of the dead and discourage the use of lavish funerary monuments. The preferred mode of burial is to inter the body wrapped in a shroud, rather than placed in a coffin, with the head facing toward Makkah. Graves of this sort were often left unmarked or identified with simple grave markers.

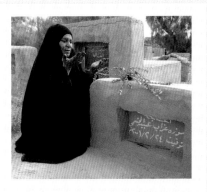

Above A woman prays at a cemetery in Iraq. Most Muslim graves are simple and unadorned.

building with a walkway around it. Two notable mausolea in this form, the Mashhad of Qasim abu Tayyib (c.1122) and that of Yahya al-Shabih (c.1150), were built under the Fatimids in Cairo.

SELJUK INNOVATIONS

The style of mausolea was changed by Seljuk rulers, who built *turbe* (square domed buildings) or *gunbads* (tomb towers). A fine

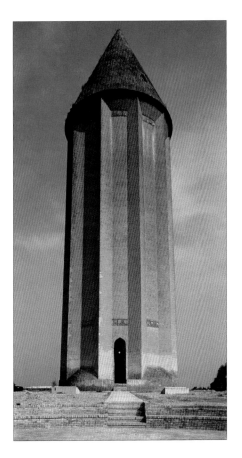

example of a *turbe* is the Gunbad-i-Surkh of 1147–48 in Maragha, Iran, decorated with mosaic faience tiles. Instead of being square, some *turbe* had 8, 10 or 12 sides, for example the decahedral (10-sided) mausoleum built for Seljuk Sultan Kilij Arslan II (reigned 1156–92) in the courtyard of the Ala al-Din Mosque in Konya (now in Turkey).

Most *gunbads* were tall towers with conical roofs: perhaps the finest of these is the Gunbad-i-Qabus built in 1006–7 in Gurgan, Iran, for Ziyarid ruler Shams al-Maali Qabus.

OTTOMAN SPLENDOUR

The mausolea of the Ottomans were impressive structures in vast complexes centred on mosques. The Suleymaniye Mosque complex (built 1550–57) in Istanbul, for instance, contains two mausolea in the garden behind the mosque; these house the remains of Suleyman I (reigned 1520–66) and his family, and those of Suleyman II (reigned 1687–91) and Ahmet II (reigned 1691–95). Also in Istanbul, the beautiful Blue Mosque (built 1609–16) likewise contains the tomb of its founder, Sultan Ahmet I (reigned 1603–17).

Left Ten triangular flanges shoot up the sides of the tomb tower Gunbad-i-Qabus, at Gurgan, Iran.

THE CITY

ISLAMIC RULERS MADE A PUBLIC DISPLAY OF THEIR POWER AND
AUTHORITY BY BUILDING GREAT GATEWAYS, PALACES AND CITADELS
– OR EVEN BY LAYING OUT ENTIRELY NEW CITIES.

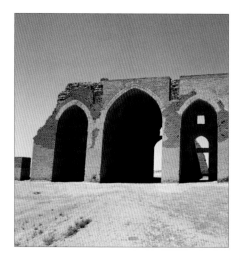

Above The Bab al-Amma in Samarra, Iraq, was once the gateway to the caliph's palace. The gateway stood at the top of steps that led up from the river Tigris.

Many major cities were established by Islamic rulers. In 762, the second Abbasid Caliph, al-Mansur, established Madinat as-Salam (the 'City of Peace'), now known as Baghdad, on the river Tigris in Iraq. The city was round and enclosed by three walls with a great gate at each of the points of the compass, which was named for the province or city that lay in that direction. Commercial and residential areas lay in the outer parts of the city, while at the centre of Baghdad stood the dynasty's imperial palace and mosque.

At Samarra, also on the Tigris in Iraq, al-Mansur's successor al-Mutasim (reigned 833–42) established a new royal capital in the years after 836. The city, which included several beautiful palaces as well as the inspiring Great Mosque, extended no less than 32km (20 miles) along the banks of the river Tigris. The name, according to medieval Islamic historians,

meant 'A delight for all who see it'. Samarra served as the capital city until Caliph al-Mutamid (reigned 870–92) returned to Baghdad.

Other examples of splendid new cities built to glorify rulers and dynasties include: Cairo in Egypt, founded in 969 by the Fatimid dynasty; Madinat al-Zahra near Córdoba in Islamic Spain, built in 936–40 by exiled Umayyad Prince Abd al-Rahman III; and Sultaniyya in north-eastern Iran, built by Ilkhanid ruler Uljaytu (reigned 1304–16). Little remains of these early structures, but magnificent monuments and complexes that were built from the 15th century onward, notably in Iran, India and Turkey, have survived.

MUGHAL GLORIES

In India, Mughal Emperor Akbar 'the Great' built Fatehpur Sikri as a new capital in 1569 to celebrate the longed-for birth of a male heir – the future Emperor Jahangir – and

raised the monumental Gate of Victory in front of the Courtyard of the Great Mosque. He built the city on the site of the camp previously occupied by Sufi mystic and saint, Salim Chishti (1478–1572), who had blessed Akbar and thereby apparently brought about the birth of Jahangir. The courtyard contains the Tomb of Salim Chishti, which

Below The elegantly domed Shaykh Lutfallah Mosque, built 1603–19, stands on the eastern side of the vast Naqsh-e Jahan Square in Isfahan, Iran.

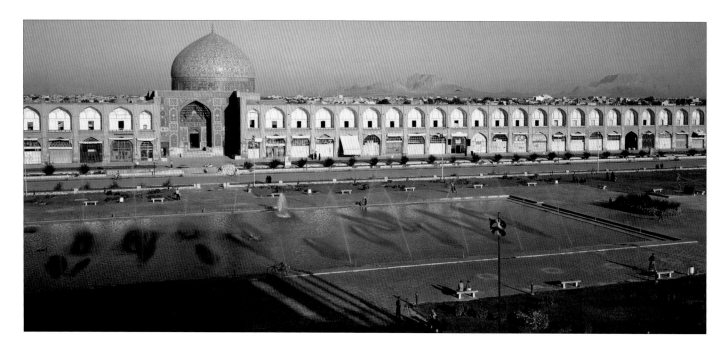

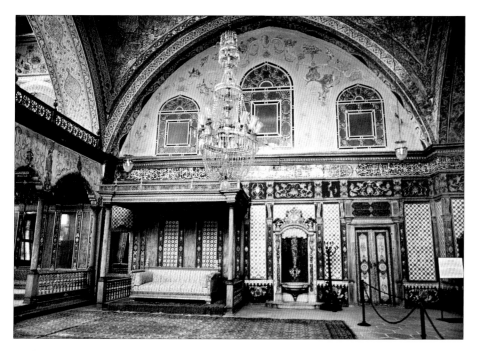

Left The Imperial Hall is part of the harem in the Topkapi Palace, Istanbul. The mother, wives, concubines and children of the Ottoman sultan lived in luxury in the harem's lavish quarters.

Akbar built in red sandstone but which was refashioned as a marble mausoleum. The city was largely abandoned later.

WONDERS OF ISFAHAN

In Iran, Shah Abbas I the Great (reigned 1587–1629) built new monumental quarters in the city of Isfahan to demonstrate the greatness and prosperity of the Safavid dynasty. He built mosques, bathhouses, bazaars, parks, bridges, palaces and shops. In the centre he laid out the palace, congregational mosque and Grand Bazaar around a vast open space known in Persian as Maidan-e Shah (now Maidan-e Imam). A popular phrase at the time was *Isfahan nesf-e jahan*: 'Isfahan is half the world', referring in part to its splendour and also to the presence of a large international community.

A CITY TRANSFORMED

In Turkey, the Ottoman emperors set about remaking the ancient Christian city of Constantinople as the capital of an Islamic empire, eventually renaming the city Istanbul. Mehmet II began the rebuilding after he conquered the city in 1453, making a bold statement of the greatness of the Ottoman sultan and his religion in the Grand Bazaar, the Topkapi Palace, the Fatih Mosque complex and the Eyyüp Sultan Mosque. A substantial part of the Ottoman rebuilding was carried out through the construction of complexes of buildings centred on mosques and containing hospitals, *madrasas, caravanserais* and other structures.

The Topkapi Palace, begun by Mehmet II in 1459, was not a single imposing building like a typical European palace, but instead consisted of a network of several small buildings, some plain and some practical, such as kitchens, but many splendid and lavishly decorated. The Topkapi Palace remained the residence of Ottoman sultans until 1853, when Sultan Abdulmecid I moved to the newly constructed, European-style Dolmabahçe Palace.

CITADELS

Set behind fortified walls the buildings of the Topkapi Palace are an example of an architectural feature unique to Islam – an enclosed city within a city, called a citadel. The Alhambra, built in Granada (southern Spain) by the rulers of the Nasrid dynasty in 1238–1358, is another well-preserved example of this feature.

The citadel in Aleppo, Syria, stands on a partly natural, partly man-made mound that dominates the city. The mound was fortified from ancient times, then the citadel was developed for military uses. Substantially rebuilt in the 12th century by Zangid rulers Imad al-Din Zangi and Nur al-Din, it was remade in the form in which it survives today by Ayyubid ruler al-Malik al-Zahir Ghazi (son of Saladin) in 1186–1216. He strengthened the walls, redug the moat around the citadel, built the bridge across the moat and furnished the citadel with all the necessities of urban life, including granaries and cisterns.

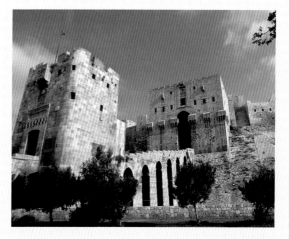

Above At Aleppo, al-Malik rebuilt the entrance block in 1213 as part of his work on the citadel. The arches are those of the bridge across the moat.

TRADE AND TRAVEL

THE MUSLIM TRADERS AND PILGRIMS WHO TRAVELLED VAST DISTANCES ACROSS THE ISLAMIC WORLD RELIED ON A NETWORK OF HOSTELRIES, CISTERNS, MOSQUES AND MARKETS.

From the early days of Islam, Muslim travellers made long journeys across inhospitable lands. Travel and trade were part of their heritage: the Prophet Muhammad came from a trading family, and the wider Islamic world is strongly dependent on lively international trade. The Quran recorded Allah's blessing on mercantile transactions: 'It is no sin for you that ye seek the bounty of your Lord by trading' (Surat Al-Baqarah: 198).

A WELL-TRAVELLED FAITH

The Islamic faith spread through military conquest, but it was also carried by merchants and scholars who travelled. Most significant of all, thousands of Muslims set out for Makkah each year, obedient to the demand of their faith that they make a pilgrimage to the *Kaabah* at least once in their lifetime.

Because of all this traffic, trade and pilgrim routes were well trodden and well maintained; the great cities depended on the safe arrival of trade caravans and Islamic rulers invested in the necessary infrastructure. People generally travelled in camel caravans. Getting lost was not usually a danger, because there were some directional markers and watchtowers. However, people needed water and a safe place to rest. *Caravanserais* were secure roadside shelters along the route, where travellers and their animals could sleep, rest, wash, water themselves and worship Allah.

THE *CARAVANSERAI*

Typically, a *caravanserai* consisted of a square enclosure with a single gateway big enough to allow access to heavily laden camels and, within,

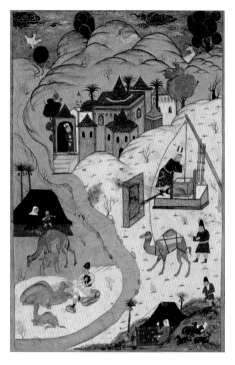

Above A caravanserai *provides a haven, promising weary travellers a chance to recuperate, in this illustration from a 16th-century Ottoman manuscript.*

individual rooms and stalls arranged around a large open courtyard; there were separate stables for the animals. There was a well or cistern to provide water for drinking and ritual washing; some *caravanserais* had bathhouses. There was also a mosque, usually a raised building in the centre of the courtyard with a fountain for ablutions beneath. There were shops or a market area for travellers to buy or sell supplies.

In Turkey, the Seljuks built a great network of *caravanserais*: around 100 survive today and there may once have been up to 400 on the trade routes across Anatolia. These are usually called *hans* (*han* is a Turkish variant of '*caravanserai*'). In a typical *han* layout there was a large main gateway leading to an open courtyard, behind which there was a second gateway leading

Left A 17th-century detail from a map of Africa shows the camel train of a trade caravan making its way from one oasis to another across the Sahara.

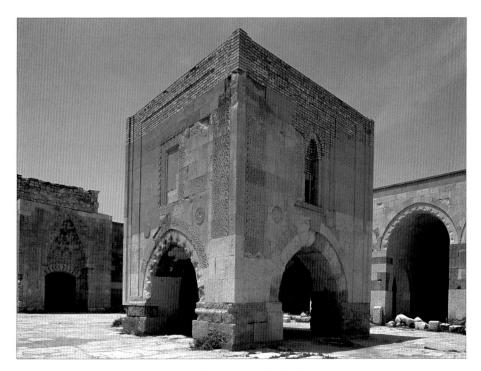

Above The mosque in the han *built by Seljuk Sultan Ala al-Din Kaykubad I between Konya and Aksaray was raised above the courtyard on arches.*

into a covered hall whose flat roof was used as sleeping space in summer. Perhaps the grandest of the Seljuk *hans* are two called 'Sultan Hans', built near Konya (now Turkey) by Seljuk Sultan Ala al-Din Kaykubad I (reigned 1220–37). The one on the road between Konya and Aksaray, dated to 1229, has an elaborately decorated stone gateway and covers 4,900sq m (52,743sq ft). It is the largest *caravanserai* in Turkey. The second, on the road between Kayseri and Sivas, was built in 1236.

In the Ottoman era, a number of *caravanserais* were built on the pilgrim route between Damascus and Makkah. Elsewhere, the Ottomans often built *caravanserais* as part of a *kulliye*, a complex of buildings centred on a mosque. The Tekkiye in Damascus, designed by the great architect Sinan for Sultan Suleyman I in the 1550s, is a fine example in which the *caravanserai* was used by *Hajj* pilgrims before they left for Makkah and after they returned.

KHANS

In urban centres, the equivalent of a *caravanserai* was a *khan*. This was more like a storehouse than a rest stop, and it often provided greater space for the storage of merchants' goods than for accommodation. Generally, the *khans* were built over several storeys, with the bottom and next floor up used for storage.

Several *khans* were established alongside *madrasas*, or religious colleges, and their profits paid for the religious and legal education of young Muslims. Examples include the splendid *khan* built by Mamluk Sultan Qansuh al-Ghuri in Cairo in 1504–5. It was laid out around a courtyard over five floors, with the lower two set aside for storage and the upper three rented out to merchants as accommodation; profits funded the sultan's adjacent *madrasa*. Similarly, the Khan Mirjan in Baghdad built in 1359 by Amin al-Din Mirjan, wali (or governor) of Baghdad under Shaykh Hasan-i Buzurg (founder of the Jalayirid dynasty of Iraq and central Iran), combined storage space below with extensive accommodation above and paid for the Mirjaniya *madrasa* (1357).

BAZAARS

Goods stored in the *khan* were sold in the market or bazaar. In an Islamic town or city, the bazaar typically consisted of a network of enclosed shopping streets, with a central secure area that could be locked at night, and one or more *hammams*, or bathhouses. The bazaar was located near the congregational mosque, which was at the centre of the community.

Major bazaars survive in several great Islamic cities, including Istanbul, Cairo, Isfahan, Damascus, Tehran, Delhi and Mumbai. The Grand Bazaar, or Kapali Carsi ('Covered Market'), in Istanbul contains 58 streets and 6,000 shops; the earliest of its two domed *bedesten* (secured areas) was raised in 1455–61 under Sultan Mehmet II 'the Conqueror'. The market was substantially extended under Sultan Suleyman 'the Magnificent' (reigned 1520–66). In Cairo, the Khan al-Khalili bazaar has its origins in a *khan* built in 1382 by Amir Jaharks al-Khalili in the reign of Mamluk Sultan Barquq (reigned 1382–89 and 1390–99).

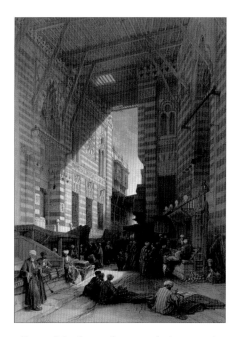

Above Merchants lay out their wares in a bazaar in Cairo in this 19th-century painting by David Roberts.

HAJJ: PILGRIMAGE TO MAKKAH

OVER THE CENTURIES, MILLIONS OF MUSLIMS HAVE MADE THE *HAJJ*, THE PILGRIMAGE TO MAKKAH THAT IS REQUIRED ONCE IN A LIFETIME OF ALL ABLE-BODIED MUSLIMS WHO CAN AFFORD IT.

Before the advent of railways in the 19th century, and of cars and aircraft flights in the 20th century, the *Hajj* often involved travelling in a camel caravan for months at a time, across deserts in punishing heat and under constant threat of attack by bandits. The routes followed by *Hajj* pilgrims in earlier centuries can be traced by examining the network of forts, *caravanserais*, mosques, paved roadways, cisterns, direction markers and milestones built to support them. A sense of the *Hajj* in medieval times can be gained from the writings of adventurers such as the Berber traveller Ibn Battuta (1304–77), who made the *Hajj* four times, and by examining Ottoman travel guides and prayer books.

DESERT ROUTES

Hajj pilgrims came from all over the Islamic world and they made the last part of their journey across Arabia to Makkah following set itineraries. There were six main routes. One went from Damascus in Syria, one from Cairo in Egypt by way of the Sinai Desert and one from Baghdad through Basra in Iraq. For those arriving by boat across the Arabian Sea south of the

Above The pilgrims' goal is the sacred stone of the Kaabah *in Makkah. This illustration of Muslims at the* Kaabah *is from the 15th-century Persian classic* Haft Awrang *(Seven Thrones).*

Arabian peninsula, there were three routes: two from Yemen, one along the coast and one inland, and one from Oman.

THE WAY FROM DAMASCUS

The principal routes were those from Iraq, Syria and Egypt, and of these the oldest was the one from Damascus, capital of the Umayyad Caliphate. Major sites on the route through Jordan include the city of Humayma, the square fortress and mosque of Khan al-Zabib, and palaces at Ma'an and Jize, which seem to have been used by leading Umayyads when on pilgrimage and perhaps as *caravanserais* to host passing dignitaries. Both were near large ancient Roman reservoirs.

The route lost importance after the caliphal's capital moved from Damascus to Baghdad in the 8th century, but it remained in use for many centuries. The Mamluks built

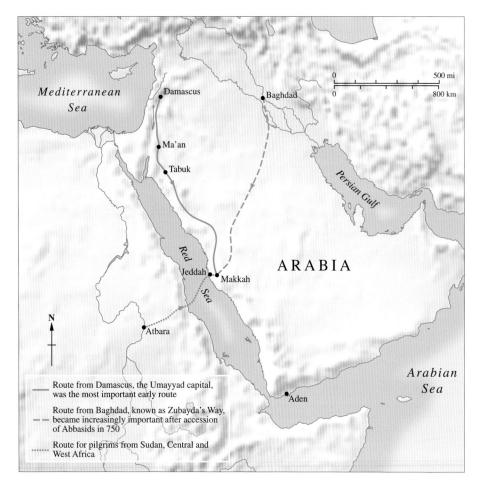

Route from Damascus, the Umayyad capital, was the most important early route

Route from Baghdad, known as Zubayda's Way, became increasingly important after accession of Abbasids in 750

Route for pilgrims from Sudan, Central and West Africa

Left The main Hajj *pilgrimage routes to Makkah. The most used early route was from Damascus.*

forts along it, such as those at Zerka and Jize. In the 14th century, Ibn Battuta followed this route on his first *Hajj* journey, taking the inland route parallel to the western coast of the Arabian peninsula. He travelled the 1,350-km (840-mile) journey from Damascus to the holy cities in a large camel caravan in about 50 days.

On Ibn Battuta's first *Hajj* pilgrimage, and typically for that era, a desert caravan was like a travelling city, a group bound by a common geographical and religious goal that stayed together for six or seven weeks. There was a *muezzin* to call the travellers to prayer, Imams to lead the prayers and *qadis*, or judges, to provide resolution if disputes arose. Typically, there were also clerks, weavers and physicians; ambassadors and merchants; and poets, singers and artisans. Soldiers and guides travelled with the caravan to provide protection from desert bandits.

Some parts of the route were over the shifting sands of the desert, but in other areas the way was well trodden and there was little danger of getting lost. The travellers made their way from one oasis to another, staying overnight or sometimes for a few days' rest in each one. In the oases, the dwellers cultivated figs, oranges, peaches, apricots, pomegranates and lemons.

FORTS AND CISTERNS
Under the Ottomans, forts and cisterns were built along the Damascus–Madinah/Makkah route and garrisoned with troops. The forts guarded the cisterns and provided protection for pilgrim camps alongside them against attacks by Bedouin raiders.

Right In a Hajj *caravan, people from many backgrounds lived together for weeks at a time. This Ottoman illustration is based on a 13th-century painting.*

The Ottomans upgraded these facilities in the 18th century and again in the early 20th century, when a railway was laid along the entire Damascus to Madinah route, with new forts to protect key sites.

BAGHDAD TO MAKKAH
In the 8th century, after the Abbasid caliphs established a new capital at Baghdad on the banks of the river Tigris in Iraq, they drove a new *Hajj* route through the desert to Makkah. Zubayda bint Jafar, wife of Caliph Harun al-Rashid (reigned 786–809), paid for a network of wells, reservoirs and other facilities along the way, which was dubbed Darb Zubayda ('Zubayda's Route') in her honour. Archaeologists have identified more than 50 stopping points on the route: these always included a cistern for watering camels (and drinking water for pilgrims) and often also consisted of a fort or

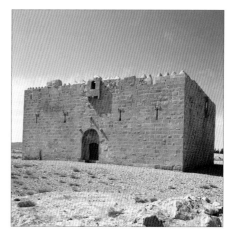

Above This fort at Qatrana in Jordan was built in 1559, one of the network of forts built by the Ottomans along the Hajj *route from Damascus to Makkah.*

palace, plus a residential area and a mosque. The most important of the sites is al-Rabadah, a substantial desert city. Mosques have been excavated at al-Qac and Zubalah, and palaces have been studied at Al-Ashar and al-Shihiyat, as well as at al-Qac and Zubalah.

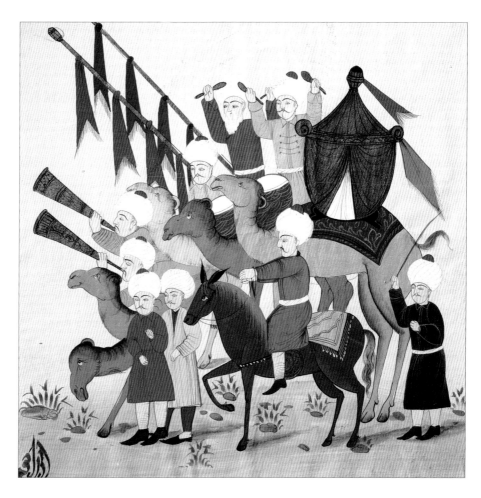

CALLIGRAPHY

THE MOST HIGHLY ESTEEMED ART FORM IN ISLAMIC CULTURE IS CALLIGRAPHY, PRIMARILY BECAUSE OF ITS SIGNIFICANT ROLE IN TRANSCRIBING THE WORD OF ALLAH, AS WRITTEN IN THE QURAN.

By reproducing the Quran's holy words, the calligrapher was held in the highest respect – far above other crafts and specialist artistic skills. The honour accorded for copying out a text of such spiritual and legal importance reflected the great responsibility of such a task. The writing itself also took on a spiritual quality, as did the *qalam*, or reed pen; in fact, one of the chapters of the Quran is called *Surat al-Qalam*, or 'the Pen'.

A scribe should always pray before commencing the copying of Quranic verses, which should be reproduced without any adulteration whatsoever. Important demands were also made of the Arabic script itself: it had to be legible, respectfully beautiful and unambiguous, worthy to record the word of God. Calligraphic reforms were undertaken in the 10th and 11th centuries on this basis: improvement to the legibility and gravitas of the written Quran was not only spiritually meaningful, but politically expedient.

ARABIC SCRIPT

One of the earliest Arabic scripts, used in the first Qurans, is usually referred to as kufic. Initially, art historians linked it exclusively with the Iraqi city of Kufa, but this is no longer considered the case. It is a dense rectilinear script, which was often written without the use of diacritics (marks appended to letters) or other conventional orthographic signs, so it could be difficult to read and potentially lead to variant readings of the authoritative sacred text.

In the 10th century, government reforms in Baghdad corrected this issue, and a new *khatt al-mansub*, or proportioned script, was developed under the supervision of the wazir (minister) Ibn Muqla (886–940). Six canonical cursive (joined-up) scripts emerged, known as the *sitta qalam*, or 'Six Pens', and these became the standard repertoire of a professional calligrapher. By the 11th century, cursive script was considered good enough to be used to copy out the

Above This page of Persian verses copied in nastaliq *script by Mir Ali of Herat was decorated and mounted in a 17th-century Mughal Indian album known as the* Minto Album.

Quran: the earliest extant example was executed in *naskh* by the calligrapher Ibn al-Bawwab.

LEARNING CALLIGRAPHY

Calligraphy was only taught to an apprentice by a master. The student had to learn to reproduce the canonical scripts with perfection, with absolutely no variance from the script of the teacher. The moment of graduation was usually the point when the student could truly replicate his master's hand. Great calligraphers kept proud note of their lineage from renowned masters, down generations of teachers and students. For example, the famous calligrapher Yaqut al-Mustasimi (d.1298) had six pupils, later known

Left This page from a 9th-century Quran was written in Kufic script on vellum; it has an illuminated gold roundel in the margin.

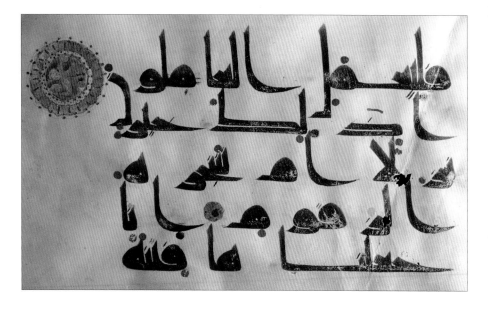

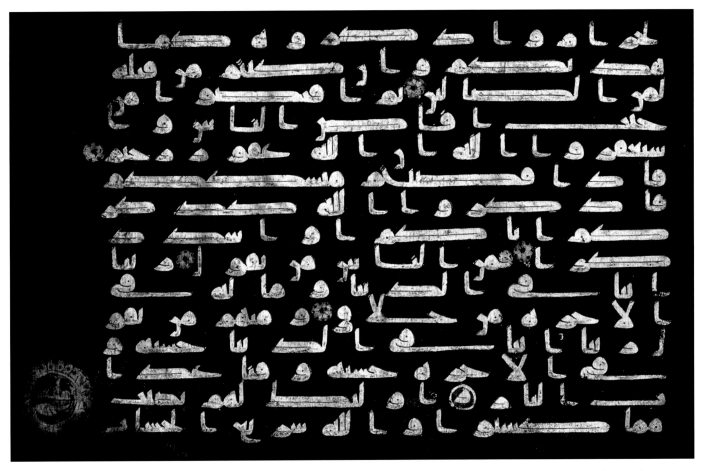

Above A page from a unique 10th-century Quran, known as the Blue Quran, was written in gold Kufic script on indigo-dyed vellum.

simply as *sitta*, or 'the Six', from whom calligraphers in Timurid, Safavid and Ottoman times could still trace their descent.

As Islam spread across Western Asia, Arabic script was adopted to write other languages used in the wider Muslim world, such as Persian and Ottoman Turkish. Slight adaptations were necessary to provide new letter forms for Persian and Turkish sounds that did not feature in Arabic, such as 'ch' and 'v'. The fine art of calligraphy continued to be practised in the written literature of these other languages, and indeed a Persian calligrapher, Mir Ali, is credited with inventing a new style of (Arabic) script, entitled *nastaliq*, or hanging *naskhi*. This elegant, somewhat italicized script became the characteristic mode for Persian poetry.

Above The thuluth *script around the neck of this mid-14th-century enamelled glass mosque lamp quotes the Surah of Light from the Quran.*

A DECORATIVE ART

The art of the pen was not limited to the written page, and calligraphy is found in almost every decorative medium: apt quotations of Quranic verses on a mosque façade, poetry on a jade drinking cup and informative details about the object's production, such as a patron's name, the artist's signature or the date it was made. Playful script also appeared in the decorative arts, such as 'knotted Kufic' with plaits or braids adjoining letters, or anthropomorphic text that features human faces peering out from tall letters. The beauty of the script and the prominence of epigraphy demonstrate that text was not just literally informative but also important to the decorative value of the object.

ORNAMENT

ISLAMIC ART AND DESIGN WERE SHAPED BY CERTAIN RESTRICTIONS ON THE DEPICTION OF THE LIVING IMAGE. THIS LED ARTISTS TO DEVELOP STYLIZED FORMS TO GREAT EFFECT.

Figurative art, so important in the Christian tradition, has always been among the least important aspects of Islamic art. Strictly speaking, the creation of living forms is believed to be unique to Allah, so instead of seeking to produce convincing representations of the world on religious objects, Islamic artists created images that were either stylized or abstract, geometric, visibly unreal. Although this restriction obviously limited the scope of narrative themes, the sheer versatility of the designs proved inspirational, and craftsmen realized that the patterns employed in ceramics or metalwork could work equally well on other materials, such as glassware or tiles. This adaptability was sometimes reflected in the name of the design. For example, the ornamental pages in illuminated manuscripts were dubbed 'carpet pages', because of their debt to textile styles.

Above An end-piece from a Quran of 1568, produced for the Sharifi Sultan of Morocco, includes complex patterns constructed around a simple, geometric shape – a radiating star.

GEOMETRIC PATTERNS

One of the most recognizable and typical forms of Islamic art is geometric design, which is used with great symmetrical precision across the media, in art and architecture. Craftsmen utilized a simple repertoire of shapes – circles, squares, stars, lozenges, hexagons – but assembled them in patterns of dazzling complexity. Larger compositions could achieve the mesmeric effect of an optical puzzle, as the viewer struggled in vain to work out the underlying design. Similarly, in an architectural context, long stretches of geometric patterns could act as a shimmering screen, concealing the physical structure that lay beneath. The walls of the courtyard in the Yusuf *madrasa* at Marrakech in Morocco provide a typical example.

Perhaps the most popular of all the motifs was the star. The most common version was the eight-pointed star, formed out of a square rotating around a circle; however, the number of points could be

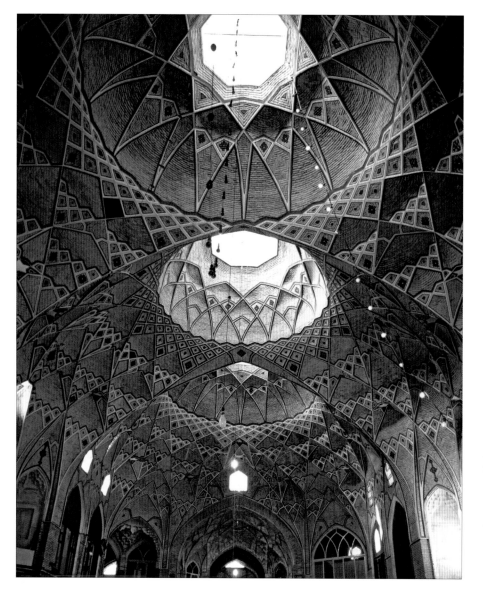

Left A vaulted arcade from the carpet bazaar in Qom, Iran, displays waves of muqarnas decoration, rippling out from the apertures in the centre of each dome.

increased considerably. Radiating stars were used as basic components in a huge variety of designs: from the marginal decorations in illuminated manuscripts to a brickwork façade or the base of an earthenware bowl. Some of the most intricate examples can be found in Egyptian woodwork, especially in the ornate *minbars* (Islamic pulpits), where they were combined with ivory inlays.

The most distinctively Islamic form of geometric decoration was *muqarnas*, or stalactite vaulting. This was used to create a rich, honeycomb effect in vaulted ceilings. The most celebrated examples can be found in the halls of the Alhambra, in Granada, Spain.

STYLIZED FORMS

The portrayal of living creatures was not considered appropriate for the spiritual context of mosque furnishings or Quran decoration, but stylized plant and floral decoration was always permitted. Many figural themes were adapted from pre-Islamic Iranian or late classical Byzantine models, and from at least the 13th century, there was a strong tradition of illustrating the great works of history, poetry and science with lively manuscript-paintings. The depiction of human figures on art objects, such as tilework, textiles and tableware for non-sacred contexts, went in and out of fashion.

THE ARABESQUE

The one motif that is most closely associated with Islamic art is the arabesque. In essence, this was a form of leafy scrollwork, composed of tightly packed, S-shaped tendrils. The inspiration

Above A fine example of 16th-century Iznik tilework, from the Circumcision Chamber in Topkapi Palace, Istanbul, includes birds, peonies and lotus flowers.

Above Flowers were popular motifs, such as the one on an Iznik tile from the Selimiye Mosque, built under Selim II (1566–74) in Edirne (Turkey).

seems to have come from the bands of vine and acanthus decoration popular in the classical world. Early hints of this influence were apparent in the 8th century, in the stonework decoration on the Umayyad Palace of Mshatta, in Jordan.

Over the centuries, designers transformed this pattern by making the interwoven coils more dense and intricate. At each turn, the winding stems split off into new shoots, which in turn spiralled off into ever more complex scrolls. In their most extreme form, arabesques lost their vegetal form and dissolved into geometric abstraction. Alternatively, overlapping arabesques could be used to create a sense of depth in a design scheme.

Arabesques were employed in a wide variety of media, but some of the most spectacular examples can be found on the polychrome tiles that adorned mosques and *madrasas*. Here, they were often combined with Chinese motifs, such as cloud bands.

CHINESE MOTIFS

Islamic craftsmen borrowed a range of Chinese imagery, particularly after Mongol invasions during the 13th century, when large quantities of blue-and-white porcelain were imported. The most common motifs were floral. Peonies and lotus blossoms were especially popular, finding their way into pottery designs, Mamluk metalwork and illuminated manuscripts. The oriental taste for fabulous creatures also made an impact, and stylized dragons began to appear on tiles, while the *simurgh*, a mythical Iranian bird, was transformed into a Chinese phoenix.

THE LIVING IMAGE

FIGURAL REPRESENTATION WAS FREQUENTLY USED IN THE LUXURY
ARTS OF THE ISLAMIC WORLD, THOUGH ORTHODOX DISAPPROVAL OF
IMAGERY AFFECTED ART PRODUCED FOR SACRED USAGE.

It is often believed that figural images are prohibited in Islamic art, but this is not the case. The Quran forbids the use of idols for religious worship. It does not ban figural representation. However, statements in *hadith* literature do speak out against the depiction of living creatures, and condemn the artist for seeming to create a living form, a power exclusive to God. For both of these reasons, images are never used in the Quran, mosque decoration or any strictly religious context in Islamic art. Instead, sacred art and architecture are decorated with geometric designs, scrolling stylized leaves and flowers, and calligraphy – usually quoting Quranic verses.

FIGURATIVE ART

Outside of the sacred realm, pictures of people, animals and birds have been produced throughout Islamic art history, from Spain to India, in almost every decorative medium. Even three-dimensional sculpture was known: incense-burners, ewers, fountainheads and other figurines in the shape of animals and birds, as well as high-relief stucco wall panels. Particularly popular in the 11th–14th centuries, figures and animals are the main decorative theme of Cairene lustreware, rock crystal and ivory, Kashan lustreware and *minai* ceramics, and inlaid metalwork from Mosul, to name only a few centres of production.

Right The surface of this 12th–13th-century Spanish bronze lion fountainhead is engraved with inscriptions expressing good wishes to the owner.

THEMES AND MOTIFS

Typical subjects dwell on aspects of court life: drinking with musical entertainment and dancers, romantic encounters, hunting on horseback, and formal throne scenes, where visiting dignitaries are received. Motifs of hunting animal pairs, such as a lion attacking a deer, were also commonly used. They reinforce the theme of power, and the ruler's right to it.

Many figural themes show artistic continuity from pre-Islamic times: Samanid polychrome ceramics made in the 10th century in north-eastern Iran seem to favour royal images recalling the pre-Islamic Sasanian empire of Iran.

Above A portrait of the physician and author Dioscorides appears in this 1229 Arabic translation of Dioscorides' De Materia Medica.

In 10th–12th-century Egypt, Fatimid art shows a vogue for genre scenes, such as wrestlers, which may refer to inherited, classical traditions.

MANUSCRIPT PAINTING

Across the Islamic world, figure painting can be seen in luxury manuscripts. Books have long been treasured in the Middle East, and many bibliophile rulers and civilians collected books with passion. Historic libraries are recorded

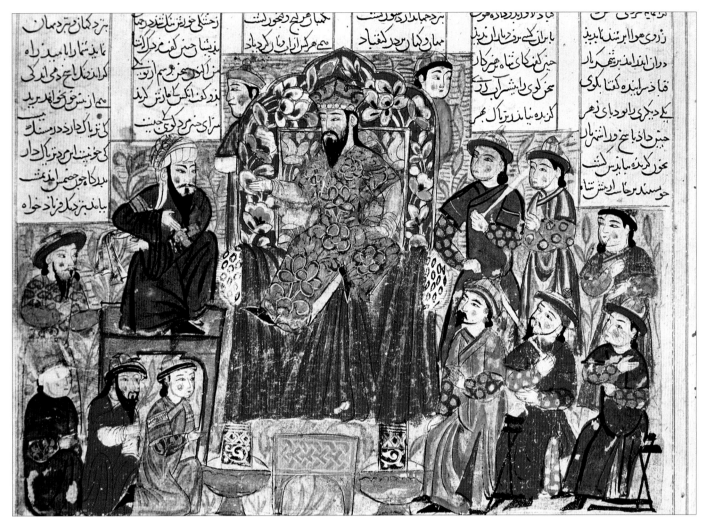

having thousands of volumes, and royal and private collectors often made their collections available to visiting scholars.

These were works of science as well as fine literature: the earliest surviving manuscript paintings from the Islamic period are geographical maps, diagrams of the constellations, plants, animals and even mechanical automata. Scientific illustration also extends to scenes of doctors and scholars at work: harvesting medicinal plants, treating a patient or consulting with other sages. The frontispiece portrait usually depicts the author in the company of his patron, whose support is thus acknowledged. This relates to the late classical genre of author portraiture, carried over into the Islamic world. The author's portrait was gradually replaced by that of his patron.

Above The subject of this 1330 illustration from the Shahnama (Book of Kings) by Firdawsi is a king and his court.

LITERARY PORTRAITS

As long as their patrons could afford the expense, works of literature written in Arabic, Persian and, later, Turkish were also furnished with paintings: history, romantic poetry and heroic epics all provided apt subjects for illustration. Luxury copies of the classic Persian works by Firdawsi, Nizami and Sadi were made for rulers and the rich over the centuries, and Persian manuscript painting was produced to an exquisite level. The patron's portrait in the frontispiece remained a standard part of the book, and often provided an insight into the court world, showing princes, guests and entertainers with detail to their furniture, tableware and architecture.

Above This 17th-century Isfahan copy of a 10th-century treatise on the stars discusses the constellation Bootes.

THE PRINCELY CYCLE

THE MOST FREQUENT FIGURAL SUBJECT IN ISLAMIC ART IS A THEMATIC RANGE REFERRED TO AS THE 'PRINCELY CYCLE', DESCRIBING THE PLEASANT PURSUITS OF COURT LIFE.

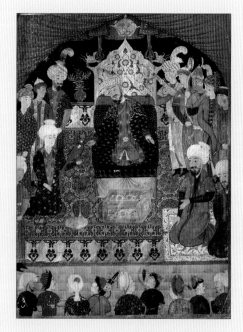

The theme of the princely cycle can be found throughout the various forms of media in Islamic art, most particularly in those produced before the 15th century. Works of inlaid metal, painted ceramics and especially frontispiece painting dwell upon the portrayal of the ruler and his world. In an attempt to show the appropriate reverence to royalty, the prince is usually depicted slightly larger than his surrounding courtiers, attendants and guests.

BANQUETS

While the series illustrates court pleasures, such as hunting and banqueting, it often draws attention to the ruler's central power by using imposing compositions. The theme of feasting may take place in a palace interior or at a picnic in the royal gardens. This is depicted with a series of party guests, each sitting with legs crossed and wine cup in hand. The role of the *al-nadim* (boon companion) was to provide good company at court, with intelligent conversation and handsome appearance. Attendants stand ready with trays of food and more wine. The entertainment includes musicians performing with a range of instruments (lute, tambourine, flute, harp), dancers (holding long trailing scarves in their hands) and sometimes even acrobats.

This series is typically used to decorate items of luxury tableware, such as inlaid metalwork, probably intended for actual events of convivial hospitality. An assembled company of companions, dancers and musicians would transform a gathering with their respective talents, both in reality and again on the decorated surface. In that intended context, these decorative scenes of spectators and entertainers would reflect their real setting.

HUNTING

The dominance of the hunter over his prey is central to ancient pre-Islamic iconography of the princely ruler, who was often portrayed in the princely cycle hunting wild animals. The ruler and his friends

Above A court assembly is shown in this manuscript painting from a late 15th-century copy of the Shahnama *by Firdawsi.*

ride on horseback in pursuit of game (usually deer or wild ass), hunting with dogs and shooting with bow and arrows. The hunters also use falcons for hunting water birds or rabbits, and even tame cheetahs for larger quadrupeds.

PRINCELY POWER

These hunting scenes often showed a range of animals, sometimes in specific predator-and-prey pairs: for example, dog and hare, lion and deer, as well as mythical beast pairs,

such as the griffin and sphinx. In these images, the political power of the prince was shown to be as 'natural' as the power of predators in the animal world.

ILLUSTRATING AUTHORITY

The royal audience was another strong theme in the princely cycle. The ruler is shown seated on a high-backed throne, usually at the centre of the composition. The throne is often flanked by soldiers, and in some versions winged spirits hold a canopy over the ruler to signify honour. Ranks of courtiers observe the scene, while visitors kneel or bow at the throne.

Above A pair of 19th-century Iranian tiles depict two noblemen hunting, one with a falcon, the other with a bow and arrow.

Left An 11th-century stucco panel from Iran depicts a ruler being attended by servants, and is framed within a 12-pointed star.

***Below** This section of a carved ivory panel, made in Egypt or Syria in the 12th century, illustrates scenes from a hunt, one of the many pleasures of court life.*

The whole composition is deliberately designed to affirm and idealize authority and power.

A variant of the throne scene was included in some luxury manuscripts as the frontispiece illustration. The ruler is shown sitting in majesty, receiving the book from the author. By crediting him as the all-important sponsor of the work in this way, the artist places the ruler at the forefront of a major intellectual endeavour, thus endowing him with academic glamour.

THE UMAYYAD CALIPHATE

The first caliphal dynasty of the Islamic empire was founded by al-Muawiyah of the Umayyad clan in 661 and lasted for 90 years. A former governor of Syria, al-Muawiyah ruled from Damascus, where he set about establishing the governance and profile of the new Islamic empire. The grandeur of Umayyad imperial architecture – seen at its most beautiful and imposing in the Dome of the Rock in Jerusalem and the Great Mosque in Damascus, as well as in several luxurious and richly decorated desert palaces – demonstrates a strong sense of competition with past regimes and religions. When establishing features of the new state, such as coinage and architectural design, however, Umayyad rulers also borrowed from defeated predecessors, such as Sasanian Iran and Byzantium. In the Dome of the Rock and the Great Mosque, there are many typical Byzantine elements, not least the use of wall mosaics, as well as essential Islamic qualities, such as calligraphy and the preponderance of decorative patterns based on plant motifs. Gradually, however, a distinct Islamic aesthetic emerged.

Opposite The mosaic decoration in the inner courtyard of the Great Mosque of Damascus, built by Umayyad Caliph al-Walid I in 706–15, represents Roman-style buildings beneath great trees.

Above *A fresco in the bathhouse area of the Umayyad desert palace of Qusayr Amra in Jordan (c.712–15) depicts wild animals. The artists were influenced by late classical traditions.*

THE UMAYYAD PERIOD

THE UMAYYADS WERE THE FIRST ISLAMIC RULERS TO ESTABLISH A
DYNASTY (661–750). THEIR BUILDINGS PROMOTED THE AUTHORITY
OF THE REIGNING FAMILY, AS WELL AS THE YOUNG FAITH OF ISLAM.

The first member of the Umayyad family to become caliph was Muawiyah I, a provincial governor who challenged the authority of Ali ibn Abi Talib, the Prophet's cousin and son-in-law, as ruler of the Islamic world.

Muawiyah did not take power until 29 years after the Prophet Muhammad's death, in 632. Abu Bakr, a companion of the Prophet and an early convert to Islam, had been chosen as the caliph, or successor, to be both religious leader of Muslims and political ruler of the Islamic world.

Shortly before his death in 634, Abu Bakr nominated Umar ibn al-Khattab as the next ruler. In 644, Umar's successor as caliph, Uthman ibn-Affan, was elected by a committee of religious elders. On Uthman's murder in 656, Ali ibn Abu Talib, one of the elders who

had elected Uthman, assumed control. However, Ali struggled to impose his authority, and the *ummah*, or Islamic religious community, had its first great schism. Muawiyah was among those who did not accept Ali's authority.

RULERS FROM MAKKAH

Like Muhammad himself, the Umayyad family belonged to the powerful Quraysh tribe of Makkah. They had initially opposed Muhammad but accepted his rule and converted to Islam when the Prophet took control of Makkah in 630. Muawiyah then fought in the Arab Islamic army in Syria against the Byzantine Empire, and in 640 he was appointed Governor of Syria

***Below** At its peak, c.750, the Umayyad Empire stretched from Spain in the west to Persia in the east.*

***Above** Husayn ibn Ali is attacked during the Battle of Kerbala as he tries to obtain water from the Euphrates.*

by the second caliph, Umar ibn al-Khattab. Throughout the reign of Ali ibn Abu Talib, Muawiyah maintained his independence and expanded the Umayyad power base by taking military control of Egypt. When Ali was murdered in 661, Muawiyah seized power and forced

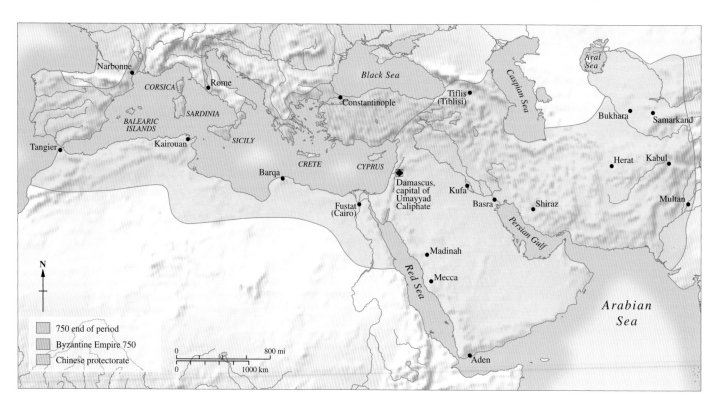

46

Ali's son Hassan to abandon his own claim to be caliph. Muawiyah declared himself *amir al-mumineen* ('Commander of the Faithful').

Ali's principal power base was the city of Kufa in Iraq, built as a garrison town following the Arab victory over the Byzantines at the Battle of Yarmouk in 636, but Muawiyah established Umayyad rule in the ancient city of Damascus in Syria. Such had been the military expansion under the first four caliphs that by 661, when Muawiyah took power, the Islamic Empire already stretched from Iran in the east to Egypt in the west.

Muawiyah held these disparate landholdings together through ties of personal loyalty. Government was strong under his rule: he developed bureaucracies on a Byzantine model; in Syria, he appointed Christians – many with experience of government under the Byzantines – to key positions.

SHIAH OPPOSITION
Muawiyah established the first dynasty in Islamic history when he passed the Caliphate to his son Yazid I in 680. This created further conflict: Husayn ibn Ali, son of Ali and, through his mother Fatima, a grandson of the Prophet, claimed the right to rule, but he was killed by Yazid's troops at the Battle of Kerbala on 10 October 680.

The Prophet's descendants continued to oppose the authority of the Umayyad rulers: in particular, they never forgave the Umayyads for Ali's death at Kerbala. Gradually the group of followers, or Shiah, of Ali grew. In 750, when members of the Hashim clan, who were descended from Muhammad's uncle al-Abbas, led a revolt against

Right The façade opens into the courtyard at the Great Mosque of Damascus, built on the site of the Christian Church of St John the Baptist in 706–15.

the Umayyads, they were supported by several Shiah groups. The Hashim were successful and their leader, Abu al-Abbas, became the first of the Abbasid caliphs.

ARCHITECTURAL GLORIES
The Umayyad rulers, especially Abd al-Malik (reigned 685–705), al-Walid I (reigned 705–15), Sulayman (reigned 715–17), Hisham (reigned 724–43) and al-Walid II (reigned 743–44), financed an imperial building programme, primarily in Syria. They established a splendid court in Damascus and built a series of grand palaces on country estates nearby. In Damascus, they lived in a palace south of the Great Mosque: from contemporary descriptions it is known that the building had a green dome, and included a pool. They also invested heavily in an infrastructure to promote agriculture across Syria, building vast numbers of dams, wells, canals and gardens. Syria became a prestigious place to live.

In these years, Damascus was the capital and Syria the centre of an empire in which a variety of pre-Islamic architectural and artistic traditions still existed. To the east were Mesopotamia and Iran, where the Assyrians, Babylonians, Achaemenids and Sasanians had

Above Caliph Hisham built Qusayr al-Hayr al-Gharbi in the Syrian desert (8th century). It was either a palace or a caravanserai, a travellers' lodge.

ruled; to the west, south-west and north were lands that had once been part of the Byzantine Empire, where Graeco-Roman traditions were strong. To the south, in the deserts of Arabia, was the birthplace of Islam. The Umayyads summoned craftsmen from every part of this diverse empire to work on their building projects. Documents found in Upper Egypt provide evidence that a local governor was required to send workers to labour on the Great Mosque of Damascus, built under al-Walid I. These workmen applied their local styles and skills to Umayyad mosques and palaces, such as Coptic carving from Egypt and Persian stucco work.

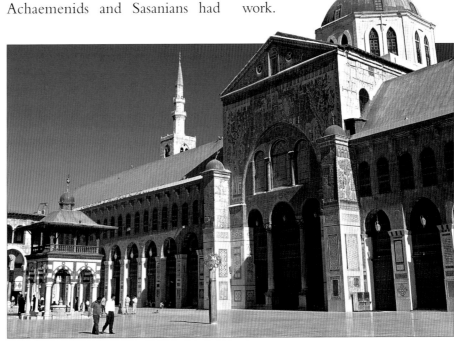

UMAYYAD COINS

AFTER INITIALLY MAKING ONLY MINOR AMENDMENTS TO THE COINAGE OF THEIR PREDECESSORS, THE UMAYYAD CALIPHS GRADUALLY DEVELOPED NEW DESIGNS THAT WERE DISTINCTIVELY ISLAMIC.

Coins known as the dinar and dirham are mentioned in the Quran, but scholars believe that the Arabs had very little of their own money in circulation in Arabia. However, when they took over the government of the former Sasanian and Byzantine empires, the Umayyads understood the importance of continuity in economic matters. To maintain healthy levels of trade, it was essential that merchants had confidence in the coinage, and a sudden change to unfamiliar designs might have endangered this.

ECONOMIC CONTINUITY

The earliest surviving Arab-Sasanian coins in fact just predate the Umayyad era (661–750). These early coins are marked 653, which is 21 years after the Prophet's death in 632 and 8 years before the establishment of the Umayyad Caliphate by Muawiyah I in 661.

When they first came to power, the Umayyads kept familiar coins in circulation. Umayyad coins minted in former Sasanian territory (Persia and Iraq) were adaptations of Sasanian silver coinage; they continued to feature the head of the Sasanian Shah Khosrow II (reigned 590–628) on the front and – because the Sasanian kings followed the Zoroastrian religion – a Zoroastrian fire altar appeared on the reverse.

The Umayyads seem to have continued using Persian die-makers to mint their coins. The coins bore the mint marks and sometimes the name of the Arab governor in the Pahlavi script that had been used by the Sasanians. The date of issue was given both in the Sasanian reckoning and in the Hijra calendar (counted from the Prophet Muhammad's migration from Makkah to Madinah in 622). However, Umayyad rulers also clearly felt the need to promote the Islamic faith that was driving their imperial expansion and coins began to appear incorporating pious Muslim doctrinal slogans in Kufic script, such as 'All praise be to Allah' and 'In Allah's name'.

Left A coin from the reign of the second Sasanian king, Shapur I (reigned 241–72), features the Zoroastrian fire altar.

Above This silver drachm bears the head of Sasanian monarch Khosrow II. The Arab conquerors of Iran kept coins of this type in circulation.

BYZANTINE INHERITANCE

In Syria, which had previously been part of the Byzantine Empire, the Arab conquerors also initially issued coins identical in appearance to those of their forerunner. The coins bore images of Byzantine imperial figures, including Emperor Heraclius (reigned 610–41) with his sons. As in Iraq and Persia, the Umayyad rulers had decided to keep the coins looking as similar as possible in the interests of continuity, but they gradually began to make minor changes in order to nullify the Christian symbols used on the coins. For example, they removed the horizontal arm of the crucifix found on the back of some coins, or they cut out the 'I' from the monogram 'ICXC' used to represent Christ's name in orthodox Christianity.

In time, the figure of the Byzantine ruler was replaced with a turbaned and clearly Arab male, standing and holding a sword. This figure has been interpreted by some scholars as an image of the caliph giving the *khutbah* sermon at Friday prayers, and the coins have become known as 'standing caliph' coins.

On the reverse they bore an image of the lance associated with the Prophet, set within a niche – clearly a modification of the Christian image of the cross standing at the top of a flight of steps that appeared on Byzantine coins. According to Islamic tradition, the lance was given to one of the Prophet's companions by an Ethiopian ruler and it was then passed on to Muhammad himself; the image was used in the first mosques to indicate the direction of Makkah. The niche on the coin, although it may appear to suggest the *mihrab* prayer niche found in mosques, is most likely a reference to niches in Byzantine architecture as *mihrabs* were probably not yet in use in mosques.

AN ISLAMIC COINAGE

In around 696–98, Islamic coinage was reformed under Umayyad Caliph Abd al-Malik, builder of the Dome of the Rock in Jerusalem. A new weight standard was set for coins, and all figurative images were replaced with Islamic messages written in Arabic *kufic* script. The purpose of the epigraphs was to remind all subjects of the empire of the success and supremacy of the conquerors' Islamic faith. Just as the interior of the Dome of the Rock was emblazoned with mosaic messages that set Islamic beliefs apart from Christian and Jewish doctrines, so the new gold dinars issued by Abd al-Malik declared the key beliefs that differentiated Islam from rival faiths. The coins bore doctrinal statements, such as the *kalimah* ('words') *La ilahu illa Allah, wa Muhammad Rasul Allah* ('There is no god but Allah, and Muhammad is Allah's Messenger'), and directly dismissed the concept that Christ is (in the words of the biblical Gospel of John) 'the only begotten Son of God', declaring 'Allah has no associate' and 'Allah does not beget, and was never begotten'. There were two denominations of coins: the copper fals and the silver dirham. Although there was a great variety in the issues of the lesser copper coins, there was remarkable uniformity among the silver dirhams, all of which bore calligraphy of the same type. All the coins bore a date and the name of the mint at which they were struck.

Below These 10th-century coins show that epigraphy became the dominant theme of Islamic coinage.

AFTER THE UMAYYADS

The style of coins introduced in the late 7th century under the Umayyad caliphs was the standard one used to produce Muslim coinage for several hundred years, and was used also by the Umayyads' Abbasid successors. The name of the ruling caliph was generally not included on the coins until the Abbasid era, beginning with those issued by al-Mahdi (reigned 775–85). Thereafter, it became standard practice to include the name of the reigning caliph on coins.

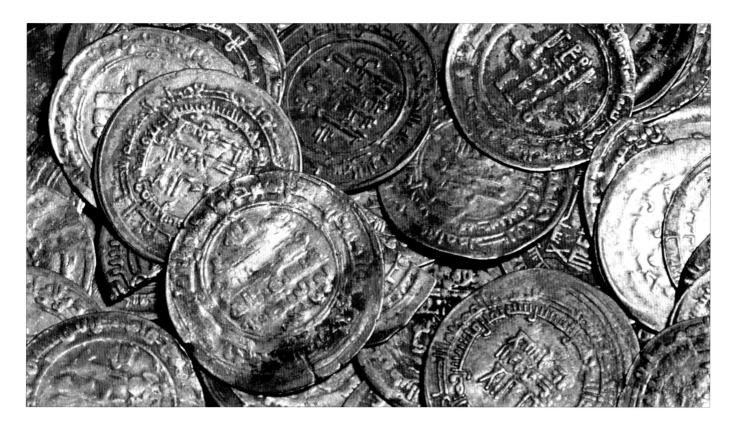

DOME OF THE ROCK

THE IMPOSING DOME OF THE ROCK IN JERUSALEM, COMPLETED IN 691–92 BY UMAYYAD CALIPH ABD AL-MALIK, IS THE WORLD'S OLDEST SURVIVING ISLAMIC SACRED BUILDING.

By building the Dome of the Rock, Abd al-Malik made a bold statement of the power of the Umayyad caliphs and the wealth of the spreading Islamic empire. He diverted the entire taxation revenue of Egypt for seven years to pay for the project. Moreover, he chose a position and form of building that would give Islam a highly visible and spiritually resonant presence in Jerusalem, challenging the two rival Abrahamic faiths of Judaism and Christianity.

Neither a mosque nor a mausoleum, the Dome encloses an area of rock, known as the Foundation Stone, that is sacred in Islam because of its associations with prophets before Muhammad and because Muslims believe that it was the place from which Muhammad rose to heaven in the course of his blessed Night Journey in 620. Muslims call the precinct *al-Haram al-Sharif* ('The Noble Sanctuary').

BYZANTINE FORM

Abd al-Malik built the Dome to commemorate the sacred rock beneath it, overseeing the design of the octagonal domed structure with its double walkway, or ambulatory, centred on the Foundation Stone.

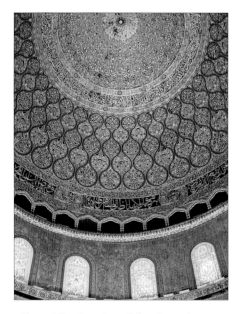

Above The interior of the dome is decorated with painted arabesques in applied stucco work.

Below The Umayyads understood the effect grand structures, such as the Dome of the Rock, had in promoting their dynasty.

A SACRED SITE

The Dome of the Rock stands on the area known to Jews as Har HaBayit ('Temple Mount'), which is believed to have been the site of their historic First and Second Temples (957BCE and 537 BCE). The Mount is regarded by Jews as the world's most sacred spot, the place from which the planet expanded into the form that is seen today, where God took the dust with which he made the first man, Adam. The Dome is built around a large rock known as the Foundation Stone, which is believed to have been the site of the Holy of Holies within the Jewish temples and the place at which Abraham prepared to sacrifice his son Isaac to God, and where Jacob dreamt of a ladder connecting the earth and heaven.

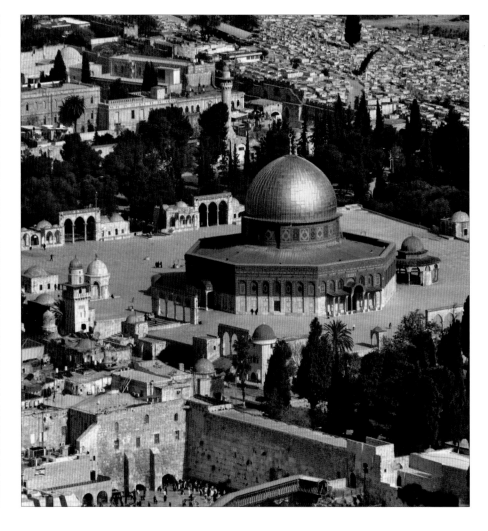

The building's overall form and its grand dome were a challenge to Jerusalem's most sacred Christian structure, the Church of the Holy Sepulchre, which had a grand dome and was also built around an area of rock – in this case encompassing Calvary, the hill on which Christ was crucified, and the tomb in which he was buried.

The 10th-century geographer al-Maqdisi made explicit the competition with the Church of the Holy Sepulchre: he declared that Abd al-Malik worried that Muslims would be 'dazzled' in their minds by the greatness of the Church of the Sepulchre, so he had the Dome of the Rock erected in a prominent and ancient sacred position, where it could be an equally imposing holy building for Muslim followers.

The Dome's builders appear to have based their calculations on a close study of the Church of the Holy Sepulchre, because the Dome of the Rock's dome is 20.2m (66ft 3in) in diameter and 20.48m (67ft 2in) high, compared to dimensions of 20.48m (67ft 2in) in width and 21.05m (69ft) in height for the dome of the Church of the Holy Sepulchre. Although the Dome of the Rock was, marginally, the smaller of the two buildings, it occupied a highly visible position on ancient and holy ground outside the city walls.

The wooden dome, which is mounted on an elevated drum, stands above a circuit of 12 columns and 4 piers within an octagonal walkway of 16 columns and 8 piers. The walkway is matched by 8 outer walls, each around 18m (59ft) wide and 11m (36ft) high, in an octagonal formation. The dome is filled with light, which enters through 16 windows in the drum and 40 windows in the octagonal lower part. Building and dome together rise a full 30m (98ft) above the Foundation Stone within.

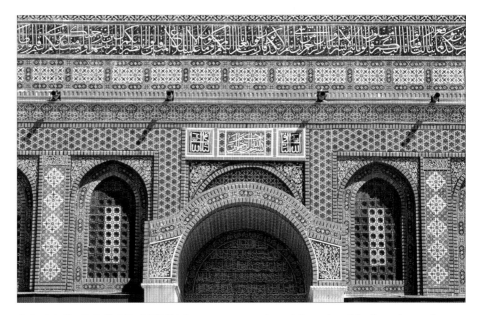

GRAND DECORATION

According to al-Maqdisi, around 100,000 gold coins were melted down and used to cover the dome's exterior. As a result, he wrote, it glittered so that no one could look at it for long in bright sunlight. In the 16th century, the ancient mosaics on the outside of the building were replaced by exquisite Iznik tiles in a seven-year redecoration project ordered by Ottoman Sultan Suleyman I 'the Magnificent' (reigned 1520–66). During 1960–64, the Dome was covered with a

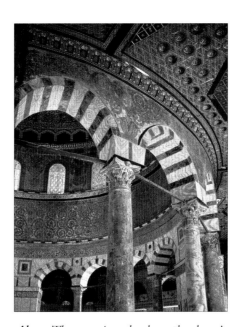

Above The mosaic cycle above the dome's arcade is part of the original 7th-century building programme.

Above The colourful tilework on the exterior of the Dome of the Rock was added in the 16th century by Ottoman Sultan Suleyman 'the Magnificent'.

bronze-aluminium alloy, and this covering was renewed in 1998 using 80kg (176lb) of gold.

The interior of the Dome is lavishly decorated with original glass mosaics from the 7th century. Many of the images – including trees, bejewelled vases and chalices, and beautiful plants – recall Sasanian and Byzantine imagery and are thought to refer to Islam's victory over these two great empires.

Around the interior walls is a gold mosaic freize, 240m (more than 785ft) in length, bearing a Kufic inscription proclaiming the message of Islam, including '*la sharik lahu*' ('God is without companions'), which is repeated five times. Although Jesus (or Isa) is mentioned here as an honoured prophet, the inscription also confronts the Muslim objection to the Christian doctrine of the Trinity, as explained in the Quran (Surah Maryam: 35) – 'It befitteth not (the Majesty of) Allah that He should take unto Himself a son.' The inscription is dated 72H (691 or 692), which historians take to be the date of construction of the Dome.

THE GREAT MOSQUE OF DAMASCUS

CONTEMPORARIES HAILED THE UMAYYAD MOSQUE IN DAMASCUS AS ONE OF THE WONDERS OF THE WORLD. THEY WERE AWESTRUCK BY ITS GRAND PRAYER HALL, COURTYARD AND GOLDEN MOSAICS.

The sixth Umayyad caliph, al-Walid I, built the Great Mosque in Damascus in 705–15, when the empire he controlled was expanding fast in size, power and wealth. In 711, during the construction of the monumental mosque, Islamic armies crossed from Africa into the Iberian peninsula, swept away the power of the Visigothic rulers and extended Islam and Umayyad power into Spain. In Damascus, al-Walid set out – like his father Abd al-Malik, builder of the Dome of the Rock – to make an impressive statement of Umayyad rising imperial power and to promote Islam as a major world religion.

To build the Great Mosque in Damascus, al-Walid I took over the city's principal sacred place, once the site of an ancient Aramaic temple to the storm god Hadad, then of a Roman temple to Jupiter and most recently a Christian basilica dedicated to John the Baptist. After the conquest of Damascus by Arab Muslims in 661CE, the church had been shared by Christians and Muslims. But al-Walid purchased the site and planned a grand congregational mosque, retaining only the original Roman exterior walls and columns.

DESIGN OF THE MOSQUE

Using the model of the Prophet's Mosque in Makkah, which was the prototype for all early mosques, the builders laid out a vast enclosed courtyard with a prayer hall along its southern side, containing a *mihrab* wall arch, indicating the required direction of prayer toward the *Kaabah* in Makkah. They filled

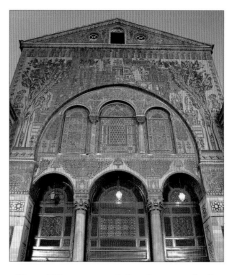

Above *The courtyard façade was rebuilt and redecorated after a major fire damaged the mosque in 1893.*

the temple area of the ancient Roman temple: the mosque and courtyard measured 100m by 157.5m (328ft by 517ft). At each corner of the enclosure they raised a minaret, or watchtower – these were initially lookout towers, but in time they were used for calling the faithful to prayer.

Within the prayer hall, the space was divided into three aisles by two rows of columns with Corinthian capitals, spaced well apart so that worshippers could see clearly across the prayer hall and obtain a good view of the *mihrab* niche in the *qibla* wall, so they knew the direction of prayer. The division of space into aisles with columns was an essential element in the layout of a Byzantine basilica, but in the Damascus mosque the columns ran parallel to the *qibla* wall, so the building's orientation (toward the *qibla* wall) is at right angles to the long rows of columns. At the centre of the prayer hall and opposite the *mihrab* they built a great vaulted dome; originally the *maqsura*, behind which the caliph was set apart from his people when praying, was beneath it. Light entered the mosque through windows in the dome and high in the side walls of the prayer hall.

JOHN THE BAPTIST

The mosque contains a shrine to John the Baptist, who is revered in the Islamic tradition under the name Yahya b. Zakariyya as one the prophets. It is within the main prayer hall of the mosque and the shrine is still in place today. Christians visit the mosque to pray at the shrine and in 2001, when Pope John Paul II entered the mosque for this purpose, he became the first pope ever known to have entered a mosque.

Right *Behind the Muslims bowing to Makkah is the shrine that reputedly holds the head of St John the Baptist.*

Right The Great Mosque's treasury survives on its original eight classical columns in the inner courtyard. The mosaics on the upper part date from the late 20th century.

This was the first prayer hall in Islamic history in which the *mihrab* was given a particular prominence by raising a dome before it. The design was to be highly influential.

The builders constructed a single-aisle ambulatory around the other three sides of the courtyard. In the centre of the courtyard they raised a fountain, at which the faithful could wash themselves before worship, and in the north-west corner a domed treasury.

IMAGES OF PARADISE

The interior of the Great Mosque was decorated with Byzantine-style mosaics. The lower parts of the walls were faced with veined marble slabs, above which there was a band of gold glass mosaics. The decorations also included large landscape scenes containing trees, ancient Roman-style palaces, pavilions and bridges along a riverbank. The mosaics have been interpreted as representing the palaces and gardens of paradise, a world at peace under Islamic rule, or the luxurious palaces of the Umayyads themselves along the Barada river in Damascus.

The golden decorations inside and outside the mosque originally covered 4,000sq m (43,000sq ft) and were one of the reasons the building was viewed with such awe by contemporaries.

LATER ADDITIONS

The Great Mosque of Damascus is Islam's oldest extant monumental mosque. However, the three

Right The beautiful mosaic decoration of tall trees and classical buildings is on the inner west wall of the prayer hall.

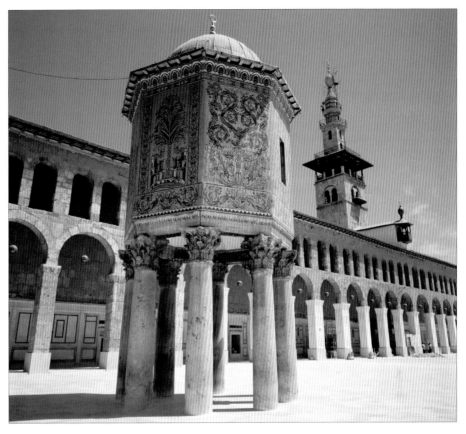

minarets standing today are not survivors of the original four, but are later replacements – the Minaret of the Bride (9th–12th centuries); the Minaret of Jesus (13th–18th centuries), so-called because many Muslims believe that Jesus will appear here just prior to the end of the world; and the Minaret of Qayt Bey (16th century). The building has survived several disasters over the centuries, including Timur's invasion of Damascus in 1401, an earthquake in 1759 and a serious fire in 1893. It was heavily restored in 1970.

DESERT PALACES

THE FINEST SURVIVING EXAMPLES OF SECULAR BUILDINGS FROM THE
UMAYYAD ERA ARE THE *QUSUR*, OR DESERT PALACES, SUCH AS QUSAYR
AMRA IN JORDAN AND QUSAYR AL-HAYR AL-GHARBI IN SYRIA.

*Above Hunters and maidens cavort in
a detail from the wall frescoes at Qusayr
Amra. These are the largest surviving
group of early medieval frescoes.*

Although called 'desert palaces',
these structures were built
alongside agricultural land or oases.
While some stood on trade routes
and incorporated *khans* (travellers'
lodgings), and others were perhaps
used as hunting lodges, they were
principally country houses at the
centre of farming estates.

FRESCOES AT QUSAYR AMRA

The small palace of Qusayr Amra
was probably built under Caliph
al-Walid I in 712–15, and stands
beside an oasis in semi-arid land
around 80km (50 miles) east of
Amman in Jordan. The remains of a
castle, tower, waterwheel and well
have been uncovered, but the
principal surviving buildings are a
rectangular throne room and
audience chamber and a bathhouse.
The internal walls of both are
decorated with remarkable frescoes.

One fresco in the audience
chamber shows a ruler, probably
Caliph al-Walid I, grandly enthroned
in the Byzantine fashion beneath a
canopy. He faces a fresco in which six
kings stand in line as if paying
homage. Other subjects include the
pleasures of life at the Umayyad
court, such as a royal hunt and scenes
of relaxation in the bathhouse,
together with some of the many
crafts activities carried out under the
Caliph's patronage. The vaulted ceiling
is divided into rectangular sections
and also shows craftsmen working.

The walls of the three rooms
in the bathhouse are decorated
with musicians and dancing girls,
and scenes of animals, including
gazelles, camels, donkeys, and even a

*Below The abandoned complex of
Qusayr Amra was rediscovered in 1898
by Czech orientalist Alois Musil.*

bear playing a musical instrument.
The domed ceiling in one room
is painted with the main
constellations of the northern
hemisphere – the oldest surviving
representation of the stars of the
night sky on a domed surface.

The wonderful images at Qusayr
Amra are confidently drawn and
delicately coloured, using methods
and iconography from the classical
worlds of Greece and Rome. They
are part of a princely propaganda
attempt to establish the Umayyad
rulers and their court on an equal
footing with other imperial rulers
and establishments past and present.

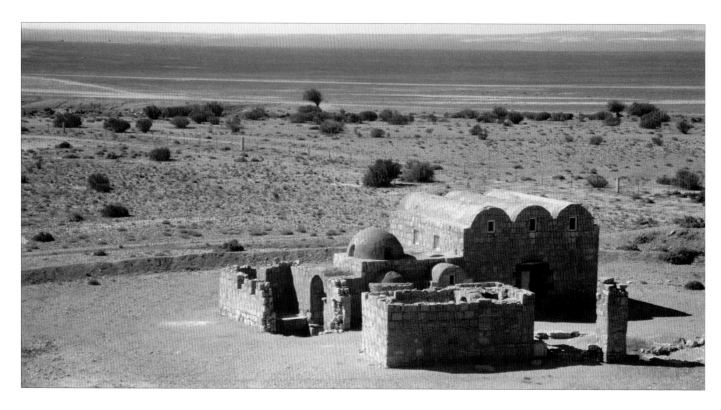

FINE STUCCO WORK

Qusayr al-Hayr al-Gharbi was built by Caliph al-Hisham about 60km (37 miles) west of Palmyra, a caravan trade city on the road from Damascus. The complex includes a palace, bathhouse and *khan* (travellers' lodge), together with agricultural land, all surrounded by a protecting wall set with semicircular towers. An irrigation system is fed by underground canals that connect to an ancient Roman dam at Harbaqa, 16km (10 miles) to the south.

Within the enclosing wall, the *khan* is laid out around a courtyard. The palace is square in shape with sides measuring 70m (230ft). It originally had two storeys, although only the lower one survives, and a monumental gateway with carved stucco decoration – the oldest Islamic example of this type of decoration, which was derived from the work of Sasanian craftsmen. The stucco work is now in the National Museum, Damascus.

The palace complex at Khirbat al-Mafjar in the Jordan Valley near Jericho in Palestine was built in the years before 743 by Caliph al-Hisham. Set within a protective wall, the grouped buildings include a two-storey palace, a mosque, and a great domed bathhouse with audience room, together with a large courtyard with central fountain and circular colonnade. The very grand bathhouse and audience room contain a bathing pool and a second plunge pool that reputedly once held wine, as well as a latrine with space for 33 guests at once. The bathhouse floor consists of no fewer than 39 adjoining mosaic panels decorated with geometric designs; together these form the world's largest floor mosaic still surviving from antiquity. Another striking mosaic panel, located in the audience hall, depicts a lion attacking a gazelle.

The palace at Mshatta, built in 743–44 by Caliph al-Walid II around 32km (20 miles) south of Amman in Jordan, was seemingly intended to be the grandest of all the Umayyads' royal buildings, but work was abandoned when the Caliph was killed in a battle against rebels in 744. The unfinished square

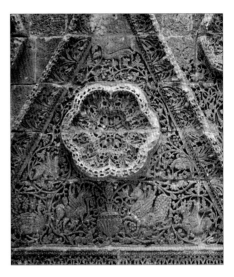

Above A detail from the stone façade of the palace at Mshatta in Jordan (743–44) shows Sasanian-style rosettes.

complex, built in limestone and brick, includes a mosque, entrance hall, audience hall and residential quarters covering a vast 144sq m (1,550sq ft). Its splendid stone façade reveals many influences: it is decorated with Sasanian-style solar rosettes divided by a zigzag band moulding of a kind often seen in Christian Syrian buildings and backed by a detailed classical-style relief of animals and vines.

Above This beautifully decorated doorway is part of the Umayyad desert palace of Qusayr al-Hayr al-Gharbi, built under Caliph al-Hisham in Syria.

SASANIAN INFLUENCE ON METALWORK

The earliest Islamic metalwork shows the artistic influence of work produced under the Sasanians, the pre-Islamic Iranian dynasty who ruled a Persian empire in 226–651. In particular, the Umayyad metalworkers shared the Sasanian taste for decorating their objects with birds, animals and composite creatures, such as the mythical winged griffin and the senmurv, a creature from Persian mythology that was half bird and half dog.

A bronze ewer believed to have been made in the reign of Caliph Marwan II (744–50), and now kept in the Islamic Museum in Cairo, Egypt, has its spout carved in the shape of a rooster and water was poured out through the creature's open beak. The bird's body is lightly engraved all over with solar rosettes and animals. The ewer is typically Islamic in having all-over decoration; at this stage, decoration was usually engraved. A similar example is a yellow bronze incense-burner in the shape of a bird of prey decorated with complex ornamentation based on plant life and geometric designs. The incised decorations on the ewer and the incense-burner recall the carvings found in the palaces of Khirbat al-Mafjar and Mshatta.

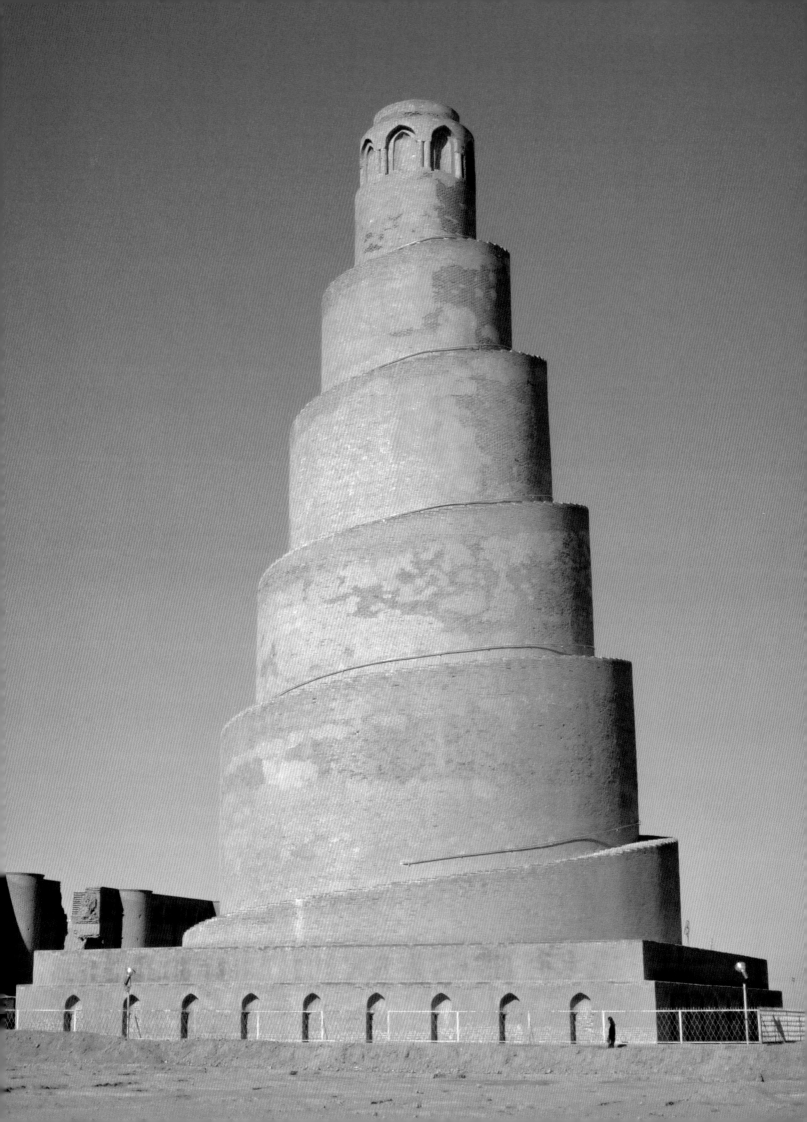

CHAPTER 3

THE ABBASID CALIPHATE

In 750, the Sunni Umayyads were ousted in a revolt led by the Abbasids, cousins of the Umayyads and descendants of the Prophet's uncle al-Abbas. The Abbasids established a new caliphate that lasted for 500 years and moved the capital of the empire to Baghdad in Iraq. The city quickly grew to become a vibrant centre for trade, culture and intellectual life. In 836, the Abbasids moved their capital to Samarra. Although the move proved temporary, the Abbasids built luxurious palace compounds there, complete with parks, artificial water basins, barracks and racecourses. The 8th to 10th centuries are renowned as a golden age for Islamic culture. Luxury arts thrived: metalworkers, weavers and potters produced beautiful, highly crafted objects, while scribes created the first Qurans to be produced on paper. This was also the era of the Translation Movement, when scientific texts from the classical world were translated into Arabic. The Caliphate came to an end in 1258, when invading Mongol tribesmen entered Baghdad and executed the last Abbasid caliph, to the dismay of the wider Islamic world.

Opposite The striking 52-m (170-ft) tall minaret of the Great Mosque of Samarra was built in the new imperial capital in 848–52 by the Abbasid Caliph, al-Mutawakkil.

Above A 13th-century work on paper depicts the classical scholar Solon (638–559 BCE). Scholars of all faiths and ethnicities were welcomed and given employment at the highly cultured Abbasid court in Baghdad.

BAGHDAD

ONE OF THE WORLD'S MOST POPULOUS AND WEALTHY CITIES,
ABBASID BAGHDAD WAS A GREAT CENTRE OF LONG-DISTANCE TRADE
AND AN INTELLECTUAL AND ARTISTIC CAPITAL.

In 762, the Abbasid Caliph al-Mansur founded a great city called Madinat as-Salam ('The City of Peace'), or Baghdad as it soon became known, beside the river Tigris in Iraq. This was a vast project: according to the 9th-century Arab historian al-Yaqubi, an army of labourers 100,000 strong was drafted in to build the city.

The city was laid out in a vast fortified circle centred on the caliph's palace and a great *jami*, or Friday Mosque. In choosing the circular layout, al-Mansur was following ancient local tradition going back at least to the foundation of the Assyrian city of Dur Sharrukin in the 8th century BCE, and evident in the city of Ghur (modern Firuzabad) established by the Sasanian Shah Ardashir I (reigned 226–41CE).

FORTIFIED CITY

Little remains of the early structures of Baghdad, but contemporary written accounts enable experts to build up a picture of its design. The Round City was 2.7km (1.68 miles) in diameter and stood within a double set of mud-brick walls and a moat flooded from the Tigris. Four gates led to and were named after Basra (at the south-east), Kufa (south-west), Khurasan (north-east) and Damascus (north-west). Each gate had a bent entranceway to make it easier to defend against attackers, and each stood beneath a chamber accessed by a ramp or stairs. These chambers had a raised domed roof topped with a weathervane shaped like a man.

From the gates, long vaulted and arcaded avenues ran into the centre of the city. Along the inside of the defensive walls was an outer circuit of buildings used as residences for the caliph's family and members of the court. Key government buildings, including the treasury and the weapon store, were part of an inner ring of buildings. In the centre of the city were a building for guards as well as the mosque and palace.

MOSQUE AND PALACE

The central mosque was a square hypostyle design, its sides 100m (330ft) long and enclosing an open courtyard. Next to it, the palace covered four times the area of the mosque. A large *iwan* reception hall, with sides measuring 15m by 10m (50ft by 33ft), led into an audience chamber with sides 10m (33ft) long.

A second audience hall had a dome called Qubbat al-Khadra ('Green Dome'), which was 40m (130ft) tall and topped with a

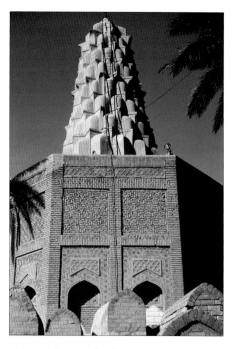

Above The Tomb of Zumurrud Khatun was built c.1193. It is celebrated for its tall cone-shaped muqarnas *dome.*

weathervane shaped like a warrior on horseback holding a spear. This figure was celebrated as a symbol of Abbasid power: wherever he faced he looked out over lands ruled by the caliph. According to tradition, the caliph learned of rebellions, as well as of meteorological storms, from the movements of this figure. The dome and the horseman collapsed in 941. This was an ill omen, as just four years later the Buyids established themselves as de facto rulers of the empire, leaving the caliphs in only nominal control.

PALACE OF UKHAYDIR

The buildings of Baghdad owed much to local tradition, marking a shift from Umayyad style. No traces of the original city survive in Baghdad itself, but the nearly contemporary fortified desert palace of Ukhaydir, built in c.775 near Kufa, about 200km (125 miles) south of Baghdad, gives experts an idea of the likely appearance of the Round City. This vast

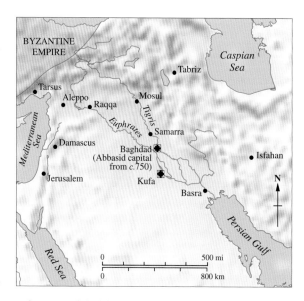

Above Baghdad became the Abbasid capital in 762. Kufa was the original capital.

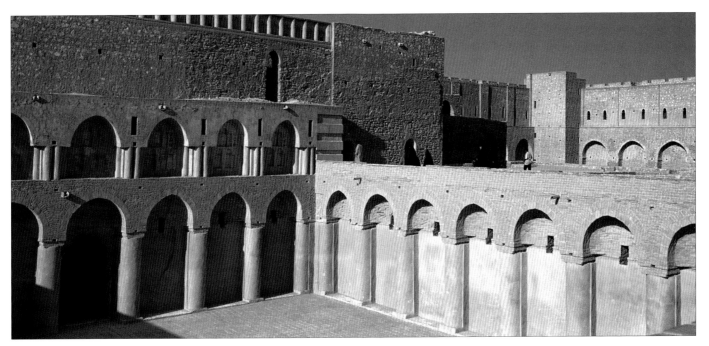

Above The original buildings of Baghdad resembled Ukhaydir Palace, near Kufa, built c.775.

complex stands within walls 19m (62ft) tall and in a slightly elongated square measuring 175m by 169m (574ft by 554ft). It contained courtyards, halls, a mosque and a bathhouse. It is characteristic of the Abbasids' preference for surrounding audience chambers and palatial buildings with fortifications – they combined a commitment to grand ceremonial with security.

ARTS AND LEARNING

Baghdad was a centre for luxury arts, attracting artisans from all over the Islamic Empire while exporting its metropolitan style far and wide. This was an important phase in Islamic art and architecture. Baghdad, and later Samarra, drew in eastern influences from Iran and passed these westward as part of an identifiable Abbasid style: in al-Andalus (Islamic Spain), artisans copied the textiles of Baghdad, and in Egypt architects used decorative stucco as found in Samarra. Under

these influences, Islamic artisans and architects moved away from Graeco-Roman and Byzantine styles.

Baghdad was also an intellectual capital, where scholars contributed to the highly influential 'Translation Movement', translating into Arabic ancient Greek works of philosophy, medicine, mathematics and astrology by classic authors, such as Aristotle (384–322BCE), Galen (129–216CE) and Ptolemy (c.100–161CE), and Indian texts by the mathematicians Sushruta (6th century BCE) and Aryabhata (476–550CE).

HARUN AL-RASHID

Harun al-Rashid (reigned 786–809), the fifth Abbasid caliph, ruled Baghdad at the height of the city's prosperity and prominence as a centre of art and learning. He was a poet and scholar and a great patron who invited intellectuals to his court from far and wide. His own fame reached as far as Western Europe: he exchanged a series of ambassadors and gifts with Charlemagne, King of the Franks (reigned 747–814). In return for gifts of hunting dogs and Spanish horses, Harun sent Charlemagne an elephant called Abdul-Abbas, chessmen made of ivory and a water clock that astonished all who saw it at the court of the Franks in Aachen (now western Germany). He even features as a character in the world's most celebrated piece of literature in Arabic, *Alf laylah wa laylah* ('The Thousand and One Nights'), which began as an oral tradition and was first written down in the 9th century.

Left A detail from a 15th-century manuscript from Nizami's Khamsa *(five poems or 'Quintet'), showing Harun al-Rashid in a bathhouse.*

SAMARRA

THE CITY OF SAMARRA IN IRAQ WAS THE ABBASID IMPERIAL CAPITAL FOR JUST OVER 50 YEARS, 836–92. ITS NAME REPUTEDLY DERIVED FROM THE PHRASE *SURRA MAN RA'A* ('A JOY FOR ANY WHO SEES IT').

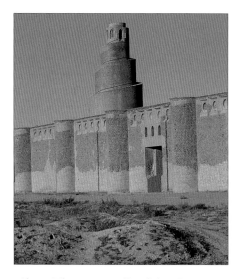

In Baghdad, Abbasid caliphs lived in their vast palace complex isolated from their people. As their authority began to wane in the 9th century, they became increasingly dependent on their Turkish slave troops from Central Asia. In 836, violent clashes in Baghdad between the slave troops and local citizens persuaded Caliph al-Mutasim to move the imperial capital to Samarra 125km (78 miles) north of Baghdad.

In Samarra, al-Mutasim and his successors raised a huge city, which extended for 50km (30 miles) along the banks of the river Tigris and covered 150sq km (60sq miles); it included several sprawling palaces, grand boulevards, extensive barracks and lush gardens, as well as the Great Mosque of Samarra, at the time the world's biggest mosque. Outside the city limits were large hunting parks and three tracks for horseracing. Samarra remained capital of the Abbasid Empire until 892, when Caliph al-Mutamid moved the administration back to Baghdad.

HOUSE OF THE CALIPH

The main palace at Samarra was the Dar al-Khilafa ('House of the Caliph'), a huge assembly of court-yards, chambers, apartments and pools that covered 70ha (173 acres). The structure dwarfed the relatively small palaces of the Umayyad era.

A bank of steps rose from the Tigris to the main public entrance, the Bab al-Amma, which had three large brick archways. The principal audience chamber was a domed hall at the centre of four vaulted *iwans*, or halls, and opening on to a garden overlooking the river Tigris. In the audience hall, the caliph held public audiences on a Monday and Thursday. Nearby and within the palace complex was a field used for polo matches and parades.

THE GREAT MOSQUE

In 848–52, al-Mutasim's son and successor al-Mutawakkil built the Great Mosque, which measured 239m by 156m (784ft by 512ft) and was protected by tall walls supported

Above The outer walls of the Great Mosque in Samarra, restored by Saddam Hussein.

by 44 semicircular towers. The whole was set within an enclosure of 444m by 376m (1,457ft by 1,234ft).

The mosque originally had hypostyle halls around a courtyard: the flat roof of the sanctuary on the south wall was supported by 24 rows of 9 brick-and-stone columns. The *mihrab*, or prayer niche, was decorated with gold glass mosaics with two rose-coloured columns of marble on each side. Little remains

Below The Qusayr al-Ashiq in Samarra, on the right bank of the river Tigris, was built by al-Mutamid (reigned 870–92).

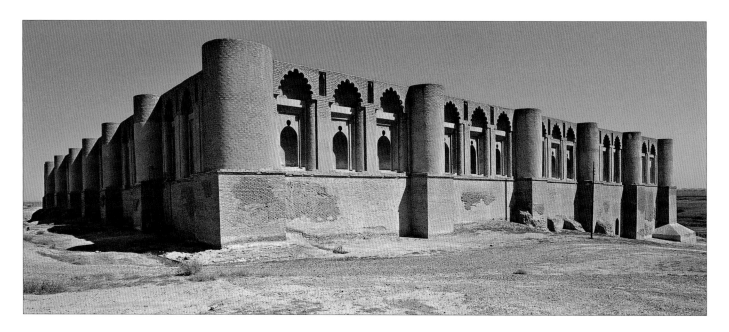

of the mosque's interiors, except for its distinctive spiral minaret known as al-Malwiya. It stands on a square base, from which a round tower rises 55m (180ft) above ground. A spiral ramp runs counter-clockwise around the outside of the tower to a pavilion at the top. This particular form of minaret appears to have been inspired by ancient Mesopotamian ziggurats, or temple towers.

OTHER PALACES

In addition to the Great Mosque, al-Mutawakkil built as many as 20 palaces, leaving the Abbasid treasury badly depleted by the end of his reign. In the 850s, he laid out a new area north of Samarra, called Jafariya, that contained a vast palace called the Jafari, as well as a second grand congregational mosque (now called the Mosque of Abu Duluf), built in imitation of the Great Mosque and with a similar spiral minaret, but on a smaller scale.

The building of large palaces set behind high walls probably reflected the development of a more hierarchical society in the Abbasid era, when the caliphs adapted Persian ideas of kingship. At the same time, religious and political authority, once united in the person of the caliph, began to diverge, and the mosque became more the preserve of the *ulama*, or religious legal scholars.

Although most of the buildings, even the palaces, were built of only mud brick, they were lavishly decorated, with glass mosaics and

elaborate wood or marble panelling. The setting was one of high luxury: glass objects, gold and silver dishes and lustreware have been excavated.

STUCCO DECORATION

A distinctive type of carved and moulded multicoloured painted stucco decoration was developed and made popular in Samarra, and from there spread throughout the Islamic Empire. The decoration appears in three distinct styles.

The first was derived from the vegetal carving of the Umayyad period: a surface was divided into compartments by roundels and filled with curling vine tendrils. In the second style, the compartments contained carved plant decoration so stylized that it could no longer be associated with plants; in some, the contemporary Chinese symbols for the properties of yin and yang appeared. In the third, the compartments contained abstract decorative motifs, such as palmettes,

Above The first style of Samarran stucco wall decoration uses curling plants; this example is from the Qusayr al-Ashiq.

bottle shapes and spirals. Known as the 'bevelled style', this was made with a shallow cut using moulds in symmetrical patterns that could be repeated as far as required, so it could be applied quickly across wide areas of wall. The third style had an important influence on later Islamic art as it led directly to the development of arabesque decoration.

The walls were also decorated with paintings, including naturalistic images of human figures. These included hunting scenes with wild animals and naked women. A wall painting from the Dar al-Khilafa shows two serving girls dancing while pouring wine into goblets.

Below This is an example of the third Samarran style, made with a shallow cut and using symmetrical designs.

MAJOR ABBASID CALIPHS
Abu al-Abbas al-Saffah (750–54) Dynastic founder
al-Mansur (754–75) Founded Baghdad
Harun al-Rashid (786–809) Great patron
al-Mutasim (833–42) Moved to Samarra
al-Mutawakkil (847–61) Great builder in Samarra
al-Mutamid (892–902) Moved capital back to Baghdad
al-Mustasim Billah (1242–58) Final Baghdad caliph

POTTERY AND LUSTREWARE

IN AN ATTEMPT TO IMITATE IMPORTED CHINESE WARES, ISLAMIC POTTERS DEVELOPED A WHITE TIN GLAZE BUT SOON ADDED THEIR OWN DESIGNS WITH COBALT AND LUSTRE.

The earliest pottery production in the Islamic world was a continuation of local traditions. Functional green- and turquoise-glazed earthenwares were made for the storage and transportation of goods, such as oil, dates and honey. However, in the late 8th to early 9th centuries, the pottery industry in Iraq was transformed, and the first distinctively Islamic ceramics were produced here. This was a development that coincided with the luxurious taste and demands of the Abbasid court, and it was triggered by the importation of porcelain and stoneware items from China. These wares provided inspiration to the Iraqi potters, who sought to imitate them.

FOREIGN INFLUENCES

Basra was the main centre of pottery production: several contemporary writers describe the fine quality of the white clay found in deposits near the city and it was also the port of entry for imported Chinese wares that came by sea. Persian and Arab sailors had recently opened a direct sea route between the Persian Gulf and the South China Sea. They took ivory, incense, spices and pearls to China and returned with silk, paper and ceramics. The goods also travelled by land over the Silk Route. A contemporary account of one diplomatic gift to Harun al-Rashid, the caliph in Baghdad, included: '200 pieces of imperial porcelain, including basins and bowls and other things the like of which had never been seen before at a royal court, and 2,000 other

Chinese ceramic vessels, including covered dishes, large bowls and large and small pottery jars.'

BLUE-AND-WHITE POTTERY

The Iraqi potters could not reproduce the shiny white surface and hard compact body of the Chinese wares exactly because they did not have access to the same type of clay – white kaolin – or the kiln technology that was needed to achieve high firing temperatures. Instead, they closely imitated the Chinese vessel shapes and copied the whiteness of the surface by covering the yellow body of the pots with an opaque white glaze made by mixing tin oxide with a lead glaze.

Initially, the potters left the surfaces of these wares unadorned, like the Chinese prototypes, but it was not long before they began to add decoration in cobalt blue pigment. The colour had a tendency to sink into the glaze, an effect that has been described as 'ink on snow'. The designs were generally limited to floral and geometric motifs or calligraphic inscriptions. The use of writing, in the form of signatures and phrases, such as 'blessing to its owner', was an entirely new and Islamic decorative device. In a second phase, splashes of green were added to the cobalt designs, probably influenced by imported Chinese splashware vessels.

Above Iraqi potters imitated Chinese white wares by coating the earthenware body with an opaque white glaze, as seen in this 9th-century bowl.

LUSTRE GLAZING

Following the commercial success of the blue-and-white pottery, the Basra potters developed a new technique known as lustre glazing, a complex process that required expensive materials. Borrowed from

Above This 9th-century dish has been pressed into a mould to form the relief decoration. The raised dots and lustre glaze were used to imitate metal.

glass technology, the technique used powdered metallic oxides of silver and copper, which when applied to the ceramic body produced a lustrous metallic sheen. The pots were painted with a plain white glaze and fired in an ordinary kiln. When they were cool, the potter painted on the design in a mix of metallic compounds that were finely ground together, mixed with clay and diluted in grape juice or vinegar. The vessel was then put into a reduction kiln and fired a second time; carbon monoxide in the reducing atmosphere extracted the oxygen from the silver and copper oxides and bonded them as a thin layer of metal on to the surface of the glaze.

STYLISTIC CHANGES

The earliest lustre-glazed vessels were decorated with a range of tones known as polychrome lustre and were characterized by busy geometric and floral patterns that entirely covered the surface. Over time the process was simplified and a single golden colour, described as monochrome lustre, was adopted. This simplification may have been intended to reduce the costs of the process, or it could have been that after much experimentation the potters had achieved a real understanding and control of the technique.

With the change in palette, a new iconography was developed and the abstract patterning was replaced with figural imagery. Large-scale figures of men bearing arms, or seated and holding a glass, or animals, such as deer, camels and birds, became popular. These monochrome lustreware pieces are particularly distinctive; the contours of the image are outlined, leaving a narrow white space to separate

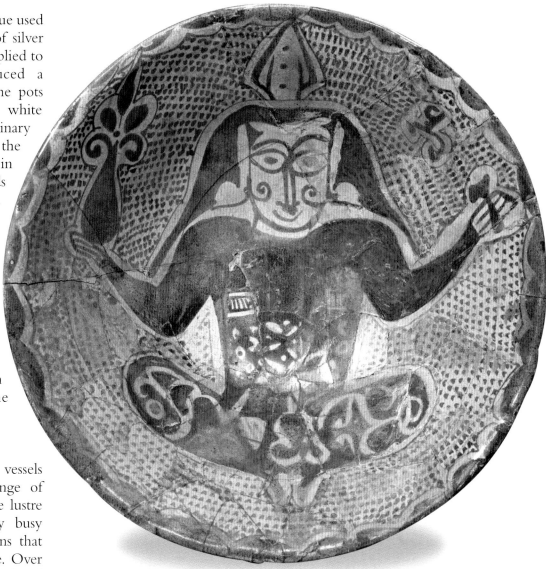

Above This late 9th–early 10th-century bowl is painted with a stylized figure in a cross-legged position. It resembles a bodhisattva, which is a Buddhist religious figure.

and distinguish it from the background, which is filled with roughly shaped dots or dashes like the punching found on metalwork. In this period, the Abbasid rulers recruited their armies from the tribes of Central Asia and it was probably through these Turkish immigrants that this type of imagery was introduced.

By the late 10th century, pottery production in Basra declined. Many of the potters seem to have moved to Egypt, where the Fatimid court was beginning to flourish.

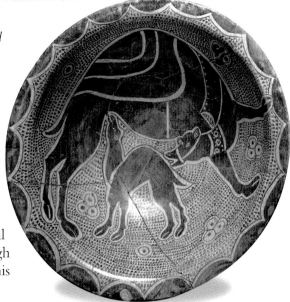

Above By the late 9th–early 10th century, potters in Iraq were expertly using lustre and had limited the palette to one colour.

GLASSMAKING

IN THE 9TH AND 10TH CENTURIES, ISLAMIC GLASSMAKERS DEVELOPED IMPRESSIVE NEW DECORATIVE TECHNIQUES FOR CUTTING AND COLOURING THE GLASS SURFACE.

Above This cup was found in a palace of the Abbasid Caliph al-Mutasim (reigned 833–42). Vertical lines of inscription read 'drink and be filled with delight' and 'made in Damascus'.

Long before the Arab conquest, glassmaking had flourished across the Middle East for more than two millennia. Glassmaking was a conservative craft in which technical methods continued unchanged over long periods. The political upheavals of the Islamic conquest had little impact on the glass workers, except that they increased the production of their wares in response to demand from their new patrons.

AN EXPORTED WARE
Islamic glass was traded widely across the Islamic world and also in Europe, China and South-east Asia. It was exported in the form of luxury vessels but also as broken glass, known as cullet, which was suitable for remelting and making new glass inexpensively. This wide distribution makes it difficult to identify with any certainty where much of Islamic glass was produced. One broad distinction is that glass workers in Iran and Iraq favoured cutting and moulding techniques, whereas those in Egypt and Syria preferred to experiment with colour.

LUSTRE GLASS
A technique known as lustre decoration was invented in the 7th century. This was a complex process where powdered metallic oxides containing silver or copper mixed with vinegar were painted on to a blown glass vessel, which was then reheated in a reducing kiln at a temperature lower than the original firing so that the vessel did not collapse. The oxides left a brownish or yellow stain, sometimes with a metallic sheen, on the pale glass. Several lustre-painted glasses have inscriptions, a few of them naming their patrons, making the value placed on such objects evident. Two lustre glasses have been found with inscriptions stating that they were made in Damascus.

PRODUCING CUT GLASS
The art of cutting glass became highly developed in Iran and Iraq in the 9th and 10th centuries. Glass vessels were blown into the desired shape and then allowed to cool to

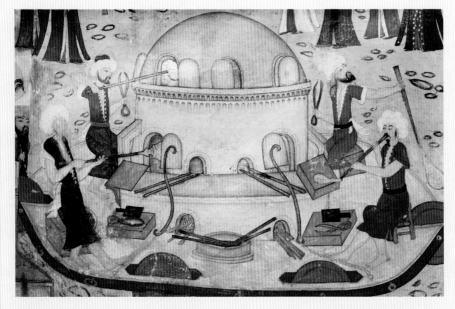

Above This 16th-century manuscript painting shows the stages of glass-blowing and the tools required. On the right, a craftsman is blowing a glass bubble.

THE GLASSMAKING PROCESS
Glass is essentially made from silica, or sand, which melts at very high temperatures. To lower the melting point, a flux obtained from the ashes of the glasswort plant or from natron, a mineral widely available in Egypt and also used in the mummification process, was added to the silica and heated in an iron pot in the hottest part of the furnace. When the mixture had melted, the craftsman gathered up a mass, known as a 'gather', on the end of his blowpipe to create a bubble of glass, which he then shaped and decorated with various tools.

let the glass worker grind, cut and polish the surface on a rotating wheel – as he might do if working with gemstones. Facet cutting, a method that was popular in Iran in the Sasanian period (226–651 CE), was achieved by blowing vessels with relatively thick walls and then cutting away parts of the surface to create a honeycomb pattern of shallow facets. Fine geometric and floral patterns could be incised into the surface with a tool set with a diamond point, and this technique is referred to as scratch engraving. Several blue glass dishes of this type were found in the crypt of a temple in China that was sealed in 874.

The technique of relief-cut glass required extraordinary skill and precision. The pattern was created by cutting and grinding the surface to remove the background and most of the inner areas of the main design, leaving the outlines and some details in relief. A version

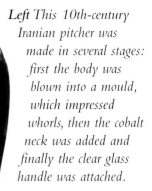

Left This 10th-century Iranian pitcher was made in several stages: first the body was blown into a mould, which impressed whorls, then the cobalt neck was added and finally the clear glass handle was attached.

of this technique is known as cameo glass: the colourless glass vessel was dipped in molten coloured glass to form a coating, and after cooling, sections of the coloured layer were cut away to form an overlaid decorative design.

TRAILED GLASS

In Syria and Egypt, a number of techniques were used where the glass was manipulated and decorated while it was hot and malleable. Applied trails of glass, in a contrasting colour to the vessel, could be wound around the vessel and then manipulated with a pointed tool or a fine pincer to create patterns in thin strands of glass. A group of small animal figures, shaped as camels or donkeys, have flasks (probably for storing perfume or scented oils) attached to their backs that are enclosed by a network of trailed threads like a basket. If the vessel with its applied trails was rolled on to a flat slab, known as a marver, the trails became integrated into the vessel wall and made striking wavy or festooned patterns; this is called 'marvered' glass.

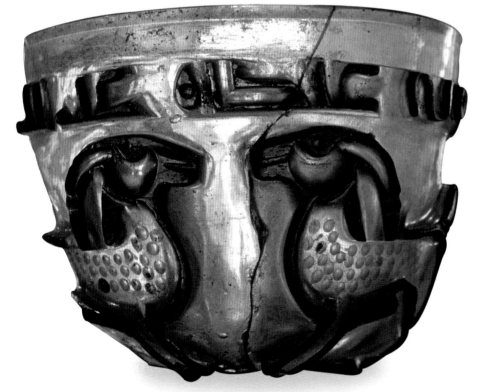

Left To make this 10th–11th-century glass vessel, it was dipped in a layer of molten turquoise glass; after it cooled, it was ground on a wheel using techniques devised by gemstone cutters.

EARLY QURANS

THE FORMAL SPLENDOUR OF ARABIC CALLIGRAPHY DEVELOPED WITH THE COPYING OF THE QURAN. INITIALLY WRITTEN IN A STIFF ANGULAR SCRIPT, IT WAS GRADUALLY REPLACED BY ROUNDER STYLES.

Although the Quran was revealed orally, the practice of copying its sacred text dates from the mid-7th century, when Caliph Uthman (reigned 644–56) sent out standardized versions to all the main Islamic strongholds.

REFINED CALLIGRAPHY

In their quest to emphasize the wonder of the sacred word, scribes took ever-increasing pains to enrich and adorn the beauty of the holy text of the Quran. Like all scribes at that time, they used delicate pens, cut from dry reeds, varying the sharpness of the grooved nibs, according to the type of script that was employed. The earliest Qurans were normally copied on vellum (dressed animal hide), usually sheepskin. This was gradually superseded by paper in the 7th and 8th centuries, when Muslims learned the art of paper technology from China.

KUFIC SCRIPT

The predominant angular style is often called kufic, although it is no longer associated with the Iraqi city of Kufa from which it took its name, and, more recently, codicologists have termed the style 'early Abbasid' instead. This script was written with an elegant, imposing hand, notable for its bold, angular appearance. In its simplest form, the letters have a strong horizontal bias, rarely descending below the baseline. There are few confirmed Qurans dateable to the 7th century, but contemporary inscriptions on architecture and epigraphic coinage show that this measured formal style was well established. However, over the years more decorative forms of the script evolved. With 'foliated Kufic', which became popular in Egypt, the tips of the characters were adorned with leaf or palmette shapes. Similarly, 'floriated Kufic'

Above North African scribes developed a regional style of calligraphy in the 9th century. Known as 'Western Kufic', it was lighter and more dynamic than the solid form of the parent script.

combined the letters with floral motifs and rosettes. During the 10th century, angular scripts were gradually superseded by more legible, rounded scripts, which had previously been restricted to more mundane and secretarial use. At the same time, paper technology had improved to the degree that it could also be used for Qurans for the first time.

IBN MUQLA

Rounded Arabic script reached a new peak of refinement during the time of Ibn Muqla (886–940), who is often hailed as the father of Arabic calligraphy. A wazir and chancery secretary in Abbasid Baghdad, he is credited with the proportional system of writing based on

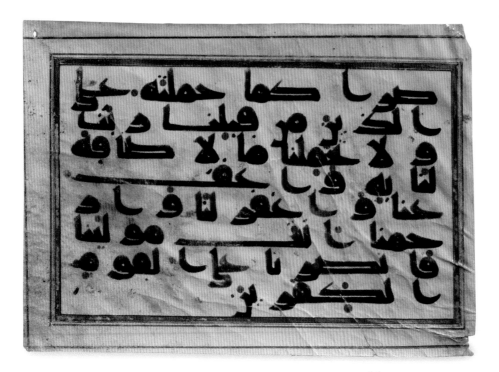

Left Many early Qurans were written on horizontal leaves of parchment in order to distinguish them from other types of manuscript. This was echoed in the long, horizontal strokes of archaic Kufic calligraphy.

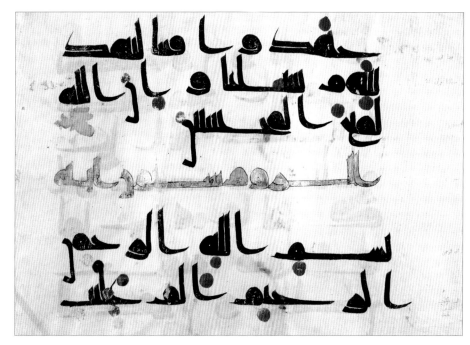

IBN MUQLA'S DOWNFALL

The ordered nature of Ibn Muqla's calligraphy was not echoed in other areas of his life. He had a tempestuous political career, serving under three caliphs, but became embroiled in bitter conflicts with his rivals. Following one of these disputes, his right hand was severed as a punishment, although it is said that he learned to write equally well with his left. He ended his days imprisoned and disgraced.

geometric principles known as *al-khatt al-mansub*, or proportioned writing. His precise and perfect handwriting led one contemporary, al-Zanji, to compare Ibn Muqla's skill to 'the (God-given) inspiration of the bees, as they build up their cells'.

Later, Ibn Muqla's reforms became associated with the establishment of six canonical scripts, the 'Six Pens': *naskh*, *muhaqqaq*, *thuluth*, *rayhani*, *riqa* and *tawqi*. These are organized in three pairs of large and small versions: *tawqi* and *riqa*, *thuluth* and *naskh*, *muhaqqaq* and *rayhani*. (Today, *naskh* is the style most commonly employed in everyday use across the Arab world.)

IBN AL-BAWWAB

Ibn al-Bawwab ('Son of the Doorkeeper') was the greatest calligrapher of the

Right This striking calligraphic script is from a 14th-century Mamluk Quran. The panels highlighted in gold are surat, or chapter, headings.

Abbasid period. An outstanding copyist regarded ever after as a paragon of skill, he was an illuminator as well as a scribe, using his artistic talents to endow the proportioned script established by Ibn Muqla with a rhythmic flow and elegance. He also wrote a very influential treatise on calligraphy, stressing the importance of measure, balance and spacing. It is believed that Ibn al-Bawwab completed 64 Qurans, but only one has survived into modern

Above A fragment from a 9th-century Quran, written out in the Persian form of kufic. The red dots are conventional markings, indicating the position of the vowels.

times. This Quran is held in the Chester Beatty Library in Dublin, Ireland. Dating from 1000–1, it combines his inimitable smooth script with a sumptuous array of illumination, both floral and geometric; artwork for which he was also responsible.

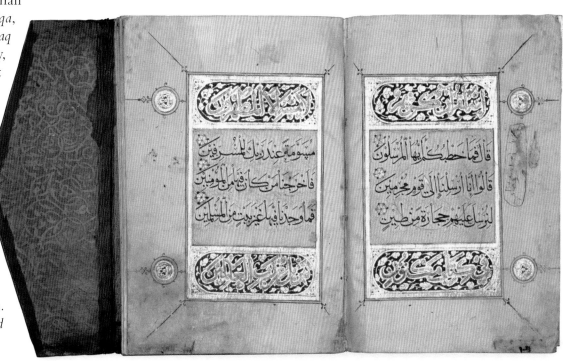

THE ART OF THE QURAN

ISLAMIC CALLIGRAPHERS DEVELOPED A REPERTOIRE OF FUNCTIONAL YET DECORATIVE DEVICES AS THEY COPIED THE SACRED TEXT, TO HELP FIND THEIR WAY AROUND THE QURAN AND ALSO BEAUTIFY IT.

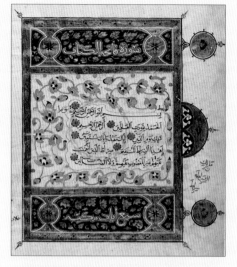

With the spread of Islam, the text of the Quran inspired some of the world's greatest artworks. Calligraphers and illuminators joined forces to create some of the finest manuscripts ever produced. From the first, the main emphasis was on the beauty and clarity of the written word. As a result, calligraphers enjoyed a higher status than other artists.

EARLY SIGNS AND SYMBOLS

From the outset, the text of the Quran was adorned with a number of markings. Many of these were orthographic signs, added above and below the letters to indicate short vowels, doubled letters and other features of spelling. In early Qurans, these signs could also indicate variant readings of the text, and they were written in up to four different colours: red, yellow, green and blue. In addition, there were a variety of symbols positioned at the end of verses and chapters, which were designed to help readers navigate their way around the text. In the earliest manuscripts, these symbols could be simple – the end of a verse, for example, might be marked by a cluster of gold dots. However, over the years these adornments grew more elaborate.

CHAPTERS AND VERSES

The text of the Quran is divided into 114 suwar (literally 'degrees', sing: surah), or chapters. From around the 9th century, the headings of these suwar became an important focus for decoration. In most cases, this took the form of an inscription in a decorative, rectangular frame, or *unwan*, specifying the title of the surah, the number of its verses and the site of its revelation (such as Makkah or Madinah). The inscription often featured a different script or colour than the one used for the main body of the text, usually Kufic or *thuluth*. In the margin adjoining the frame,

Above The inscriptions for suwar were written in a different style to the main text and contained within rectangular frames, as in this 12th-century example.

the illuminator sometimes added a palmette, a hasp ornament to emphasize a break in the text.

Some suwar received more attention than others. The pages relating to the first two, known as al-Fatihah and al-Baqarah, were always especially ornate. Surat al-Fatihah is short, filling just a page, and often recited as a prayer. The two suwar therefore begin on the same page opening. In later Qurans, the entire text of this initial section was enclosed in decorative borders, and the calligraphy itself was superimposed on a background of swirling patterns.

Illuminators also focused on the breaks between the *ayat* (sing: *ayah*), or verses, which made up these suwar. This provided a useful guide for those reciting the text, because the verses were of varying lengths. Different symbols were used, but rosettes or *shamsahs* (sunbursts) were common. In addition, artists

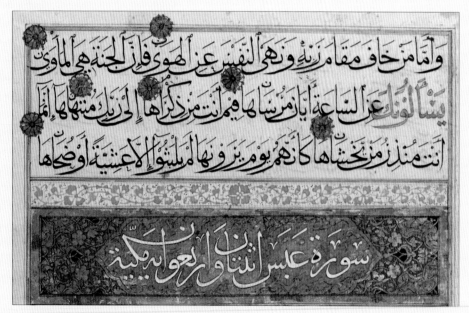

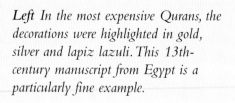

Left In the most expensive Qurans, the decorations were highlighted in gold, silver and lapiz lazuli. This 13th-century manuscript from Egypt is a particularly fine example.

added more elaborate symbols in the margins, to denote every fifth and tenth *ayah*. These symbols mainly took the form of circular rosettes or tear-shaped medallions, with a brief inscription in the inner roundel.

OTHER DECORATION

Many Quran manuscripts also contained marginal decorations, which were used in the passages to indicate where ritual prostration was required. Here, the word *sajdah* was inscribed in an ornamental setting. There was no fixed format for this marking, although medallions and stars were

Below In later Qurans, the margins were often filled with lavish borders. This 18th-century manuscript was commissioned by the Sultan of Morocco.

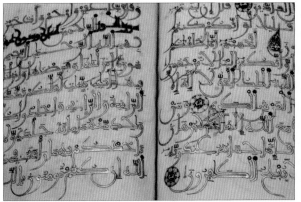

Above A double-page section from a 14th-century Quran produced in North Africa. The ayah divisions are marked by rosettes and the script is Maghribi.

popular choices. A more unusual variation can be found in a Mamluk Quran commissioned by Sultan Faraj ibn Barquq. Here, the *sajdah* inscriptions were contained in a tiny image of a mosque.

LATER ERAS

The splendour of Quranic manuscripts reached a high point in the Middle Ages, during the Mamluk and Ilkhanid periods. It was at this time that illuminators found their greatest creative outlet in magnificently designed frontispieces. These double-page spreads were designed to list the number of verses contained in the individual volume (the text of the Quran was frequently divided into 30 separate volumes).

Qurans were still copied out by hand in the 19th century, many years after the advent of printing, and calligraphers continued to use classic archaic scripts, such as kufic and *thuluth,* after they were no longer in general use.

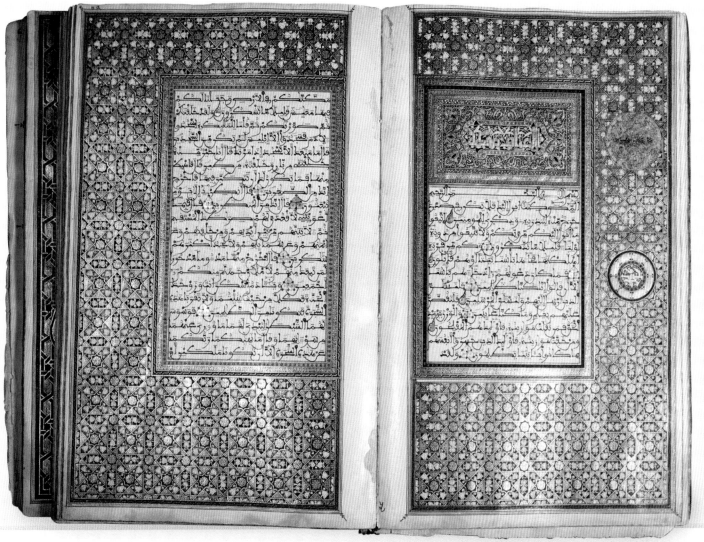

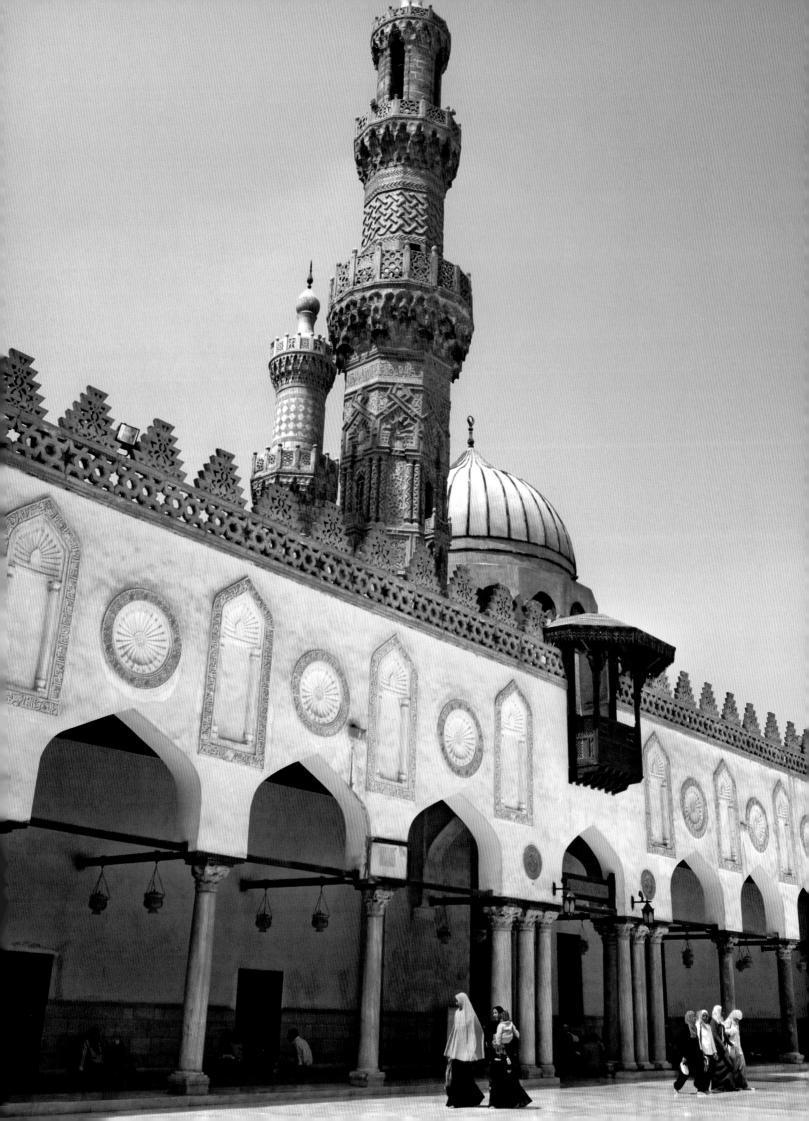

CHAPTER 4

THE FATIMIDS

In the 10th century, the Fatimids, a dynasty based in North Africa and claiming descent from the Prophet's daughter Fatima, challenged the rule of the Abbasids in Baghdad and established a rival caliphate. The Fatimids belonged to the Shiah Islam sect known as Ismaili, and did not recognize the authority of the Abbasids, who by this time had renounced their Shiah allegiance and regarded the Fatimids as heretics. The Fatimids governed first from Tunisia, and then created a new capital at Cairo, in Egypt, which became the pre-eminent city in the Islamic world. At the height of their power, the Fatimids ruled a prosperous empire that reached north to Syria, west along the North African coast, and south to the Hijaz and Yemen on the Arabian peninsula. With a wide geographical spread through much of the Mediterranean world, Fatimid art was influenced by the late-antique figurative traditions of the classical world. Written accounts from the Fatimid era describe incredible levels of luxury and sophistication at their court, while luxury objects made from intricately carved wood, ivory and rock crystal and lustreware ceramics were also produced for the cosmopolitan merchant elite.

Opposite The Fatimid al-Azhar Mosque dates right back to the foundation of al-Qahira (Cairo) in 969. It was a great centre of Shiah Islam and became one of the Islamic world's premier universities.

Above Fatimid gold work was exported far and wide: this piece was found in Ashkelon (now in Israel). The Fatimid caliph reputedly sat behind a golden filigree screen during court ceremonies.

THE FATIMID CALIPHATE

THE FATIMID CAPITAL OF AL-QAHIRA (THE VICTORIOUS), LATER KNOWN AS CAIRO, WAS A WALLED PALACE CITY CENTRED ON THE CALIPH'S RESIDENCE AND A CONGREGATIONAL MOSQUE.

The Fatimids emerged as an Ismaili sectarian movement in Syria, and then moved to Tunisia. It was in Tunisia, in 909, that Ubayd Allah declared himself the Mahdi, or Holy One, and founded a Fatimid Caliphate in their temporary capital, Raqqada. The dynasty claimed sacred descent from Ali, the Prophet's son-in-law, and his wife Fatima, the Prophet's daughter – from whom the name Fatimids derives.

Supported by missionary activity around the Islamic world, the Caliphate quickly grew, and in 921 Ubayd Allah built the splendid palace city of Mahdia on the Tunisian coast. He was succeeded as ruler by al-Qaim (934–46), al-Mansur (946–53) and al-Muizz (953–75). During al-Muizz's reign, the Fatimids moved eastward to conquer the Ikhshidid governors of

Egypt, and in 969 al-Muizz ordered General Jawhar al-Siqilli to found a new dynastic capital on the Nile, to be called al-Qahira 'the Victorious' and now known as Cairo.

This walled settlement was a proud statement of the power and ambition of a youthful dynasty. The walls, which had eight gates set into them, enclosed a large area measuring 1,100m by 1,150m (3,610ft by 3,773ft).

TWIN PALACES

A broad street called Bayn al-Qasrayn ('between the two palaces') ran through the middle of the city. Across this street, two royal palaces faced each other; the Eastern

Below At its greatest extent, the Fatimid Caliphate stretched across North Africa and into the Arabian peninsula. Sicily was also part of the Caliphate.

Above An 11th-century wall painting from a bath near Cairo depicts a young man drinking wine. In secular settings, Fatimid artists used figurative drawings.

Palace larger than the more secluded Western Palace. The Bayn al-Qasrayn was a parade ground where elaborate processions and public ceremonies were held to celebrate religious holidays and other significant dates, such as the start of the agricultural year.

According to contemporary accounts, these palaces were beautifully planned and furnished, with cloisters of marble and rooms bedecked with the finest textiles. The gardens, which were set within high walls, had artificial trees

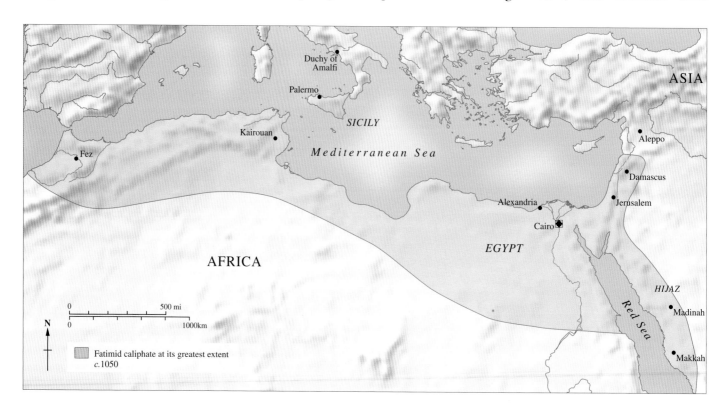

Duchy of Amalfi

Palermo

ASIA

SICILY

Kairouan

Aleppo

Fez

Mediterranean Sea

Damascus

Alexandria

Jerusalem

Cairo

EGYPT

AFRICA

0 500 mi
0 1000km

N

HIJAZ

Red Sea

Madinah

Fatimid caliphate at its greatest extent
c.1050

Makkah

carved from precious metal with clockwork singing birds.

The 11th-century Persian traveller Nasir-i Khusrau visited the Western Palace in 1049, and reported seeing a raised dais carved with hunting scenes and fine calligraphy, a golden balustrade and silver steps. During a financial crisis in 1068, the unpaid Fatimid army rose up and looted the Fatimid treasury, where they found huge numbers of precious luxury items – and promptly sold them on the open market to the great astonishment of the Cairo public.

MOSQUES

The magnificent Mosque of al-Hakim was begun in 990, under the rule of Caliph al-Aziz, and finished in 1012, by Caliph al-Hakim (reigned 996–1021). Four arcades enclose a courtyard. Within the prayer hall there are five bays: the bay before the *mihrab*, or prayer niche, and, unusually, the two corner bays at each end of the *qibla* wall that indicates the direction of prayer are domed. The outer walls are surmounted by battlements, and there is a three-part façade with a monumental entrance gateway, plus a spectacular minaret at each end – one circular and one square. The design of the façade was derived from that of the Great Mosque (916) in Mahdia.

UNDER THE VIZIERS

In the late 11th and 12th centuries, the power of the Fatimid caliphs weakened. Cairo was governed by its viziers, or ministers. One of these was Badr al-Jamali, wazir to Caliph al-Mustansir (reigned 1036–96), who rebuilt and extended the city walls. The splendid fortified gates of Bab al-Nasr and Bab al-Futuh are from this period. Bab al-Futuh has twin towers 8m (26ft) high, rising to a battlement with parapet. It was built with the latest defensive features,

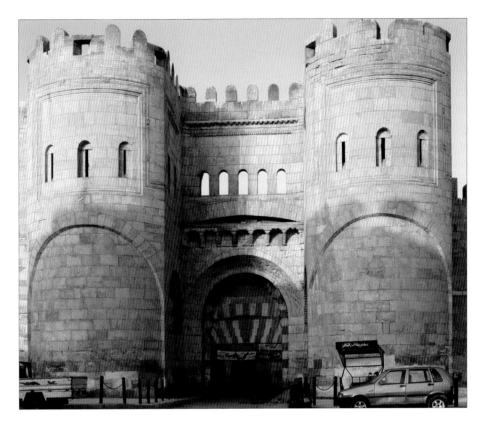

Above Bab al-Futuh (the Gate of Victories) was built in 1096 for wazir Badr al-Jamali by Armenian builders.

such as machicolation (openings through which to drop missiles).

Mamun al-Bataibi, another wazir, founded the remarkable Aqmar Mosque in Cairo in 1125. This mosque has a decorated façade with a central porch bearing a medallion inscribed with the names of Muhammad and Ali – who is revered by Shiahs as the first Imam – at its centre.

A distinctive aspect of Fatimid architecture in Egypt is the building of tombs and often lavish mausolea. The Fatimids and their fellow Shiah contemporaries in Iran, the Buyids, were the first rulers in Islamic history to build funerary monuments. Shiah Islam encourages religious devotions at the tombs of saints and Imams, while orthodox Sunni Muslims are discouraged from venerating any human forebears. For this reason, the building of tombs and mausolea was initially found more

FATIMIDS IN JERUSALEM

In 969, the Fatimids captured Jerusalem. They rebuilt the citadel, and in 1035 Caliph al-Zahir rebuilt the Al-Aqsa Mosque, which had been destroyed by an earthquake two years earlier, in the form in which it survives today. Deciding to promote Jerusalem as a pilgrimage site to rival the holy cities of Makkah and Madinah, Fatimid rulers encouraged writers to create works about the beauties of Jerusalem, and a new genre came into being: *Fada'il al-Quds* (Songs in Praise of Jerusalem).

in the Shiah tradition than in Sunni Islam. The Fatimid caliphs were buried in a splendid dynastic tomb in the Eastern Palace, but their wealthier subjects built many tombs, principally to celebrate Shiah martyrs and saints in large cemeteries at Aswan and Cairo.

ROCK CRYSTAL

THE FATIMIDS VALUED ROCK CRYSTAL BOTH FOR ITS BEAUTY AND ITS 'MAGICAL' POWERS. ASTOUNDING QUANTITIES OF THIS PRIZED MATERIAL WERE FOUND IN THE FATIMID TREASURY.

Several deposits of rock crystal, a transparent quartz, can be found across the Middle East and Asia. Writing in the early 11th century, the Persian scholar and scientist al-Biruni stated that the finest pieces of rock crystal were produced at Basra in Iraq and that the raw material was imported from the Laccadive and Maldive islands and from the islands of Zanj in East Africa. The Iranian traveller Nasir-i Khusrau, who visited Cairo in 1046 and saw rock crystal being carved in the lamp market, mentions that Yemen was the source of the purest rock crystal but that lesser quality crystal was also imported from North Africa and India.

THE CRAFTSMEN

Rock crystal is a hard mineral that requires great expertise to carve. Skilled lapidaries from Basra probably migrated to Cairo to seek the patronage of the Fatimid court, just as the potters are known to have done. The craftsmen cut blocks of crystal roughly the shape of the vessel they intended to make and then laboriously drilled out the interior, leaving walls of remarkable thinness before carving the decoration and polishing the exterior.

Right Carvings of a large bird of prey attacking a horned deer appear on this 10th–11th-century ewer from Cairo. The carvings symbolize the power of the ruler over his enemies.

THE FATIMID TREASURY

When the Fatimid palace was looted in 1068–69, many of the valuable artefacts that had been concealed in the storerooms were dispersed. The *Kitab al-Hadaya wa al-Tuhaf* (Book of Gifts and Rarities), compiled in the 11th century, refers to the gifts exchanged between Muslim and non-Muslim rulers and officials. It contains an eyewitness account of some of the items that were removed. The author refers to 36,000 objects of glass and rock crystal that were found in the treasury, but also lists a number

Above A crescent carved from rock crystal is mounted in a 14th-century European silver and enamel monstrance. A Kufic inscription carved into the crystal gives the name of the Fatimid Caliph al-Zahir.

of specific rock-crystal objects, including a spouted ewer of smooth rock crystal with a handle carved from the same block, a large storage jar with images carved in high relief, and a box with a lid cut from a single block of rock crystal, made to store small rock crystal dishes.

The same source that listed the precious items dispersed from the Fatimid treasury also described how these objects were sold in the local markets and bazaars and also sold to the courts of neighbouring countries, such as Spain and Sicily, as well as the Byzantine court in Constantinople. Many of these rock-crystal pieces ended up in church treasuries across Europe, often as containers for storing saintly relics.

SURVIVING TREASURES

Several of the surviving pieces contain inscriptions naming their patrons, who include two caliphs and a general. Eight complete ewers have survived, each one of similar pear-shaped form, carved with pairs of animals beside scrolling foliage and with an intricately pierced handle topped with an animal as a thumb rest. One of these ewers, now in the treasury of San Marco in Venice, Italy, bears a dedicatory inscription to Caliph al-Aziz (reigned 975–96). It is carved with face-to-face lions, the quintessential symbol of royalty. Another ewer, decorated with a pair of birds with elegant curving necks and long beaks, was commissioned for Husayn ibn Jawhar, a general of Caliph al-Hakim. The final inscribed piece is a curious crescent-shaped object that may have been mounted on a horse's bridle as a royal emblem; it contains the titles of Caliph al-Zahir (reigned 1021–36). Other types of objects made from rock crystal include lamps, small bottles that probably contained precious oils, chess pieces and small animal figures.

Right This 10th–11th-century rock crystal ewer from Cairo, carved with a pair of birds below a Kufic inscription, is now in the Musée du Louvre, Paris.

MAGICAL LINKS

Although rock crystal was valued for its aesthetic qualities, it was also held in great esteem by the Fatimids, along with other cultures, because they believed it had magical properties linked with its similarity to water and air. In fact, the Arabic name for 'rock crystal', *maha*, is a synthesis of the two components of which it was believed to be made: *ma*, or 'water' and *hawa*, or 'air'. The Persian-born author and judge al-Qazwini (1203–83) explained that kings preferred to drink out of rock-crystal vessels because they had the power to prevent them from ever becoming thirsty. In the Quran, there are two passages that describe how cups of rock crystal filled with pure water will be offered to the believers in paradise.

Left This rock crystal ewer, now broken, was inscribed with the title of Husayn ibn Jawhar, a general of Caliph al-Hakim who held the title from 1000 until 1008.

LUSTREWARE

SKILLED POTTERS MIGRATED FROM BASRA TO SEEK THE PATRONAGE OF THE FATIMIDS IN THEIR FLOURISHING CAPITAL, CAIRO. THE LUSTREWARE THEY PRODUCED WAS SUPERBLY PAINTED.

During the Abbasid Caliphate, Egypt was controlled by Ahmad ibn Tulun, a governor brought up in Samarra who surrounded himself with luxurious objects. Large quantities of lustreware items were imported from Basra, and when civil unrest disrupted that city in *c*.870, some of its artists skilled in the lustre technique may have migrated to ibn Tulun's rising artistic centre. (One source of evidence is from a condiment dish of this period now in the British Museum; it is signed by Abu Nasr of Basra in Misr, that is, in Egypt, however, the dish was not painted with a lustre glaze.)

When the Fatimids established their capital in Cairo a century later, they too attracted a wave of new craftsmen seeking the court's patronage. Among them were potters from Iraq, who brought with them the highly specialized knowledge needed for the manufacture of lustre pottery.

POTTERY BODY

The local supply of clay was not of the same high quality as was available around Basra, and Fatimid lustreware items are of much poorer quality. The potting body is often heavy, the glazes are technically imperfect and, overall, the pottery

Above The female figure portrayed on this shallow, early 11th-century lustre bowl (from Fustat) has her foot raised as she dances. The dancer also holds castanets in her hands.

has a rougher, more careless finish. However, while the bodies and glaze may have been of inferior quality, any defects were amply compensated for by the superior quality of the painting.

Sometime in the early 11th century, probably in an effort to overcome the poor quality of the earthenware, potters started to experiment with a new body, which had quartz and glass added to the clay to make it harder, whiter and more like porcelain. The technology had a long history in Egypt, although it had lain dormant for a long time; in the Pharaonic period (278–330CE) a glassy, quartz-rich body known as faience had been developed.

A DEVELOPING STYLE

Initially, the potters worked in a recognizably 'Basra' style, using the same type of large abstracted figures set into a highly patterned

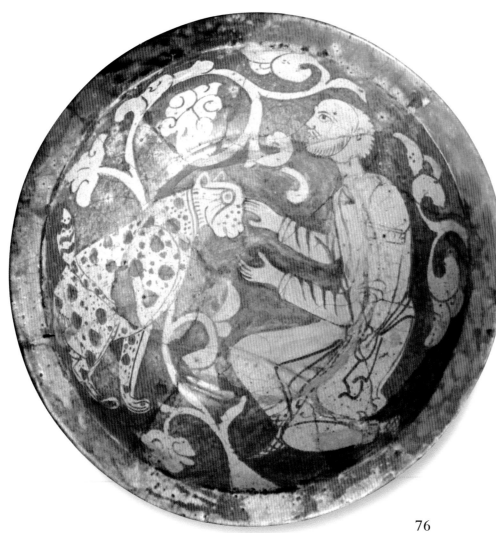

Left A leopard is shown with its keeper in this 11th-century lustre bowl. The figures were kept 'reserved', or unpainted, against the background as a way to highlight the details.

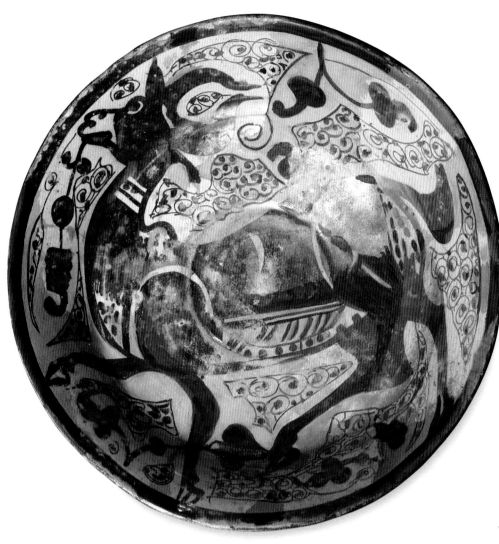

lustreware and other pottery items in the Cairo markets. These were so highly prized in Italy they were often set into the walls of churches, a fashion particularly popular in Pisa, where several churches built at the beginning of the 12th century have Egyptian, as well as Syrian and North African bowls, known as *bacini*, cemented into their façades. Fragments of pottery from Syria and Egypt were also set into mosaics in several churches in and around Ravello, perhaps to make use of the glowing colours if the pieces had broken in transit.

In the late 11th century, there was economic and political unrest in Cairo and many of the potters left the area to seek patronage in safer areas such as Syria and Iran.

Left The gazelle on this early 11th-century lustre bowl was a popular motif in Fatimid decorative arts. It has been found on several other lustre dishes.

background. As the Egyptian potters became more confident, they began to paint a wide variety of scenes of courtly life in a realistic style: musicians and dancers, scenes of horsemen ready for hunting, exotic animals from the court menagerie, such as a giraffe led by its keeper. They also illustrated scenes from everyday life, such as cockfighting and wrestling. The market for this luxurious pottery was not confined to the court but also appealed to wealthy members of the wider society, which included merchants and minor officials.

AN EXPORTED COMMODITY
During the 11th century, Egypt dominated Mediterranean trade and developed close trade links with Italy, whose merchants travelled to Cairo and bought

SIGNED BY MUSLIM
The fragmentary rim of a dish in the Benaki Museum in Athens, Greece, contains the inscription: 'The work of Muslim ibn al Dahan (Muslim, son of the painter) to please Hasan Iqbal al-Hakimi.' The patron cannot be identified, but he must have been an official at the court of the Caliph al-Hakim (reigned 996–1021). More than 20 fragments and pieces with the signature of Muslim are known, sometimes (as with this dish) in an obvious place within the main decorative scheme and sometimes on the underside of the vessel. It is possible that the signature indicated the mark of the workshop rather than the potter. This suggestion is backed by the wide range of styles, from the floral and epigraphic to an elaborate figural piece, found in pieces signed Muslim.

Right This 11th-century bowl with a griffin set within a frame of floral design is signed by Muslim. As with the styles, the quality of the pieces with this signature was diverse.

WOOD AND IVORY CARVING

THE SKILLED ARTISANS OF FATIMID EGYPT CREATED SUPERB CARVED WOOD AND IVORY PIECES, PRODUCING INTRICATE ABSTRACT GEOMETRIC DESIGNS AND LIVELY FIGURAL DEPICTIONS.

Several beautiful carved wooden friezes once graced the lavish Western Palace of the Fatimid caliphs in Cairo. The palace was abandoned after the fall of the Fatimid dynasty in 1171, and later made part of the Hospital of the Mamluk Sultan Qalawun (completed 1284). The friezes were discovered by chance during restoration work on the hospital, and, remarkably, are all that survives of the once magnificent setting of the Fatimid court as described in medieval accounts.

Above Fluid horses' necks and heads emerge from a delicate geometric pattern on this teak door panel carved by Fatimid artisans in the 11th century.

SECULAR WOODCARVING

The surviving fragments are typical of Fatimid secular woodcarving in representing the pleasures of court life, such as hunting, musical entertainment, dancing and drinking wine. Human and animal figures are framed by winding plant tendrils or interlaced geometric patterns, and sometimes also by bands of calligraphic inscriptions. One splendid frieze depicts a hunter spearing a lion and a courtier pouring wine while another plays a pipe. It has a recurring image of long-eared hares and a perched bird, a characteristic element in Fatimid figurative decorations. Fragments of paint found on the frieze suggest that it was once coloured blue with the figures highlighted in red.

Another frieze shows two gazelles, with beautifully fluid heads, horns and haunches, and stylized trunks, probably the Tree of Life. The figurative representations of animals and people produced by Fatimid artisans in woodcarving are generally more fluid than the stiff images created by earlier Islamic artists.

CARVED *MIHRABS*

One of the best surviving examples of sacred woodcarving is the *mihrab* from the Mausoleum of Sayyida Ruqayya in the Southern Cemetery in Cairo, built in 1154–60. Sayyida Ruqayya was a daughter of Ali, husband of the Prophet's daughter Fatima, though another of Ali's wives was her mother. She went to Cairo with her stepsister Zaynab and the two women are seen as being among the city's patron saints.

Sayyida Ruqayya's tomb is a *mashhad*, or pilgrimage shrine, much visited by Shiah Muslims. The *mihrab* has been removed from the shrine and is housed in the Islamic Museum in Cairo, but a fine wooden screen remains in the shrine.

Another beautiful wooden *mihrab* now in the museum was taken from the Fatimid shrine to Sayyida Nafisa (great-granddaughter of the

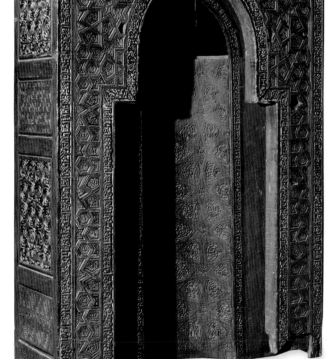

Left This portable mihrab (1133) from the Mausoleum of Sayyida Ruqayya has wooden panels carved with six-pointed stars, a design known as the star-shaped medallion.

Prophet's grandson Hasan), who died in Fustat in 824. While alive, she gained a reputation for piety and for performing miracles, and during the Fatimid era her shrine was a great attraction for Shiah pilgrims, who sought to benefit from her *baraka* (divine blessing).

Fatimid wooden panels and fragments of friezes carved with Kufic inscriptions also survive. Some bear phrases of benediction calling down happiness and favour on a patron; others are quotations from the Quran.

A fine poplar wood panel surviving from Fatimid Syria and dated to 1103 is now in the National Museum, Damascus, Syria. It bears a Kufic inscription of the *basmalah* (the Arabic phrase that translates as 'In the name of Allah, Most Gracious, Most Merciful'), the words 'Allah' and *al-salam* ('peace') and a quotation from Surah III: 18 of the Quran, together with an inscription stating that the patron for the panel, made in 1103, was Abu Jafar Muhammad b. al-Hasan b. Ali.

LUXURY WORK

Whereas in some parts of the Islamic world, such as Turkey and northern Iran, wood was common and was used as a basic building material, in Egypt it was scarce; the woods used for the fine Fatimid carvings that have survived, which include acacia, box, cedar, cypress, ebony, pine and teak, would all have been imported. As well as palace friezes and internal

mosque features, such as wall-mounted wooden *mihrabs*, the Fatimid woodcarvers also produced ceiling rafters, door panels, mosque furniture, caskets and portable *mihrabs*. Large pieces were inlaid with ivory. Wooden furniture and fittings from mosques were often reused not only because the wood was scarce but also because it had acquired a degree of sanctity from its sacred setting.

IVORY CARVINGS

Fatimid Egypt was a great centre for ivory carving in the Islamic world because of its proximity to the main source of the material in East Africa. Craftsmen in Egypt were concentrated in Fustat in particular, but Fatimid ivory carvers were also at work in what is now Tunisia and in Sicily.

Carvers produced inlay panels to decorate objects made from wood, together with small ivory items, such as caskets, combs and chess pieces. They also carved delicate decorations on to pieces of elephant tusk. Initially, only the broad end of the tusk was decorated, but later examples are carved along the whole length. These items – which are often called 'oliphants'

Left This carved ivory figure was made at Fustat, Egypt, the principal centre of ivory carving in Fatimid times.

Above This detail from a 11th–12th-century ivory plaque celebrates wine. The plaque may have been used to decorate a piece of furniture.

from the archaic English word for 'elephant' – were exported to many countries of Christian Europe.

Larger ivory carvings, intended to be inset in wooden furniture or used as room decoration, were similar in style to those found on woodcarving. They represented scenes of court life featuring huntsmen and animals, dancers and musicians, all so delicately rendered that the details of an animal's fur or the fall of a dancer's costume can be clearly seen. Whether working in wood or ivory, the Fatimid artisans demonstrated a supreme mastery of their materials.

SICILY

ARTISTS FROM THE FATIMID EMPIRE WORKED FOR THE NORMAN
LORDS OF SICILY IN THE 11TH AND 12TH CENTURIES, MOST
PROMINENTLY IN THE CAPPELLA PALATINA (PALATINE CHAPEL).

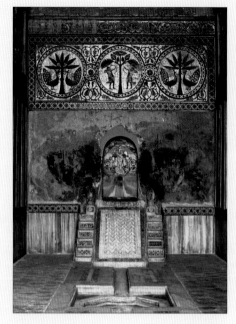

At the start of the Fatimid era in 909, the island of Sicily was largely under the control of the Muslim Aghlabid amirs of Tunisia. They had first attacked Byzantine-held Sicily in 827, but the conquest of the island took almost 140 years, until 965. Under their rule the island thrived: Palermo replaced Syracuse as capital and became one of the great cities of the Islamic Mediterranean world. Architects converted Palermo's basilica into a great mosque and made the former citadel into a splendid royal palace.

Infighting made the amirate vulnerable, and Norman warlord Robert de Hauteville (also known as Guiscard), with his brother Roger, conquered Sicily in 1072. Roger reigned as Count of Sicily in 1072–1101 and was succeeded by his sons Simon (count in 1101–05) and Roger II, who was count from 1105 and then, with papal backing, was crowned King of Sicily in Palermo on Christmas Day 1130.

His glorious coronation mantle made of red silk interwoven with silver-and-gold thread must have been made after his coronation, because it bears an inscription with the Hegira date 528, which corresponds to 1133–34. At this time, the products of the textile workshop in King Roger's palace became famous far beyond Palermo.

THE PALATINE CHAPEL

Muslim craftsmen served at the Christian court of Roger II. In 1132–40, Roger had a magnificent chapel built at the royal palace. Dedicated to St Peter, the Palatine Chapel has splendid floors, elegant Byzantine wall mosaics and a grand wooden ceiling painted in tempera in a style similar to frescoes in the 9th-century palaces of Abbasid Samarra and contemporary paintings in royal buildings in Fatimid Cairo. There are almost 1,000 paintings covering a profusion of *muqarnas* (small vaults

Above Water flowed down the shadirwan at the summer palace of La Zisa in the Jannat al-Ardh hunting grounds.

arranged in tiers). They mainly depict the pleasures of life at an Islamic court, with images of kings served by attendants, noblemen playing backgammon or chess, dancers, wrestlers, courtiers drinking wine, elephants, beasts of prey and exotic birds, processions, and scenes of racing and hunting. The architectural backgrounds to the images are mostly the arcades and domed roofs of an Islamic palace city. There are also scenes associated with the zodiac and mythology, such as sirens, griffins and sphinxes. The pictures have beaded edgings and the bands between the images contain Kufic inscriptions that wish fame, great power and charity on the chapel patron. Other rooms in the palace are as magnificent. The Roger Hall has mosaics depicting stylized landscapes that feature lions, peacocks, palm trees and leopards.

Left A Norman church in Sicily with an Islamic architectural influence, the 1161 Church of San Cataldo has red domes familiar from North African architecture.

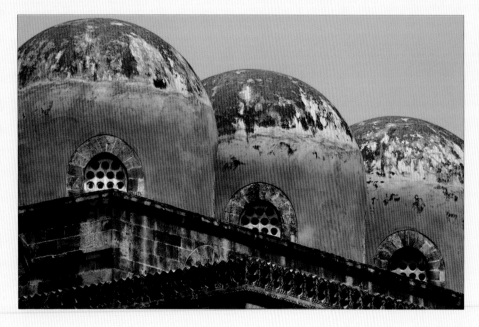

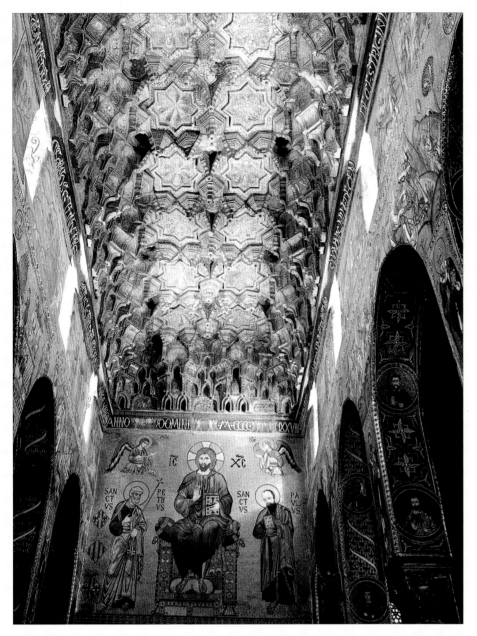

1154, probably the most accurate made in the medieval period. Known as the 'Tabula Rogeriana', the map shows all of Eurasia and northern Africa. Al-Idrisi also wrote a geographical work named the *Nuzhat al-Mushtaq*, which appears to contain an account of Muslim sailors crossing the Atlantic and landing in the Americas, where they encountered natives 'with red skin'. He also made a silver planisphere, a circular device for demonstrating the shift of the constellations and the signs of the zodiac.

SUMMER PALACES

The Norman lords used the Jannat al-Ardh ('Paradise of the Earth'), the Kalbid hunting grounds outside Palermo's city walls. They laid out summer palaces, set – like the Umayyad desert palaces – within agricultural fields, in this case date palms, citrus and olive trees. The summer palace of La Zisa was built in the last years of the Fatimid era, in 1166. As was typical of country palaces in the Islamic world, water played a major role at La Zisa: the building had pools around it, and an elegant *shadirwan*, or fountain room.

Above In the Palatine Chapel, fine Byzantine mosaics adorn the end and side walls, while Fatimid-style paintings decorate the ceiling above the nave.

The co-existence of Christian and Muslim iconography is striking in the Palatine Chapel. The scenes of Fatimid court life in the *muqarnas* suggest that Fatimid culture and the magnificent city of Cairo were the primary reference point in the Mediterranean for those who aspired to courtly splendour. Furthermore, it is noteworthy that Roger II, who was seeking to enhance the dignity

of his position by building an impressive sacred space, turned to North African Fatimid artists and architects.

MEDIEVAL WORLD MAP

Roger was also a patron of great Islamic scholars and writers, such as the geographer Muhammad al-Idrisi (1100–66), who worked at the court in Palermo for 18 years and drew a celebrated world map in

Right Muhammad al-Idrisi's world map, known as the 'Tabula Rogeriana', was the most accurate map of its day. North is at the bottom.

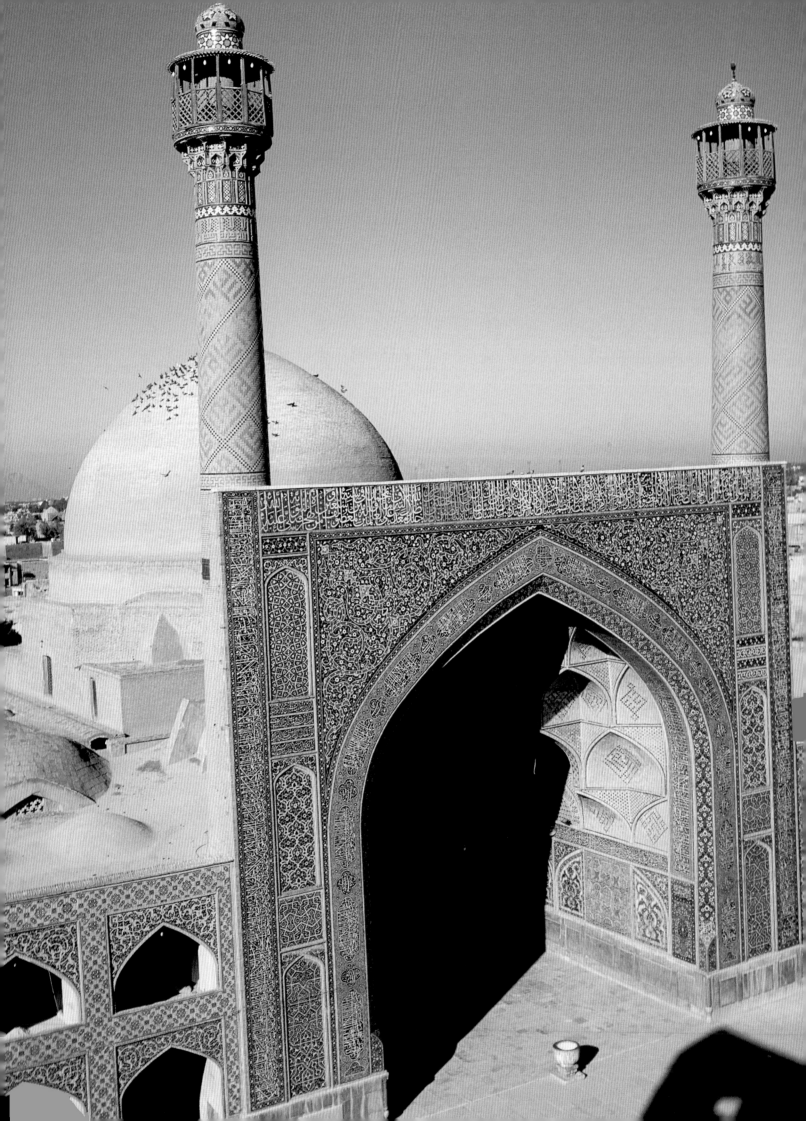

FROM THE SAMANIDS TO THE SELJUKS

From the 9th century onward, the Abbasid Caliphate's provinces in Iran were controlled by local governors, such as the Samanids and Ghaznavids, who became increasingly independent from Baghdad. In the great Iranian cities of the period – Isfahan, Samarkand, Merv, Balkh, Nishapur, Herat and Rayy – Persian cultural traditions became dominant in art and architecture, and a taste for sophisticated objects developed, perhaps owing to an increasingly wealthy and discerning merchant bourgeoisie. The 11th century saw the arrival in the region of the Seljuk Turks, tribesmen from the Central Asian steppes who initially served in the armies of Samanid and Ghaznavid sultans. The Seljuks carved out a vast territory stretching from north-eastern Iran to Anatolia and then, following steppe traditions of power-sharing, they divided their empire between the Great Seljuks, who controlled Iran (1040–1194), Iraq and Syria, and the Anatolian Seljuks, who built an empire in the former Byzantine territory (1081–1307) of Anatolia. Rulers of both Seljuk empires were energetic builders of monumental architecture.

Opposite The twin-minaret south iwan (hall) of the four-iwan Friday Mosque at Isfahan is in the direction of Makkah and leads into the domed sanctuary, behind, built by Nizam al-Mulk in 1086–87.

Above An elegant Kufic inscription in turquoise-glazed tiles quotes Quranic suwar on the side of the towering Minaret of Jam, built in the late 12th century in Afghanistan by Muhammad of Ghur.

THE SAMANID DYNASTY

THE SAMANID RULERS OF NORTH-EASTERN IRAN AND CENTRAL ASIA FOSTERED AN IMPORTANT REVIVAL OF PERSIAN CULTURE DURING THE 9TH AND 10TH CENTURIES.

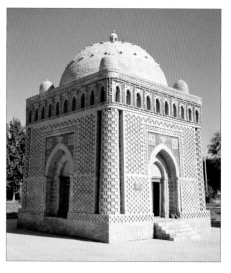

The Samanids first rose to prominence as local governors in Transoxiana (a province spanning modern-day Tajikistan, Uzbekistan and Turkmenistan) under the Tahirids, who served the Abbasid caliphs in Baghdad. The dynasty took its name from Saman Khuda, an 8th-century feudal aristocrat from the province of Balkh in Afghanistan who had served the Abbasid governor of Khurasan. According to many accounts, Saman was a Zoroastrian who converted to Sunni Islam.

In the early 9th century, Saman's grandsons Ahmad, Nuh, Yahya and Elyas helped to defeat an uprising against Abbasid Caliph al-Mamun (reigned 786–833) and in return were given the provinces of Ferghana, Samarkand, Shash and Herat. The Samanids reached the peak of their power under Ahmad's son Ismail Samani (reigned 892–907). Ismail defeated Amr, the Saffarid ruler of Khurasan, in 900, and the following year defeated Muhammad b. Zaid, ruler of

Tabaristan, thus conquering new territory across northern Iran to add to the provinces of Khurasan and Transoxiana. Ismail made his capital at Bukhara (now in Uzbekistan).

The Samanids were staunch Sunni Muslims and were opposed to, and tried to repress, the Ismaili strand of Shiah Islam promoted by their Fatimid contemporaries. Under Samanid rule thousands of Turkish tribesmen converted to Islam. The dynasty claimed descent from the pre-Islamic Sasanian shahs, and were keen sponsors of Persian culture, overseeing a renaissance in art, architecture and literature and the emergence of New Persian as a literary language.

SAMANID ARCHITECTURE

The finest monument of the Samanid era is the mausoleum in Bukhara. It is traditionally associated with Ismail Samani, but may also have been used as a tomb for later Samanid princes. It takes the form of a tapering cube built from cream-coloured bricks topped with

Above The mausoleum of Ismail Samani and the Samanid rulers in Bukhara now stands alone but was once at the centre of a substantial cemetery.

an elegant hemispherical dome rising from a flat roof with a small cupola at each corner. Both within and without, the mausoleum is notable for its intricate brickwork and the symmetry of its design.

PERSIAN CULTURE

The wealth and sophistication of this period survives in the luxury objects that are known today. Samanid potters produced fine work in the cities of Samarkand and Nishapur, reviving ancient Persian imperial iconography, such as bulls' heads, mounted horse riders, birds and lions, but also courting Islamic culture through the use of pithy Arabic calligraphy. Metalwork of the period also made self-conscious reference to Sasanian artistic traditions, as did textiles. A remarkable pictorial silk fragment, depicting elephants, camels and peacocks, generally known as the St Jossé silk, was made for an amir of Khurasan, Abu Mansur Bukhtegin, in *c.*955.

Left Nuh-Gunbadh Mosque, now in ruins, was one of 40 mosques built in Balkh in the 9th century. This fine example of Samanid architecture was influenced by earlier styles.

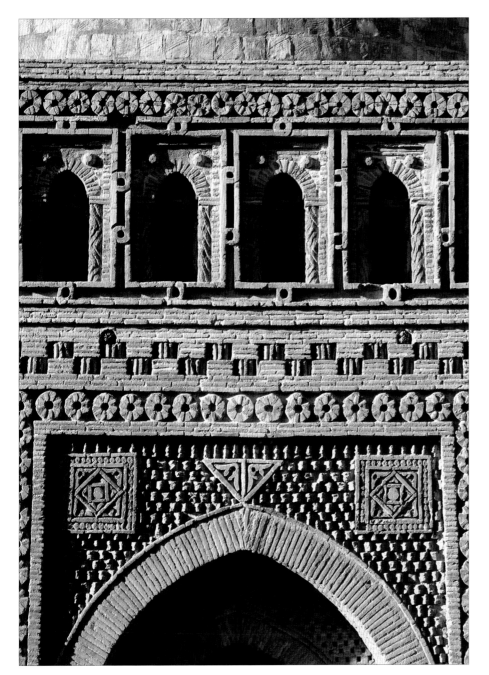

Ghaznavid patronage. Another great poet of the era was Rudaki (859–c.941), who served at the court of Samanid ruler Nasr II (reigned 914–43). He is celebrated as one of the founders of modern Persian literature and reputedly wrote more than 1.3 million verses.

FALL FROM POWER

From c.950 onward, the rulers of the vast Samanid empire began to lose their power, challenged by both palace rebellions and external threats from the Qarakhanid Turks to the east. The Samanids were finally defeated by the Ghaznavids, who ruled from Ghazni (modern-day Ghazna in Afghanistan, south of Kabul) and had previously served them as governors.

First, Mahmud of Ghazni (998–1030) led a revolt, deposed Samanid ruler Mansur II (reigned 997–99), and took Khurasan to found the Ghaznavid Empire, which eventually extended as far east as the border with India. The final Samanid ruler was Ismail II, who failed to counter Mahmud and was killed in 1005.

THE FAME OF BUKHARA

Bukhara was a major city and centre of learning under the Samanids. With a population of more than 300,000, it was the largest city of central Asia and, for a period, indeed rivalled Córdoba, Baghdad and Cairo as one of the foremost cities of the world. It was a principal centre of Sufi Islam, particularly of the Naqshbandi Order.

Bukhara is known for its scholars. It is the birthplace of Muhammad al-Bukhari (810–70), revered by Sunni Muslims as the author of *Sahih Bukhari*, a collection of *hadith*, or sayings, of Muhammad that is considered the most authentic of all extant books of *hadith*. The great polymath ibn Sina (980–1037) was born near Bukhara in the Samanid era. Known in the West as Avicenna, he was a major philosopher as well as the author of the *Canon of Medicine*, used as a textbook for medical students in European universities until the 17th century.

The national poet of Iran, Firdawsi (c.935–c.1020), was born and worked under the Samanid rulers, although he completed his masterwork, the *Shahnama*, under

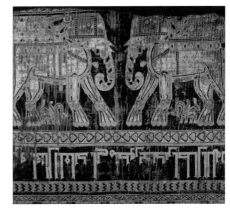

Above This detail of the St Jossé silk fragment shows a pair of elephants and part of an inscription praising an amir of Khurasan who died in 961.

SAMANID POTTERY

NISHAPUR AND SAMARKAND WERE MAJOR POTTERY CENTRES IN THE
10TH CENTURY, PRODUCING WHITE SLIPWARES WITH CALLIGRAPHIC
DESIGNS AND POLYCHROME WARES WITH FIGURAL DECORATION.

Above Over time the epigraphic style
used in Nishapur and Samarkand
evolved and red was added to enhance
the monochromatic palette. This late
10th–11th-century bowl is decorated
with dark brown and red slips.

Excavations made in the cities of
Nishapur and Samarkand have
uncovered kilns along with other
evidence of pottery production.
Samanid pottery was made using
slip technology, where a fine clay
diluted with water, known as 'slip',
was poured over the earthenware
body of the vessel to form a
smooth, even layer. When dry, the
surface was decorated with more
slip that had been coloured by
adding different oxides to the
mixture. Finally, a transparent lead
glaze was applied over the ware,
which was used to seal in the slip
colours and intensify their hue.

EPIGRAPHIC STYLE

Some of the most impressive
examples of Islamic ceramics were
made during this period in both
Samarkand and Nishapur. Using a
variety of different styles of Kufic
calligraphy, the potters inscribed
various aphorisms, or proverbs,
around the walls of large flat dishes
or deep bowls. Wares decorated in
this fashion are known as
epigraphic pottery. Sometimes
the letters were stretched and
elaborately decorated with
knots and foliated terminals
in order to fit the
proportions of the vessel.
The background colour
was generally white and
the calligraphy was usually
applied in a dark brownish
black, sometimes with

Right The kufic inscription on this
large, 10th–11th century
earthenware dish reads: 'The taste of
science is bitter at first but sweeter than
honey in the end.'

accents appearing in tomato
red. However, in a few examples
this palette is reversed, so that
white calligraphy stands out from
a dark background. Occasional
birds, drawn with spare, bold lines
and sometimes enclosing the word
baraka, meaning 'blessing', are the
only variants found in these wares.

POLYCHROMATIC WARES

In complete contrast to the
monochromatic palette that was
used for producing epigraphic ware,
a colourful and highly patterned
polychromatic ware seems to have
been the speciality of Nishapur. On
these bowls, a vivid yellow colour
serves as a background to a riot of
human figures, animals, birds and
floral motifs arranged in hectic
rotating patterns, which were
coloured in green, dark brown and
with touches of brick red. The wide
range of decorative themes was

probably drawn from local myths
and folklore: many of the figures
wear Persian costume and hold
objects that have been associated
with Zoroastrian ritual. Other
pieces have explicitly Christian
motifs, such as Nestorian crosses.

ESTABLISHING DATES

Unfortunately, the archaeologists
at Nishapur could not establish a
clear chronology for these two
contrasting types of pottery.
However, Richard Bulliet
(1940–), an American
historian who specializes in
medieval Islamic history,
looked at the dated coins
and types of ceramic
excavated with them at
three sites and deduced
that more epigraphic
pottery was found in the
earlier sites and more
figural ware in the later
sites. He extrapolated from
this distribution that the
epigraphic ware appealed to the
earliest settlers and converts who
read Arabic and wanted to uphold

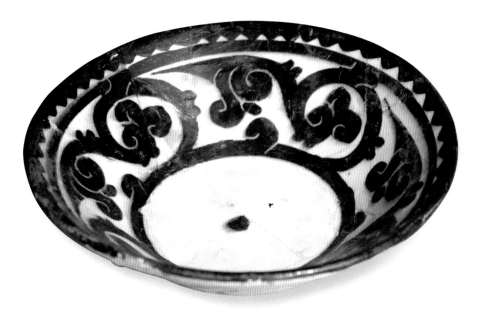

the traditions of the Abbasid court, whereas the colourful, figurative ware appealed to the indigenous population who were trying to maintain their Persian traditions. Bulliet even suggested that the different shapes of each type of ware represented the different dietary traditions of these two groups: the large flat dishes and bowls with calligraphic decoration were perfect for serving typically Arab dishes of rice and grilled meat, while the rounded bowls of the figurative ware were better suited to the more liquid Persian dishes.

FOREIGN INFLUENCES

The excavations at Nishapur also uncovered large numbers of imported Iraqi wares, such as lustreware pieces and blue-and-white ware with green splashes. The potters of Nishapur had tried to imitate both types, but it is clear they did not have access to the necessary ingredients or the specialized knowledge and were forced to approximate the techniques with locally available materials. They used a yellow-green slip and a glossy transparent glaze to imitate the colour and sheen of lustreware and copied the distinctive style of decoration closely. The same was the case

Above *The swirling leaf scroll on this 10th–11th-century shallow bowl replaces the more usual band of calligraphy. A manganese slip was used for decoration.*

Below *This Nishapuri 10th–11th-century bowl shows a figure on a horse with a cheetah on its rump. Birds, rosettes and calligraphic elements are scattered around the background.*

with the blue-and-white wares; Nishapuri potters do not seem to have had access to cobalt so substituted manganese, which produced a dark purplish colour, but combined with green splashes it produced a fair imitation.

Another popular type of ware excavated in Nishapur, but with a wide distribution across the Middle East and probably made in many centres, was splashed ware. It was made with either a plain surface or with an incised design that is sometimes described as 'sgraffito' (Italian for 'scratched'). Such pieces were covered with white slip, and then metallic oxides were used to produce various colours: copper for vivid green, iron for yellow-brown and manganese for purple were splashed on to the surface in stripes or spots. One of the few datable vessels is a jar from Susa, which contained a hoard of coins, the latest one dated 955–56.

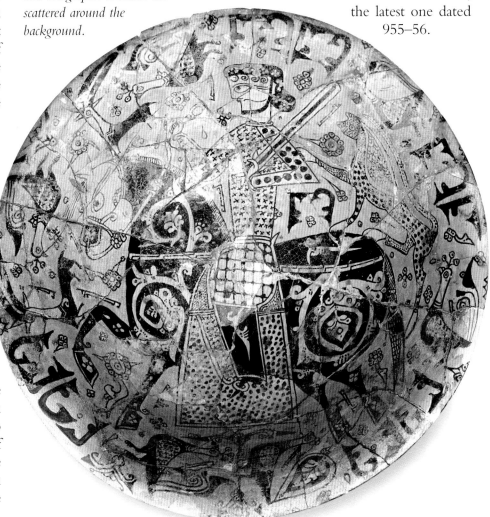

THE GHAZNAVID AND GHURID DYNASTIES

DURING THE 10TH CENTURY, THE GHAZNAVIDS QUICKLY ESTABLISHED A BROAD EMPIRE AND MADE INROADS INTO NORTHERN INDIA. IN THE 12TH CENTURY, THEY WERE SUPPLANTED BY THE GHURIDS.

By the 10th century, the political cohesion of the Islamic world was beginning to disintegrate. In the east, the Ghaznavids eventually became the dominant power, ruling from 962 until 1186. This Turkic dynasty originated from a corps of slave-guards who had served the Samanids and eventually supplanted them. From their capital at Ghazni in Afghanistan, they built up a considerable empire, which, at its height, included most of Iran, Afghanistan, Khurasan and parts of northern India.

GHAZNAVID BUILDINGS

The royal strongholds built by the Ghaznavids seem to have been modelled on those in Abbasid Samarra, in Iraq. This is certainly obvious in Lashkari Bazaar (Qalah-i Bust), a meandering complex of 11th-century palatial buildings that stretched for several miles along the banks of the river Helmand in south-western Afghanistan. These are now largely in ruins, although the remains of the winter palace, with its four *iwans* (vaulted halls) and its painted frieze of bodyguards, are still impressive.

The most tangible surviving reminders of Ghaznavid power can be seen in a number of remarkable towers. In Ghazni itself are the lower sections of two imposing, early 12th-century minarets. One was built by Masud III and the other by his son, Bahram Shah. Constructed in a similar style on a star-shaped plan, the minarets are decorated with inscriptions and geometric patterns created in

Above Dating from 1007, the tower of Gunbad-i Qabus was a potent symbol of power. Its stark, brick surface was adorned with just two bands of Kufic script.

brickwork. More impressive still is the Gunbad-i-Qabus, the best preserved of all the Islamic tomb towers. Located in north-eastern Iran, the tower was commissioned by a local Ziyarid ruler, Qabus ibn Wushngir. Cylindrical in shape, the tower has ten triangular flanges around the exterior and a strikingly austere appearance. Nominally at least, the tower was meant to be Qabus's tomb, but at over 60m (197ft) high the sheer size of the structure ensured that it was also an affirmation of his political strength. It is not clear if Qabus was ever buried there, but a medieval account claims that his body was placed in a glass coffin suspended from the roof.

THE GHURIDS

In 1186, the Ghaznavids were displaced by the Ghurids, who took their name from their native province (Ghur) in Afghanistan.

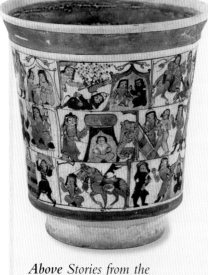

Above Stories from the Shahnama *are depicted on this 13th-century Kashan stonepaste cup.*

FIRDAWSI

The poet Firdawsi (*c.*935–*c.*1020) is one of the most celebrated figures in Iranian culture. His masterpiece is the 60,000 couplet epic *Shahnama* (Book of Kings), a monumental account of Persia's early history. Firdawsi is said to have laboured on the project for more than 30 years, beginning it under the Samanids in 977, but only completing it in the Ghaznavid era in 1010. Drawn from earlier accounts and oral sources, the *Shahnama* describes the kings, queens and heroes of pre-Islamic Iran. This beguiling mixture of history and legend provided Islamic artists with a fertile source for illustration in manuscript copies of the stories and in other media.

Like their predecessors, they extended their control over large swathes of Afghanistan, Iran and northern India. They owed much of their influence to the military success of Muhammad of Ghur (1162–1206), who conquered Lahore in 1186.

The Ghurids are associated with two famous minarets, both of which have been registered as World Heritage Sites by Unesco. The oldest of these is the Minaret of Jam, which dates back to the 12th century. It is hidden away in a remote Afghan valley – in fact, it is so remote that the tower was forgotten by the authorities until a boundary commission rediscovered it in 1886. Jam stands close to the river Hari Rud. The leaning shaft of the minaret is liberally adorned with decorative panels of calligraphy that cite all of Surah 19 of the Quran.

The purpose of this isolated minaret has been the source of considerable speculation. It is possible that it stands on the site of Firuz Kuh, the ancient summer capital of the Ghurids, and was once associated with a mosque there. Alternatively, it may have been built as a symbol of Islam's victory and never used for calling the faithful to prayer.

The huge minaret of Qutb Minar in Delhi was constructed on an even grander scale. Built on the site of an old Jain temple, it was attached to the Quwwat al-Islam ('Might of Islam') Mosque, the first great Muslim foundation on the Indian subcontinent. The 73m (240ft) high minaret dates from 1202, with many subsequent additions, and is made of red sandstone. The fluted columns of the tapering shaft owe much to local architectural traditions, but the decoration is truly Islamic, consisting of finely carved, ornamental bands of floral, geometric and calligraphic designs.

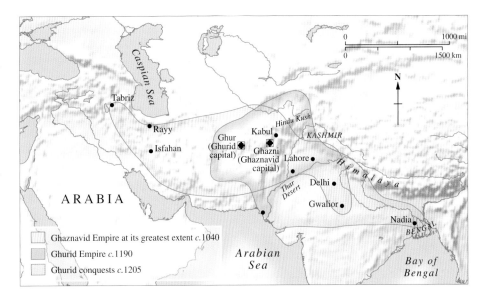

Above The Ghaznavid Empire reached its peak in c.1040 and stretched into most of Iran. The Ghurids displaced the Ghaznavids and by c.1205 had conquered most of northern India.

Below The Minaret of Jam is the finest surviving example of Ghurid architecture. Built for Ghiyath al-Din (1153–1203), it is over 60m (197ft) high and decorated with glazed-brick inscriptions.

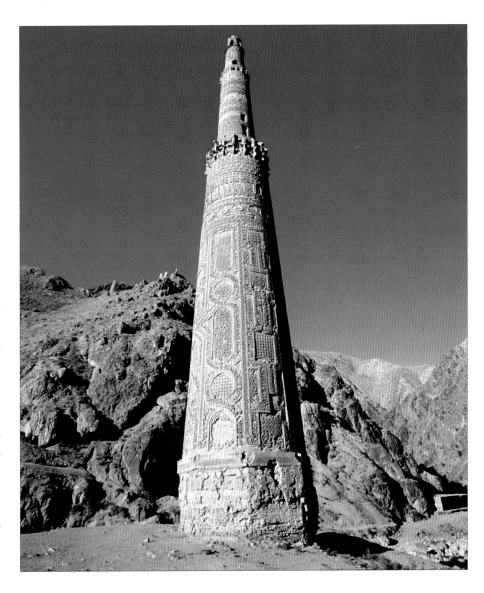

THE GREAT SELJUKS

THE SELJUK TURKS WERE GREAT BUILDERS WHO REVIVED EARLY IRANIAN TRADITIONS, SUCH AS THE USE OF THE DOMED *IWAN* (HALL), IN THEIR MANY MOSQUES, MAUSOLEA AND *MADRASAS* (COLLEGES).

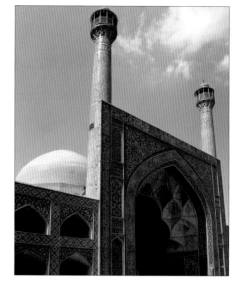

The Seljuks were Oghuz Turks from the steppes who converted to Sunni Islam in the 10th century under their leader Seljuk, after whom they are named. They entered the Islamic world as auxiliary troops, used by various dynasties in north-eastern Iran, but established an independent sultanate of great power, with several regional branches. One of Seljuk's grandsons, Toghrul Beg, defeated the Ghaznavids in 1040, conquered western Iran, Azerbaijan and Khuzestan, and marched into Baghdad in 1055 to oust the Buyids and take control of the Abbasid Caliphate. He described the war as one in support of religious ortho-doxy, to free the Sunni Muslim caliph from the Shiah Buyids.

Toghrul Beg was succeeded by his nephew Alp Arslan (reigned 1063–72), who defeated the Byzantine Empire in the Battle of Manzikert (1071). Both Alp Arslan and his son, Malik Shah, were served by the outstanding wazir, or minister, Nizam al-Mulk, who imposed centralized control over the vast empire. This branch of the dynasty are known as the Great Seljuks to distinguish them from the Anatolian Seljuks, descendants of Kutalmish, Alp Arslan's cousin, who established the independent Anatolian Seljuk Sultanate.

THE ISFAHAN MOSQUE

Alp Arslan's successor, Malik Shah, selected Isfahan in Iran as the imperial capital, and in his reign the congregational, or Friday, Mosque originally built there under the Buyids was developed into a masterpiece. The Abbasid mosque had been built with an enclosed courtyard and hypostyle prayer hall containing the *mihrab*, a niche indicating the direction of prayer. Malik Shah's wazir Nizam al-Mulk raised a grand domed chamber in front of the *mihrab*. An inscription on the base of the dome

Above *The* iwan *on the south side of the courtyard in the 11th–12th-century Friday Mosque in Isfahan has minarets that were added under the Safavids.*

states that it was raised by Malik Shah and Nizam al-Mulk; it has been dated to 1086–87. Historians believe that the chamber was a tribute to the dome at the Great Mosque of Damascus, which Nizam had visited in 1086, and that Nizam al-Mulk intended it to be a *maqsura*, a reserved area for the sultan. At the time of its construction, it was the largest dome ever built.

A second domed pavilion was built by Taj al-Mulk, the imperial chamberlain and a rival of Nizam al-Mulk, in 1088. It was aligned with the first dome, but was originally outside the mosque precincts. The purpose of the second dome may have been ceremonial, intended to mark the procession of the sultan into the mosque. Later Seljuk builders added four *iwans*, or domed halls, one on each side of the courtyard and opening on to it. This work was probably carried out some time in the first half of the 12th century.

Left *At its greatest extent in 1092, the Great Seljuk Empire stretched from the Mediterranean in the west to Afghanistan in the east.*

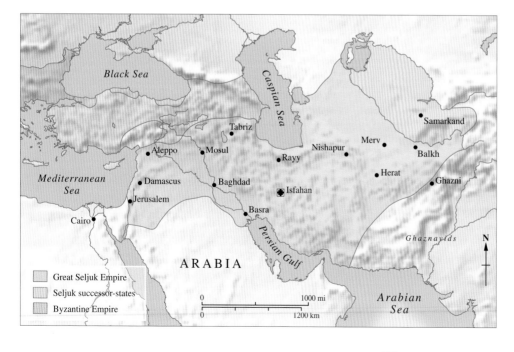

Black Sea

Caspian Sea

Tabriz

Samarkand

Aleppo Mosul Merv
 Nishapur Balkh
 Rayy

Mediterranean
Sea Damascus Baghdad Herat Ghazni
 Jerusalem Isfahan

Cairo Basra

Persian Gulf

ARABIA Ghaznavids N

Great Seljuk Empire

Seljuk successor-states

Byzantine Empire

0 1000 mi Arabian
0 1200 km Sea

The design of the Isfahan mosque, combining four *iwans* with a domed chamber containing the *mihrab*, became the standard Seljuk design for large congregational mosques. The four-*iwan* plan had roots in early Iranian architecture; the Seljuks applied it to *madrasas* and *caravanserais* (rest places for travellers). The design appears to have been well suited to the climate of Iran, because the southerly *iwan*, which was attached to the domed chamber with the *mihrab*, opened north on to the courtyard and would not receive direct sunlight for most of the year, while the other *iwans* would have been in sunlight all day.

THREE-PART MOSQUES

Another mosque design used by the Seljuks, known as the 'three-part mosque', combines a square, domed chamber with two domed side aisles. A fine example is the 11th-century Talkhatun Baba Mosque at the oasis city of Merv in Central Asia (today in Turkmenistan). All four façades are decorated with intricate

Below The Imam Mosque in Isfahan, built in the 17th century under the Safavids, is based on the four-iwan layout formalized by the Seljuks.

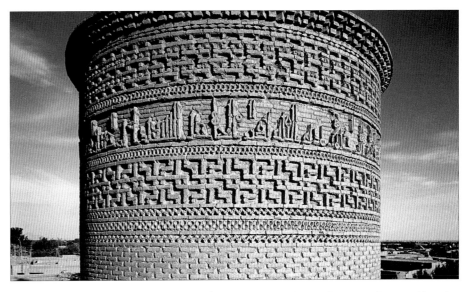

brickwork. Another example is the memorial mosque beside the tomb of poet, philosopher and Sufi saint Hakim al-Termezi in Termez, which has three rooms, the central one containing a *mihrab*. The Seljuks also built small single-chamber domed mosques, often beside the tombs of saints to provide a place for the pilgrims to pray.

SELJUK MINARETS

The Seljuks developed a new, cylindrical form of minaret that contrasted with the square minaret towers in North Africa. The Seljuk minarets were set on multi-sided plinths; they were tall, and

Above The tomb tower of Pir-e Alamdar in Damghan (1026–27) was built by government official Abu Harb Bakhtiyar for his father.

decorated with beautiful brickwork featuring geometric patterns and bands of carved inscriptions. One of the finest examples is the minaret of the mosque at Saveh, Iran, which dates to 1010; it features beautiful brick patterns and inscriptions in *naskhi* and Kufic scripts. Another fine Seljuk minaret rises above the Tari Khana Mosque at Damghan. Dated to 1026–27, its minaret inscription is the oldest surviving tile work in Islamic architecture.

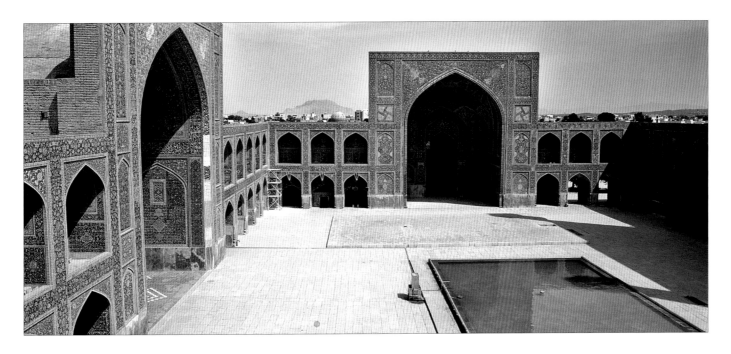

MONUMENTS AND *MADRASAS*

THE GREAT SELJUKS DEVELOPED TWO STYLES OF MAUSOLEA, THE *GUNBAD*, OR TOMB TOWER, AND THE SQUARE OR POLYGONAL DOMED MAUSOLEUM. FEW OF THEIR MANY *MADRASA* COLLEGES SURVIVE.

The Seljuk period was a time of major development in the field of architecture: builders working for Seljuk sultans were innovative and highly skilled. Distinctive styles emerged in the lands governed by the Seljuks, and examples of these styles are described as 'Seljuk architecture' even when they were built by successive regimes.

Of all the Seljuk buildings the finest are the mausolea. These were built as memorials in cemeteries or were added to mosques, *madrasas* (religious colleges) or *caravanserais* (travellers' lodges). The mausoleum commemorated the ruler whose legacy had funded the mosque, *madrasa* or *caravanserai* alongside it, or it would be raised in memory of a major religious scholar or saint.

The spread of mausolea was closely associated with that of Sufism, because it was common practice among Sufis to visit the graves of their teachers and saints. Under the Seljuks, Sufism became established in Persia and Anatolia. Officially, Islam did not permit praying at these memorials, and (unlike those in Egypt, for example) the Central Asian mausolea built by the Seljuks did not have *mihrabs*, or niches in the *qibla* wall to indicate the direction of prayer, and were generally not aligned to Makkah. A memorial mosque was often built near the mausoleum to provide a place for devotions.

PRE-SELJUK PROTOYPES

The earliest Seljuk mausolea in Persia and Central Asia were tomb towers. They were influenced by a celebrated forerunner, the Gunbad-i-Qabus of 1007 in Gurgan, Iran, which was built for a pre-Seljuk king – Ziyarid ruler Qabus ibn Wushngir. A similar circular tower

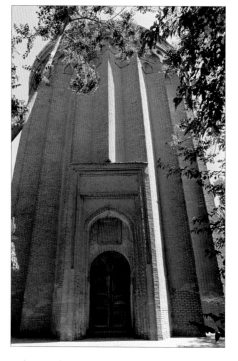

Above The 12th-century tomb tower of Seljuk ruler Toghrul Beg at Rayy in Iran is 20m (66ft) tall. The conical dome, that was originally on the top collapsed during an earthquake.

encircled with flanges was built for Seljuk Sultan Toghrul Beg at Rayy, near Tehran. This tomb had a grand entrance porch of the kind known as a *pishtaq*.

The domed square tomb of the Seljuks also derived from that of earlier rulers, notably the 10th-century Samarid mausoleum at Bukhara. The Gunbad-i-Surkh in Maragha, western Iran, was seemingly built on this model in 1147–48; it has a square chamber topped with an octagonal drum. This structure once supported an eight-sided dome.

MAUSOLEUM OF SANJAR

Another similar square-domed mausoleum was that of Seljuk Sultan Muizz al-Din Sanjar at Merv, built in *c*.1152. The four

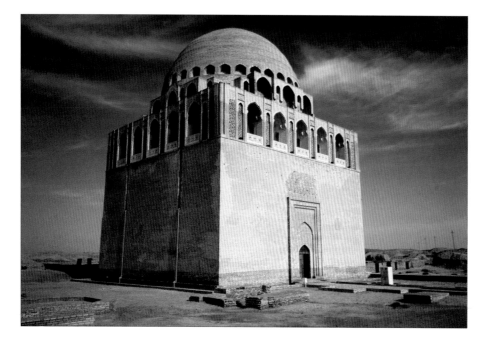

Left The Mausoleum of Seljuk Sultan Sanjar at Merv (now Turkmenistan) was once connected to a mosque within a large complex.

sides of the main chamber were each 27m (89ft) long, beneath a large octagonal dome. According to contemporary reports, originally there was an outer dome, decorated with beautiful turquoise tiles of such size that the dome could be seen by trade caravans while still a full day's travel from the city. The interior had stucco decoration, and the outside was of geometric brickwork (which has now mostly disappeared). The mausoleum was part of a palace complex, and was also attached to a mosque. Contemporaries regarded this as the world's biggest building.

MADRASAS

From contemporary accounts, there is evidence that during the Seljuk period a network of *madrasas*, or religious colleges, was established across the empire. Nizam al-Mulk, who was wazir from 1065 until 1092, during the reigns of Alp Arslan (reigned 1063–72) and Malik Shah (reigned 1072–92), was the driving force behind the building of these religious colleges as part of his efforts to help the promotion of Sunni orthodoxy. He attempted to cut the ties between Sufism and Shiah Islam and to integrate Sufism into Sunni Islam.

Like Seljuk mosques, these *madrasas* typically had a four-*iwan* format, with the four *iwans*, or halls, arranged around and leading on to a central courtyard. The *iwans* were used as teaching spaces, while the buildings enclosing the square or rectangular courtyard held kitchens and accommodation. The design usually also included a splendid portal or gateway that was flanked by two halls.

Right These octagonal tomb towers were built at Kharraqan in Iran in 1067 and 1093. Since this picture was taken they have suffered serious structural damage in an earthquake.

As was the case in other areas of architecture, this *madrasa* layout, sometimes proposed as a Seljuk invention, was derived from earlier examples. The ruined Khwaja Mashhad *madrasa* at Shahritus, in Turkmenistan, was built in this form as early as the 9th century. The two halls here were a mosque and a mausoleum, and the main focus was a courtyard with the four *iwans* built around it. The *madrasa* was functioning in the 10th century, and among its students was Nasir-i Khusrau, a celebrated Tajik poet who was a major force for the local spread of Islam. It is believed that Khwaja Mashhad *madrasa* is the oldest *madrasa* in Central Asia.

NIZAMIYYAS

The *madrasas* established by Nizam al-Mulk were known as *nizamiyyas* in his honour. He took charge of appointing the professors and teachers, while personally ensuring that each establishment was well supplied and funded. The first *madrasa* that Nizam al-Mulk set up was built in Baghdad in 1065. He appointed philosopher-theologian Muhammad al-Ghazali – the greatest Muslim intellectual of the medieval period – to teach

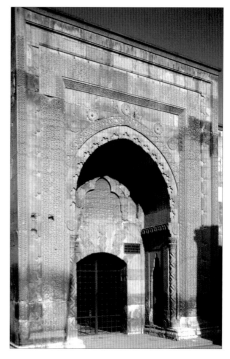

Above The Sircali madrasa of 1242 in Konya, built by Muhammad of Tus, is typically arranged over two storeys around an open courtyard. The entrance is through a wide, decorated stone portal.

there, and the renowned Persian poet Shaykh Sadi (1184–1291) was a pupil. This network of religious colleges included institutions in Balkh, Basra, Damascus, Ghazni, Herat, Isfahan, Mosul, Merv and Nishapur, but few of these colleges survive.

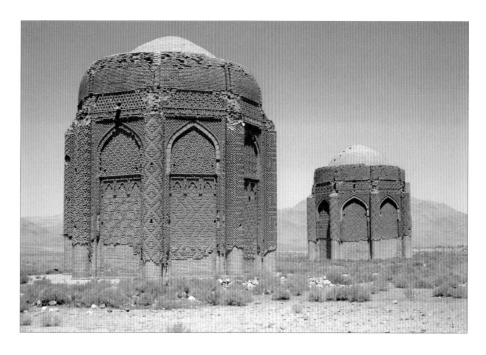

CARAVANSERAIS

THE SELJUKS BUILT A NETWORK OF *CARAVANSERAIS* ALONG TRADE ROUTES. THESE SHELTERS PROVIDED SECURE ACCOMMODATION, FOOD AND WATER FOR TRADERS, TRAVELLERS AND THEIR ANIMALS.

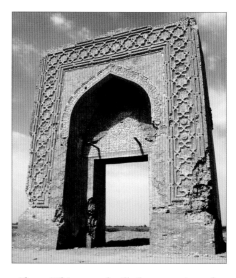

A complex of buildings could typically be found inside a *caravanserai*, often with an imposing, decorated gateway as an entrance leading to a courtyard surrounded by lodging and stables, with a fountain and mosque and normally a bazaar or trading area. These *caravanserais* became important trade centres and were often fortified. The usual layout of Seljuk *caravanserais* was of four *iwans*, or halls, surrounding the courtyard.

A traveller was typically allowed to stay for three days without paying because the *caravanserais* were built as an expression of the Muslim duty of charity toward travellers. Local rulers built the entrances in a very grand style to signal their wealth and generosity. Some *caravanserais* were built as part of a complex attached to a mausoleum and paid for by a legacy from the deceased.

The Seljuks built *caravanserais* in Iran, across Afghanistan and Central Asia toward India and Russia, and in Anatolia, where they were usually known as *hans*. (*Han* is simply the Turkish word for *caravanserai*.) They were also known as *ribats*. The *caravanserais* were positioned approximately every 30km (19 miles) along the road.

GRAND PORTAL

One typical *caravanserai* of the early Seljuk period is the Ribat-i Malik in Uzbekistan, built on the road between Bukhara and Samarkand in 1078–79 by the Qarakhanid Sultan Nasr (reigned 1068–80). The sultan was a son-in-law to Seljuk sultan Alp Arslan (reigned 1063–72) and a client ruler under Seljuk overlordship. The splendid portal gateway of the *caravanserai* still stands, bearing an inscription in Persian declaring that it had been

Below The Rabat Sharaf caravanserai near Mashhad in Iran was built in 1128. Behind its tall and elegant entrance portal, it has two courtyards.

Above This portal, all that remains of a caravanserai in Uzbekistan, on the road from Samarkand to Bukhara, would have been a welcome sight for any traveller seeking respite.

raised by the 'sultan of the entire world' and that within, by God's grace, the setting would be like that of paradise. Archaeological excavations have determined that the *caravanserai's* layout was square and that it was surrounded by sturdy walls that were set with semicircular towers.

Some later *caravanserais* were built with two courtyards, leading into each other. The 11th-century Akcha Qala near Merv (now in

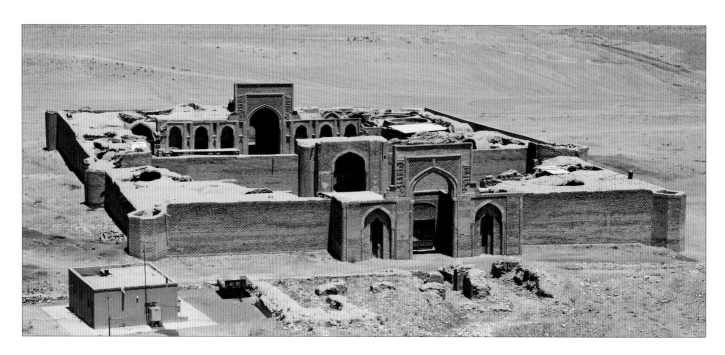

Right The courtyard of the Aksaray Sultan Han covers approximately 2,250sq m (24,220sq ft).

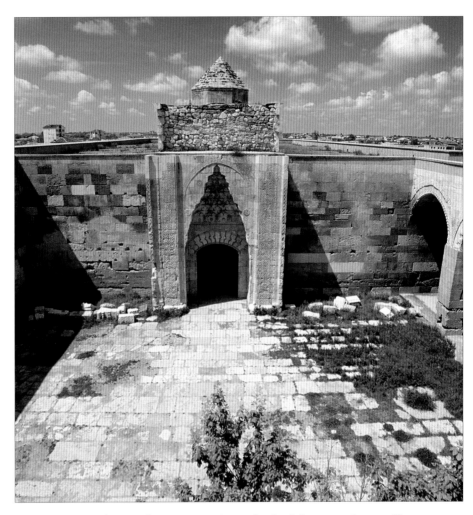

Turkmenistan) and the Rabat Sharaf *caravanserai* built on the road between Nishapur and Merv in 1114–15 are examples. In these, the first enclosure was reserved for stables for camels and areas for storing goods, while the second was used for lodging. This double-enclosure layout was used in the Seljuk-era *caravanserais*, or *hans*, in Anatolia, except that in these complexes the second courtyard was usually covered by a roof.

SULTAN *HANS* NEAR KONYA

Two particularly grand *hans* were built near Konya by the Anatolian Seljuk Sultan Ala al-Din Kayqubad I (reigned 1220–37) and are called 'Sultan Hans' as a result. The larger of the two, the Aksaray Sultan Han on the road from Konya to Aksaray, was built in 1229. With great walls, a large projecting portal almost 50m (164ft) wide and 13m (43ft) tall, 6 corner towers and 18 side towers, it has the look of a castle. However, it is also beautifully finished with elegantly carved marble side panels on the portal,

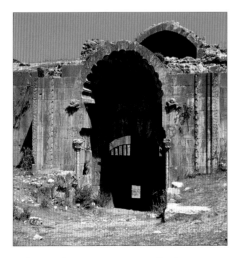

Above The Incir Han was built near Bucaq, between Isparta and Antalya (now in Turkey), in 1238 by Sultan Keyhusrev II (reigned 1238–46).

featuring polygonal geometric patterns along with naturalistic representations of flowers.

The portal faces south-west. It leads into an entrance room beneath a star-shaped vault, flanked by office rooms. The courtyard has a colonnade along its western side, which was used for stabling and storage; rooms used for kitchens, dining rooms and bath facilities are ranged along its eastern side. Beyond the courtyard a large, nine-aisled, barrel-vaulted hall provided living and sleeping areas for the winter months; in summer, residents slept outside on the roof. The hall covers about 1430sq m (15,400sq ft).

The Sultan Han found on the road between Kayseri and Sivas (on the route from Konya eastward to Iran and Iraq) was built slightly later, in 1232–36. Like the Aksaray Sultan Han, it has an entrance way

flanked by guard or office rooms. This leads into a courtyard with stables and storage areas along one side and accommodation, kitchens and bathhouse facilities along the other. Beyond, as at Aksaray, is a covered hall.

KIOSK MOSQUE

In the centre of the courtyards at both the Aksaray and Kayseri Sultan Hans is a free-standing mosque. The mosque at Aksaray is lifted above the ground on four arches, accessed by steps on the south side, beautifully decorated with stone carving without, and with a fine *mihrab* niche within. Known as a 'kiosk mosque', this kind of structure was typical of Seljuk *hans* in Anatolia. There are similar kiosk mosques in the Agzikara Han (built in 1231–37, also near Konya) and the Sahipata Han (1249–50, on the road between Afyon and Aksehir).

THE ANATOLIAN SELJUKS

THE RULERS OF THE INDEPENDENT ANATOLIAN SELJUK EMPIRE BUILT MOSQUES WITH THREE OR MORE DOMES AND GRAND *MADRASAS* AND *HANS* (*CARAVANSERAIS*) WITH CARVED GATEWAYS.

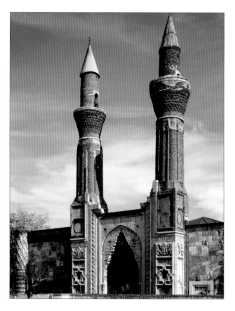

***Above** The Gok madrasa in Sivas, built in 1271, has a dramatic entrance portal. The entrance is behind a niche within a stone frame, flanked by minarets.*

The Seljuks became established in Anatolia in the wake of Sultan Alp Arslan's devastating defeat of the Byzantine Empire at the Battle of Manzikert in 1071. Anatolia is the region formerly known as Asia Minor, bound by the Mediterranean Sea to the south, the Aegean Sea to the west and the Black Sea to the north; it was part of the Byzantine Empire and fell to Seljuk troops that came in the wake of Alp Arslan's army. Under Suleyman bin Kutalmish, the Seljuks took the Byzantine cities of Nicaea (modern Iznik) and Nicomedia (modern Izmit) in 1075. In 1077, Suleyman declared himself ruler of the independent Seljuk sultanate of Rum (so-called from the medieval Islamic word for Rome, because the territories had been part of the Byzantine or eastern Roman Empire).

The Seljuk state in Anatolia survived in various forms until the early 14th century, when the region became a province of the Ilkhanid empire established by the successors of Mongol invaders who had captured Baghdad in 1258. The Seljuk capital, initially at Nicaea, was at Konya for most of this time, after being moved there by Sultan Kilij Arslan II (reigned 1156–92) in 1181. The greatest of the Anatolian Seljuk rulers was Ala al-Din Kaykubad I (reigned 1220–37), who presided over a glittering court, expanded the boundaries of the empire and oversaw a great age of building in his territories.

Right The Anatolian Seljuk Empire at its greatest extent c.1240 occupied most of modern-day Turkey.

Many more Seljuk-era buildings survive in Anatolia than in Central Asia. The Anatolian Seljuks built congregational mosques, *madrasas* (religious colleges), *caravanserais* (resting places on travellers' routes), palaces, monasteries, tombs and mausolea, bathhouses and hospitals. In addition, they pioneered the construction of building complexes typical of the Ottomans; known as *kulliye*, these incorporated mosque, *madrasa*, *caravanserai* and mausoleum in one setting. A Seljuk example is the Huand Hatun complex of 1238 in Kayseri, which includes a mosque, *madrasa*, mausoleum and *hammam* (bathhouse). It was built by Mahperi Hatun, the wife of Sultan Ala al-Din Kaykubad.

MOSQUES

The congregational mosque was called the *ulu cami* by the Anatolian Seljuks. They did not follow the four-*iwan*, or hall, design used by the Great Seljuks, but instead used variations on mosque design. One of these, called the 'basilican' design due to its similarity to church architecture, used three domes. In some mosques, such as the Ala al-Din Cami of 1223 in Nigde, the three domes were aligned above three bays in front of the *qibla* wall that indicates the direction of prayer; in others, such as the Burmali Minare Cami of 1237–46 in Amasya, the three domes were arranged above the length of the hall at right angles to the *qibla* wall. In another design, used at the Gok Cami *madrasa* of c.1275–1300 at

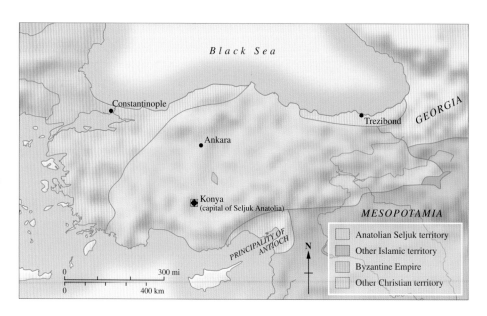

Amasya, the two options were combined, so that three domes ran parallel to the *qibla* wall and three also ran at right angles. These mosques were a direct influence on Ottoman mosque architecture.

The Anatolian Seljuks also built mosques based on the hypostyle mosque of Syria and Arabia, in which the prayer hall's flat roof was supported by rows of pillars. In many of the Anatolian examples, architects used wooden rather than stone pillars. The Sivrihisar Ulu Cami of 1232, the Afyon Karahisar Ulu Cami of 1272 and the Arslan Hane Cami of *c.*1290 in Ankara are all examples of this type.

MADRASAS

The Anatolian Seljuks built some *madrasas* on the model of those built by the Great Seljuks, with four *iwans* arranged around a courtyard, but more typically in Anatolian *madrasas* the courtyard was covered with a great dome, while a single *iwan* was built in the centre of the rear wall with one domed room to each side of it, and lines of smaller rooms arranged along the sides of the courtyard. The two most celebrated surviving Seljuk

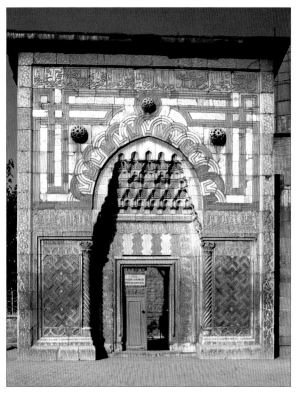

Above The dramatic façade of the Karatay madrasa *in Konya (1252) features patterns created by alternating light and dark stone, a sign of Syrian influence.*

madrasas, the Karatay *madrasa* of 1251 and the Ince Minareli *madrasa* of 1258, both in Konya, follow this plan. In the Karatay *madrasa*, which was built by Jelaleddin Karatay, wazir, or counsellor, in the service of Sultan Izzeddin Kaykavus, the dome, decorated with turquoise, white and black mosaic tiles and

calligraphic inscriptions, rises to an open top that admits daylight, and a pool beneath catches rainwater.

MAUSOLEA AND *CARAVANSERAIS*

Like their counterparts in Iran and Central Asia, the Anatolian Seljuks built tomb towers and square-domed mausolea. The Anatolian tombs are different, in that they generally have two levels – a vault used for burial and a prayer room above – while the tombs of the Great Seljuks were single-storey, without a vault. Moreover, despite the fact that prayer was not permitted at mausolea and tombs in orthodox Islam, many of the Anatolian mausolea have *mihrabs* – niches that indicate the direction of prayer.

The Anatolian Seljuks built a network of *hans*, or *caravanserais*, along the trade routes that ran east–west and north–south across their territories. Most were built under Ala al-Din Kayubad I and Ghiyath al-Din Kay Khusrau II (reigned 1237–47). The typical design, seen in the surviving Sultan Hans of Aksaray and Kayseri, had an imposing portal, a large courtyard and a vast covered hall.

VARQA AND GULSHAH

The 10th-century Persian poet Ayyuqi wrote the *Romance of Varqa and Gulshah*, his masterpiece, in 997, in the era of Sultan Mahmud of Ghazni, founder of the Ghaznavid Empire. In *c.*1250, Abd al-Mumin al-Khuyyi created a magnificent illustrated manuscript of this tragic story. The artist, who signed the manuscript, was probably working in Konya, the capital of the Anatolian Seljuks. The manuscript paintings run across the middle of the page, with the poem continuing above and below. This unique manuscript is now in the Topkapi Palace Museum in Istanbul.

Left Here, the couple embrace in a garden before fate separates them. Their union is echoed by the presence of a cockerel and hen.

SELJUK STONEWORK

ONE OF THE MOST OUTSTANDING FEATURES OF SELJUK BUILDINGS IS ITS CARVED STONE DECORATION, ESPECIALLY ON THE PORTALS, OR ENTRANCES, WHERE ARTISANS CREATED AMAZINGLY DETAILED WORK.

The Anatolian Seljuks earned a reputation as great builders. Their architecture has much in common with that of their Iranian counterparts, but they created a distinctive style of their own. In part, this was due to their location. They drew some of their ideas from neighbouring Byzantium and Armenia, and they enjoyed a better supply of building material, much of it salvaged from the buildings of their vanquished enemies.

The Seljuks produced their finest work in stone. They had several grades of masons, ranging from semi-skilled artisans, who prepared roughly shaped blocks from the quarries, to gifted carvers, who produced exquisitely detailed decoration. At their best, these men produced work of outstanding quality. They mimicked the delicate stucco designs of the Great Seljuks, achieving the same lightness and grace in a harder material.

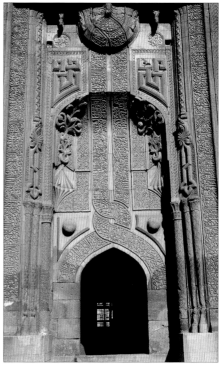

Above The calligraphy on the portal of the Ince Minareli madrasa *is intricately designed along two vertical friezes.*

CONTRASTING SURFACES

Anatolian craftsmen were fond of the contrast between large expanses of plain, smooth ashlar (square-cut stone used for facing a building) and smaller areas of compressed ornamentation. The latter was often focused around the portals of a building. This approach can be found on every major structure, from mosques and *madrasas* (religious colleges) to *caravanserais* (travellers' lodges) and tombs. In many cases, the carved decoration is in the form of a triangular, recessed arch, which has been likened to the shape of early Islamic tents.

One of the most spectacular examples can be found at the remains of the Sultan Han (or *caravanserai*) between Konya and Aksaray. There, the portal contains

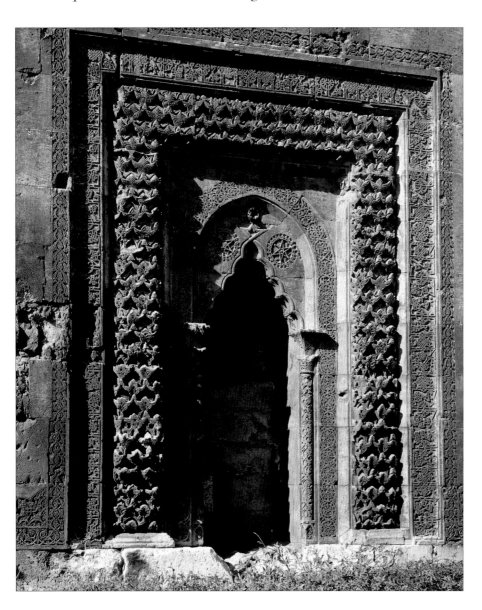

Left Seljuk stonemasons emphasized windows, doors and arches by framing them in receding bands of decoration. This example is from the Gok madrasa in Sivas, Turkey (1271).

muqarnas (stalactites) vaulting above carved calligraphy. Surrounding the recess, there is a shallow, rounded arch composed of interlocking, geometric motifs. This in turn is flanked by several vertical panels of tightly packed, carved decoration. There is evidence of similar portals at the Gok *madrasa* at Sivas (1271) and the Cifte Minareli *madrasa* at Erzurum (1253).

CALLIGRAPHY IN STONE

The decoration on the Ince Minareli *madrasa* at Konya (1258) – now a museum dedicated to Seljuk stonework – is more elaborate. The entrance is framed by two bands of intertwining calligraphy and imposing sculptures. The Ince Minareli features a mix of *naskhi* and Kufic calligraphy, but during the Seljuk period, plaited (braided) Kufic was the most common form. In this style of calligraphy, the lettering was inter-laced in a rhythmic, ornamental fashion. The trend for plaited Kufic script began farther east and spread west to Anatolia before the 13th century. Examples can be found on the Ince Minareli and Karatay *madrasas* in Konya, and the minaret of the Ulu Cami at Malatya.

SYMBOLIC WORK

Some of the stonework decoration may carry spiritual symbolism. A number of Seljuk buildings were adorned with panels of flowering or fruit-laden trees. In most cases, the foliage is in the form of palm leaves and the fruit, pomegranates. An eagle is often portrayed on top of the tree. Traditionally, these emblems were interpreted as invocations of blessings, with the main image representing the Tree of Life and the bird seen as a human soul, ascending to paradise. Variants of this emblem can be found

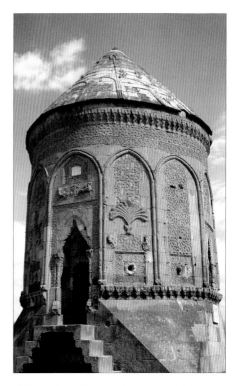

Above A stylized palm tree, with leaves sprouting from a crescent, adorns a panel on the Doner Kumbet, near Kayseri.

on the Ince Minareli *madrasa*, the Cifte Minare *madrasa* at Erzurum and the Doner Kumbet near Kayseri.

THE TURBE

One fine example of a distinctive form of Seljuk architecture is the Doner Kumbet. It is a *turbe* (tomb tower), a mausoleum with a burial vault at the base and a prayer chamber above it. The shape is usually cylindrical, with a conical roof, but square or polygonal versions can be found. The exterior walls are often decorated with blind arcading (rows of arches attached to the walls), with further decoration around the base of the roof. The example at Kayseri features carvings of lions, eagles and human heads.

There is debate about the inspiration for the *turbe*. According to one long-held theory, the design of the conical roof was based on the tents used by early nomads. Other authorities see a closer parallel with the domed churches of Armenia.

SELJUK SCULPTURE

Islamic sculpture is rare, but artisans in the Seljuk era produced particularly fine, glazed ceramic figures of animals and people. They also created beautiful high-relief sculpture as part of stucco decoration: fine examples can be found in the northern portal of the Ince Minareli *madrasa* (1258) in Konya, where medallions and large leaves, ribbons and calligraphy bands were combined effectively. Also from Konya are pieces of high-relief figurative carving of the highest quality that once decorated the citadel built in *c.*1220 by Sultan Ala al-Din Kaykubad I. These include a two-headed eagle, elephants and crowned and winged spirits or angels.

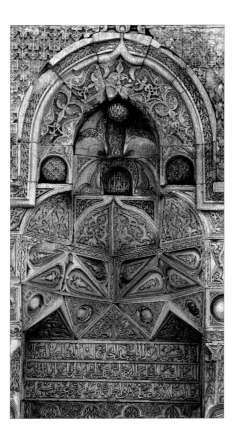

Above Calligraphy, arabesques and geometric shapes decorate the Great Mosque and Hospital at Divrigi (1229).

KASHAN POTTERY

CERAMIC PRODUCTION FLOURISHED DURING THE LATE 12TH CENTURY IN KASHAN, WHERE NEW MATERIALS AND TECHNIQUES WERE USED TO MAKE WARES WITH ELABORATE DESIGNS.

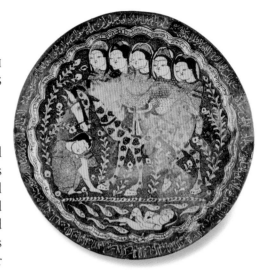

Above The composition of this 1210 Kashan stonepaste dish, with a sleeping boy beside a pond with a naked figure, along with a horse and attendants, has been interpreted as a mystical allegory regarding the quest for the Divine.

In the 12th century, an important ceramic production centre was established at Kashan in central Iran. There are no records of the city's industrial history before this time, but it was located close to the sources of raw ingredients and fuel needed to produce luxury pottery. The Persian words for tiles and pottery are *kashi* or *kashani*; it seems their manufacture became so closely identified with the town that the product was named after it.

Below This early 13th-century stool or low table is made from stonepaste with white glaze and lustre decoration; the six sides are identically decorated.

A NEW BODY MATERIAL

Much is known about the technical aspects of pottery production in this period. A treatise written by Abu'l Qasim al-Tahir in 1301 included a section on the art of glazed ceramics. He had the qualifications to write this manual because four generations of his family worked as potters in Kashan.

One of the triggers for this new production was the development of a new body material known as stonepaste (or fritware), which was white and could be translucent – both highly regarded qualities of Chinese porcelain. The technology for this new body was probably introduced to Kashan by potters from Egypt, who had moved east in search of new patronage after the collapse of the Fatimid regime. The recipe for the stonepaste body is given by Abu'l Qasim. He lists its ingredients as ten parts of sugar stone (or quartz), crushed and then strained through coarse silk, one part crushed glass and one part fine white clay.

Initially, the potters exploited the whiteness of this new body and made finely potted, thin-walled vessels that were simply covered in a transparent alkaline glaze. The walls were moulded in relief, and holes pierced through the pattern would become filled with glaze, producing a translucent effect. The stonepaste body was an excellent surface for decoration and it was not long before coloured glazes, particularly brilliant shades of cobalt and turquoise, were added.

THE KASHAN STYLE

A technical manual written in 1196 by Muhammad al-Jawhar al-Nishapuri devotes a chapter to the ingredients and processes involved

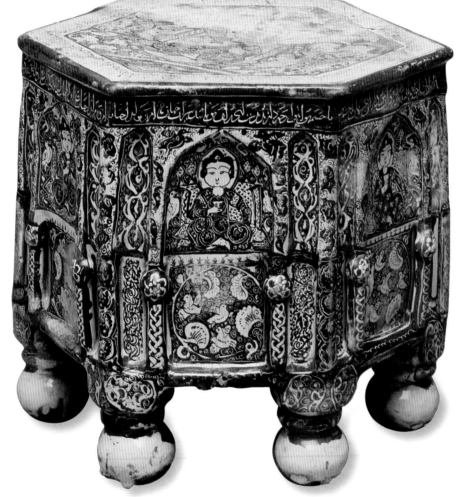

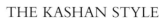

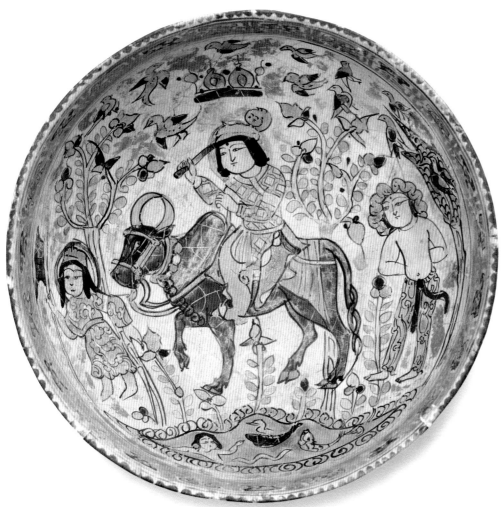

the vessel and then carved parts away, leaving the design behind in silhouette. Later experimentation revealed that the black pigment could be painted directly on to the surface of the vessel; this discovery allowed the potters greater freedom and fluency in their designs and the earlier clumsy carved decoration was abandoned in favour of delicately scrolled floral designs and bands of elegant cursive inscription. Details in cobalt were sometimes added, but this was much less stable and often ran under the glaze.

END OF AN ERA

Kashan was attacked by the Mongols in the 1220s, and although ceramic production suffered, it was not destroyed; lustre production was curtailed and for a time pieces were not signed or dated until production was revived in the Ilkhanid period.

Above This Kashan stonepaste bowl with minai *decoration is from c.1300. It shows a scene from the* Shahnameh, *a Persian poem written around 1000. The hero Faridun rides the cow Barmaya.*

in overglaze *minai* (from the Arabic for 'enamel') decoration, and lustre decoration, in which metallic oxides were painted over the glaze and fixed in a second reduction firing to create a lustre, or metallic, sheen. The Kashan potters became renowned for these two techniques.

Minai ware used a new polychrome technique developed so that the figurative imagery could be rendered with greater clarity. Like lustre decoration, this was an expensive process that required several firings in the kiln. Areas of the design were painted with colours such as turquoise, cobalt, grey and purple on to the white glaze and the piece was fired.

Further details were then applied in black, red and gold before a second firing. The figurative decoration probably reflects designs found on contemporary illustrated manuscripts and wall paintings, although none of these survive.

By 1200, what is known as the 'Kashan' style was fully developed and the majority of dated objects and tiles are decorated in this way.

UNDERGLAZE PAINTING

Another Kashan innovation was the development of underglaze painting. In the first stages of this technique, the potters applied a layer of black slip (a liquid clay) to

Right This early 13th-century stonepaste jug with black painted decoration under a turquoise glaze has a cockerel-shaped head. The outer body is pierced using a technique borrowed from metalwork; a hidden inner body contained the liquid.

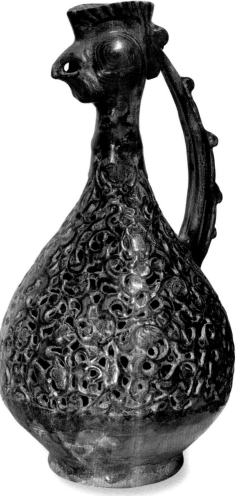

KHURASAN INLAID METALWORK

IN 12TH-CENTURY KHURASAN, LUXURY COPPER-ALLOY OBJECTS WERE DECORATED FIRST WITH ENGRAVED CHASED PATTERNS, AND THEN WITH INLAID PRECIOUS METALS.

The period from the 12th to 14th centuries saw great innovations in the technique and style of inlaid metalwork. Production centres appeared first in the Khurasan province of north-east Iran, and from the 13th century in Mosul (Iraq) and elsewhere, where the technique of inlaying brass or bronze objects with silver, copper and eventually gold details was developed to a high level, rivalling the detailed surface decoration found on contemporary ceramics, glass and even manuscripts.

On an ostentatious level, the precious metal inlays added value to an object, with the base metal acquiring the glittering surface of a more precious metal. Emulation of more expensive materials also seems to have occurred in contemporary ceramics, which used lustre glazes to echo the gleam of metal and imitated metal shapes.

INLAYING METAL

Metal inlay is a technique in which a softer and more precious metal is applied to the surface of a cheaper, stronger metal or alloy. The receiving surface is usually lightly punched to make a pockmarked area, and the softer metal is then hammered on, thus easing it into the punched grooves for a more secure grip. The technique could be used to enhance a pattern or inscription engraved on to a metal object, highlighting the lines of script, clarifying a design or framed area, or bringing up the main characters in a figural scene. Dense pictorial detail, elaborate

calligraphic inscriptions, along with sophisticated floral and geometric patterns, were all applied to metal vessels, transforming the style of previous generations of metalwork.

FORM AND FUNCTION

Khurasan metalwork was made in a wide range of forms and functions, but most of these objects were made for hospitality uses in wealthy homes, such as ewers, cups and incense-burners, or for official use, such as pen boxes and caskets. Many pieces of Khurasan metalwork, such as the Bobrinsky Bucket (see opposite page), were produced by casting them in a mould. Casting allows for more sculptural variety and flexibility in the final shape, and spectacular pieces, such as a cow, calf and lion group, demonstrate great

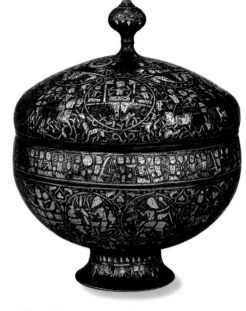

Above The c.1200 Khurasan Vaso Vescovali cast brass bowl stands on a 'foot'. The silver inlaid lid is contemporary to the bowl but from a separate object.

technical skill. According to its own inscription, all three animals were cast simultaneously. Although it is sometimes said that Islamic art features no three-dimensional sculpture, there are many functional objects that contradict this claim, such as a feline incense-burner (see opposite page).

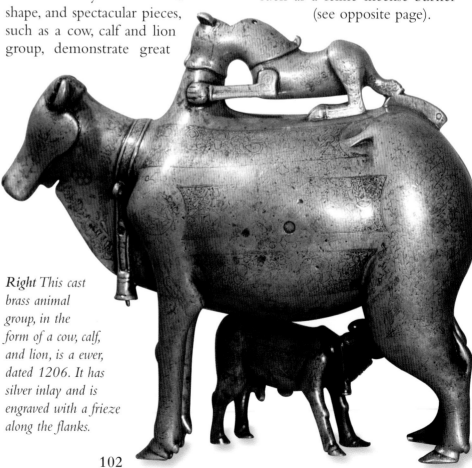

Right This cast brass animal group, in the form of a cow, calf, and lion, is a ewer, dated 1206. It has silver inlay and is engraved with a frieze along the flanks.

102

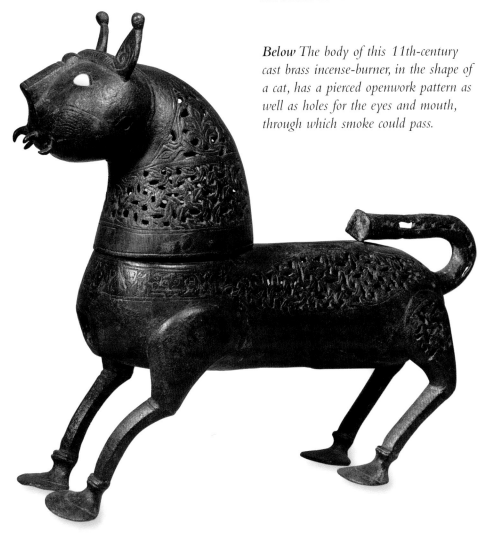

Below The body of this 11th-century cast brass incense-burner, in the shape of a cat, has a pierced openwork pattern as well as holes for the eyes and mouth, through which smoke could pass.

THE BOBRINKSY BUCKET

A key piece of Khurasan inlaid metalwork is known as the Bobrinsky Bucket, made in Herat in 1163. This remarkable bucket, for use in a bathhouse, is decorated with several layers of inlaid silver and copper, depicting the lively pleasures of drinking, enjoying music, dancing and hunting on horseback. It bears many inscriptions, mainly with the standard long formula of good wishes (such as 'Glory and Prosperity'), but also with the date, names of the patron and commissioning agent, and those of the metalworker and the inlayer. The owner is described as the 'pride of the merchants, trusted by the Muslims, ornament of the pilgrimage and the two sanctuaries', and was evidently a well-travelled merchant and *Hajj* pilgrim.

Above The densely inscribed Bobrinsky Bucket is a cast brass bucket with silver and copper inlay decoration and a handle.

DECORATIVE THEMES

The theme of courtly pleasures is ubiquitous in Islamic art of the 12th to 13th centuries, but a second recurring theme, that of astrology, echoed the benevolent wishes so frequently inscribed on luxury goods. Figures symbolizing the planets were often depicted in combination with zodiac signs, showing each planet at its most powerful and useful position, thus invoking good associations for the owners of the metal object. The Vaso Vescovali cast brass bowl features astrology as its main theme, and also includes a minor frieze depicting a party with musical entertainment and drinking guests.

These metal objects usually bore a formal inscription that delivered a consistent formula of good wishes directed at an unnamed owner, such as 'Glory and Prosperity', 'Power', 'Safety', 'Happiness', 'Success' or 'Blessings'. Because inscriptions rarely mention the owner by name, it is thought that these luxury objects were produced for the open market, not for a court context.

While silver or copper could be used to brighten some parts of a design, black substances, such as niello, bitumen or mastic, were sometimes used simultaneously to darken engraved lines. This allowed the metalworker to create a more graphic range of colour contrast.

The stylistic developments that occurred throughout this period meant that engraved designs were becoming increasingly sophisticated on Islamic metalwork. In unskilled hands, these developments could have led to an eventual incoherence of the overall design; however, small areas or lines accented with metal inlay were used as a new way to clarify the design.

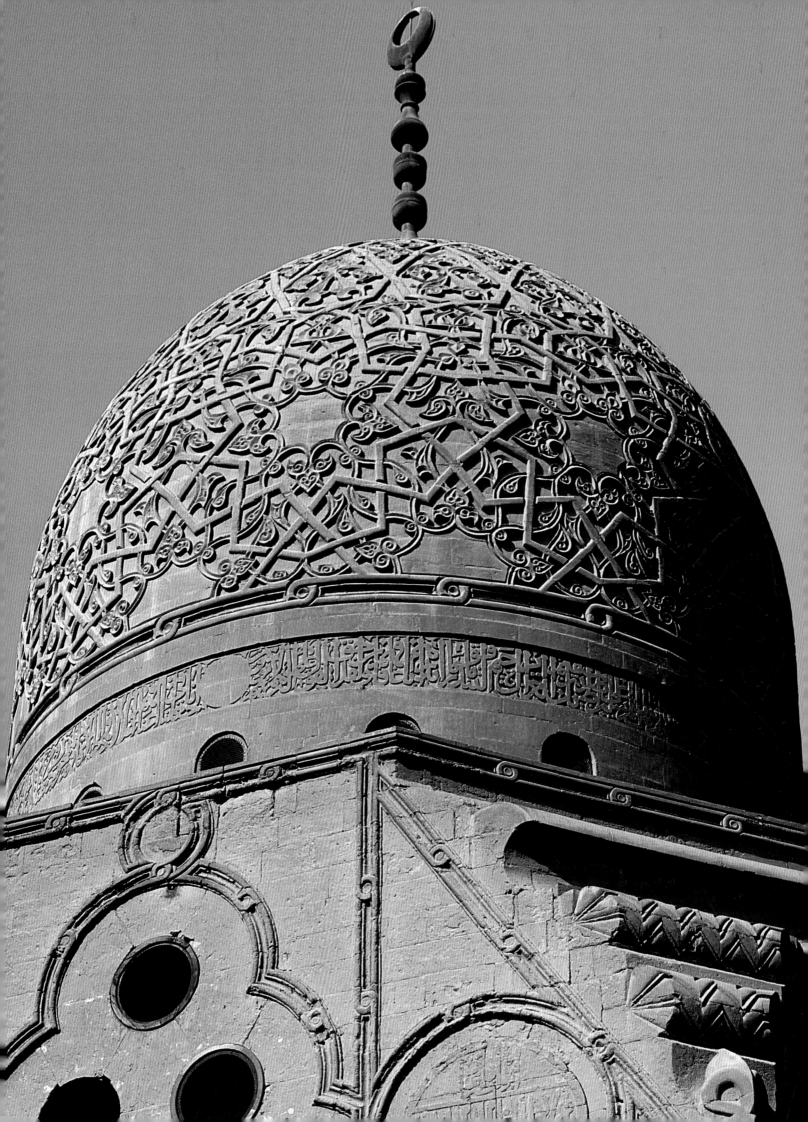

CHAPTER 6

ZANGIDS, AYYUBIDS AND MAMLUKS

As the Seljuk Empire declined in power during the 12th century, a number of small, derivative and often short-lived successor states were established in Syria, Iraq and eastern Anatolia (modern Turkey). The Turkish Zangid dynasty ruled northern Iraq and Syria in 1127–1251. Its most celebrated rulers, Imad al-Din Zangi and Nur al-Din, were promoters of Sunni orthodoxy and fierce proponents of *jihad* (holy war) against Christian crusaders. Salah al-Din Yusuf ibn Ayyub (Saladin), a Kurdish officer in the Zangid army, then created an empire based in Cairo that extended to Syria and beyond, and established the Ayyubid dynasty in 1171. In 1249, the Ayyubids were overturned by their own slave army, which took control of Egypt and Syria and founded the powerful Mamluk Sultanate (1250–1517). These rulers of the states that succeeded the Seljuks were Turks and Kurds with a heritage of nomadic tribal life. They may not naturally have been drawn to Sunni orthodoxy, but many were enthusiastic patrons of Islamic religious architecture.

Opposite The Tomb of Qayt Bay in Cairo, built in 1472–74, displays the finest Mamluk stone carving. Some of the grandest stonework can be seen in the reticulation on the dome.

Above A detail of the exquisite silver inlay on the celebrated Mamluk-era brass basin, known as the Baptistère de St Louis (14th century), shows a procession of court dignitaries.

THE ZANGIDS OF MOSUL

THE TURKISH ZANGID RULERS OF NORTHERN IRAQ AND SYRIA IN 1127–1222 WERE CHAMPIONS OF SUNNI ISLAM. THEY WERE ALSO PATRONS OF THE ARTS, ESPECIALLY IN MOSUL.

Imad al-Din Zangi, the son of the governor of Aleppo under the Seljuk sultan Malik Shah, was the founder of the Zangid dynasty. Zangi's father, Aq Sunqur al-Hajib, was executed for alleged treason against his Seljuk masters in 1094, and thereafter Zangi was raised in Mosul by the city's governor Karbuqa. Zangi established himself as *atabeg* (governor) of Basra in 1126, Mosul in 1127 and Aleppo in 1128. In seeking to extend his authority farther, he fought against both Muslim enemies and the Christian crusaders who had established the 'crusader states' (the County of Edessa, the Kingdom of Jerusalem, the Principality of Antioch and the County of Tripoli) during and after the First Crusade of 1095–99.

FIGHTING THE ENEMY
Zangi won a major victory over the crusaders when he captured the capital of the County of Edessa on 24 December 1144. This shocked the Christian world and led directly to the Second Crusade, which was

called for by Pope Eugenius III on 1 December 1145 and mounted in 1147–49.

After Zangi's untimely death in 1146 (he was murdered by a slave), his territories were split between two sons: Nur al-Din Mahmud (reigned 1146–74) ruled Syria from Aleppo, while Sayf al-Din Ghazi I (reigned 1146–49) ruled northern Iraq from Mosul. Nur al-Din, like his father, proved a scourge of the crusaders and personally led the army that broke the Second Crusade by relieving the Siege of Damascus in 1149. Thereafter, Nur al-Din took control of Damascus in 1154, and in doing so he created a united Muslim Syria.

Subsequently, the Zangids came into conflict with the nascent Ayyubid Empire that was established in Cairo by Saladin, who was the nephew of Nur al-Din's general Asad al-Din Shirkuh. The Zangid rulers of Mosul twice survived attacks by Saladin (in 1182 and 1185), but they were forced to accept his overlordship. The Zangid dynasty came to an end in Mosul with the rule of Nasir al-Din Mahmud (reigned 1219–22). He was ousted by his former slave Badr al-Din Lulu, who governed the city until 1259, when it was captured by the Mongols under Hulagu Khan.

Left The remains of the castle built by Nur al-Din at Mosul (northern Iraq) stand against sheer rock. Here, the Zangids were twice besieged by Saladin.

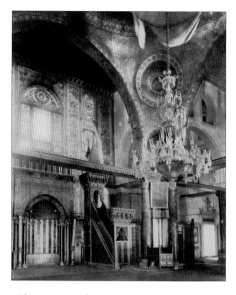

Above Nur al-Din commissioned this richly carved minbar for the Al-Aqsa Mosque in 1169. It stood beside the prayer niche from 1187 until it was destroyed in an arson attack in 1969.

PROMOTING THE FAITH
Nur al-Din was a zealous promoter of the idea of *jihad*, or holy war, against the Christians in Syria and Palestine. He had tracts read out in mosques praising the beauties of al-Quds (Jerusalem) and the Muslim sanctuaries in the al-Haram al-Sharif (Noble Sanctuary), the area known as Temple Mount by the Jews. Reports circulated that the crusaders, who had captured Jerusalem in 1099 at the peak of the First Crusade, were desecrating the Dome of the Rock and the Al-Aqsa Mosque in the Noble Sanctuary. Recapturing Jerusalem for Islam became a focus of *jihad*.

As a statement of his confidence that Islamic armies would regain the city, Nur al-Din had a fine new *minbar* (pulpit) made for the Al-Aqsa Mosque by five craftsmen from Aleppo in 1169. The cedarwood pulpit had exquisite intarsia (coloured wood inlay) and panelling in its side walls and was inscribed with a declaration of Islam's superiority and victory over rival faiths. As it turned out, the richly decorated *minbar* could not

THE ZANGIDS OF MOSUL

be installed in Nur al-Din's lifetime, but it was fitted in the Al-Aqsa Mosque after Ayyubid ruler Saladin took Jerusalem from the Christians in 1187.

BUILDING IN ALEPPO

Nur al-Din was a great builder, responsible for refortifying Aleppo's city walls and citadel, as well as for repairing the aqueduct. Within the city, Nur al-Din ordered work on the markets and the Great Mosque. Perhaps to establish his credentials as a proponent of *jihad* or possibly through religious fervour, he promoted orthodox Sunni Islam by building a network of *madrasas* (religious colleges), which were designed to combat the influence of Shiah Muslims in Syria. He also built a string of *khanqas* (institutions like monasteries) for Sufis.

PATRONS OF MOSUL

From the late 12th and early 13th centuries, there survive a number of illustrated manuscripts linked with court production at Mosul. One of these is an 1199 copy of a

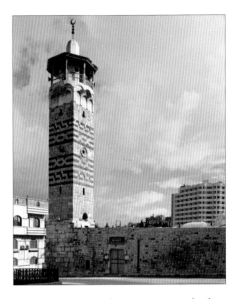

Above The Nur al-Din Mosque, built in Hama, Syria, in 1172, is celebrated for its fine square minaret.

late classical work on toxicology, *Kitab al-Diryaq* (Book of Antidotes). The manuscript's frontispiece depicts a central, seated figure holding up a large lunar crescent. A pair of entwined dragons coil around this central figure. Four attendant angels, or genies, hover at the corners. In Mosul, this seated figure is the characteristic heraldic image for the Zangid dynasty and is also used on their coinage and other metalwork.

A mid-13th-century copy of the same text was also made in Mosul, but the frontispiece shows a ruler at his court enjoying a reception. Although the exact patron is not known, the style is a close match to depictions of Badr al-Din Lulu made for frontispieces in a multi-volume set of the great poetic anthology, *Kitab al-Aghani* (Book of Songs), produced in Mosul *c.*1216–20. The frontispieces show the typical Seljuk *atabeg* costume – most notably, the *sharbush*, or fur-lined bonnet.

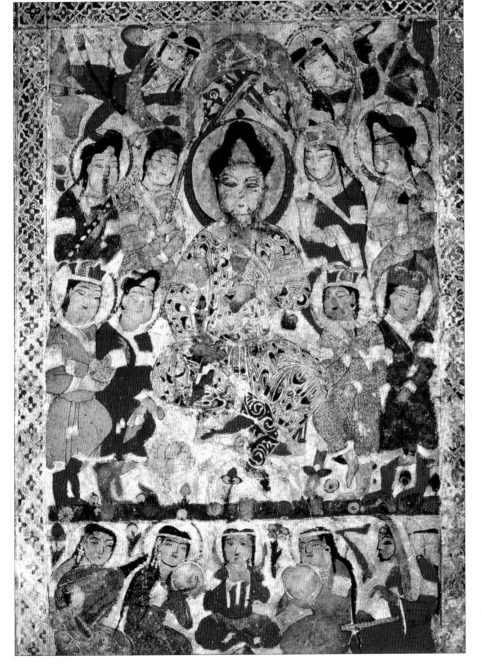

Left An illustration from Kitab al-Aghani *(Book of Songs), c.1216–20, by Abu al-Faraj al-Isfahani, showing a ruler listening to musicians.*

INLAID METALWORK OF MOSUL

IN THE EARLY 13TH CENTURY, ACCOMPLISHED INLAID METALWORK
BEGAN TO BE PRODUCED IN MOSUL IN NORTHERN IRAQ, POSSIBLY
AS A RESULT OF SKILLED CRAFTSMEN EMIGRATING FROM IRAN.

***Above** This inlaid brass basin, made for Ayyubid Sultan al-Adil II Abu Bakr in 1238–40, is decorated with vivid scenes of hunters and animals.*

The production of precious metal inlay, in which expensive metal is used to decorate the surface of a cheaper metal alloy object, was highly developed in the Khurasan province of eastern Iran. This production seems to have shifted to the city of Mosul, northern Iraq, around the same time that Mongol invasions led by Genghis Khan were creating an impact on cities in north-eastern Iran. Samarkand, Merv, Nishapur and Herat were devastated in the early 1220s, and their citizens massacred. A contemporary historian, Ibn al-Athir, described these dramatic events:

'In just one year [the Mongols] seized the most populous, most beautiful and the best cultivated part of the earth whose characters excelled in civilization and urbanity. In the countries which have not yet been overrun by them, everyone spends the night afraid they may appear there too.'

The sudden shift of metal inlay production has been interpreted as the result of the emigration of Khurasanis fleeing the Mongols. Certainly, the ruination of the region would mean that the local market for luxury wares was damaged, and it would make economic sense for producers to move to richer and less turbulent areas in western Iran and Iraq. Most Mosul metalwork is dated later than the invasion of Khurasan, and some signatures show direct connections with the Khurasani producers. One 1229 ewer confirms this connection: it is signed 'Iyas assistant of Abu'l-Karim b. al-Turabi al-Mawsili'. 'Turabi' refers to the city of Merv in north-eastern Iran, and 'Mawsili' refers to the master's new home in Mosul.

AL-MAWSILI, OR 'OF MOSUL'

The metal inlay craftsmen of Mosul often signed their wares using the *nisba*, or byname, *al-Mawsili*, meaning 'of Mosul'. However, throughout the 13th century and into the early 14th, this *nisba* features on many inlaid metal objects that were made in other places, such as Egypt and Syria. It appears that *al-Mawsili* refers to the craftsman's place of training and its specific reputation, not necessarily where the object was produced.

Mosul inlaid metal objects usually feature lively figural scenes of people or animals, either in long narrow friezes or more often in vignettes within cartouches (a type

***Left** Dinner guests, musicians and dancers are the main decorative subjects on this 13th-century candlestick, made from brass with silver inlay.*

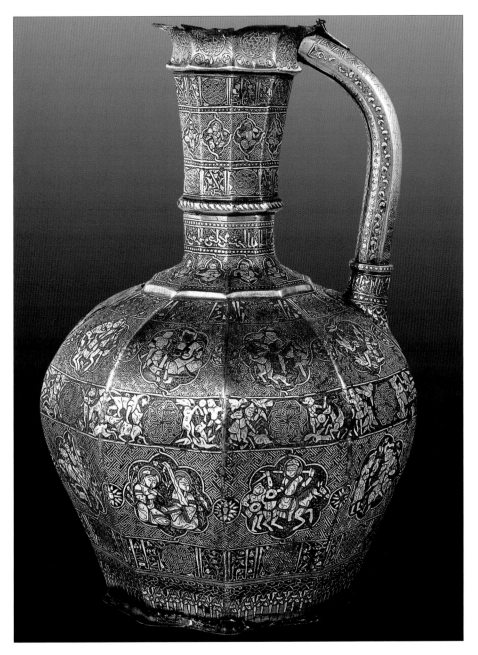

Above The Blacas Ewer, made in Mosul in 1232, is a masterpiece of al-Mawsili inlaid metalwork. The vignettes show scenes of court life, hunting and war.

MOSUL DIASPORA

Only one dated Mosul object is inscribed with the statement that it was produced in Mosul itself: this is the Blacas Ewer, dated 1232, now in the British Museum. It is signed by one Shuja b. Mana al-Mawsili 'in Mosul', and may have been made for the city's ruler Badr al-Din Lulu (d.1259). It is an object of outstanding quality, decorated with a series of framed scenes, laid in horizontal bands that draw from the 'princely cycle' repertoire of hunting and feasting, as well as astrological figures, calligraphy, and decorative scrollwork and patterns.

There are just six other known objects that most likely come from Mosul itself, as they belonged to Badr al-Din Lulu or members of his court. The *nisba* signature of *al-Mawsili*, however, is on at least 28 known inlaid metal objects, as a diaspora of metalworkers trained in Mosul was active in the rest of Jazira province and further south in the courts of Ayyubid Syria and Egypt. It reflects how craftsmen seek opportunities of rich patronage, and also shows why it is difficult to separate these regions into distinct stylistic categories of metalwork. Meanwhile, the discontinuation of red copper and the introduction of gold inlay show how this technique achieved ever greater luxury and affluence as it moved into the Mamluk period.

of decorative frame) against densely patterned backdrops. Because the metalworker can chase lines into the inlaid silver areas, even finer detail was possible. Some of these even feature Gospel scenes, implying that not all clients in this cultural environment were Muslim.

Mosul designs are different in style to Khurasan inlaid metal pieces: the repertoire is wider and the metal forms they decorate are local to Mosul and the surrounding region. Craftsmen in Mosul, as in Khurasan, exploited the metal inlay technique to make their decoration more pictorial, a practice which was also fashionable in other contemporary media, such as enamelled glass and ceramics. Illustrated manuscripts that have survived from 13th-century Iraq show many parallels of composition and pictorial motifs between these paintings and the exquisite scenes composed on inlaid metal objects.

Above Dramatically designed with a dragon's head handle, this inlaid brass incense-burner was made in Damascus, probably around 1230–40.

THE AYYUBID DYNASTY

OF KURDISH DESCENT, THE SUNNI MUSLIM AYYUBID DYNASTY RULED EGYPT, SYRIA, YEMEN AND PARTS OF IRAQ IN THE 12TH–13TH CENTURIES.

Saladin, the most celebrated of Muslim generals, established Ayyubid rule in Cairo in 1169. He was hailed for both his strategic brilliance and chivalrous bearing by the European crusaders he fought, and was acclaimed throughout the Muslim world for his triumph in recapturing the holy city of al-Quds (Jerusalem) from the Christians on 2 October 1187. The dynasty Saladin founded was named after his father Najm al-Din Ayyub ibn Shadhi, a Kurdish soldier in the service of the Seljuk Turks who became governor of Damascus.

A NEW EMPIRE

Saladin came to Egypt with his uncle Shirkuh, the principal general of the Zangid ruler of Syria, Nur al-Din. He campaigned in Egypt alongside Shirkuh three times – in 1164, 1167 and 1168–69 – and on the final occasion took power after killing the Fatimid Egyptian wazir Shawar (Shirkuh had died of natural causes). Saladin abolished the Ismaili Fatimid Caliphate on the death of Caliph al-Adid in 1171 and declared Cairo to be under the authority of the Sunni Muslim Abbasid Caliph in Baghdad, al-Mustadi. He created an empire, taking power in Syria after the death of Nur al-Din in 1174, then winning control in northern Iraq, as well as the Hijaz and Yemen.

Saladin was a champion of Sunni orthodoxy. As a proponent of the *jihad*, or holy war, he was named 'Protector of the holy sites of Makkah and Madinah' by the Abbasid caliph in Baghdad, and he waged an intermittent war against the crusader kingdoms, which culminated in his victory at the Battle of the Horns of Hattin in July 1187 and the capture of Jerusalem three months later.

On Saladin's death after a short illness in 1193, the empire was divided among his brothers and other relatives and thereafter was weakened by internal feuding. Nevertheless, the Ayyubids had

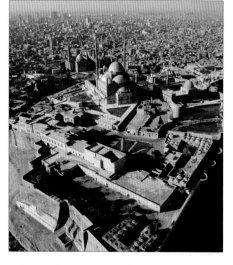

Above The great Ayyubid ruler Saladin built his citadel on Muqattam Hill in Cairo in 1176–83.

survived more than 50 years, until the establishment in 1250 of the Mamluk Sultanate by the Ayyubids' former slave soldiers.

CAIRO WALLS AND CITADEL

On taking power in Cairo in 1171, Saladin began work to extend the city walls, uniting the Fatimid royal capital of Cairo (founded in 969) to the older garrison town of Fustat (founded in 641). This task was not completed, but as part of the project Saladin built a citadel and made it the centre of government. Known as the Saladin Citadel, it was raised on the Muqattam Hill in 1176–83.

Muqattam Hill had been the site of a pavilion known as the 'Dome of the Wind', built by Hatim ibn Hartama, the city's governor, in 810; Fatimid rulers and nobility had used it to enjoy the breezes and the views of the city. Saladin, however, saw its military significance as a site for a fortified base from which to defend the city at a time when crusader armies were frequent and unwelcome visitors to Egypt.

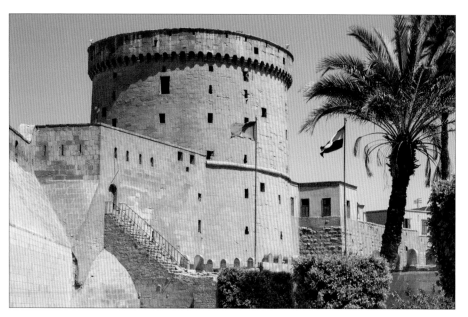

Left The towers of the Saladin Citadel in Cairo were enlarged in 1218–38 by Ayyubid Sultan al-Kamil.

The citadel raised by Saladin had walls 10m (33ft) high and 3m (10ft) thick with rounded towers from which defenders could fight off an attacking force. Within, Saladin's engineers dug a great well 87m (285ft) deep through solid rock and with a long ramp so that animals could be led down into the depths to drive machinery needed to lift water such a great height.

After Saladin's death, Sultan al-Kamil (reigned 1218–38) greatly enlarged a number of the citadel's towers – notably those known as the Blacksmith's Tower and the Sand Tower, which overlooked the narrow pass between the citadel and hills alongside. He added square towers on the wall perimeter; three of these, 30m (98ft) wide and 25m (82ft) tall, are still standing, overlooking the area today used for parking cars outside the walls. Sultan al-Kamil also built a palace within what is now the citadel's southern enclosure in 1218; this building is no longer standing.

MADRASAS IN EGYPT

As part of a programme to counter the influence of Shiah Islam and establish Sunni orthodoxy, the Ayyubids built the first *madrasas* (religious colleges) in Egypt, principally in Cairo and Fustat. Their design was based on *madrasas* built by the Seljuks of Anatolia: they had long courtyards lined with accommodation and two *iwans* (halls) at each end. In Cairo, Saladin built five *madrasas* and a mosque, and imported Sunni professors from Syrian legal schools to teach there.

The best surviving Ayyubid *madrasa* in Egypt, however, is the Madrasa of Sultan al-Salih Najm al-Din Ayyub, built by the sultan of that name toward the end of the Ayyubid era in 1242–44, on part of the site once occupied by the Fatimid Eastern Palace in the centre

Above Saladin is represented on this copper dirham coin, made in south-eastern Anatolia in 1190–91.

of Cairo. Like the Mustansiriya *madrasa*, built in Baghdad about ten years earlier (1234) by Abbasid Caliph al-Mustansir, this was designed to house all four Sunni Muslim schools of legal thought – the Maliki, Shafii, Hanifi and Hanbali – with one *iwan* each. The last of the Ayyubid sultans, al-Salih Najm al-Din Ayyub, died in 1249 and his mausoleum was added to the complex by his powerful widow, Shajar al-Durr, in 1250.

Below Parts of the Madrasa of Sultan al-Salih Najm al-Din Ayyub, built in Cairo in 1242–44, still survive.

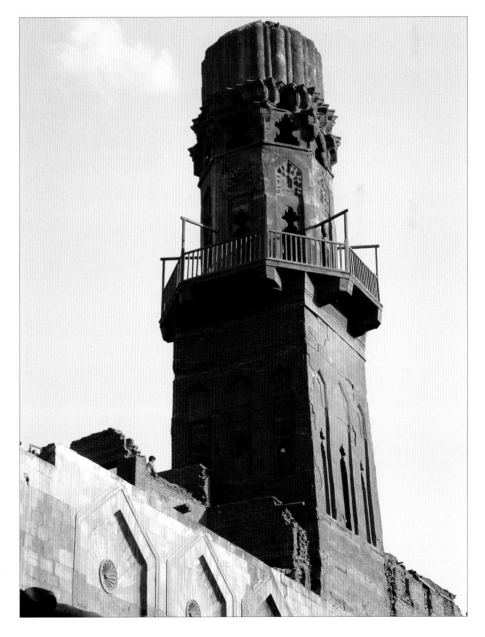

ALEPPO AND DAMASCUS

THE SYRIAN CITIES OF ALEPPO AND DAMASCUS WERE KEY STRONGHOLDS FOR THE AYYUBIDS. IN BOTH LOCATIONS, AYYUBID RULERS UNDERTOOK MAJOR BUILDING PROJECTS.

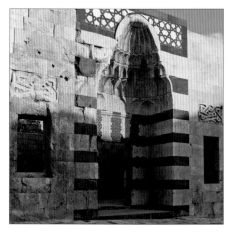

Above A half-dome of muqarnas *rises above a grand entranceway to the palace in the Aleppo citadel.*

Both Aleppo and Damascus had been important bases for Zangid ruler Nur al-Din in his war against the Christian crusaders. Later Ayyubid work complemented building begun by the Zangids: the Ayyubids refortified the citadel, built or rebuilt mosques and founded numerous *madrasas*.

THE ALEPPO CITADEL
Saladin conquered Aleppo in 1183, and his son Al-Malik al-Zahir Ghazi was made governor (1186–1216). Ghazi set to work refortifying the citadel: his men regraded the sides of the mound on which it stood, re-excavated the moat, built a bridge, strengthened the ramparts and raised a gateway flanked by towers. Within the citadel they built a weapon store, dug a deep well and reservoir, erected palaces and bathhouses and added gardens.

Ghazi also renovated the Mosque of Abraham built by Nur al-Din. According to tradition, the patriarch (and Islamic prophet) Abraham stopped on the mound that became the citadel on his voyage from Ur to the Promised Land and milked his cows there; Nur al-Din's mosque was raised on the spot where Abraham was said to have milked the creatures.

Archaeologists have excavated what they believe to be the remains of Ghazi's principal palace within the citadel, the Dar al-Izz ('Palace of Glories'), which had a grand central courtyard paved in marble with an octagonal fountain at its centre and was surrounded by four *iwans* (halls). The northern *iwan* contained an indoor *shadirwan*, or fountain, running into a pool.

MADRASA AL-FIRDAUS
Daifa Khatun, who was Ghazi's wife, founded two notable buildings in Aleppo: one a *madrasa* (religious college), the other a *khanqa* (Sufi monastery). The Madrasa al-Firdaus ('College of Paradise') was laid out around a courtyard paved with marble and centred on an octagonal fountain and pool decorated with a cloverleaf pattern; on the northern side was an *iwan*, with student quarters behind it, while on the southern side was a three-domed mosque between mausolea, and to east and west were halls probably used for teaching. The 1237

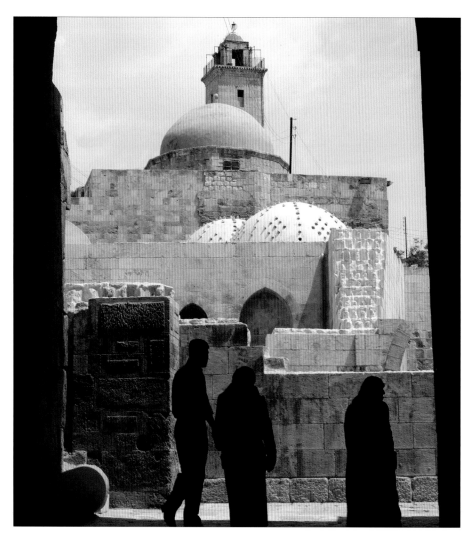

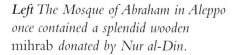

Left The Mosque of Abraham in Aleppo once contained a splendid wooden mihrab *donated by Nur al-Din.*

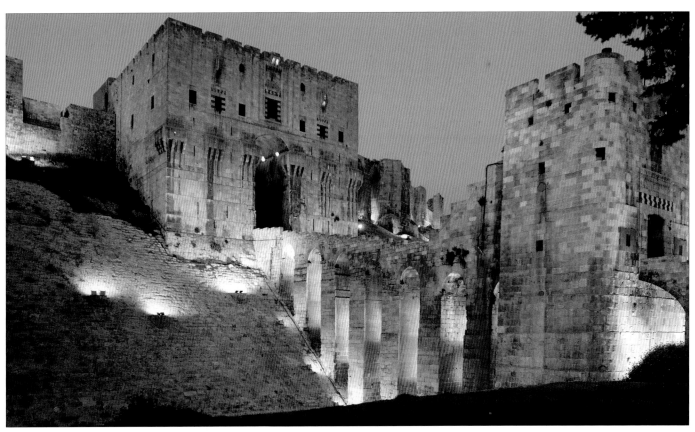

Above Ayyubid Sultan Al-Malik al-Zahir Ghazi added the bridge and fortified gateway to the Aleppo citadel.

Khanqah al-Farafra also has an *iwan*, mosque and accommodation built around a fountain in a courtyard.

This arrangement of buildings around a courtyard with octagonal fountain was typical of Ayyubid buildings in Aleppo. In palaces, the courtyard was usually surrounded by four *iwans*, and religious buildings always had the mosque on the southern side. The mosques had a dome raised above the bay in front of the *mihrab* (niche). Their *mihrabs* were often adorned with a stonework pattern of interlinking knots, which inspired Mamluk and Ottoman architectural decoration.

Ayyubid buildings were usually made of dressed stone and left undecorated on the outside, except for entrance portals ornamented with *muqarnas* (stalactite-styled vaulting) or niches. Different types of stone were combined in some buildings, for example, by laying alternating horizontal bands of light and dark stones to create a design. Known as *ablaq*, this technique was an established one in Syria, having been used in the Great Mosque of Damascus, but it may have been inspired by the Byzantine tradition of using alternate bands of white ashlar and reddish baked brick.

IN DAMASCUS

Following the death of Nur al-Din in 1174, Saladin became ruler of Damascus. Under Ayyubid rule, the citadel was strengthened, notably under al-Malik al-Adil in 1208–9. A number of mausolea and *madrasas* were built there, including the Madrasa al-Adiliya, which had been begun by Nur al-Din.

The Salihiyya quarter was established outside the city walls, where the al-Muzaffari Mosque was raised in *c.*1202–13. This historic treasure is the second oldest mosque surviving in Damascus. It contains a fine *mihrab* beneath a semidome adorned with *muqarnas* vaulting and on its right a *minbar* (pulpit) carved with geometric and floral designs, the oldest surviving *minbar* in Syria. Its design was based on the Umayyad Great Mosque of Damascus, with a plain façade, arcaded courtyard and rectangular prayer hall with three aisles on the south side of the courtyard.

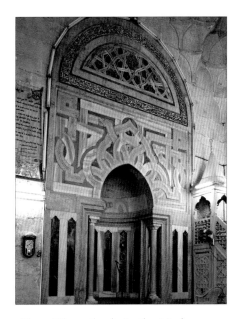

Above The mihrab *in the Madrasa al-Firdaus, Aleppo, is made from marble set in a beautiful interlacing pattern.*

ENAMELLED GLASSWARE

DURING THE 13TH AND 14TH CENTURIES, THE GLASSMAKERS OF SYRIA AND EGYPT PRODUCED ELABORATELY DECORATED GLASSWARE WITH ENAMEL AND GILDING.

Syrian and Egyptian glassmakers of this period were highly skilled. They produced glassware lavishly decorated with gilding and polychrome enamels, and their work was prized and widely exported within the Middle East and to Europe and China. One Egyptian author of the Mamluk period has written about richly ornamented glass that was produced in Damascus and being exported to Egypt, Syria, Iraq and Asia Minor. Crusaders to the Holy Land also referred to these wares in their chronicles and brought back many examples, which were donated to church treasuries or kept in their family collections.

EARLY ENAMELLING

The manufacture of enamelled glass was a lengthy and expensive process involving several stages. The first step was the creation of the glass object, which was free-blown or blown and shaped in a mould; the glass was then cooled slowly in an annealing oven. When the object was cold it was painted with enamel pigments and gold and reheated slowly until it could be picked up on a pontil (a tool used to hold the glass) and placed inside the mouth of the furnace to fuse the enamels to the vessel. Enamel colours and gold melt at different temperatures, so in theory they should have been applied and fired in sequence; however, this continual reheating would have risked the collapse of the object, and evidently methods were devised to fire all or most of the colours at once.

It is not clear exactly where or when the first experiments with enamelling took place, but a bottle inscribed with titles of the last Ayyubid ruler al-Malik al-Nasir (reigned 1237–60) has some tentative enamel decoration, though most of the surface was left undecorated.

Left This bottle was produced in c.1237–60 and is the earliest datable example of Syrian or Egyptian enamelled glass.

Above This mid-13th-century beaker, decorated with polo players, was found beneath the altar of the church of Santa Margherita in Orvieto, Italy.

SKILLED ARTISANS

By the second half of the 13th century, the craftsmen had fully mastered the enamelling technique and began to use the glass almost like a canvas, painting it with all types of figurative scenes of courtly life in a variety of colours. Images of drinkers, musicians and polo players are painted in bands around bottles and bowls of many different shapes and sizes. Christian imagery was often integrated into the scheme, possibly because pilgrims and crusaders commissioned the vessels. For instance, a pilgrim flask in St Stephen's Cathedral in Vienna, Austria, was allegedly brought there filled with earth from Bethlehem. The neck is decorated with a band of figures, cowled and dressed like monks, the shoulders with falconers in roundels and the front with a troupe of musicians flanking a stylized cypress tree.

The patronage provided by the Mamluk court in the 14th century encouraged the expansion of the glassware industry. Glass workers demonstrated their virtuosity by creating large vessels in shapes and with geometric decorative schemes often inspired by contemporary metal and pottery prototypes. The decorative repertoire began to shift from an emphasis on the figural to a style dominated by epigraphic and floral designs, with motifs inspired by imported Chinese wares, such as the lotus flower.

MOSQUE LAMPS

Cairo in the 14th century was in the middle of a building boom triggered by the Mamluk caliphs and their amirs, who were eager to demonstrate their religious fervour by commissioning new mosques and *madrasas* (religious colleges). To light the interiors of these buildings, hundreds of highly decorated, enamelled-glass mosque lamps were made to be suspended from the ceilings. The jewelled colours of red, blue, green, yellow and white enamel with large areas of gilding must have glowed richly.

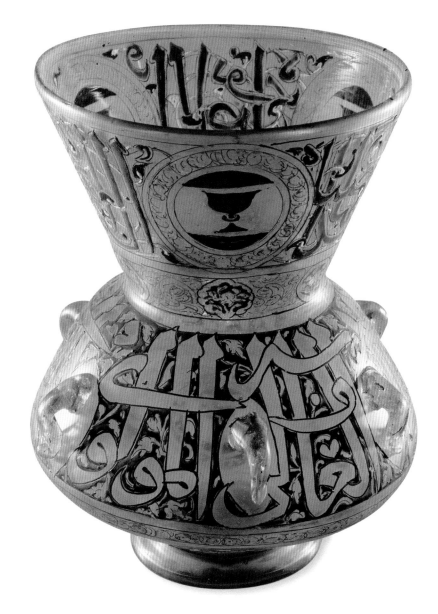

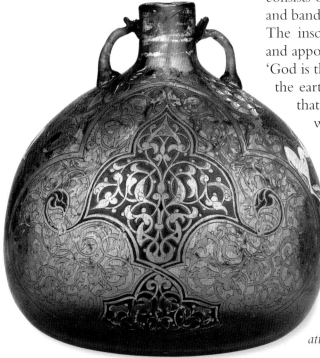

The decoration of these lamps consists of large areas of calligraphy and bands of intricate floral pattern. The inscription is often a specific and apposite verse from the Quran: 'God is the light of the heavens and the earth; His light is like a niche that contains a lamp, the light within like a glittering star.'

The patron of the lamp is generally identified in calligraphy and with a blazon containing the attribute marking the rank of the official.

Left The shape of this late 13th–14th-century bottle was modelled on the leather water flasks that pilgrims attached to their saddles.

Above This mid-14th-century Egyptian mosque lamp bears the titles and blazon of Amir Sayf al Din Shaykhu, who rose to be commander in chief under the Mamluk Sultan, Hasan.

THE END OF AN INDUSTRY

The production of enamelled glass in Syria and Egypt began to decline in the late 14th century, and by the 15th century many workshops had closed altogether. When Timur sacked Damascus in 1400, it has been said that he removed its glass workers to his capital in Samarkand – however, there is no evidence of glass production from there. By the late 15th century, the production of enamelled glassware had shifted to Europe – to Venice, Italy, in particular.

THE MAMLUKS

FORMER SLAVE-SOLDIERS FOUNDED THE MAMLUK SULTANATE, WHICH RULED EGYPT, SYRIA AND THE HIJAZ FROM 1250 TO 1517. MAMLUK SULTANS EMBARKED ON A MAJOR BUILDING PROGRAMME IN CAIRO.

Izz al-Din Aybak, amir (military commander) for the Ayyubid regime, took control in Cairo in 1250. After the last Ayyubid sultan al-Salih Ayyub died in late 1249, his son and successor Turanshah was murdered and his widow Shajar al-Durr (meaning 'Tree of Pearls') seized the throne and briefly ruled as sultana. She did not receive the backing of al-Mustasim Billah, the Abbasid caliph in Baghdad, who had originally given her to al-Salih as a slave girl. So, to consolidate her position, Shajar al-Durr married her Mamluk military commander, Izz al-Din Aybak, and then passed the throne to him. Aybak founded the Bahri Mamluk Sultanate (1250–1382), subsequently replaced by the Burji Mamluks (1382–1517).

The Mamluks swiftly established themselves as the defenders of Islam and of Sunni orthodoxy. They won a series of military victories against Mongol invaders, beginning with the great Battle of Ain Jalut in Palestine in 1260, after which they took control of Syria, and also drove the Christian settlers from Palestine and Syria in 1291.

THE MAMLUK CAPITAL

Cairo had been a great city under the Fatimids and Ayyubids, but with the rise of the Mamluks it replaced Baghdad as the centre of Sunni Islam, especially after the Mongols killed the last Abbasid caliph in Baghdad in 1258. Cairo also benefited from the exodus of Iraqi and Iranian craftsmen avoiding the advancing Mongols. These men were at the centre of a growth in metalwork and fine tiling in Egypt and introduced the ribbed dome into Egyptian buildings. Both Cairo and Damascus became established as centres for a wide-ranging international trade, with mercantile connections to the emerging city-states of Italy, southern Russia, the steppes of Eurasia, India and South-east Asia.

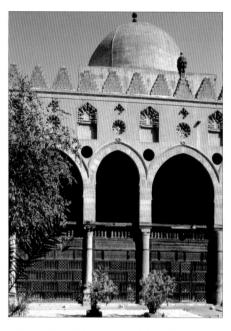

Above The Mosque of al-Maridani in Cairo was built in 1338–40 for Amir Altunbugha, who served as cup-bearer to Sultan al-Nasir Muhammad.

The Mamluks maintained their court in a grand style, with colourful pageantry and ceremony. In Cairo, their architecture also placed emphasis on style, with grand façades competing for attention on the major streets, such as the former square between the Fatimid Eastern and Western palaces and the main road leading to the Saladin Citadel. As the most highly prized locations became built up, it was a challenge for architects to fit their complexes into enclosed spaces. New buildings could not be aligned as was traditional on the *qibla* wall that faces the direction of prayer; the façades were treated separately, while the *qibla* orientation was achieved in the building's interior.

MAMLUK MOSQUES

The Mamluk sultans built several courtyard mosques on the model of the first Arab hypostyle designs, but

Left Cairo's mosque of Sultan al-Muayyad, built in 1415–20, has a magnificent dome carved with chevrons, placed behind the great entrance portal.

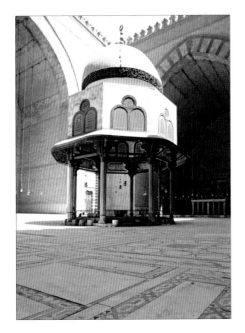

Above A large ablution fountain sits at the centre of the marble courtyard of the Sultan Hasan mosque and madrasa *complex, built in 1356–62 in Cairo.*

Below Many of the decorative elements of the Sultan Hasan mosque survive – including the gold and multicoloured marble design of the qibla *wall.*

with a vast dome above the *maqsura* (a private area in the prayer hall) before the *mihrab* (niche). Sultan al-Zahir Baybars (reigned 1260–77) built the first of these, in the newly developed area of Husayniyya, outside the northern gates in Cairo's city wall in 1266–69. Its courtyard was surrounded on three sides by arcades and on the fourth by a prayer hall. Contemporary sources claim the large dome before the *mihrab* was based on that of the Mausoleum of Imam al-Shafii, built by the Ayyubid sultan al-Kamil in 1211 – to that date the grandest mausoleum yet built in Cairo.

Later courtyard mosques of this type included the Sultan's Mosque within the Citadel, built by al-Nasir Muhammad in 1335–36. Many congregational courtyard mosques, all with large domes, were built by al-Nasir Muhammad across Cairo. His son-in-law Amir Altunbugha built another mosque of this type, the Mosque of Amir Altunbugha

al-Maridani, in 1338–40, on the road running to the citadel from the gateway of Bab Zuwayla.

The final substantial Mamluk congregational courtyard mosque was the Mosque of Sultan al-Mu'ayyad Shaykh (reigned 1412–21) built in 1415–20. Its south-east end stands against Bab Zuwayla and the Fatimid-era towers of this gate are the base for the mosque's minarets.

FOUR-*IWAN* MOSQUES

Many mosques were built on the four-*iwan* plan imported from Iran by way of Syria, in a cross-shape with four *iwans* (halls) arranged around a courtyard. These mosques were often included in complexes with *madrasas* (religious colleges). Major examples include the mosque and *madrasa* of Sultan Hasan which was built in 1356–62 and combined *madrasas* for the four leading schools of Sunni legal thought, a four-*iwan* congregational mosque, and a mausoleum.

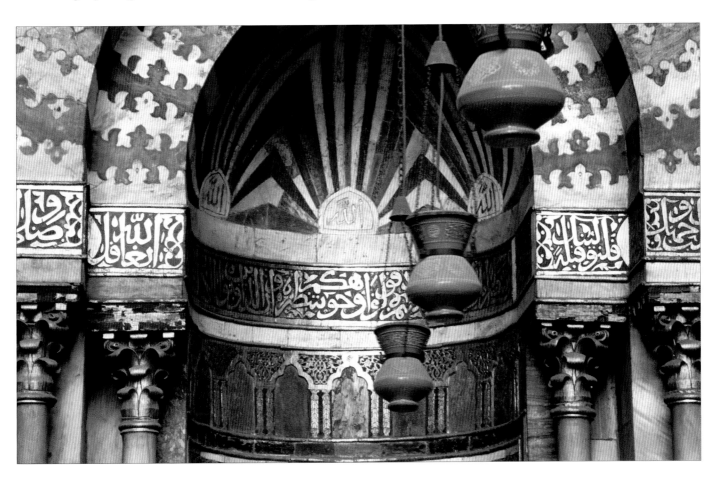

MAMLUK MAUSOLEUM COMPLEXES

COMPLEXES BUILT BY MAMLUK RULERS IN CAIRO BETWEEN THE LATE 13TH AND EARLY 16TH CENTURIES GROUPED MOSQUES AND RELIGIOUS COLLEGES WITH MAUSOLEA AND FOUNDATIONS.

The Mamluks were responsible for creating charitable building complexes that incorporated the mausoleum of the founder. These foundations included mosques, *madrasas* (religious colleges) and sometimes hospitals. One example is the complex of Sultan Qalawun, seen as the most ambitious – as well as impressive – complex to have been built by the Mamluks in Cairo.

QALAWUN COMPLEX

The complex of Sultan Qalawun was built in 1284–85 on al-Muizz Street, on the site of and using building materials salvaged from the Fatimid Western Palace. It stands behind a grand street façade that runs for almost 70m (230ft) and contains a superb mausoleum and *madrasa* and originally also had a hospital based on a four-*iwan* (hall) courtyard, although little of this last building survives.

Below The tall, ribbed domes of the complex of amirs Salar and Sanjar al-Jawli are visible from street level.

Above The madrasa complex of al-Nasir Muhammad has a Gothic marble portal, removed from a crusader church.

Instead of the usual square-dome design used for such buildings, the mausoleum features an inner octagon supported on four piers and four granite columns on which stands a high drum containing windows beneath a superb dome. The octagonal shape is a tribute to the design of the 7th-century Dome of the Rock in Jerusalem. The interior of the building is opulently decorated. The *madrasa* was laid out with two *iwans* at either end of a square courtyard, and rooms for accommodation or teaching space placed along the sides; in the *qibla iwan* (orientated to the direction of prayer), there were three naves.

GOTHIC PORTAL

Standing alongside the *madrasa* complex of Sultan Qalawun, the Madrasa and Mausoleum of al-Nasir Muhammad of 1295–1303 was in fact begun by al-Adil Kitbugha prior to his deposition in 1296. Kitbugha was responsible for the building's most celebrated feature – a Gothic marble portal, carried to Cairo by Sultan al-Ashraf Khalil (reigned 1290–93) from a crusader church in Acre (now in Israel) and installed in the façade;

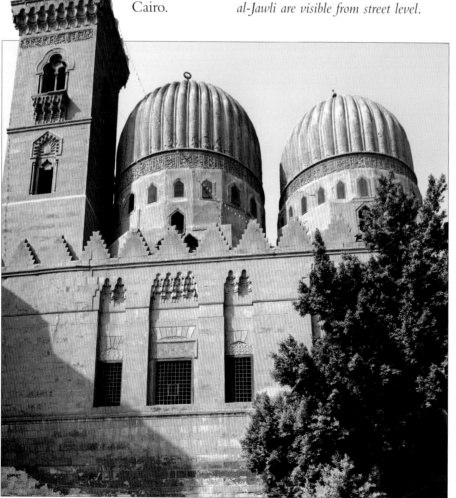

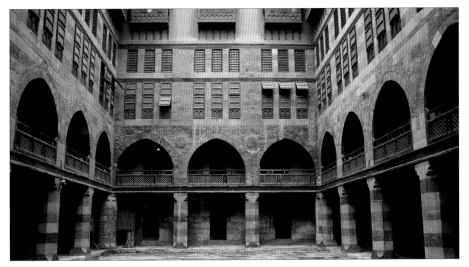

Above Rooms around the courtyard of the Sultan Qansuh al-Ghuri's caravanserai in Cairo provided rest for merchants.

it was intended as a statement of Islamic triumph over Christianity, as the word 'Allah' was added at the portal's apex by Sultan al-Nasir. The complex was completed by Muhammad, who added the widely admired minaret with its lace-like stucco decoration on the lower square shaft; the upper octagonal part of the minaret was added at a later date. Within the complex, little remains except the beautiful carved stucco prayer niche.

OTHER COMPLEXES

The mausoleum complexes of the amirs Salar and Sanjar al-Jawli, dating to 1303–4, have a number of interesting features: the ribbed, pointed brick domes of the mausolea are raised on high drums well above the façade for maximum visual effect, and the minaret is an early example of the 'pepperpot' shape that became standard in Mamluk Cairo, combining square, octagonal and circular sections. Behind the mausolea is a hall topped with what is probably Cairo's first stone dome. The mausolea and adjoining hall are orientated toward Makkah, but the attached two-*iwan* courtyard that was either a *madrasa* or *khanqa*

(Sufi monastery) is not. This is an example of Mamluk builders having to adapt their layout to a constrained urban site – or perhaps, in this case, making use of the building structures that were already in place. The courtyard contains open arches with carved stone screens.

Built in the late Mamluk period, the complex of Sultan Qansuh al-Ghuri (reigned 1501–16) is an example of the architecture of the period at its most expansive. The complex occupies sites on both sides of al-Muizz Street, with the mausoleum and *khanqa* on the eastern side and a large *madrasa* and congregational mosque on the western side. Its façades are set back from those of the rest of the street, forming a wider area resembling a square. Income raised by stalls and shops set into the lower façades would have helped to pay for the upkeep of the complex. The large mausoleum once had an elegant dome coated with blue faience.

Nearby, the same sultan built an impressive 'wakkala' or urban *caravanserai* in 1504–5: this was centred on a great courtyard lined on all sides by storerooms on the two lower storeys, and on the upper floors, three-room apartments to be rented to merchants, pilgrims and travellers. In the centre of the courtyard was originally a kiosk mosque.

MAMLUK HERALDRY

The buildings and all the associated furnishings and regalia of the Mamluk military elite were typically marked with the owner's personal identity. Until the mid-14th century, this was done with heraldic blazons, a system with a symbol assigned to each Mamluk amir, which represented his household role when he had been a slave-soldier. From their adolescence, all Mamluk amirs and sultans had passed through a system of education, training and service as a slave. On manumission, each became an amir with slaves of his own. Deeply loyal, each was proud of his service role and, from then on, used it as a heraldic badge – for example: a pen box emblem for the secretary; a cup for the cup-bearer; and a sword for the sword-bearer. The blazons were gradually replaced by emphatic calligraphy in the late 14th century.

Above Amir Tabtaq's heraldic blazon – a cup – was inlaid on to the neck of this 14th-century Mamluk ewer.

MAMLUK METALWORK IN EGYPT AND SYRIA

THE MAMLUK RULERS COMMISSIONED SPLENDID PIECES OF METALWORK, RICH WITH GOLD AND SILVER INLAY. METALWORKERS ALSO PRODUCED WARES FOR DOMESTIC AND EXPORT MARKETS.

Mamluk inlaid metalwork belongs to an art tradition that had spread across Syria and Egypt from Mosul (in northern Iraq) during the 13th century. Craftsmen used the signature *al-Mawsili* ('of Mosul') to signify their training background, even while making objects in Damascus or Cairo. Large basins, trays, bowls, pen boxes, incense-burners, ewers, candlesticks and caskets were all among the objects produced by Mamluk metalworkers.

Gold was used increasingly as an inlay, enhancing the luxury of these spectacular objects all the more. Mamluk decoration typically follows one of three key themes –

flamboyant epigraphy; figural imagery; and Chinese-style motifs reflecting contact with Mongol power in Iran – sustained into the 14th century primarily by the European export industry.

EPIGRAPHIC DECORATION

Typical *al-Mawsili* designs present a series of figural scenes describing the ruler's princely lifestyle and entourage, including royal hunts, audience scenes, grand banquets and hunting animals, as well as astrological figures of the planets and zodiac signs. While this fashion was popular in late 13th-century Mamluk metalwork, the imagery was shortly superseded by a vogue

Above This brass basin – with inlay in silver, copper and niello (a black infill substance) – dates from the early 14th century.

for large-scale inscriptions in majestic *thuluth* calligraphy, set in horizontal bands and surrounded by fine stylized patterns.

A consistent feature of early Mamluk metalwork is the heraldic blazon adopted by officers in this

Below Made in 14th-century Egypt, this brass pen box has gold and silver inlay. The exquisite decoration includes floral details and Kufic calligraphy.

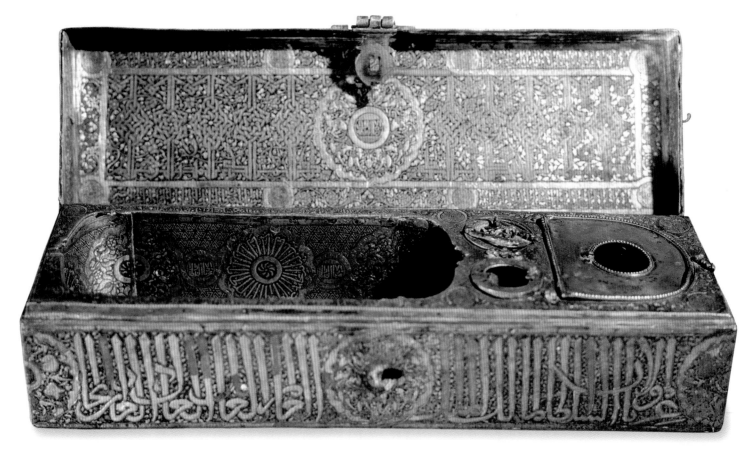

military caste system, which signalled their erstwhile positions of service. The icons of the secretary, cup-bearer, or even polo master were toted as personal badges throughout the career of an amir or sultan and were attached to their material furnishings and architectural projects. However, around 1350, these blazons were gradually replaced by the large calligraphic inscriptions naming the patron with his full titles. Both styles show how the Mamluks wanted to be associated personally with their acts of patronage, especially with charitable religious foundations, promoting themselves as pious as well as powerful.

CHINESE INFLUENCE

The presence of the Mongol dynasty, the Ilkhanids, in Iran and Iraq, bordering Mamluk territory, inspired new design ideas among Mamluk metalworkers. Despite the fact that the Mongols were political enemies of the Mamluks, elements of 'chinoiserie', or Chinese-style designs, were adapted by Mamluk artisans as a direct influence from Mongol visual culture: the lotus, peony, dragon and phoenix joined Mamluk designs across the media, including metalwork.

EUROPEAN EXPORTS

While grand epigraphy was increasingly fashionable for Mamluk-commissioned inlaid metalwork, figural imagery did continue in Mamluk production – but apparently only to satisfy a lively export market to Europe. A group of objects, many signed by the craftsman Muhammad ibn al-Zayn and datable to the mid-14th century, may belong to this category. These objects are decorated with complex figural programmes, which match Mamluk manuscript-painting style

of the same period, but not contemporary metalwork trends. The archaic design may have been retained to satisfy a Western preference for pictures over Arabic calligraphy.

Italian merchants were based chiefly in Damascus, and served a keen market for Middle Eastern luxury goods in their home cities and beyond in Western Europe. Working for export, Mamluk craftsmen left areas usually reserved for heraldic blazons blank, allowing foreign merchants to sell to prospective owners – who could add their own family crest. These blank shields are in the typical European shield shape – not the round badge of Mamluk amirs and

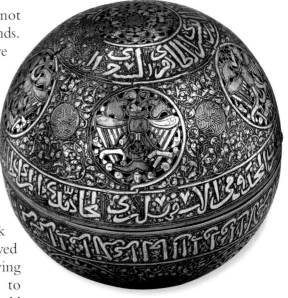

Above Dating from the late 13th century, this brass incense-burner with gold and silver inlay is from Damascus. It is inscribed to the powerful amir, Badr al-Din Baysari.

sultans. Certainly the evidence of European paintings is that metal-work, ceramics and textiles from the Islamic world were displayed with proud ostentation in Western European domestic contexts. An Italian pilgrim, Simone Sigoli, who visited Damascus in 1384–85, described the luxury of local metalwork:

'They also make a large quantity of basins and ewers of brass, and in truth they look like gold; and then on the said basins and ewers they put figures and leaves, and other subtle work in silver – a most beautiful thing to see...Verily if you had money in the bone of your leg, without fail you would break it off to buy of these things.'

Left This brass ewer – with gold, silver and niello inlay – is inscribed with the name and titles of al-Nasir Ahmad, who ruled briefly in 1342.

MAMLUK QURANS

THE ART OF PRODUCING ILLUSTRATED MANUSCRIPTS OF THE QURAN REACHED NEW HEIGHTS DURING THE 13TH CENTURY, WHEN THE MAMLUKS CAME TO POWER.

From the mid-13th century, the Mamluks and the Ilkhanids were responsible for producing some of the largest and most lavish Qurans ever made. The overriding trend was to produce grander, more ornate manuscripts.

Mamluk Qurans often opened with a double-page frontispiece of lavish illumination. In addition, the calligraphers increasingly opted for large, dramatic scripts, such as *muhaqqaq* or *thuluth*.

RELIGIOUS FOUNDATIONS

The most sumptuous Qurans were not normally produced for the private use of wealthy patrons. In fact, these large-scale Qurans were usually commissioned for a religious institution, such as a mosque or a *madrasa* (religious college) founded by a particular amir or sultan. Their precise purpose was often set out in a *waqf*, a type of endowment set up to fund a religious or charitable purpose:

the Baybars *khanqa waqf*, for example, specifies that the Quran should be read each day at noon.

THE BAYBARS QURAN

An ambitious Mamluk amir, Baybars al-Jashnagir, briefly ruled as sultan in 1309–10. He built a charitable *khanqa* (Sufi residence) in Cairo, which was completed in 1309. Baybars commissioned a magnificent seven-volume Quran for his new foundation, now in the British Library. The Quran volumes are dated 1304–6 and represent the Mamluk arts of the book at their very best. The text is written in gold *thuluth* script and was copied by a famous calligrapher, Ibn al-Wahid (1249–1311), who had trained with the Baghdad master Yaqut al-Mutasimi (d.1298). An anecdote suggests that this renowned calligrapher could behave in a slightly underhand manner: Baybars once paid Ibn al-Wahid 1,600 dinars to copy out a new Quran –

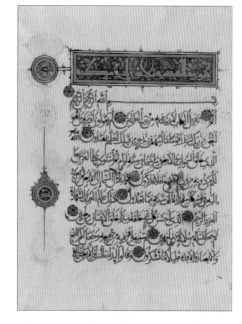

Above Beautiful calligraphy in gold enhances this Mamluk-dynasty Quran. It is at the Smithsonian Institution in Washington, DC, USA.

he spent only 400 on materials, pocketing the rest. Baybars' mild response was simply to ask: 'When will there be anyone else who could write out a Quran like he can?' Two renowned illuminators worked on the Baybars Quran: Ibn Mubadir decorated volumes one, two, four and six, while Abu Bakr – better known as Sandal – designed and executed the illumination in volumes three, five and seven. Both signed their work. Ibn Mubadir may have worked on Ilkhanid Quran projects, but it seems certain that he trained in Baghdad. The illuminator Sandal was famous among his contemporaries. He developed a delicate but ordered style of decoration, which was to influence a future generation of illuminators. This is most evident in his frontispieces, which usually took the form of a central star polygon, surrounded by elaborate trelliswork

Left The frontispiece of volume one of Sultan Baybars' seven-volume 1304 Quran – one of the most magnificent Islamic manuscripts.

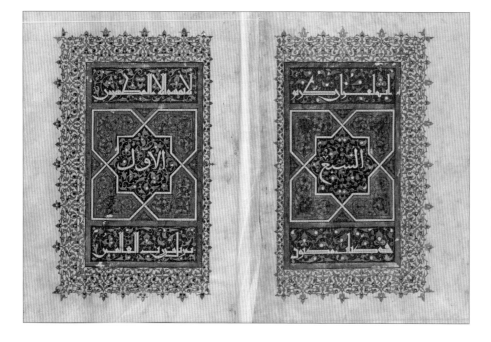

infilled with palmettes. Several other Mamluk Qurans are signed by or attributed to Sandal. Little is known about the artist himself, except that he held a high position and may have been a eunuch. This particular detail is indicated by his name, Sandal or 'sandalwood': fragrant nicknames were typically given to eunuch slaves.

ILKHANID INFLUENCES

The Mamluk illuminators were undoubtedly influenced by some Ilkhanid trends, perhaps because Iraqi-trained artists like Ibn Mubadir were moving to Cairo. Influence is often attributed to two famous Ilkhanid Qurans. The first of these was a 30-volume Quran produced in 1313 in Hamadan for Sultan Uljaytu (reigned 1304–16), which was sent to Cairo in 1326, probably as a gift for the Mamluk Amir al-Nasir Muhammad. This was too late to have influenced the 1304–6 Baybars Quran in any way. The second, a Quran commissioned by Sirghitmish al-Nasiri, arrived in Egypt in the 1350s, and immediately made an impact. It was written in the *muhaqqaq-jali* script, a form that was instantly copied by Mamluk calligraphers. *Muhaqqaq* script uses shallow, sublinear curves with mid-line curvatures that extend horizontally, forming compact words that sweep toward the left.

The Ilkhanid influence on Mamluk Qurans was not confined to the lettering but can also be seen in the artwork. Chinese motifs played an increasing role in manuscript decoration,

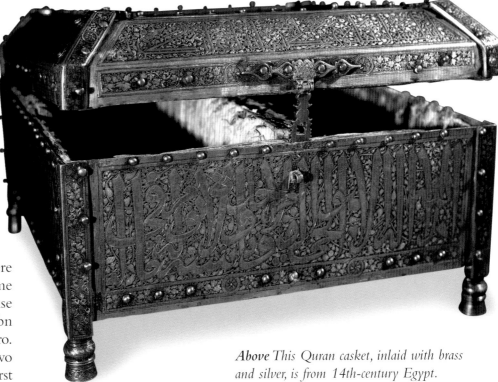

Above This Quran casket, inlaid with brass and silver, is from 14th-century Egypt.

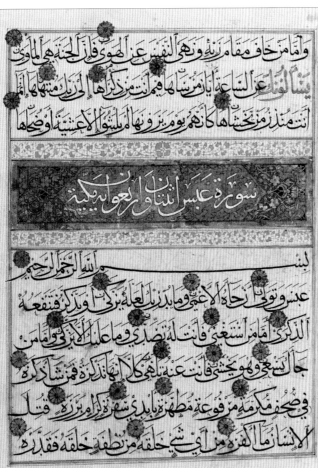

Above This Mamluk Quran has wonderfully elegant calligraphy and decoration, around the surah heading, in gold and pigments.

especially in the large, ornate frontispieces. Many of these had been decorated in the margin with a band of floral patterns, featuring peonies, lotus buds and other oriental blooms.

STAR POLYGON GROUP

Very fine Mamluk Qurans were produced in Cairo between 1363 and 1376, during the reign of Sultan Sha'ban. These include a number of manuscripts known collectively as the Star Polygon group. These manuscripts were named after their exquisite frontispieces, which were constructed around the radiating points of a star. A second group encompasses the work of Ibrahim al-Amidi, who was the most celebrated illuminator of the age. He used spectacular geometric designs, with unusual colour combinations and a broad range of motifs.

TRADE WITH EUROPE

EUROPEANS WERE IMPRESSED BY THE HIGH QUALITY OF MATERIAL GOODS FROM THE ISLAMIC WORLD. LUXURY ITEMS WERE BROUGHT TO EUROPE, WHERE THEY INFLUENCED LOCAL CRAFTSMEN.

Across the Islamic world, a dedicated export market developed. Craftsmen in Egypt, Syria and al-Andalus worked to meet a demand from Europe. The luxury goods purchased by pilgrims and merchants included carpets, glass, ivories and textiles, as well as inlaid metalwork and ceramics.

VENICE AND THE MAMLUKS

The main European trading partners of Mamluk Egypt were Venice and Genoa. The great trade routes through Damascus and across the Red Sea to South and South-east Asia passed through Mamluk lands, and in many cities there was a permanent diplomatic staff from Venice, safeguarding the interests of Venetian merchants. Indeed, Francesco Foscari, Venice's longest-reigning doge (in power 1423–57), was born in Egypt. Venice was particularly important in the trade in glass and ceramics, but also played a key part in the import of metalwork. It is known from trade documents that Venetian merchants exported brass and copper in significant quantities to craftsmen in the Middle East and at the other end of the process imported the finished inlaid products.

At one time historians proposed that Muslim craftsmen actually lived and worked in Venice, producing what was once termed 'Veneto-Saracenic metalwork' for the local luxury market. Modern historians reject this theory, arguing that the crafts guilds in Venice were so tightly managed that no foreign workers would have been able to establish themselves in the city.

STATUS SYMBOLS

Items of inlaid metalwork imported from the Islamic world into Europe included ewers, incense-burners and candlesticks as well as basins. These acquisitions were then proudly and prominently displayed in the homes of the wealthy.

Above This fine engraved 16th-century brass dish with a raised centre is an example of the Islamic metalwork once called 'Veneto-Saracenic wares'.

On many of these items, a space was left blank for a European coat of arms to be added by the customers.

Some of the artefacts, such as the Baptistère de St Louis (see opposite page), found their way into royal collections and from there into modern museums, where we can admire them today, and their provenance and history are carefully detailed. Another key area of evidence for the trade between the Islamic world and Europe can be found in Italian paintings of the Renaissance period. Islamic art objects were often depicted in portraits of patrons and their families, shown standing in a domestic context: many of the objects were beautiful, exotic and expensive – and so, naturally enough, they were symbols of status, wealth and international connections.

Above Danzig merchant George Gisze made a prominent display of his carpet, imported from what is now Turkey, when he was painted by Hans Holbein in 1532.

CERAMICS AND GLASSWARE

Imported wares were copied by local European craftsmen, and in some cases the trade in Islamic products inspired the development of European production centres. For example, craftsmen in the Middle East developed gilding and enamelling techniques for decorating glass. Afterward, in the 13th century, Venice became the European centre for decorated glass objects, in part because of its maritime trade with the Islamic world but also because exiled Byzantine craftsmen settled in Venice. The craftsmen in Venice used forms and decorative styles developed in the Islamic Middle East but also turned for inspiration to narratives and motifs from Italy's classical past.

Glazed lustre pottery from al-Andalus was also imported to Europe. In Italy, tin-glazed wares were named 'maiolica' after the contemporary Italian name for the island of Mallorca, which was a key staging post on the maritime route for pottery from al-Andalus. In Venice, Florence and elsewhere in Italy, craftsmen made their own maiolica wares from the late 1200s onward. From Middle Eastern potters, Italian craftsmen learned how to scrape through the glaze to uncover the darker surface beneath – a technique called 'sgraffito'.

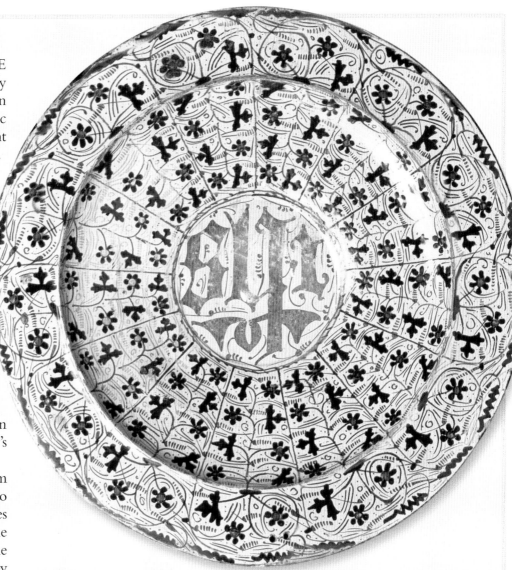

Above This Italian plate is an example of maiolica, tin-glazed ceramics made either by Islamic craftsmen or under their influence. Stylized floral designs surround a central inscription.

Above The design on the magnificent Baptistère de St Louis shows dignitaries carrying weapons and symbols of their status at court.

THE BAPTISTÈRE DE ST LOUIS

A notable example of Mamluk export wares is the Baptistère de St Louis, an exquisite brass basin covered with figural engraved decoration and inlaid with silver and gold. The basin was signed by Muhammad ibn al-Zayn, probably in the mid-14th century – a time when this figural, decorative style had gone out of fashion among the Mamluk sultans and amirs, suggesting that the item was made for European customers.

The basin passed into the collection of the French royal family and was used as a vessel to hold holy water for the baptism of princes and princesses; it was part of the royal collection of the Sainte-Chapelle ('Holy Chapel') in the Château de Vincennes (built in the 14th century by King Charles V and now in the suburbs of Paris). The Baptistère de St Louis was given its name, which means the 'baptismal vessel of St Louis', because of an anachronistic association with St Louis (the French King Louis IX, died 1270). The basin is now in the Musée du Louvre in Paris.

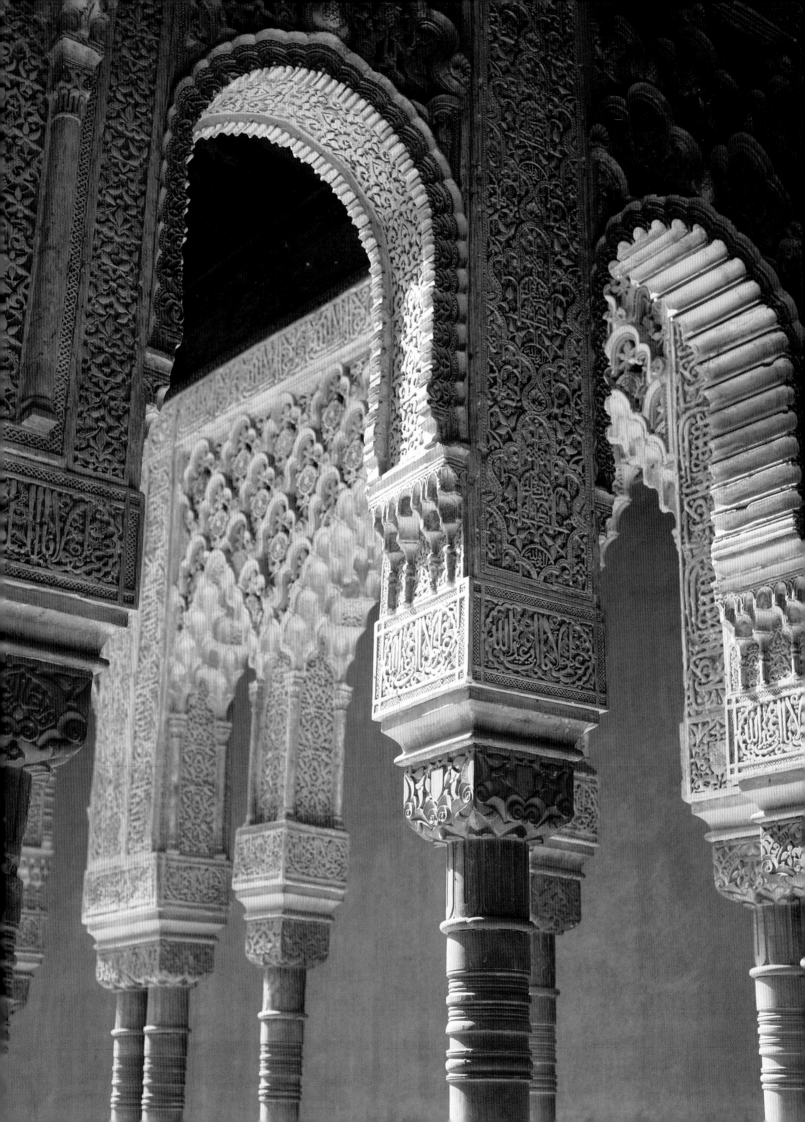

ISLAM IN SPAIN AND NORTH AFRICA

The Muslims conquered North Africa ('al-Maghreb') within the first decades of the Umayyad Caliphate, and reached Spain ('al-Andalus') in 711. After the overthrow of the Umayyad Caliphate by the Abbasids in 750, one survivor fled Syria and established an independent Umayyad power in Spain, ruling from prosperous Córdoba and the nearby palace city of Madinat al-Zahra. Political power fragmented following Umayyad decline, and al-Andalus was invaded from al-Maghreb by two consecutive Berber dynasties: the Almoravids (1062–1147) based in Marrakech, and then the Almohads (1130–1269), who made Seville their capital. Increasingly, the Christian kingdoms of northern Spain were pressing southward, and the Almohads were defeated by a Christian confederation at Las Navas de Tolosa in 1212. The last Muslim dynasty in Spain was the Nasrids (1232–1492), who retreated to Granada in the south and built the Alhambra, a spectacular palace citadel that survives to this day. In 1492, the last Nasrid sultan was expelled from Spain by the Catholic monarchs Ferdinand and Isabella.

Opposite An exquisitely decorated stucco arcade runs around the Palace of the Lions in the Alhambra Palace, Granada. Originally, the stucco was painted in bright colours. The columns are marble.

Above This elegant 10th-century archway in the Great Mosque of Córdoba is decorated in glass mosaic with Arabic calligraphy and stylized foliate designs.

THE UMAYYADS OF SPAIN

THE MUSLIM CONQUEST OF IBERIA IN 711 WAS CONSOLIDATED BY THE LONE SURVIVOR OF THE UMAYYAD CALIPHATE OF DAMASCUS, WHO FOUNDED A DYNASTY THAT RULED THE PENINSULA UNTIL 1031.

In 711, an army of Arabs and Berbers, unified under the Umayyad Caliphate of Damascus, invaded the Christian Visigothic Kingdom of the Iberian Peninsula. During the eight-year campaign, the entire peninsula, except for Galicia and Asturias in the north, was brought under Muslim control. The conquered territory, under the Arabic name al-Andalus, became part of the Umayyad Empire.

ESTABLISHING A DYNASTY

When the Umayyad Caliphate of Damascus was overthrown by the Abbasid Revolution in 750, the only member of the Caliphate to survive the subsequent massacre of the royal family, Abd al-Rahman I, escaped from Syria and fled to North Africa, reaching southern Spain in 755. Welcomed by Syrian immigrants loyal to his family, he re-established the Syrian Umayyad dynasty in Spain, which was to last for two and a half centuries. Nonetheless, nostalgia for Syria was a key theme in Spanish Umayyad

culture. At his capital of Córdoba, he began the construction of the Great Mosque, which was later enlarged by his successors.

During his 32-year reign, Abd al-Rahman I had to contend with numerous uprisings, some of which were supported by the Abbasids and one by Charlemagne. His successor, Abd al-Rahman II, was a poet and patron of the arts whose rule was marked by peace and prosperity. He brought scholars, musicians and poets from all over the Islamic world to Córdoba. The brief reign of his son Muhammad I was a period of crisis, but his successor, Abd al-Rahman III (912–61), was to reign for half a century. Abd al-Rahman III was the first Spanish Umayyad to declare himself caliph in 929, openly challenging the Abbasids in Baghdad and countering Fatimid claims from Cairo. Under his rule, and that of his son al-Hakam II (961–76) – a great patron of the arts and bibliophile – Umayyad Córdoba was a worthy and aspiring competitor

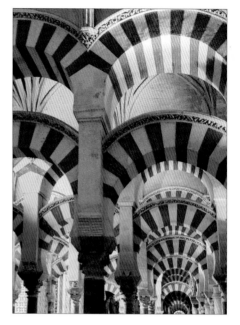

Above With its double tier of horseshoe arches, the Great Mosque at Córdoba, begun by Abd al-Rahman I in 784, is one of the great medieval buildings.

to the great courts of Byzantine Constantinople, Abbasid Baghdad and Fatimid Cairo. Art, poetry, philosophy and science flourished. Works in the 'courtly love' tradition were carried by troubadours (from an Arabic word meaning 'to be transported with joy and delight') into southern France. Al-Andalus became a centre for the translation of Arabic works (via Spanish) into Latin and Greek, and for innovations in music. Court culture followed sophisticated codes of manners for gastronomy, cosmetics, perfumes, dress codes and polite behaviour. Luxury objects, such as carved ivory boxes, bronze statues of animals and richly patterned silks, adorned the palaces, which were decorated with ornate capitals and marble fountains.

TECHNICAL INNOVATIONS

The introduction of new farming methods and the improvement of the Roman irrigation system turned the Guadalquivir Valley, the wetlands of the Genil and the fluvial areas of the Mediterranean

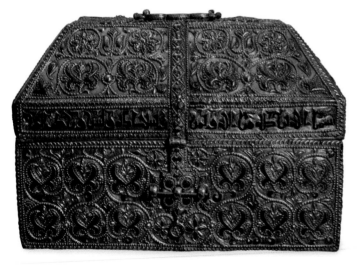

Left This gilt silver casket, dating from 976, bears the name of the Umayyad Caliph al-Hisham II. Luxurious silver caskets like this one were commissioned by caliphs to demonstrate their wealth and kingly authority.

128

Above The diminutive mosque, Bab al-Mardum, in Toledo is one of the oldest Moorish monuments in Spain. It was built in 999 by Musa ibn Ali.

coast into fertile orchards and fields. Among the crops that were introduced into the region are pomegranates, apricots, peaches, oranges, rice, sugar cane, cotton and saffron. Andalusian products were sold in Baghdad, Damascus and Makkah and as far away as India and Central Asia.

Al-Hakam II's son, al-Hisham II, was usurped by al-Hisham's opportunistic chamberlain, Muhammad ibn Abi Amir, who adopted the title of al-Mansur, or 'the Victorious One'. Al-Mansur carried out more than 50 punitive expeditions against the Christians of northern Spain. It was during one such expedition that the Basilica of Santiago de Compostela, the most famous Christian sanctuary in Spain, was sacked. However, these victories only served to unite the Christian rulers of the peninsula against al-Mansur. In 1002, he was succeeded by his son Abd al-Malik, known as al-Muzaffar, who ruled until 1008.

CIVIL WAR
After Abd al-Malik, Sanchuelo, his ambitious half brother, took over. However, his attempt to take the Caliphate for himself plunged the country into a devastating civil war leading to the end of the Umayyad Caliphate in Spain. The region then fragmented into several weaker, rival *taifa* kingdoms who were unable to resist encroaching Christian powers from the north.

Left This impressive water wheel was built on the site of a Roman mill, during Abd al-Rahman II's reign (822–52), to raise water from the Guadalquivir river to the Caliphal Palace, Córdoba.

UMAYYAD TIMELINE
The Umayyad dynasty was interrupted by the Hummudid (or Amirid) dynasty between 1017 and 1023, and al-Andalus was governed by a regent, al-Mansur. Below are the main dates important to this dynasty:

711–18	Umayyad conquest of Spain
750	Umayyad Caliphate of Damascus taken over by Abbasids
755	Abd al-Rahman I arrives in Spain
756–88	Abd al-Rahman I reigns
786	Construction of Great Mosque, Córdoba begins
788–96	Hisham I reigns
796–822	al-Hakam I reigns
822–52	Abd al-Rahman II reigns
852–86	Muhammad I reigns
886–88	al-Mundhir reigns
888–912	Abdallah ibn Muhammad reigns
912–61	Abd al-Rahman III reigns
929	Abd al-Rahman III declares himself Caliph of Córdoba
936	Building starts on Madinat al-Zahra
947	Government of Umayyad Caliphate transferred to Madinat al-Zahra
961–76	al-Hakam II reigns
976–1008	al-Hisham II reigns
997	al-Mansur sacks Santiago de Compostela
c.1010	Madinat al-Zahra sacked
1010–12	al-Hisham II (restored)
1010–13	Civil War
1026–31	al-Hisham III, last Umayyad Caliph of Córdoba

CÓRDOBA

UNDER THE UMAYYAD CALIPHATE, CÓRDOBA BECAME ONE OF THE MOST WONDERFUL CITIES OF THE WORLD, ITS OPULENCE AND CULTURE UNRIVALLED THROUGHOUT WESTERN EUROPE.

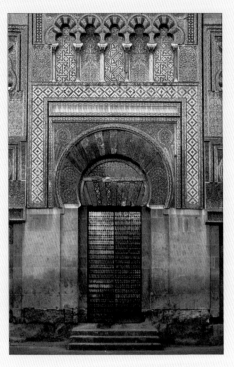

Situated along the Guadalquivir river, Córdoba had half a million people living in 113,000 houses scattered among 21 suburbs at the height of its prosperity. There were 1,600 mosques, 900 public baths and more than 80,000 shops. The Spanish Umayyad caliphs followed the pleasure-loving ways of their Syrian ancestors, and the elegance of life at court depicted on the ivory caskets was one of the specialities of Córdoba's skilled craftsmen.

During the caliphate of al-Hakam II, one of the most scholarly caliphs, Córdoba became the most cultured city in Europe. The library of al-Hakam is believed to have held 400,000 manuscripts. A great state institution, al-Hakam's library was a hub for a range of intellectual activities on an international level.

THE GREAT MOSQUE

With its complexity of design, decorative richness and delicacy of its superimposed arches, the Great Mosque at Córdoba is the finest surviving monument of Umayyad Spain. Its construction was begun by Abd al-Rahman I in 784, reportedly on the site of a Roman temple and a Visigothic church. Subsequent

Above This ornate doorway, with its horseshoe arch, is part of the additions made by al-Hakam II to the exterior of the Great Mosque at Córdoba.

Umayyad rulers extended and embellished the Great Mosque, creating a truly remarkable building.

The mosque interior is a deep hypostyle hall, featuring a dense forest of arched columns. Set on salvaged classical stone columns, the double arches are striped in red brick and white stone voussoirs, and mounted in pairs. This gives a dazzling visual result, heightening the hall and emphasizing the effect of receding perspective.

In 962, al-Hakam II added a new *mihrab* (niche) area, a small domed room exquisitely decorated in gold glass mosaic and carved stucco panels. Many aspects of the Great Mosque of Córdoba may be deliberate evocative references to the architecture of Umayyad Damascus.

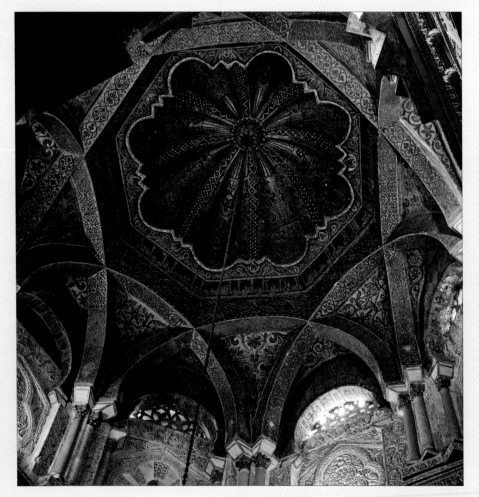

Left The dome in front of the mihrab in Córdoba's Great Mosque is decorated with Quranic inscriptions and flowing designs of plant life.

MADINAT AL-ZAHRA

The splendid palace-city of Madinat al-Zahra, about 5km (3 miles) east of Córdoba, was modelled after the old Umayyad palace in Damascus, and it served as a symbolic tie between Caliph Abd-al-Rahman III and his Syrian roots. Only ten per cent of this remarkable city has yet been excavated, but a palatial complex of great luxury has come to light. Its construction began in 936 and continued for 25 years. Built in three large terraces on the hillside at the base of the Sierra Morena, with the caliph's palace at its highest point, the city was visible from miles around. In 941, the city's mosque was consecrated, and by 947 the government had transferred there from Córdoba.

At its zenith, Madinat al-Zahra was said to have a population of 12,000 people. The city was a vast and luxurious complex of buildings and irrigated gardens, including the caliph's residence, court reception halls, mosques, *hammams,* state mint,

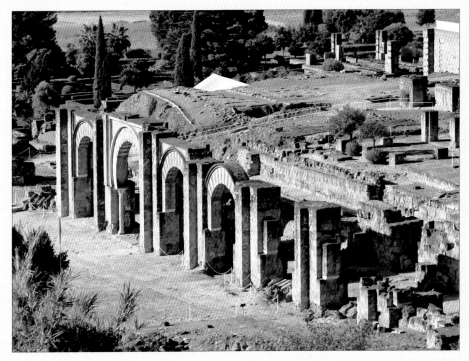

pharmacy, barracks, court textile factory, plus a large urban quarter on the lowest terrace. This magnificent city was to last for only 50 years. It was sacked and looted during the Civil War (1010–13) that led to the end of the Caliphate of Córdoba and marked the beginning of the *taifa* period.

Above With its series of hillside palaces, Madinat al-Zahra commands an impressive prospect over the surrounding landscape.

Below These horseshoe arches in the Audience Hall in the Great Mosque have amazingly rich decoration, with panels of carved stone applied to the walls.

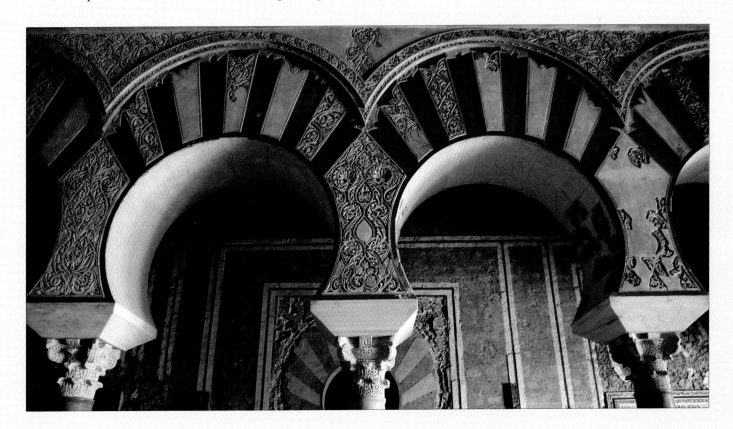

SPANISH IVORIES

THE INTRICATELY CARVED IVORIES OF ISLAMIC SPAIN ARE EVIDENCE OF THE ARTISTIC AND TECHNICAL EXPERTISE REACHED BY CRAFTSMEN DURING THE 10TH AND 11TH CENTURIES.

Craftsmen turned pieces of elephant ivory into small containers, and carved them with beautiful calligraphic inscriptions and lively depictions of birds, animals, gardens and human figures. The earliest Spanish carved ivories were made at Madinat al-Zahra, the Umayyad royal city near Córdoba, in the mid-10th century, at the height of the Caliphate. Ivory was carved into two shapes: either into a casket, a small box with a flat or pitched lid, or into a cylindrical container with a domed lid known as a pyxis.

ROYAL COMMISSIONS

The tradition of ivory carving spread from ancient Syria and Egypt to Spain in the Islamic period. The royal court at Madinat al-Zahra commanded vast wealth and monopolized the ivory industry of Islamic Spain. They imported tusks of ivory from its source in East Africa and received ivory as gifts from foreign royalty. It was reported that 3,630kg (8,000lb) of the most pure ivory was sent as part of a present to Caliph al-Hisham II by a Berber prince in 991.

The craftsmen worked in royal workshops with the finest ivory to create their unique objects, often working in teams. The pyxides were carved on a lathe, while the caskets were constructed from 1-cm (½-in) thick plaques sawn from the tusk and fitted to a wooden frame. They were carved in relief with sharp chisel-like tools.

INSCRIPTIONS

An Arabic inscription was often carved around the lid of the completed ivories in foliate script.

These often tell us the place, for whom and when they were made and sometimes even the name of the craftsmen. Most of the ivories were specially commissioned for members of the caliph's family or courtly entourage. However, one pyxis at the Victoria and Albert Museum was made for the prefect of police, while two pyxides and two flat boxes were made in 964 and 966 for a lady called Subh. She was a Basque from Gascony, the consort of Caliph al-Hakam II and mother of his son and successor al-Hisham II. The poetic inscription on another pyxis in the Hispanic Society of America hints that these luxury objects were used as containers to store precious jewels, spices and unguents:

Above A detail of an ivory casket, with peacock designs, made for the concubine of Caliph al-Hakam II, Subh.

Above This intricately carved lid dates from 999 and bears the name of the Umayyad wazir (minister), Sanchuelo.

'Beauty has invested me with
splendid raiment,
Which makes a display of jewels.
I am a receptacle for musk,
camphor and ambergris.'

AL-MUGHIRA PYXIS

The 'al-Mughira' pyxis was made in 968 and is a masterpiece of intricate design and skill. It was made for Prince al-Mughira, second son of Abd al-Rahman III and considered a hopeful for the throne of his brother al-Hakam.

The carvings on the pyxis are not fully understood. They might show scenes from the life of the prince, or perhaps they celebrate seasonal festivals or pursuits. Four cartouches, read from right to left, start under the beginning of the inscription, with the image of a youth reaching up to steal eggs from three eagles' nests. The second image shows a lute player flanked by two barefoot youths, while the third and fourth scenes show lions attacking bulls and a pair of youths on horseback picking dates from a tree. These images are surrounded by smaller vignettes of wrestlers, wolves, fighting animals and pairs of birds, filled in with delicately intertwining leaves, resulting in an intricate mix of agricultural and hunting images.

Above This casket of wood and gilded leather was made in c.1049. The mounts are later 17th-century European additions.

PAMPLONA CASKET

With the decline of the caliph's power in the late 10th century, production of luxury carved ivory moved to Córdoba, where the ambitious chamberlain al-Mansur commissioned a superb casket, which is now in Pamplona. Al-Mansur had virtually taken over the rule of al-Andalus from the weakened caliph, and the depiction of the chamberlain in royal guise seated on a throne and flanked by attendants is an obvious display of this new authority. The signatures of a whole team of craftsmen are hidden throughout this casket.

Right An ivory box, dated 1004, which has elaborately carved panels showing figures drinking and playing musical instruments.

One of them, Misbah, even carved his name on the throne platform under the chamberlain's feet.

THE CUENCA IVORIES

In the 11th century, when al-Andalus was fragmented into *taifas* (small kingdoms), the carved ivory workshops moved from Córdoba to Cuenca, where craftsmen worked under the local ruling family known as the Dhu'l-Nunids. The ivories the family commissioned were made by single craftsmen, such as ibn Zayyan, who signed the 'Silos' casket of 1026–27. These Cuenca ivories are less richly carved than the earlier ivories, with simpler, more repetitive decoration.

EARLY ISLAMIC RULE IN NORTH AFRICA

THE AGHLABIDS (800–909) RULED THE PROVINCE OF IFRIQIYA IN NORTH AFRICA AND LED INVASIONS OF SICILY, SARDINIA, MALTA AND PARTS OF MAINLAND ITALY.

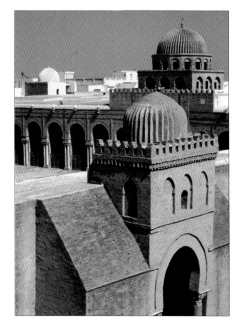

Above Kairouan's Great Mosque, rebuilt in 836, was the most influential Aghlabid building – a prototype for early North African architecture.

In 800, the Abbasid Caliph, Harun al-Rashid (reigned 786–809), appointed his army general, Ibrahim ibn al-Aghlab from Khurasan, to pacify and rule the unstable province of Ifriqiya (the area of Tunisia and Eastern Algeria), making him semi-autonomous. The Aghlabids ruled from Kairouan until 909.

THE GREAT MOSQUE

The heart of Aghlabid culture is found in the holy city of Kairouan and, in architectural terms, the jewel in its crown is its magnificent Great Mosque. This was the first building of outstanding quality in the region, and today it is classified as a Unesco World Heritage Site. The mosque was originally founded in 670 by Umayyad general Sidi Uqba b. Nafi, but was

Below The Aghlabid Empire was centred on present-day Tunisia – but extended into Algeria and Libya.

entirely renovated in 836 by the Aghlabid ruler Ziyadat Allah (reigned 817–38). It forms a large, rectangular courtyard with ablution pool, and a deep hypostyle hall of arcaded columns, with semicircular, horseshoe arches. Many of the 414 marble and porphyry columns are classical spolia, recycled from earlier Roman buildings on the site. The square, three-storey minaret is said to be one of the oldest in the Islamic world.

The most remarkable feature of the interior is the impressive array of early lustre tiles set in the *mihrab* (niche) arch and its adjoining walls. These were imported from Baghdad in the mid-9th century, and they are considered to be the oldest known example of Abbasid tiles still in situ. The surviving 139 examples display a wide variety of designs, including winged palmettes, crowns and peacock-eye motifs. The mosque's *minbar* (pulpit) dates from the 9th century and was made from 300 pieces of imported teak.

OTHER MOSQUES

The design of the Great Mosque at Kairouan was extremely influential, shaping the development of other Aghlabid mosques in Sfax (849), Sousse (850) and Tunis (864). It also had an impact on the Mosque of

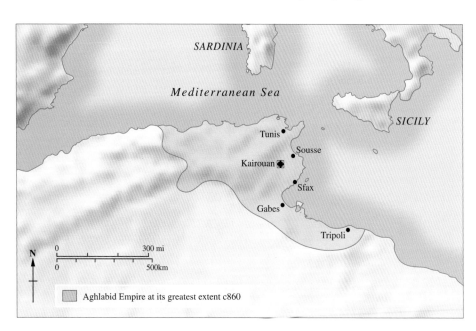

Mediterranean Sea

SARDINIA

SICILY

Tunis
Sousse
Kairouan
Sfax
Gabes
Tripoli

N

| 0 | 300 mi |
| 0 | 500km |

▨ Aghlabid Empire at its greatest extent c860

Above These 9th-century tiles from the Great Mosque of Kairouan feature linear designs and centrifugal shapes, arranged in a chequerboard pattern.

the Three Doors in Kairouan. Built in 866 by Muhammad ibn Khayrun, it takes its name from the triple horseshoe arch on the façade, which is surmounted by three bands of decoration, featuring Kufic inscriptions and floral patterns.

THE BASINS

In a different vein, the Aghlabids created an important civic amenity in Kairouan, a hydraulic system known as the Basins. These two interlinked pools acted as reservoirs, settlement tanks and filters, and provided the city with clean water. They were commissioned by Abu Ibrahim Ahmad ibn al-Aghlab and took four years to complete (859–63).

ISLAMIC *RIBATS*

In the year that Kairouan was granted World Heritage status (1988), Unesco bestowed the same honour on another Aghlabid city: Sousse. This was a major port that held a key strategic and commercial significance, because it was only separated from Sicily by a narrow stretch of water. For this reason, Sousse was well fortified, with powerful ramparts and a *ribat*.

Ribats, which have been described as monastic fortresses, were a distinctive form of Islamic architecture, combining military and spiritual needs. Essentially, they were designed to house the Murabitun (holy warriors), but they also had facilities for prayer and study in times of peace. The minaret at Sousse, for instance, served as a watchtower and a landmark for shipping, as well as its traditional military and religious purpose.

The borders of the Aghlabid territories were protected by a line of *ribats*, with major outposts at Tripoli, Sfax, Monastir, Bizerte and Sousse. The latter is by far the most

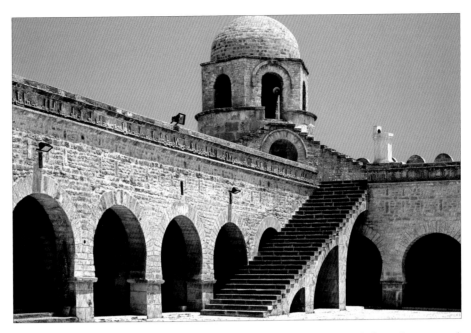

impressive, but the one at Monastir is also a fine, early example (796). Built by Ziyadat Allah in 821, the Sousse Ribat is notable for its lofty battlements, pierced with arrow slits, its galleries of arcades enclosing the inner courtyard, its rib-vaulting, and the first-floor cells, which were accommodation for the troops.

Above A stairway leads from the courtyard of the Great Mosque of Sousse (850) to the vaulted sanctuary. A long Kufic inscription features above this arcade.

Below Enlarged in the 10th century, the ribat at Monastir has large fortified walls and a tower which served as watchtower and minaret.

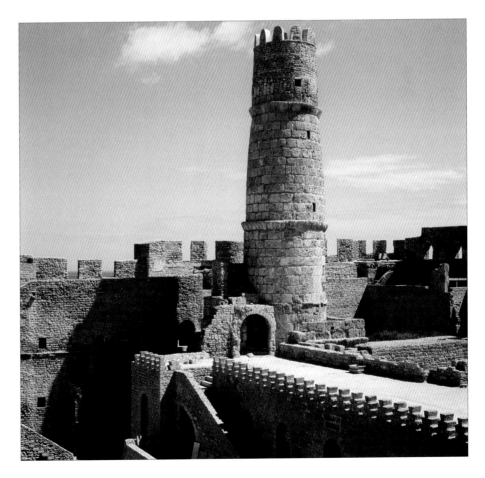

THE ALMORAVIDS AND ALMOHADS

THE BERBER DYNASTIES OF THE ALMORAVIDS (1060–1147) AND THE ALMOHADS (1133–1269) RULED THE MAGHREB AND AL-ANDALUS. THEY BUILT MOSQUES AND PALACES AND OVERSAW A THRIVING TRADE IN SILK.

The Almoravids were from the western Sahara and established themselves in the Maghreb under religious leader Abdallah ibn Yasin in c.1030–59. Their name derives from al-Murabitun (meaning 'men of the *ribat*'), as the ascetic and highly disciplined followers of ibn Yasin were known; the word *ribat* refers perhaps to a religious institution, a fortified monastery in which the men trained, or simply to a bond of religious brotherhood, a shared commitment to *jihad* (holy war). At the end of the 11th century, the Almoravids extended their power north into al-Andalus and also south of the Sahara in West Africa, eventually creating an empire that covered 3,000km (1,865 miles) from north to south. Their capital was Marrakech.

Almoravid leader Yusuf ibn Tashfin (reigned 1060–1106) first arrived in al-Andalus in 1085, at the invitation of the small Islamic *taifa* kingdoms, requesting support against the Christians. He defeated King Alfonso VI of León and Castile (reigned 1065/72–1109) at the Battle of Zallaka in 1086 and, in 1090, took control of Andalus and defeated the *taifa* kings as well.

ALMORAVID MOSQUES

The Great Mosque of Tlemcen (in Algeria, near the Moroccan border) is a key surviving Almoravid construction, built in 1082 after Yusuf ibn Tashfin led the conquest of the central Maghreb and captured Tlemcen. The mosque is celebrated for its highly decorated minaret and for the splendid horseshoe *mihrab* (prayer niche) and great dome in the prayer hall, both closely based on the Great Mosque of Córdoba. Built by Yusuf ibn Tashfin, the Great Mosque underwent many alterations under the rule of his son Ali ibn Yusuf (reigned 1106–43).

The Qarawiyyin Mosque in Fez was expanded and improved with beautiful domed vaults under Ali ibn Yusuf. The mosque had been founded in c.850 by immigrants from Kairouan in Tunisia, and named after them; Ali ibn Yusuf expanded the already large 18-aisle

Left The beautifully tiled courtyard at the Qarawiyyin Mosque in Fez has its own mihrab *and serves as a prayer hall in summer.*

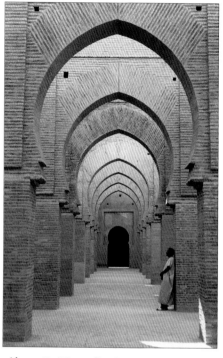

Above In Tinmal's Great Mosque, a prototype of the Almohad T-plan design, nine aisles run across the prayer hall.

prayer hall to contain 21 aisles – measuring 83m by 44m (272ft by 144ft), it was one of the largest mosques in the Maghreb. Ibn Yusuf's craftsmen also increased the height of the central aisle that leads to the *mihrab* and added five domed vaults decorated with *muqarnas* (tiers of small niches). Under the Almoravids, this mosque was also developed into a major university.

Other contemporary Almoravid religious foundations include the Great Mosque of Nédroma (near Tlemcen in Algeria), built in 1086, and the Great Mosque of Algiers, built in 1096.

RISE OF ALMOHADS

Known as *al-Muwahiddun* ('the Unifiers'), the Almohads swept the Almoravids from power in 1145–47. They were followers of the preacher Imam Muhammad al-Madhi ibn Tumart, a Berber from southern Morocco who declared himself the infallible imam Mahdi. After ibn Tumart's death in 1130, Abd al-Mumin became

leader of the movement, defeated the Almoravids at Orhan in north-western Algeria in 1145 and captured Marrakech in 1147.

The Almohads also took control of al-Andalus and made their capital in the city of Seville. However, after 1212, when their leader Muhammad III al-Nasir was defeated at the Battle of Las Navas de Tolosa by a Christian coalition of Aragon and Castile, Almohad power in al-Andalus swiftly failed, and they lost Córdoba (1236), Murcia (1243) and Seville (1248) to Ferdinand III of Castile. Back in the Maghreb, the Almohads survived in Marrakech until 1269, when the city was taken by the rival Berber power of the Merinids.

ALMOHAD T-PLAN MOSQUES

In the Maghreb, the Almohads built a series of mosques to a standard plan, with a many-aisled prayer hall and forecourt in the shape of a rectangle. These are known as T-plan mosques because the prayer hall's central aisle aligned on the *mihrab* met the transept to form a T-shape. Perhaps the principal prototype was the Mosque of Taza in Algeria, founded in 1142 by Abd al-Mumin; another was the Great Mosque of Tinmal (1153),

built in the Atlas Mountains around 100km (62 miles) south-east of Marrakech, in memory of Almohad founder Muhammad ibn Tumart.

THE ALMOHADS IN SPAIN

The remains of Almohad buildings can still be found in Seville. The Almohad Great Mosque, constructed in 1172–98, was later the site of the city's Christian cathedral. The minaret and the mosque's main courtyard survive. Today, the minaret serves as the cathedral's bell-tower. It features significant later additions, including a 17th-century Baroque belfry at its top, together with a rotating weathervane, and is called 'La Giralda'. The courtyard is planted with orange trees.

Among the more significant Almohad remains in Seville are parts of the city walls and a 12-sided tower on the banks of the Guadalquivir river near the city gates. The tower was once covered with glazed golden tiles and is known as the Torre del Oro ('Golden Tower'). Originally, it was matched by a similar tower on the other riverbank, which was covered with glazed silver tiles and called the Torre de la Plata ('Silver Tower'); the two towers were connected by a chain, which was

Above Seville's 12-sided Torre del Oro ('Golden Tower') was originally part of the 12th-century city walls.

lifted to allow ships access to the city harbour. Two Almohad palace buildings, the Patio de Yeso and the Patio de Contratacion, survive within the city.

Above This Almoravid silk cloth (c.1100) survived in a tomb in the Burgo de Osma Cathedral, Spain.

SILK PRODUCTION IN AL-ANDALUS

The history of silk weaving in Spain goes back to the Muslim conquest in the 8th century. Under Almoravid rule the city of Almería became the centre for textile production. According to the geographer Muhammad al-Idrisi (1100–66), in the mid-12th century Almería alone had 800 weaving mills, while the geographer Yaqut notes: 'In the land of Andalus there is not to be found a people who make more excellent brocade than those of Almería.' Generally, under the Almohad rulers figurative decoration on silks disappeared, to be replaced by abstract patterns of geometry and calligraphy.

As with many other Islamic art media, luxurious woven silk textiles were often adopted for use in sacred Christian contexts, such as royal burial, because of their remarkable quality. This (illustrated) silk and gold thread Almoravid fragment was re-used as a shroud for Christian relics of San Pedro de Osma: the design features lions, harpies, griffins, hares and people.

RABAT AND MARRAKECH

THE ROYAL CITIES OF MARRAKECH AND RABAT IN MOROCCO
WERE FOUNDED IN THE ALMORAVID–ALMOHAD ERAS AND ARE RICH
IN ARCHITECTURAL REMAINS OF THE PERIOD.

Marrakech gives its name to the country of Morocco: from Arabic *Marakush*, it came to English by way of Spanish *Marruecos*. The city was founded by Almoravid leader Yusuf ibn Tashfin (reigned 1060–1106) in 1062. He erected a grand palace named Dar al-Hajar ('House of Stone').

ALMORAVID BUILDINGS

A great mosque was built by the Almoravids in Marrakech, but it was destroyed when the city was

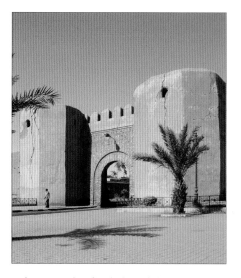

Above Built of red clay, the Bab er Reha gate is part of the 11th-century city wall of Marrakech.

captured by the Almohads in 1147. However, a small cube-shaped and domed building built over a well survives from the reign of Ali ibn Yusuf (1106–43). Named after its founder, the Qubbat al-Barudiyin is just 8m (26ft) tall. The walls are decorated with polylobed arches derived from those in the Great Mosque of Córdoba and with composite arches (alternately convex and concave curved outlines) based on the arches in the Palace of Aljaferia in Saragossa (1050–83), a product of the *taifa* (small kingdoms) of al-Andalus. The dome interior has magnificent stucco decoration. Historians believe that the building was a place for ritual washing used by those visiting the mosque.

The Almoravid rulers typically installed large, fine wooden *minbars* (pulpits) in their mosques. The beautifully carved *minbar* that once stood in the Great Mosque of Marrakech was ordered by Ali ibn Yusuf in *c.*1120 from renowned craftsmen in Córdoba. It stands 4m (13ft) high and has 1,000 carved panels featuring a complex design of geometric shapes. When the Almohads sacked Marrakech and destroyed the mosque in 1147, they saved the *minbar* and transferred it to the Kutubiyya Mosque that they built in the city.

ALMOHAD MOSQUES

In fact, the Almohads built two Kutubiyya mosques in Marrakech. The first, constructed in 1147, had

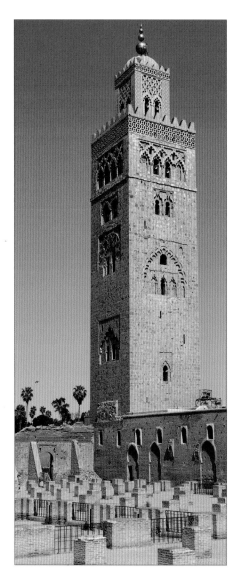

Left Measuring 67.6m (222ft) in height, the elegant minaret of the second Almohad Kutubiyya Mosque in Marrakech was built from 1158.

17 aisles and was a T-plan design with the principal aisle aligned on the *mihrab* (niche) and a pronounced transept cutting across it at right angles to form a T. However, this building was demolished almost as soon it was finished, perhaps due to a slight mistake made in its alignment with Makkah. The second mosque, built to the south of the first, beginning in 1158 was on a different alignment.

The second Kutubiyya Mosque has five cupolas above the *qibla* aisle (facing the direction of prayer) and six above the transept; there is also a splendid 67.6-m (222-ft) high minaret with a square tower surmounted by a lantern-shaped section. It contains six floors and a ramp to give the *muezzin* (who makes the call to prayer) access to the platform at the top. Four copper globes adorn the tower: according to local legend, there were originally three gold globes, until a wife of the Almohad ruler Yaqub al-Mansur (reigned 1184–99) donated the fourth globe after giving up all her gold jewellery to compensate for her failure to fast for a single day during Ramadhan. The minaret was the model for the minaret of the Mosque of Hasan in Rabat.

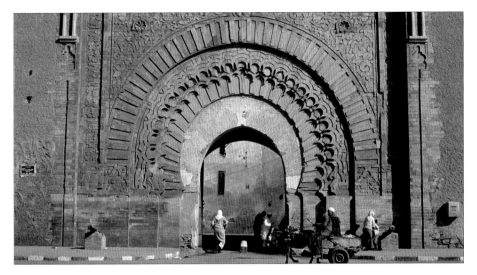

At Marrakech, the Almohads also laid out fortified city walls that incorporated monumental gates, such as the Bab Agnaou. Yaqub al-Mansur also built a *kasbah*, or fortified palace (citadel), in the city, as well as an associated mosque, the El Mansouria, completed in 1190.

RABAT

The city of Rabat, the modern capital of Morocco, grew from a *ribat*, a fortified camp or monastery, established by the first Almohad ruler Abd al-Mumin (reigned 1130–63) in 1146 as a base from which to launch the military attacks he was planning against al-Andalus.

Above The 12th-century Bab Agnaou gate at Marrakech bears an inscription from the Quran in Maghribi script. It leads into the royal citadel.

Below The unfinished Mosque of Hasan (1195–99) in Rabat contains 200 columns and a half-built, but beautifully decorated, red limestone minaret.

Yaqub al-Mansur gave it the name Ribat al-Fath ('Victory Camp'), from which its modern name derives, and built the fortifications that still survive.

At Rabat, this proud ruler, who took the name al-Mansur Billah ('Granted Victory by God') after he defeated King Alfonso VIII of Castile at the Battle of Alarcos on 18 July 1195, began building the Mosque of Hasan. This mosque was left unfinished, but survives today as a splendid square minaret and long lines of pillars, originally intended to support the roof of the prayer hall. The mosque was a vastly ambitious project: the surviving minaret is on a base 16m (52ft) square and may have been intended to rise to 80m (262ft), while the planned mosque was to cover 178m by 138m (584ft by 453ft) – bigger even than the Great Mosque of Córdoba, which measured 173m by 127m (568ft by 417ft), after it had been extended many times. The Mosque of Hasan may have been left unfinished because Yaqub al-Mansur overreached himself and could not complete such a vast building. After his death in 1199, building work ground to a halt.

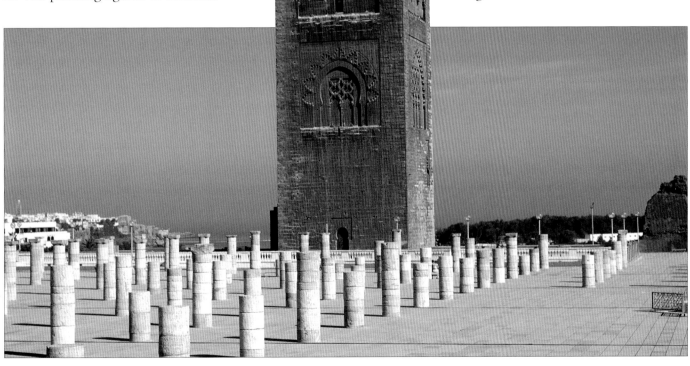

THE NASRIDS

THE LAST MUSLIM SULTANS ON THE IBERIAN PENINSULA, THE NASRIDS
(1232–1492) WERE RULERS OF THE SMALL KINGDOM OF GRANADA IN
SPAIN, WHERE THEY BUILT THE MAGNIFICENT ALHAMBRA CITADEL.

Above A steam bath was part of the
harem area of the Comares Palace at the
Alhambra. The tiles are original.

Almohad power in Spain never recovered from the defeat of Sultan al-Nasir by an army led by King Alfonso VIII of Castile in 1212. The Christians captured Córdoba in 1236, the cities of Murcia and Jaén in 1243 and 1245, and Seville in 1248. During this period, several small Muslim kingdoms were established, and one of these was created in Jaén by Muhammad ibn Yusaf ibn Nasr (reigned 1232–73), self-styled Sultan Muhammad I of Arjona, who made his capital in Granada in 1237. Ibn Nasr was a client-ruler under King Ferdinand III, but he managed to pass on his kingdom to his son Muhammad II (reigned 1273–1302), who consolidated Nasrid power in Granada.

The Nasrid kingdom was at its height under Sultan Yusuf I (reigned 1333–54) and Sultan Muhammad V (reigned 1354–9 and 1362–91), both of whom devoted themselves to rebuilding the fortified palace-city of the Alhambra that was the Nasrids' most enduring legacy.

After the reign of Muhammad VII (1392–1408), the power of the Nasrids entered a slow decline as rival family members fought over the sultanate. The final sultan, Muhammad XII, also known as Boabdil, seized the throne from his father Abu'l Hasan Ali in 1482, but the following year he was captured by Christians. Boabdil's uncle took the throne as Muhammad XIII, then King Ferdinand released Boabdil as a vassal-ruler, and the two rivals fought while Ferdinand's army advanced toward Granada. There, Boabdil was forced to hand the city to the Christians in 1492. The 'Reconquista' (reconquest) was complete.

GLORIES OF GRANADA

The Alhambra's name derives from the Arabic words for 'the red one': it is so-called from the reddish colour of the sun-dried, clay-and-gravel bricks of which its outer walls are constructed. A fort is known from contemporary accounts to have stood on the site as early as 860, but there are no remains dating to earlier than the 11th century, when builders of the Zirid dynasty erected an earlier version of the Alcazaba. The complex began to be established in its current form under the early Nasrid sultans, and the most celebrated features, including the Comares Palace and the Palace of the Lions, date to the reigns of Yusuf I and Muhammad V in the 14th century.

In its final form, the fortified palace-city of the Alhambra stands behind walls 1,730m (5,675ft) long with 30 towers and 4 main gates, on a plateau overlooking the city of Granada. The Alhambra has three main areas: the Alcazaba, or citadel, a barracks area for the guard; the palaces used by the sultan and family; and the madinah, a residential area for officials and artisans.

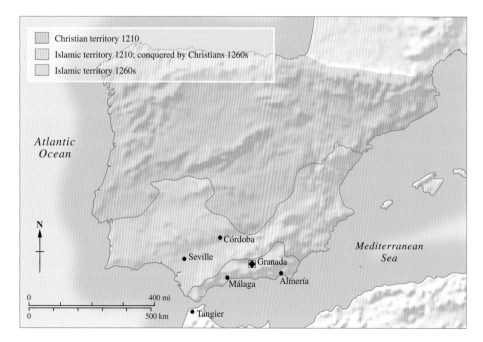

Left By 1260, Muslim rule in Spain
was limited to a small, mountainous
area in the south-east of the country.

Christian territory 1210
Islamic territory 1210; conquered by Christians 1260s
Islamic territory 1260s

Atlantic
Ocean

N

Córdoba
Seville
Granada
Málaga Almería
Tangier

Mediterranean
Sea

0 400 mi
0 500 km

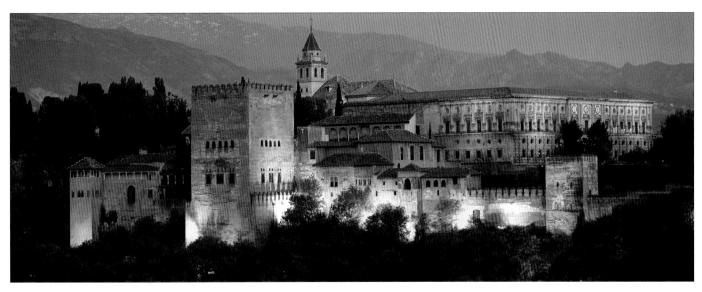

Above The fortified palace-city of the Alhambra sits on a plateau in front of the Sierra Nevada mountains.

TWO PALACES

Within the palace complex the two outstanding Nasrid buildings are the Comares Palace and the Palace of the Lions. The former was built by Yusuf I around a series of courtyards that led on to reception rooms. Beyond a highly decorated façade, added by Muhammad V in 1370, the main rooms are arranged around the Court of the Myrtles. The main residential areas are off the long sides of the court, while at one end is an administrative complex and at the other a public room with the large Throne Room (or 'Hall of the Ambassadors') occupying the Comares Tower. With its exquisite ceiling of inlaid wood rising to a *muqarnas* dome, it is one of the most beautiful parts of the entire complex.

The Palace of the Lions was added to the Comares Palace by Muhammad V. At the centre of its main courtyard is a marble fountain, its dodecagonal bowl supported by 12 lions. Verses inscribed into the fountain's edge praise the hydraulic

Right In the Alhambra's Hall of the Kings, a fresco depicts a Christian knight slain by a Muslim warrior.

system that supplies its water. A colonnade with horseshoe arches runs around the patio and gives access to royal apartments and reception rooms, including the Sala de los Reyes ('Hall of the Kings'), with a dome featuring paintings of people thought to be the principal Nasrid kings. The Sala de los Mocarabes ('Muqarnas Chamber') once had a *muqarnas* dome.

When the city passed into Christian hands, King Charles V of Spain built a large Renaissance-style palace within the walls of the Alhambra in 1526. The Comares Palace and Palace of the Lions were thereafter together called the Casa Real Vieja ('Old Royal Palace'), while the Renaissance building was called the Casa Real Nueva ('New Royal Palace').

MADINAH

In Alhambra, the madinah held stores, a mosque, public baths and the sultans' mausoleum. Many of these were built by Muhammad III (reigned 1302–9). There was also a *madrasa* (religious college). Outside the Alhambra walls were the Generalife Gardens, incorporating vegetable gardens as well as ornamental plantings, pavilions, fountains and the summer palace of the Generalife.

THE GARDEN IN ISLAMIC ARCHITECTURE

THE IMPORTANCE OF ENCLOSED AND IRRIGATED GARDENS HAS A LONG HISTORY IN THE MIDDLE EAST. GARDENS ARE OFTEN DESCRIBED AS AN EARTHLY VERSION OF THE PARADISE PROMISED IN THE QURAN.

The descriptions of the eternal garden of paradise in the Quran refer to springs, brooks and four rivers containing water, milk, honey and a non-intoxicating type of wine. In a landscape 'as large as heaven and earth', thornless trees provide restful shade and fruits.

Chapter 55, the Surat al-Rahman ('The Merciful'), describes four gardens in paradise, all with flowing waters, trees and fruits. There are references to gates, so the gardens are enclosed by walls. Throughout these gardens are shelters and buildings, including tents, castles, houses and rooms that have running water. The buildings are isolated among green spaces and stretches of water rather than gathered in a settlement, because in contrast to Judaism and Christianity – which both look forward to a 'heavenly Jerusalem' – Islam has no city in visions of the afterlife.

THE GENERALIFE

Laid out at the Alhambra citadel in Granada are the much restored Generalife Gardens. The name comes from Arabic *janna al-rafia*, or 'garden of lofty paradise'. The Generalife Gardens are like the *jannat al-firdaws* ('gardens of paradise') of the Quran in that they are beautiful and green, with flowing water and abundant in fruit, flowers, vegetables and foliage, all set within a containing wall.

In line with many other Islamic palace or mausoleum gardens, they are both a tribute to the paradise of the Quran and a work of sacred art. In walking the pathways, Nasrid princes and their courtiers could worship Allah and be drawn nearer to his presence.

Below The beautiful Shalimar Gardens in Srinagar, India, were laid out by Mughal Emperor Jahangir in 1619.

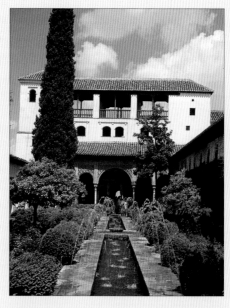

Above Fountains and flowing water are central to the design of the Patio de la Acequia in the Generalife Gardens.

USES OF WATER

In its description of paradise, the Quran tells of 'gardens beneath which rivers flow'. With many Islamic cultures rooted in dry regions, irrigation plans were central to the design of gardens. One scheme, developed in pre-Islamic Iran and exported throughout the Islamic world, was to dig canals underground that carried water around the garden down gentle gradients from a raised water source.

As in the Quranic example, the waterway was beneath the garden; it was covered so the water did not evaporate in sunlight. In other places, where the heat was less intense, open canals were used.

In Islamic culture, water is a symbol of life. Control and provision of water were also the gift of the ruler – symbolic of his gracious generosity and responsibility as a fellow Muslim. Fountains, pools and waterways were given prominence so that visitors could enjoy the air-cooling qualities, movement and music of running water. In princely gardens integrated within palace complexes, water flowed in covered canals into the interior of the palace, where it emerged from fountains, ran down tiled walls and fell in waterfalls down stairs.

FOUR-PART GARDEN

The description of the four gardens and four rivers of paradise in the Quran gave resonance to the four-part Persian *chahar bagh* garden design. The *chahar bagh* was named from the Persian words *chahar* (four) and *bagh* (garden). The design was derived from a pre-Islamic source: the gardens in Pasargadae laid out by Cyrus the Great (reigned 576–530BCE), ruler of the Persian Achaemenid Empire.

The *chahar bagh* layout was used for palace gardens and, particularly in Mughal India, for formal gardens surrounding mausolea. In Delhi, Mughal Emperor Akbar the Great (reigned 1566–1605) placed a mausoleum in honour of his father Humayan (reigned 1530–40 and 1555–56) at the centre of a *chahar bagh* garden. Near Agra, the design was used again for the Taj Mahal, the memorial shrine built in 1632–54 by Mughal Emperor Shah Jahan (reigned 1628–58)

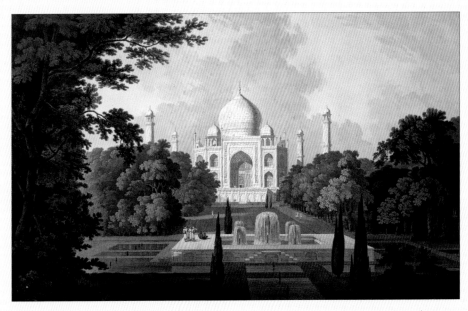

to honour the memory of his wife Mumtaz Mahal. Here, the tradition was slightly altered: in a normal *chahar bagh* layout, the tomb stands at the centre of the quadrilateral garden, but at the Taj Mahal it is at the northern end overlooking the river Yamuna.

A GREEN SHADE

Many of the early Muslims hailed from arid lands, such as the deserts of Arabia and north Africa, and historians draw on this heritage to explain the love in Islamic culture for well-watered shady places. As well as the Quranic

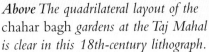
Above The quadrilateral layout of the chahar bagh *gardens at the Taj Mahal is clear in this 18th-century lithograph.*

imagery of paradise as a garden, there was a well-established literary tradition in which gardens were revered as blissful places of refuge. Poets conjured the image of shady retreats from the heat of day, where moving water made soothing music. In the Abbasid Empire from the 8th century and in al-Andalus, particularly in the 11th century, the *rawdiya* ('garden poem') was a popular genre. Many Islamic gardens survive attached to palaces and mausolea, but many more have been described in contemporary literary sources. According to these sources, for example, there were 110,000 gardens of fruit trees in Damascus, magnificent parks outside the city walls in Samarra, and miles of canals and gardens in Basra. In al-Andalus, Valencia, Seville and Córdoba were famous for their beautiful gardens.

Left In Islamic gardens, water in pools, streams and fountains is symbolic both of earthly life and the abundance promised in paradise.

SPANISH LUSTREWARE

THE SKILLED POTTERS OF ISLAMIC SPAIN CREATED MASTERPIECES IN CERAMICS, USING THE ISLAMIC TECHNIQUE OF LUSTRE PAINTING THAT ARRIVED IN SPAIN IN THE 11TH CENTURY.

It is thought that the technique of lustre decoration was invented in Iraq at the end of the 8th century by potters who borrowed techniques from glass technology. Powdered metallic compounds of copper and silver were painted on to the fired ceramic body, which was fired again at a low temperature in a kiln with a reduced oxygen supply. After cooling, the object was polished to reveal the lustrous metallic sheen.

Lustre-decorated ceramics were popular in Egypt during the Fatimid period from the late 10th century. The technique probably spread from Egypt to Spain in the early 11th century, where fragments of imported Fatimid lustreware pottery have been found. Fatimid potters may have moved west to the wealthy patrons of Islamic Spain, bringing the secrets of this complicated technique with them. The earliest lustreware made in Spain is a bowl that can be dated to the early 11th century. There is evidence for the dating of early Spanish lustreware in the so-called *bacini*, the imported glazed bowls that were used to decorate the façades of 12th-century churches in northern Italy, particularly Pisa. These show that the Spanish potters had mastered lustre production by the early 12th century. They also produced sculptural vases covered with intricate motifs in blue and gold.

EARLY SPANISH LUSTRE

By the 13th century, a lustreware industry was established in the port town of Málaga. The Arabic word *mālaqah* has been found written on a number of lustre fragments, indicating they were made in the town, which had grown in size and wealth under the patronage of the Nasrid rulers from 1238.

Early documentary evidence of Spanish lustreware is found in a document from Britain dated 1289, which mentions that pottery of 'a strange colour' was bought from a Spanish ship in Portsmouth for Queen Eleanor of Castile, who was the wife of King Edward I. In 1303, another document lists the customs duty that was paid on pottery from Málaga, which was described as '*terra de Malyk*', when it was

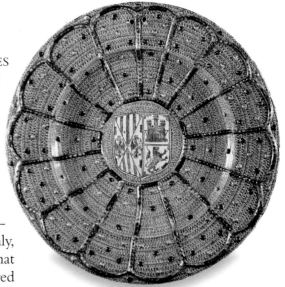

Above This dish, made in the pottery-making centre of Manises, near Valencia, in 1496, bears the arms of Ferdinand of Aragon and Isabella of Castile.

imported to Sandwich in Kent. The fact that these ceramics were exported as far as Britain shows that lustreware was prized as a luxury object. The Moroccan traveller Ibn Battuta wrote in about 1350 that 'at Málaga is made the wonderful gilded pottery that is exported to the remotest countries.'

ALHAMBRA VASES

The magnificent 'Alhambra vases' have been described as the closest that pottery has ever come to architecture. Standing almost as tall as a human being, they are the largest Islamic ceramics ever made. Ten unique vases survive mostly intact, but excavated fragments suggest a greater production. The vases have been found in Spain, Sicily and Egypt, indicating that they were exported throughout the Mediterranean. Analysis of fragments of a vase found in Fustat, Egypt, confirmed that they were made in Málaga under the Nasrid Empire during the 14th century.

The name 'Alhambra vases' comes from the theory that they may have been made to grace the

Left This large Hispano-Moresque lustre dish, made from earthenware, dates from the 15th century.

wall niches in the halls of the Nasrid Alhambra Palace in Granada. Their distinctive, elegant shape resembles that of traditional unglazed storage jars known as *tinajas*, used to store and transport oil, wine and water. However, the vast size and winged handles of the Alhambra vases mean they could not have been easily lifted, while the rich decoration suggests a purely ornamental function. The golden lustre and cobalt blue decorative scheme is usually arranged in horizontal bands that are decorated with arabesques, inscriptions and symbolic motifs, such as the *khams*, or 'hand of Fatima'. The monumental inscription on the vase in Palermo

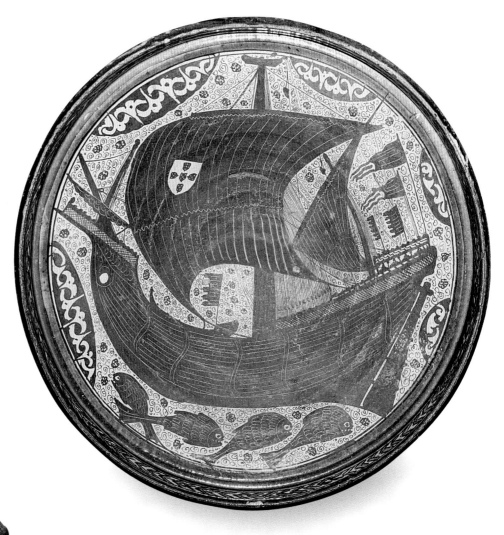

Left One of the so-called 'Alhambra vases', this vessel stands over 1.2m (4ft) high and has golden lustre and cobalt blue decoration.

Above This porcelain lustreware bowl was made by the potters of Manises for Christians. The design incorporates the Portuguese coat of arms on the sail.

repeats continuously the word '*al-mulk*', or 'kingship', while the vase in St Petersburg is inscribed in Arabic with the words 'pleasure', 'health' and 'benediction'.

MÁLAGA SHIP BOWL

One of the most splendid examples of early 15th-century Nasrid lustreware is a truly magnificent bowl at the Victoria and Albert Museum in London. Measuring 50cm (20in) in diameter, the lustre decoration on the interior depicts a caravel, a type of ship that was developed in the early 15th century by the Spanish and Portuguese for their voyages of exploration. The ship is shown in

full sail and bearing the arms of ancient Portugal. Perhaps the Nasrid potter was commissioned to make it by a maritime merchant from Portugal to commemorate a successful voyage. Analysis of this bowl conducted in 1983 identified the clay as Málagan and therefore of Nasrid production – before then it was thought it came from Valencia.

After the fall of the Nasrid Empire in 1492, lustre ceramics stopped being made in Málaga. The technique was not lost though, as the lustre tradition was developed by mudéjar artists of Manises and Paterna in eastern Spain, with their famous Hispano-Moresque ceramics that flourished in the 15th and 16th centuries.

145

MUDÉJAR STYLE

THE DISTINCTIVE ARTISTIC STYLE OF THE MUDÉJARS FLOURISHED IN THE ARCHITECTURE AND DECORATIVE ARTS OF SPAIN FROM THE 14TH TO THE 16TH CENTURIES.

Those Muslims who stayed in Spain after the end of Islamic rule and the Christian 'Reconquista' in 1492 were known as the mudéjars. The word 'mudéjar' is probably a medieval Spanish corruption of the Arabic word *al-mudajjanun*, meaning 'those permitted to remain'. During this period, the new Christian rulers were under pressure to repopulate the lands they had conquered, to irrigate and farm the lands and to create vital tax revenue. The mudéjars were allowed to continue practising their religion, customs and language under Christian rule.

The Christian aristocracy, who wanted to emulate the sophisticated art and architecture of the previous Muslim rulers, became patrons of the mudéjar artisans. Even the Catholic monarchs of the Reconquista, Ferdinand and Isabella, commissioned works of mudéjar craftsmanship, including lustreware and carpets. The craftsmen, who sometimes formed guilds, worked in masonry, carpentry, textiles, ceramics and metalwork, areas in whch they had amazing technical proficiency. Mudéjar style is characterized by its integration of Islamic decorative style with elements from the Christian arts.

ARCHITECTURE

The new Christian kings and noblemen were fascinated with the luxury and refinement associated with the Islamic style. New palaces were built and old ones renovated by mudéjar craftsmen, who created royal residences in brick, wood and plaster. The 11th-century Islamic fortified palace of Aljaferia in Saragossa was substantially renovated in the 14th century by mudéjar artists working for King Pedro IV. The Alcazar of Seville was

Above These tiles from the Santa Cruz district of Seville are in the mudéjar style. Painted tin-glazed ceramic tiles like these are known as azulejos *tiles.*

rebuilt in 1364 for the Christian ruler Pedro I, emulating the style of the Islamic palaces of al-Andalus, with patios and ornamented façades, carved wooden doors, fountains, elaborately carved stucco and even Arabic inscriptions referring to Pedro I as 'sultan'.

The mudéjars were responsible for religious as well as aristocratic and secular art, as Islamic motifs invoked notions of power and wealth in the church as well as the palace to a population that had until recently lived under Islamic rule. In synagogues and cathedrals, they used brick and wood instead of stone as a primary material. The magnificent painted wooden ceiling of Teruel Cathedral in Aragon is a masterpiece of the mudéjar style from the late 13th century. A look up to the ceiling

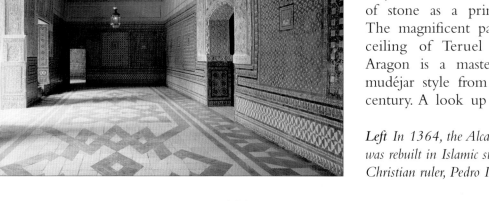

Left In 1364, the Alcazar of Seville was rebuilt in Islamic style for the Christian ruler, Pedro I.

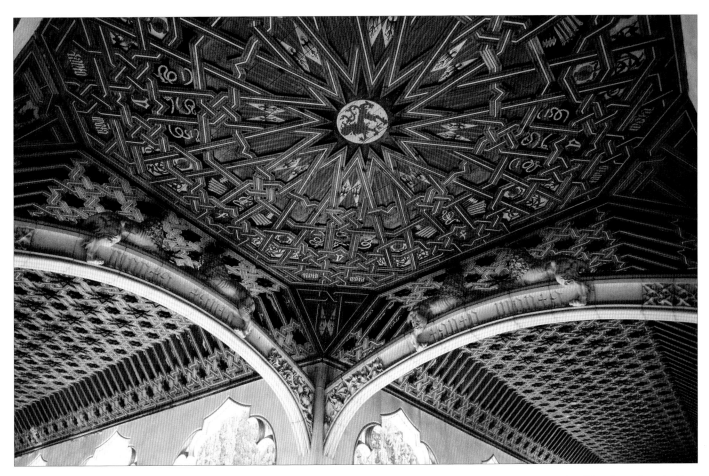

above the nave reveals a lively and colourful mix of scenes from everyday life, with musicians, knights on horseback, animals and even a group of carpenters.

Mudéjar craftsmen also worked for Jewish patrons, in buildings such as the 'el Transito' synagogue in Toledo. This prayer hall was built in the mid-14th century by mudéjars working for Samuel Halevi Abulafia, tax collector for King Pedro I. Beautifully detailed inscriptions in Arabic and Hebrew are finely carved in stucco on the walls.

CERAMICS

Mudéjar ceramics reached a high point both aesthetically and commercially in the lustreware made in the villages of Manises and Paterna just outside Valencia. Their distinctive ceramics, known as 'Hispano-Moresque' ware, combined motifs from Islamic culture, such as pseudo-Arabic inscriptions and arabesques, with Christian elements

Above This elaborate mudéjar ceiling, built after 1504, is in the monastery of San Juan de los Reyes, in Toledo.

of heraldry and cartouches with Christian inscriptions, to create a distinctive mudéjar aesthetic.

The early pieces were greatly influenced by Nasrid ceramics. It is thought that potters from Nasrid Granada may have emigrated to Manises in the early 14th century at the request of Pedro Buyl, Lord of Manises. Demand outstripped supply as potters began to work on a level approaching mass production. They worked for a wealthy Christian clientele and made plates, bowls, basins, pharmacy jars and pots meant for everyday use. Italian nobility soon became the largest market for Manises lustreware. In fact, many surviving

Right A Hispano-Moresque faience dish, with metallic highlights, made in Manises in the 15th century.

objects are datable by the Italian coats of arms that decorate them. Images of Manises ceramics are even found in Renaissance paintings from as early as the 15th century.

Mudéjar art declined in Spain during the 16th century, and finally disappeared at the time of the forced conversions, and finally expulsions of Muslims in 1609–10.

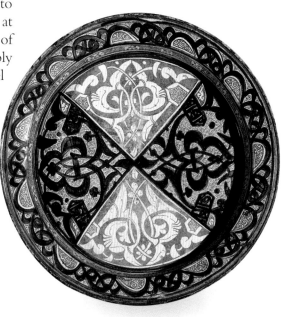

ISLAMIC ARCHITECTURE IN AFRICA

MUSLIMS TRAVELLED FROM NORTH AFRICA ACROSS THE SAHARA AND DOWN THE EAST AFRICAN COAST. THEIR FINE ARCHITECTURAL REMAINS HAVE SURVIVED IN WEST AND EAST AFRICA.

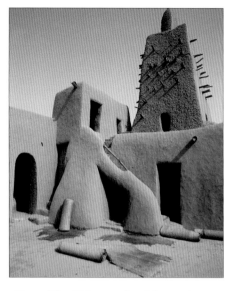

The earliest known mosques in West Africa were established in Tegadoust and Koumbi Saleh, trading centres for the Ghana Empire (750–1076) in the 10th–11th centuries. The empire was based in the land between the upper Senegal and Niger rivers (now eastern Senegal, western Mali and south-western Mauritania), where it grew rich from trade in gold, slaves, salt and ivory. Excavations show that these first West African mosques consisted of a courtyard, prayer hall and square *sawma'a*, or minaret. The empire had many trading contacts; the mosques were for the use of Muslim traders and other travellers, as the natives of the Ghana Empire were pagans.

In the 11th century, the Berber Almoravids of the Maghreb and al-Andalus conquered parts of West Africa. The Almoravids launched a *jihad*, or holy war, in 1062 against the empire under General Abu Baker ibu-Umar, who captured Koumbi Saleh in 1076. The empire fell apart into diverse tribal groups.

MOSQUE OF DJÉNNÉ

In *c.*1240, Prince Sundiata Keita of the small kingdom of Manden (today's northern Guinea and southern Mali) conquered several neighbouring territories creating the Kingdom of Mali. In 1240, a great mud-brick mosque was built in Djénné in Mali. The current structure is one of the most distinctive Islamic buildings in Africa.

Sundiata Keita's nephew Mansu Musa (reigned 1312–37) took the cities of Gao and Timbuktu, and formed an empire. The Mali rulers were staunch Muslims, and traced their lineage to Bilal ibn Ramah (578–642), whom the Prophet Muhammad chose as the first *muezzin* (caller to prayer) of the

Above The Djinguereber Mosque in Timbuktu in Mali was built from dried earth in 1327.

faith: the Mali princes are said to be descended from Lawalo – one of the seven sons of Bilal, who reputedly settled in Mali in the 7th century.

BUILDINGS IN TIMBUKTU

When Mansu Musa made the *Hajj* pilgrimage to Makkah in 1324–26 he persuaded the poet and architect Abu Es Haq Es Saheli to return to

Below Built in 1907, the Great Mosque at Djénné is the largest dried earth building in the world.

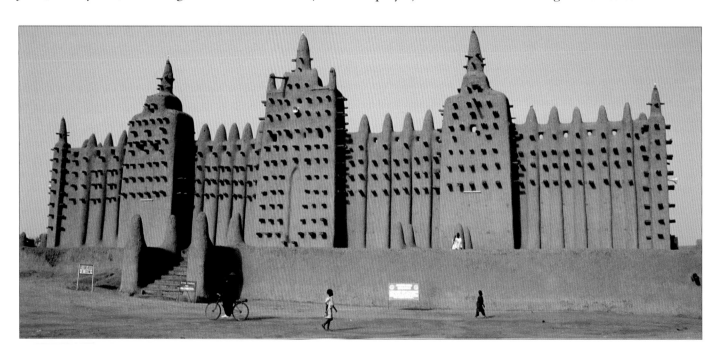

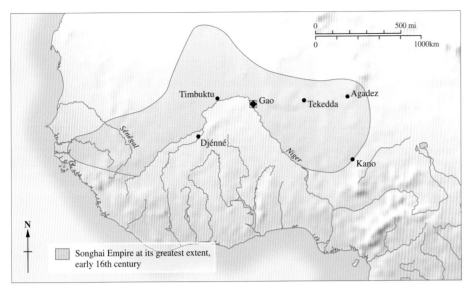

Left The Songhai Empire lasted from the early 15th century to the late 16th century. It followed the course of the river Niger and had its capital at Gao.

West Africa. Es Saheli built mosques and palaces in Gao and Timbuktu, including the Djinguereber Mosque in 1327. This building is made of dried mud bricks and stone rubble, and the walls are rendered in clay. It has a minaret 16m (52ft) in height and a prayer hall with a flat roof supported by mud piers arranged in 25 arcades, three of which have stone horseshoe arches. Above the *mihrab* (niche) there is a conical tower. The mosque, although 14th-century in origin, has been rebuilt several times over the centuries.

Two mosque-*madrasa* (religious college) complexes were built in Timbuktu in this period. The Sankoré Mosque was constructed in the early 14th century, but its oldest surviving buildings date to 1581; the Sidhi Yahya Mosque was built in 1400–40 and named after its first professor, Sidi Yahya Tadelsi. The Sidhi Yahya Mosque was rebuilt in the 16th and 20th centuries, but it retains its original 15th-century minaret. Together the Djinguereber, Sidhi Yahya and Sankoré buildings formed the University of Sankoré, a major teaching institution and force for the dissemination of the faith.

The Mali Empire was eclipsed in the region by the Songhai Empire in the mid-15th century. Major Songhai rulers, such as Ali the Great

(reigned 1465–92) and Askia Muhammad I (reigned 1492–1528), supported the Timbuktu mosques. At Agadez, now in northern Niger, Askia Muhammad I is believed to have built the original Great Mosque in 1515. This striking foundation has a rectangular prayer hall with single *mihrab* and a tapering tower minaret with projecting beams. The mosque was rebuilt in 1844.

CHINGUETTI MOSQUE

On the caravan route through the western Sahara at the oasis city of Chinguetti (now in Mauritania), Berber or Arab traders built a great dry-stone Friday Mosque in the 13th or 14th century. The mosque has a square minaret, a courtyard and a flat-roofed prayer hall with walls of split stone and clay, four aisles, a twin *mihrab* and *minbar* (pulpit) and a sand-covered floor. Crenellations at each corner of the top of the minaret are topped with clay sculptures of ostrich eggs, with a fifth egg sculpture in the centre. When looked at from the west, it identifies the direction of Makkah. By tradition, the area was once home to many ostriches.

EAST AFRICAN BUILDINGS

The oldest surviving religious foundations along the East African coast are the Mosque of Fakhr

al-Din in Mogadishu (now capital of Somalia) and the Great Mosque of Kilwa Kisiswani (an island port off the coast of what is now Tanzania). The first of these religious foundations was built in 1269 by the first sultan of Mogadishu. It has a marble-panelled main façade and three doorways leading through into a lobby that is used for ablutions. The lobby opens into a courtyard, beyond which stands an arcaded, five-bay portico with a central dome, and beyond that a prayer hall. The hall has nine bays, with a high dome above the central one; the marble *mihrab* is inscribed with the image of a lamp hanging from a chain.

The Great Mosque at Kilwa Kisiswani has a smaller 11th–12th-century northern prayer hall and a larger 14th-century southern prayer hall. Both parts are covered with vaulted roofs and domes: the mosque is notable as one of the earliest built without a courtyard.

Above The Great Mosque on Kilwa Kisiswani island, East Africa, was built from the 11th century onward.

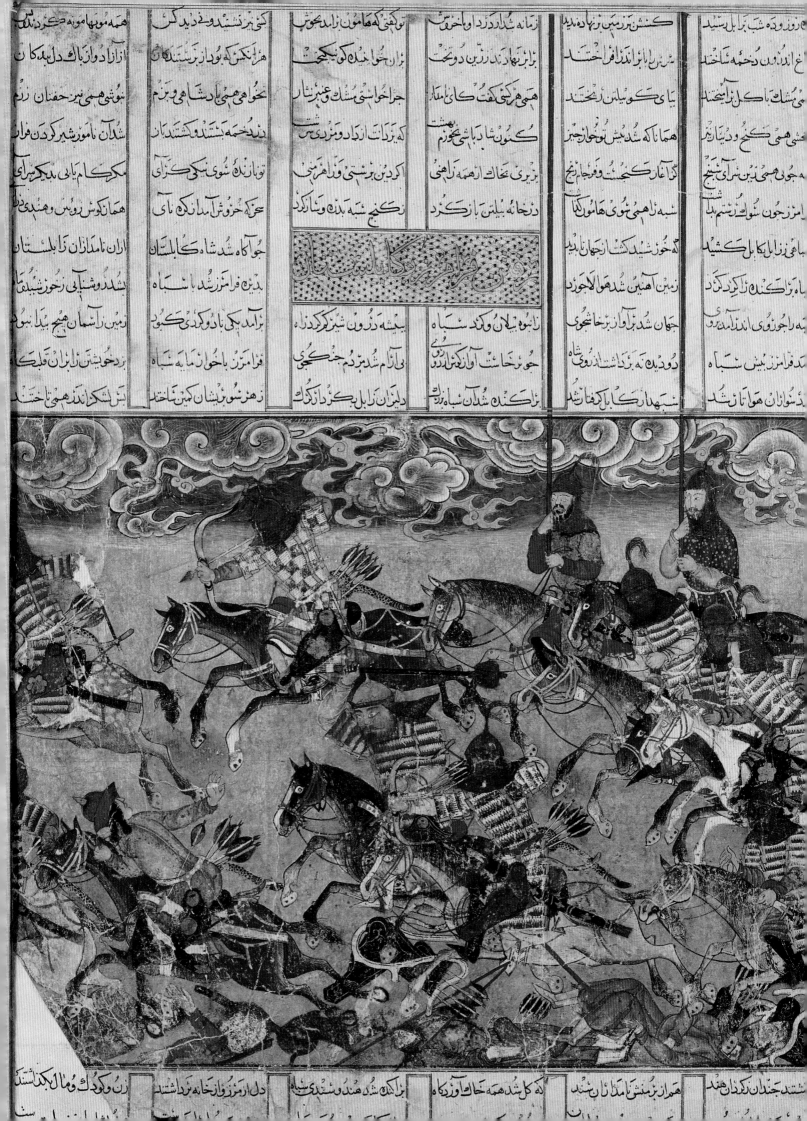

IRAN AFTER THE MONGOL INVASIONS

During the 13th century, the Mongols invaded the Islamic world not once but twice. This seemingly invincible cavalry first emerged from the steppes of Mongolia under the leadership of Genghis Khan (d.1227). The second Mongol invasion was led by Genghis Khan's grandson Hulagu, who established the Ilkhanid dynasty, ruling from Maragha, Takht-i Sulayman and then Tabriz. The Ilkhanids were important patrons of Islamic and Persian culture, particularly architecture and the arts of the book. The dynasty remained subordinate to the Great Khan in China and the visual arts were strongly influenced by Chinese contact. Following the decline of Ilkhanid power in the 1330s, different interests took control across Iran and Iraq, including the culturally rich Jalayirid dynasty of Tabriz. These were swept away by another brutal steppe invasion in the 1370s, led by the renowned conqueror Timur (d.1405). Like the Ilkhanids, the Timurids knew that cultural patronage would guarantee a place in history and sponsored great works of art and architecture at their courts in Samarkand, Herat and Shiraz.

Opposite The Ilkhanids transformed the arts of the book in Iran, with grand projects such as this c.1330s copy of the Shahnama *(Book of Kings) by Firdawsi.*

Above *Dramatic azure, yellow and blue tiles cover the dome of the Gur-e Amir ('Tomb of the King') in Samarkand. Many Timurid mausolea and mosques have slender ribbed domes with bright blue tile work.*

THE ILKHANIDS AND THEIR ARCHITECTURE

AS THEY SET OUT TO DEMONSTRATE THEIR GREATNESS BY BUILDING ON A GRAND SCALE, THE ILKHANID SULTANS FOLLOWED IRANIAN ARCHITECTURAL TRADITIONS ESTABLISHED IN THE SELJUK ERA.

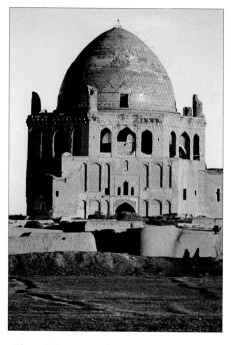

Above The magnificent dome, spanning an impressive 25m (82 ft), at Uljaytu's tomb at Sultaniyya, in Iran is one of the masterpieces of world architecture.

Former nomads, the Ilkhanid rulers spent winters in the region of Baghdad and summers in grassy pasturelands of north-western Iran. There, the second Ilkhanid Sultan, Abaqa Khan (reigned 1265–82), built the vast, lavishly decorated summer palace of Takht-i Sulayman and the fourth sultan, Arghun Khan (reigned 1284–91), established Tabriz as the capital of the Ilkhanate.

When he came to power, Ghazan Khan (reigned 1295–1304) converted to Sunni Islam, and with his Iranian wazir Rashid al-Din he embarked upon an enormous building programme, constructing *caravanserais* (travellers' inns) along major trade routes and building a congregational mosque and bath-house in each city. Ghazan Khan also rebuilt the walls of Tabriz, which he developed into a major city of international standing. He then built a grand funerary complex to house his own remains in western Tabriz, with two *madrasas* (religious colleges), an astronomical observatory, library, hospice and other buildings around his tomb. Rashid al-Din constructed a complex in his own name in the eastern part of the city.

ILKHANID MOSQUES

One of the best-preserved mosques of the Ilkhanid period is the Friday, or congregational, Mosque built in 1322–26 under Abu Said, the ninth ruler of the Ilkhanate at Varamin, 42km (26 miles) south of Tehran. The Varamin Mosque was built following the traditional Iranian pattern established under the Seljuks: four *iwans* (halls) built around a central courtyard, with a domed prayer hall with the *mihrab* (niche) behind the *qibla iwan* (the hall in the direction of Makkah).

In Tabriz, however, the mosque of the wazir Ali Shah built in 1315 under the rule of Uljaytu (reigned 1304–16) had a different layout: there was a single *iwan* leading on to the courtyard, which contained a pool and was enclosed by walls 30m (98ft) in length, 10m (33ft) thick and 25m (82ft) high; the *mihrab* was set in a vast semicircular bastion extending behind the *qibla* wall. Originally, there was a grand entrance portal at the far end of the courtyard, and a *madrasa* and hospice for Sufis stood on either side of the *iwan*.

ULJAYTU'S MAUSOLEUM

The eighth Ilkhanid ruler Uljaytu constructed a new capital called Sultaniyya ('Royal Ground') about 120km (75 miles) north-west of Qazvin in north-western Iran, where Arghun Khan had built a

Left Under Hulagu, Genghis Khan's grandson, the Mongol invasions of the 1250s gave the Ilkhanids control over a huge empire.

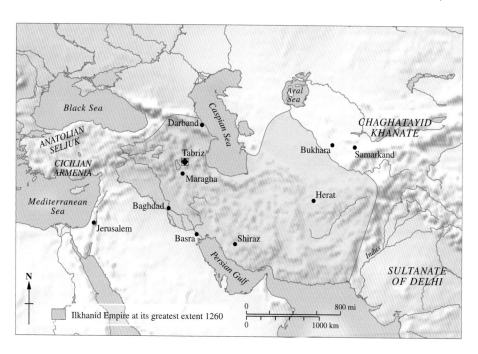

Ilkhanid Empire at its greatest extent 1260

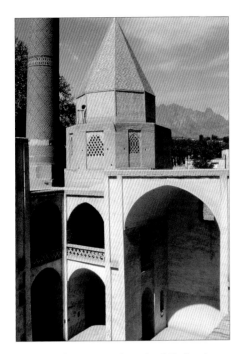

Above The octagonal tomb of Sufi saint Abd al-Samad is part of a fine early 14th-century complex at Natanz in Iran that includes a four-iwan Friday Mosque.

summer residence. All that remains today of the city is the Uljaytu's vast octagonal mausoleum, 38m (125ft) in diameter, with eight minarets. It has a beautiful, pointed dome, standing 50m (164ft) high, that was once covered in turquoise tiles. Beneath the dome is an arcaded gallery with a ceiling decorated in coloured stucco and terracotta carving. There are views for miles across the plain from a circuit of vaulted galleries, in which the ceilings are decorated with carved plaster designs painted in patterns markedly similar to those found in the contemporary illuminated manuscripts.

This mausoleum's extraordinary dome is recognized by architects as one of the greatest architectural achievements in the world. According to tradition, it was built on such a grand scale because

Right Calligrapher Haydar picked out floral decoration and sacred phrases on this stucco mihrab *of 1310 in the winter* iwan *at the Friday Mosque, Isfahan.*

Uljaytu, who was a Shiah Muslim, was originally planning to move the body of Imam Ali from his tomb at Najaf in Iraq and re-inter it beneath the dome at Sultaniyya. Uljaytu was later dissuaded from this plan and instead made the building his own tomb.

CARVED DECORATION

During Uljaytu's reign, in 1310, a magnificent stucco *mihrab* was added to the winter *iwan*, or prayer hall, of the Friday Mosque in Isfahan. It was designed and carved by Haydar, the pre-eminent calligrapher of the day, and featured arabesque decoration, floral designs and calligraphic inscriptions. The building of the *mihrab* was ordered to mark the conversion of Uljaytu to Shiah Islam in 1309, an event that had provoked opposition among the mostly Sunni inhabitants of Isfahan.

Haidar's work can also be seen in an inscription band on the north *iwan* at the Friday Mosque in Natanz, central Iran. The mosque was part of a complex built in 1300–10 by wazir Zayn al-Din Mastari around the grave of revered Sufi saint Abd al-Samad, who had died in 1299. The complex included a hospice for Sufis, as well as the tomb and mosque.

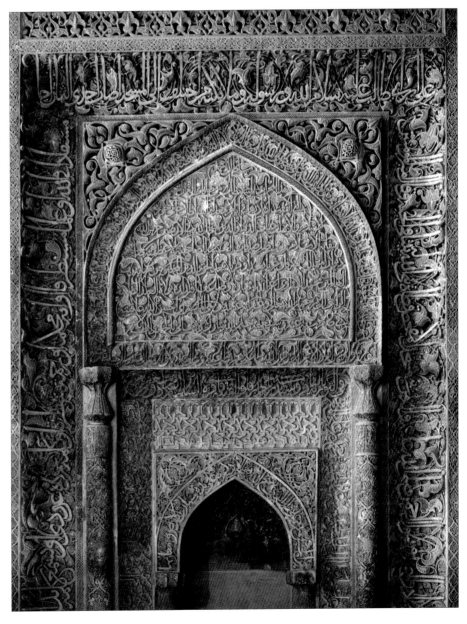

TAKHT-I SULAYMAN

THE SUMMER PALACE OF TAKHT-I SULAYMAN IN NORTH-WESTERN IRAN (*C*.1275) IS A RARE EXAMPLE OF SURVIVING ILKHANID SECULAR ARCHITECTURE. A NOTED OBSERVATORY WAS BUILT NEARBY.

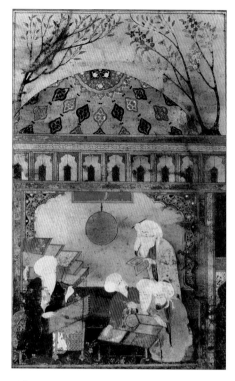

When Abaqa Khan, the second sultan of the Ilkhanid Empire, built Takht-i Sulayman, he set out to demonstrate his legitimacy as ruler of an Iranian empire. It stands in a breathtaking natural setting. He chose the site on which it was built because it held a ruined sanctuary used for the coronations of the pre-Islamic Sasanian emperors of Iran (226–651CE). Dragons and phoenixes featured in the lavish tiled decoration of the palace, because these mythical creatures were established Chinese motifs that symbolized kingly authority. Quotations from the *Shahnameh* (Book of Kings), the national epic poem of Iran written by Firdawsi in the 11th century, were also incorporated into the decoration.

Below The lake was central to the design of the once-magnificent royal summer palace of Takht-i Sulayman, built by Ilkhanid Sultan Abaqa Khan.

The site was located south-east of Lake Urmia in the Azerbaijan province of north-western Iran. It had been called Shiz by the Sasanians and was the location of an important Zoroastrian fire temple at which Sasanian kings performed rituals before they ascended the throne; in the Ilkhanid era it was called Saturiq. The later name Takht-i Sulayman means 'the Throne of Solomon'. The palace stands on an extinct volcano, where a spring flowing into the central crater had created a lake. According to local folk legend, King Solomon bound monsters in the nearby volcano and created the lake that dominates the site.

COURTYARD AND LAKE

The remains at Takht-i Sulayman were excavated in 1959–78. The palace was built around a vast courtyard running north to south, measuring 150m by 125m (492ft by

Above Astronomers at work in Hulagu Khan's observatory at Maragha, from a 16th-century edition of the Nusretname.

410ft) and incorporating the lake. The courtyard was surrounded – as was traditional in an Iranian palace (or mosque) – by four *iwans* (halls) situated behind great porticoes.

The south *iwan* was 17m (56ft) wide and featured a grand staircase at the centre rising to a domed hall.

At the other end of the complex, the north *iwan* stood before a domed chamber, probably used as an audience room. The courtyard had to be large because the lake's dimensions could not be altered: as a result it is one of the largest four-*iwan* layouts in the Persian tradition.

TWIN PAVILIONS

Beyond the west *iwan* was a flat-roofed hall between two domed octagonal pavilions; this was the sovereign's living quarters. The remains of what must have been a beautiful set of *muqarnas* (vaulting) were found in the southerly pavilion. The northern pavilion – built on the site that the Ilkhanids believed was once the coronation

Above This celestial brass globe (1275), at Maragha, was signed by 'Muhammad ibn Hilal, astronomer from Mosul'.

area of the Sasanians – was lavishly decorated. The lower walls of the pavilion were covered in tiles in star and cross shapes; above was a frieze of tiles depicting scenes and quotations from the *Shahnama* (Book of Kings) and Chinese symbols of kingship.

Archaeologists also discovered a square stucco plaque with sides measuring 50cm (20in), covered in drawings of part of a *muqarnas* vault at Takht-i Sulayman. Historians believe the drawings were used as a guide by workmen to help them put cast units together to form the dome. From contemporary accounts we learn that designs for buildings of this kind were often drawn up in the capital before being sent to the site in question; this plaque is one of the few pieces of evidence that this occurred.

MARAGHA OBSERVATORY

At the Ilkhanids' summer capital Maragha, 30km (19 miles) west of Takht-i Sulayman, Hulagu Khan (*c.*1216–65) built an astronomical observatory atop a hill around 500m (1,640ft) north of the town, beginning in 1259. The director was Nasir al-Din al-Tusi (1201–74), the notable scientist and astronomer, working with a large team of eminent scientists. There was a central tower of four storeys with a quadrant measuring no less than 45m (148ft) in diameter, a foundry used for making astronomical instruments and a library that reputedly held 400,000 volumes. Observations made at the observatory in 1260–72 were recorded in Persian in the *Zij-i Ilkhani* (Ilkhanid Tables), which included data tables for working out the positions of the planets. By tradition, Hulagu Khan attributed his military successes to the advice he received from

BAHRAM GUR TILE

A celebrated example of the Takht-i Sulayman Palace's beautiful frieze is the Bahram Gur tile, now in the Victoria & Albert Museum, London. The tile illustrates a tale told in the *Shahnameh* (Book of Kings), and also the *Khamsa* (Quintet). The king Bahram Gur was hunting antelopes on a camel, with his slave Azada riding behind him. She asked Bahram Gur to transform a male antelope into a female, and a female into a male, so he fired two arrows that knocked the horns from the head of a male antelope, before firing two more to create 'horns' on the head of a female antelope. Unimpressed, Azada laughed at him and declared that practice had simply made him perfect. Bahram Gur was maddened and threw her from her perch, and she was trampled underfoot.

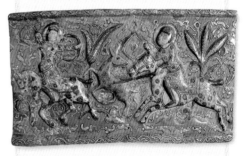

Above Hunting scenes were a favourite subject for palace decoration. This tile shows riders bringing down an antelope.

astrologers, so to ensure future success he built the observatory and funded the collection of information for the *Zij-i Ilkhani*. The Maragha scientists sought to resolve inconsistencies with the geocentric model of the universe and their work influenced the Polish astronomer Nicolaus Copernicus (1473–1543).

ILKHANID POTTERY

BY THE MID-13TH CENTURY, CHINESE MOTIFS WERE APPEARING ON ILKHANID CERAMICS, REFLECTING A CHANGE OF DECORATIVE STYLE THAT WAS INFLUENCED BY THE MONGOL INVASIONS.

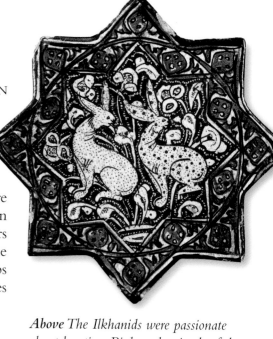

Duuring the Mongol invasions in the first half of the 13th century, the production of luxury ceramics at Kashan was severely disrupted. Large-scale production was not resumed until the 1260s, by which time the Mongols had installed themselves as the Ilkhanid rulers of Iran and had established their capital in Tabriz.

There seems little doubt that ceramic workshops would have been active in the capital, and Abu'l Qasim, a contemporary historian and member of the famous Kashani family of potters, refers in his treatise to the type of wood burnt to fire the kilns in Tabriz. So far it has not proved possible to identify what type of wares were made there. However, it is known that the Abu Tahir family of potters remained closely involved in the running of the pottery workshops in Kashan in Iran, because tiles signed by them have survived.

MONGOL INFLUENCES

Ilkhanid pottery shows a distinct change of style in its decoration, which must have reflected the tastes of the new patrons. The so-called Pax Mongolica, or 'Mongol Peace', created an environment of free

Above The Ilkhanids were passionate about hunting. Birds and animals of the chase, such as these startled hares, were popular decorative themes.

cultural exchange across the Islamic world and beyond, and many Chinese motifs were introduced into the Islamic artistic vocabulary. New ornamental motifs included lotuses and peonies, cloud bands, dragons and phoenixes. The new styles also show the influence of Chinese design in vessel shape. Celadon forms, such as the rounded bowl with relief petals on the exterior, known as the lotus bowl, were widely imitated.

Lustreware was still being produced with a different emphasis. Floral and geometric designs replaced the earlier figurative schemes, and turquoise as well as cobalt formed a counterpoint to the lustre. The principle of the overglaze *minai*, or enamelled, technique was not abandoned, but the palette was transformed by 1301, when Abu'l Qasim says that the old style was replaced by *lajvardina*. The word *lajvard* is Persian for 'lapis lazuli', which describes the colour of the cobalt background

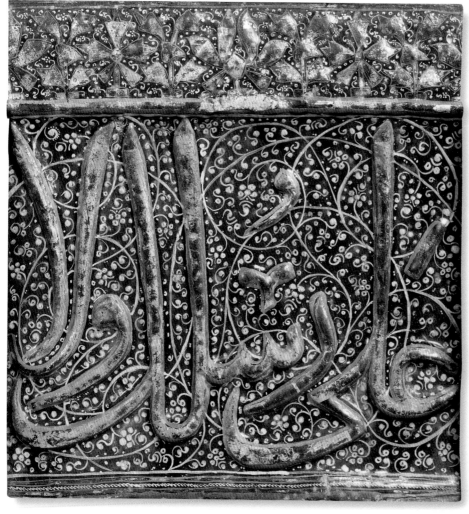

Left An Ilkhanid stonepaste tile with cobalt glaze and overglaze decoration of white, red and gold.

over which was painted a showy combination of white and gold, with gold leaf applied in intricate, often geometric designs.

SULTANABAD WARE

A new style of wares became known as Sultanabad ware, not because they were produced in the city, but many pieces were found near it. With a new monochromatic palette, probably inspired by Cizhou wares imported from China, the body of the vessels was covered with a thin slip (liquid clay) of a purplish grey or pale brown colour on which designs were painted in a thick white slip, outlined in black and set against a black hatched ground. A loose overall pattern of leaves painted in the thick white slip forms the background to the main motif, which often has a Mongol flavour: pheasants, ducks in flight, deer and gazelles, and scenes of figures in Mongol dress.

ARCHITECTURAL TILES

The use of tiles to decorate architectural surfaces was an old tradition in Iran, but it had a new resurgence in the Ilkhanid period. The potters concentrated on fulfilling commissions for producing tiles for shrines, mosques and palaces. A number of tombs commemorating Shiah and Sufi saints were built in the late 13th and 14th centuries with whole walls decorated with eight-pointed and cross-shaped lustre tiles.

Takht-i Sulayman, the summer palace built by the Mongol ruler Abaqa Khan *c*.1275 (*see* pages 154-155), consisted of several buildings that were lavishly decorated with tiles. Many fragments were discovered on the site and tiles are thought to have been used to line

Right Walls were often tiled with geometric patterns of eight-pointed star tiles with cross-shaped tiles filling the interstices.

both internal and external walls. The tiles were of all different shapes and sizes, from large rectangular figural scenes to smaller geometric shapes that would have formed part of interlocking patterns. The production techniques also showed a wide range: lustre, *lajvardina*, monochrome glazed, underglazed and unglazed tiles were found together. A kiln and workshop were also discovered, indicating that the workload was so extensive that

craftsmen were transferred to work on the site. Some of the tiles were painted with episodes from the *Shahnama* (Book of Kings), while others were inscribed with quotations from this same epic history, and further tiles show the dragon and phoenix, mythical animals that were Chinese royal symbols. By invoking both Persian and Chinese symbols of authority, the Ilkhanid rulers were clearly underlining their own legitimacy.

ILKHANID MANUSCRIPTS

IN THE LATE 13TH CENTURY, THE ILKHANID RULERS SPONSORED MANUSCRIPTS THAT HIGHLIGHTED MONGOL LEGITIMACY ALONGSIDE THE HISTORICAL AND LEGENDARY KINGS OF THE WORLD.

After the rulers of the Ilkhanid dynasty converted to Islam in the late 13th century, they set about establishing their cultural legacy as legitimate rulers of the Islamic world. They did this by writing their own history and appending it to older accounts of world history. Many notable illustrated works were produced, including the Compendium of Chronicles and 'The Great Mongol *Shahnama*'.

A WORLD HISTORY

The grandest of these projects was ordered by Ghazan Khan (reigned 1295–1304), who commissioned a multivolume universal history from his minister Rashid al-Din (d.1318).

Below Rashid al-Din's universal history included an account of the Islamic world: this section illustrates the Samanid dynasty of Iran, showing Mansur b. Nuh coming to the throne in 961.

The location of this endeavour was the Rab-i Rashidi precinct, which was founded by Rashid al-Din himself, north-east of the Ilkhanid capital Tabriz. This vast personal suburb included a mosque, the patron's tomb, a Sufi hospice, a hospital (Rashid al-Din was also a royal physician), library and teaching facilities, with over 300 employees. The scale of this foundation is relevant to the magnitude of the universal history project, which was ambitious.

Entitled *Jami al-tawarikh*, or Compendium of Chronicles, the work comprised the history of Ghazan Khan and the Mongols, a world history describing the Arabs, Jews, Turks, Persians, Indians, Franks and Chinese, and a geography volume. Earlier works of history had to be assembled from across the known world, translated and collated together, and, in order to

Above Produced in c.1330 Ilkhanid Tabriz, this Shahnama *painting shows Shah Bahram Gur, a legendary marksman, out hunting onager.*

do this, an international team of scholars was formed, as well as copyists and painters.

According to the foundation documents, two large copies of this compendium were to be produced every year, one in Arabic and one in Persian, and dispatched to different cities of the Ilkhanid realm,

either Arabic- or Persian-speaking. The completed work was officially presented to Ghazan's successor Uljaytu in 1310, but it was an ongoing project of systematic and centralized production.

Densely illustrated, the earliest extant copy is dated 1314, and is now divided between Edinburgh University Library in Scotland and the Khalili Collection, which is privately owned. The painting style is strongly influenced by Chinese illustrated narratives, and reflects the international resources available to artists at the Rab-i Rashidi, but also the quick pace imposed upon them. The project did not last more than a few years. In 1318, Rashid al-Din was accused of poisoning Uljaytu. Following his execution, his foundation and estates were plundered and the project ceased.

MAKING A STATEMENT

The Compendium of Chronicles presented an account of world history with the Mongol Empire positioned in a global context, ennobling their current supremacy in cultural terms. The dynasty also sponsored illustrated manuscripts of Iranian cultural heritage, thereby deliberately reasserting Iranian identity within the Ilkhanid court. The same tactic was applied by Qubilai Khan in Yuan China, where the Mongols also seized power in the 13th century. Dynastic histories were commissioned in order to enlist the support of the Chinese administrative elite.

'THE MONGOL SHAHNAMA'

To this day the Shahnama (Book of Kings) by the 11th-century poet Firdawsi remains the national epic of Iran, and the earliest illustrated copies were apparently produced in Ilkhanid centres. This classic poem is extremely long, and describes generations of kings and heroes of pre-Islamic Iran, in their ancient feud with neighbouring Turan. The political meaning of commissioning this text is evident: by promoting ancient Iranian kings, the Mongols were aligning themselves as worthy royal successors in a long and noble line. Several illustrated copies date from the early 14th century. From this point onward, it becomes a characteristic mode of kingship for Persian rulers to commission personal illustrated manuscripts of Firdawsi's work.

Above In 'The Great Mongol Shahnama', Alexander the Great orders the construction of massive iron walls to keep out the savage people of Gog and Magog (shown top left).

The manuscript known as 'The Great Mongol Shahnama' is a masterpiece of Ilkhanid painting, and was probably ordered for Abu Said in the 1330s. The paintings reflect some of Rashid al-Din's style, but have a deeper range of colour, more exciting compositions and a more dynamic range of figures recounting the adventures, tragedies and romances of Iran's ancient heroes. The manuscript contained at least 60 paintings. Today, these are dispersed in worldwide collections – due to the fateful decision made by a 20th-century art dealer to dismantle the book and sell the folios.

ILKHANID QURANS

WHEN THE ILKHANIDS CONVERTED TO ISLAM IN THE LATE 13TH CENTURY, THEY BEGAN PRODUCING QURANS OF THE HIGHEST QUALITY. THEY WERE THE FIRST TO PRODUCE MULTIVOLUME SETS.

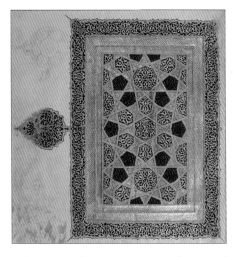

The Mongol invasions of the 13th century marked an important development in Islamic culture. The death of the last Abbasid caliph in 1258 must have felt like the end of an era. At the same time, the change in regime opened up new possibilities, bringing direct contact with Chinese civilization, and introducing stability and wealth.

MULTIVOLUME QURANS

The new Qurans were created on a grander scale than anything seen before. The Ilkhanids pioneered a deluxe format, spreading the text over several volumes. Traditionally, the Quran has 30 sections, each of which is known as a *juz*. Ilkhanid manuscripts often devoted a separate volume to each of these sections, boxing them together in a container known as a *rabah*. Other divisions of the text can be found, ranging from 2 to 60 volumes.

By enlarging the format, the Ilkhanids offered new opportunities for both calligraphers and illuminators. Most volumes opened with an ornamental, double-page frontispiece and, in some cases, there was an additional decorative endpiece. The calligraphy, too, was far more impressive, as various types of monumental cursive script, using flowing joined-up letters, were

Above A 14th-century Quran illuminated by one of the great Ilkhanid masters, Muhammad ibn Aybak. The complex geometric design is typical of his work.

adopted. These included different combinations of *muhaqqaq, thuluth, rayhani* and *muhaqqaq-jali*.

The new regime did not, however, sever all connections with the past. The greatest calligrapher of the age was Yaqut al-Mustasimi (d. 1298), a Turkish eunuch who had worked

***Below** A 14th-century Quran copied in* muhaqqaq *script – this particular type was often used for Ilkhanid Qurans.*

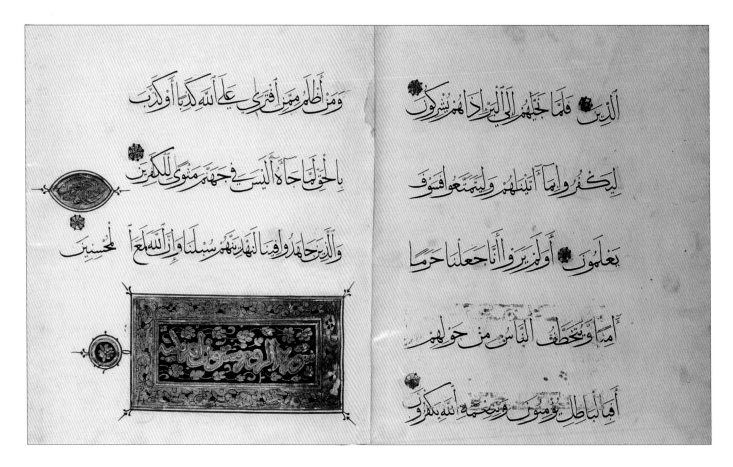

for the last caliph of Baghdad. He is said to have trained six gifted pupils, collectively known as the *sitta*, who preserved and transmitted his style during the Ilkhanid period. Although there is disagreement over the precise identity of some of these calligraphers, they are usually listed as Arghun ibn Abdallah al-Kamili, Nasrallah al-Tabib, Zarin-Qalam ('Golden Pen'), Yusuf al-Khurasani, Gandah-Navis and Shaykh-Zadah.

ULJAYTU AND THE QURAN

The most important Ilkhanid Qurans were produced in Iraq and western Iran, in the early 14th century. The chief patron was Sultan Uljaytu (reigned 1304–16). He founded a new capital at Sultaniyeh, which he chose as the site of his elaborate mausoleum, now in ruins. Uljaytu commissioned a magnificent, 30-volume Quran for the memorial. Dating from *c.*1307–13, the manuscript is unusually large at 71cm by 51cm (28in by 20in) and features outstanding calligraphy. The script is mainly *muhaqqaq* or *muhaqqaq-thuluth*, and the lettering alternates between black outlined in gold, and gold outlined in black. The illuminator was Muhammad ibn Aybak, who displayed a preference for complex geometric compositions, with overlapping diamonds, circles and stars.

Uljaytu commissioned a number of other influential Qurans. These include another 30-part manuscript, which was produced in Mosul but was probably destined for the mausoleum in Sultaniyya. In this instance, both the calligraphy and the artwork appear to have been carried out by the same man, Ali ibn Muhammad al-Husayni. At the same time, Uljaytu also ordered a Quran from the Iranian city

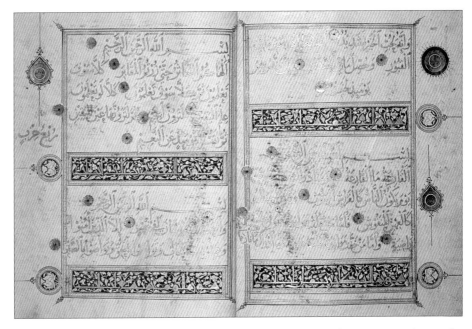

of Hamadan. This appears to have been commissioned as a gift, because the manuscript was sent to Cairo, where it caused a stir in Mamluk circles. The style is different from Uljaytu's Iraqi Qurans. The script is *rayhani,* and the decoration, in predominantly blue and gold, is simple but elegant.

PATRONAGE FROM A WAZIR

The other major patron of the period was Uljaytu's wazir, Rashid al-Din. He commissioned or

Above Calligraphers increasingly opted for more monumental styles of script and made the marginal symbols more ornate.

collected hundreds of Qurans, but, unfortunately, only a few fragments of these have survived. The most significant one was produced in Tabriz and is now housed in the Topkapi Palace.

Below This early 14th-century Ilkhanid Quran is copied in stately muhaqqaq *script, written in gold ink, with illuminated panels.*

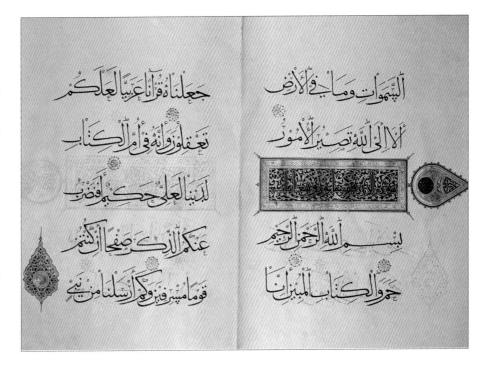

THE TIMURID DYNASTY

TURKIC CONQUEROR TIMUR THE LAME IS KNOWN CHIEFLY FOR HIS RUTHLESSNESS. YET, HE AND THE SUCCESSORS OF HIS DYNASTY CREATED AN IMPRESSIVE ARCHITECTURAL AND CULTURAL LEGACY.

Probably the greatest conqueror in Islamic history, Timur rose from being a minor chief near Samarkand, to rule an empire stretching from Anatolia to the borders of China. He achieved this despite a birth handicap that won him the nickname of Timur Lenk ('the Lame') – his upper thigh, right knee and right shoulder were malformed and he could get about only by using crutches or on horseback. The variations of his name, such as Tamerlane or Tamburlaine, are European corruptions of Timur the Lame. In 1941, Soviet scientists examined his skeleton and found evidence of these disabilities.

A MONGOL DESCENDANT

Timur was descended from the Barlas tribe, a Mongol tribal group that settled in Transoxiana (roughly in modern Uzbekistan). With his brother-in-law Amir Husayn, he won control of Transoxiana by 1366; then he turned against Husayn

and in the ancient city of Samarkand declared himself sole ruler in 1370. His culture was Turkic: he used the Turkic title *amir* rather than the Mongol *khan*. But he set out to restore the Mongol Empire created by his ancestors, and kept marriage ties with Genghis Khan's bloodline.

Despite having defeated many Muslim rulers, Timur presented himself as a religious warrior, or *ghazi*. His conquests were brutal. According to estimates, 17 million people were killed in the course of his campaigns; he sacked and burnt many ancient cities, creating gruesome pyramids of his victims' heads, and laid waste to vast areas. He died at the age of 69 in 1405 while leading an invasion of China. Yet, the Timurid dynasty he founded survived until 1526, despite dynastic in-fighting, and in India more than 300 years longer still, as the Mughal Empire that ended only in 1857, which was founded by an Asian Timurid prince, Babur (1483–1530), a direct descendant of Timur.

Above *The battered remains of the vast 50-m (164-ft) tall entrance portal is all that survives of Timur's Aq Saray Palace in Shahr-i Sabz (or Kesh).*

TIMURID PATRONAGE

On campaign, Timur spared artisans and craftsmen when he could, and despatched hordes of conscripted sculptors, masons, stucco workers, painters, mosaicists, potters, weavers and glass-blowers to Samarkand. There, they reputedly worked on splendid palaces, fitted with carpets and decorated with mosaics and murals depicting his conquests, but these structures are now lost.

In Timur's lifetime, and in the Timurid era that followed, when princes of the dynasty competed

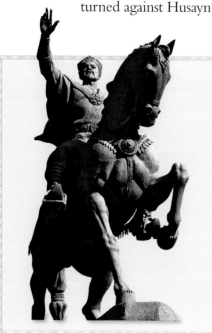

TIMUR'S REPUTATION

Timur was celebrated in Renaissance Europe as the embodiment of ruthless conquest, particularly for his defeat and capture of Ottoman Sultan Bayezid I at the Battle of Ankara in July 1402, followed by his humiliation of Bayezid in captivity. According to traditional (but probably invented) tales of these events, Timur kept Bayezid in a cage and used his kneeling body as a footstool when mounting his horse. Timur was the subject of the play *Tamburlaine the Great* (1590) by English dramatist Christopher Marlowe, and of the opera *Tamerlano* (1724) by Handel. Today, he is celebrated as a national hero in the former Soviet republic of Uzbekistan, independent since 1991; an equestrian statue of the conqueror stands in the capital, Tashkent.

Left *An equestrian statue of Timur has been erected in Tashkent, where the conqueror is celebrated as a hero of Uzbekistan.*

as patrons of architecture and the arts, magnificent mosques, *madrasas* (religious colleges) and palatial tomb complexes were built in the major cities of the empire, such as Samarkand and Herat. These buildings were characterized by their vast size and beautiful facing of multicoloured tile mosaic.

In his hometown of Shahr-i Sabz (or Kesh), 80km (50 miles) south of Samarkand, Timur built the grand Aq Saray Palace ('White Palace'), with a decorated entrance portal 50m (164ft) high bearing the inscription: 'If you have doubts as to our power, just look at the buildings we raise.' He also built a grand memorial complex named Dar al-Sadat ('House of Power'), which appears to have contained a domed chamber and mausoleum. The Dar al-Sadat was seemingly intended to house Timur's own remains. Both these grand buildings survive only in fragments.

BIBI KHANUM MOSQUE

In Samarkand in 1399–1404, Timur oversaw the construction of the Bibi Khanum Friday (congregational) Mosque, which contained a prayer hall with a dome 44m (144ft) tall that measured 140m by 99m (460ft by 325ft), making it one of the largest mosques in the world. The entrance portal stood between polygonal towers covered in mosaic decoration, and behind it the courtyard was surrounded by galleries beneath domes that were supported by marble columns. There were two smaller domed rooms at the courtyard's cross-axis and a tall, thin minaret at each corner. Soon after construction

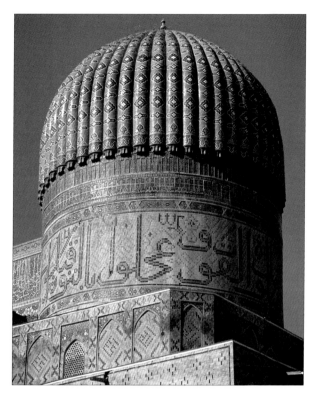

***Above** Small domed side chambers at the Bibi Khanum Friday Mosque in Samarkand are exquisitely tiled in geometric patterns and bands of sacred inscriptions.*

parts of this enormous building began to fall apart under the weight of its own bricks, which was not helped by the region's frequent small earthquakes. In the 1970s it was rebuilt by the Soviet Union at third of its original size.

In Bukhara in 1400–50, the Kalan Friday Mosque was built on the same model, but with a polygonal niche at the entrance portal; the galleries around the courtyard have 288 domes held on pillars, and the prayer hall has a grand *maqsura* (private prayer area) with a beautifully tiled *mihrab*.

MADRASAS OF ULUGH BEG

Timur's grandson Ulugh Beg is remembered as a man of learning, a mathematician and astronomer, and the builder of three great *madrasas*: at Bukhara in 1418, at Samarkand in 1420 and at Gishduwan in 1437. The *madrasa* at Bukhara has a tall entrance portal with pointed arch and two-storey arcade sections on

each side leading to corner towers; behind the entrance a square hall gives access to two domed side chambers (one a mosque for winter use, and one a classroom) and the courtyard, which has two *iwans* (halls).

The *madrasa* in Samarkand had a *pishtaq* (projecting portal) 45m (148ft) tall in the entrance façade, which faces the city's main square. The *madrasa* covers 81m by 56m (266ft by 184ft): its interior courtyard, measuring 30sq m (98sq ft), has a minaret at each corner and four *iwans*, as well as 50 student rooms arranged around the yard over two storeys. In the rear wall there is a rectangular mosque set between domed chambers. This was a highly prestigious *madrasa* and it hosted many great religious and secular scholars of the Timurid period. The *madrasa* at Gishduwan has a grand entrance portal, but is more modest, with just four sets of student rooms on each side of the courtyard. Ulugh Beg also built an important astronomical observatory in Samarkand in 1428–29.

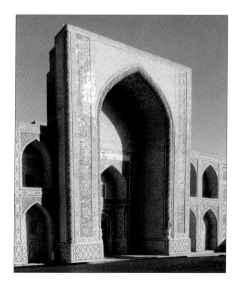

***Above** The magnificent entrance portal to Ulugh Beg's madrasa at Bukhara was built in 1418.*

SAMARKAND TOMBS

TIMUR'S CAPITAL SAMARKAND, NOW IN UZBEKISTAN, IS CELEBRATED FOR DOMED MAUSOLEA DECORATED WITH EXQUISITE TILE WORK AND MOSAICS, BUILT IN THE LATE 14TH TO 15TH CENTURIES.

One of the grandest of the Samarkand tombs is the Gur-e Amir (Lord's Tomb) mausoleum, initially built in 1403 to house the remains of Timur's favourite grandson, Muhammad Sultan. The Gur-e Amir was built as part of a complex containing a *madrasa* (religious college) and a *khanqa* (hospice), around a walled courtyard with a minaret at each corner. Today, only the entrance portal, part of one minaret and the foundations of the *madrasa* and *khanqa* remain in addition to the mausoleum, which has been substantially restored.

A DYNASTIC MAUSOLEUM

Timur had built a mausoleum for himself in his hometown of Shahr-i Sabz. However, on his death in 1405, his body could not be carried to Shahr-i Sabz because the route was blocked by snow, so instead he was buried in the Gur-e Amir Mausoleum. Ulugh Beg oversaw the completion of the mausoleum,

and added a grand entrance portal to the complex in 1434: the beautifully tiled portal bears the name of its builder Muhammad ibn Mahmud al-Banna al-Isfahani. During Ulugh Beg's reign, the Gur-e Amir tomb became established as the dynastic mausoleum. Along with Timur and Muhammad Sultan, it was the burial place of Timur's sons Shah Rukh and Miran Shah, and of Ulugh Beg himself.

The mausoleum is octagonal on the outside but has a square chamber within, 10m (33ft) long on each side, and supporting a high drum with decorative facing beneath a ribbed, pointed, azure blue dome 34m (112ft) high. The outside of the drum bears a Kufic inscription, set in tiles, declaring that 'Allah is eternal', and there are geometric patterns of glazed and plain bricks. This particular use of glazed bricks arranged in geometric patterns within groups of unglazed bricks has become known as the *banna'i* technique.

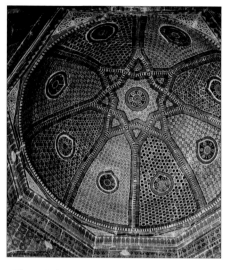

Above The interiors of the mausolea in the Shah-i Zinda complex in Samarkand are tiled in intricate patterns. No two decorative schemes are the same.

The inside of the building is lavishly fitted and decorated. The internal dome rises to a height of 26m (85ft), its inner surface once coloured with relief work of gilded papier-mâché; hexagons of onyx and painted decoration cover the lower walls rising to a cornice of *muqarnas* (stalactite-like decorative vaulting), and above, an inscription band. Each wall has a rectangular bay beneath *muqarnas* domes. In the south-east corner of the square chamber, steps lead down to the cross-shaped, domed burial crypt beneath. Some historians identify this breathtaking domed building as the model for the mausolea built by the Mughal descendants of the Timurids in India, notably the Tomb of Humayan in Delhi and the Taj Mahal in Agra.

SHAH-I ZINDA COMPLEX

Another beautiful collection of tombs in Samarkand is the Shah-i Zinda ('Living King') complex. This was built up over the years

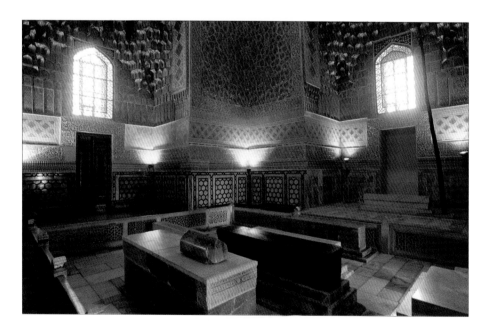

Left The tomb chamber beneath the Gur-e Amir mausoleum in Samarkand contains the bodies of Timur and several of his descendants.

Right Remains of the Gur-e Amir complex include the grand entrance portal and the distinctive mausoleum, with its ribbed dome set upon a cylindrical drum.

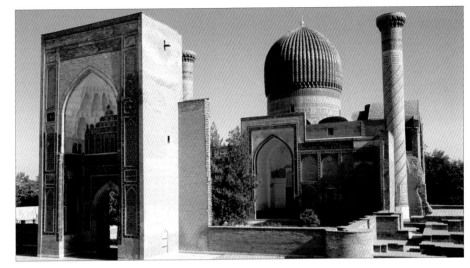

1360–1434 in the vicinity of the reputed Tomb of Qutham ibn Abbas, the cousin of the Prophet, which had been restored in 1334–60. According to tradition, after Qutham ibn Abbas came to the region in the 7th century to preach the new faith founded by Muhammad, he was beheaded but escaped down a well or crevice, where he is said to be living still.

Arranged along a stepped pathway that runs 70m (230ft) to the north from the old city walls, the tombs in this complex were mostly single-room structures. A monumental entrance marks the start of the complex and was added by Ulugh Beg after 1434.

Many of the entrance portals are beautifully decorated with tile mosaics, some with gold leaf added; there are also glazed bricks, glazed terracotta, wall paintings, wood carvings, *muqarnas*, stucco, coloured glass and painted ceramic pieces; and there are beautiful calligraphic inscriptions in both Arabic and Persian that quote from the Quran and from poetic elegies.

There are fine examples of work produced with the minai or *cuerda seca* techniques that were also used by Safavid craftsmen in the holy buildings of Isfahan. *Cuerda seca* means 'dry cord' and refers to lines of a black substance used to mark out areas of glaze: the artists applied the glaze within these lines, which burnt away in the kiln.

OTHER COMPLEXES

Elsewhere in Samarkand, the Ishrat Khane ('Place of Joy') mausoleum complex was built by Ishrat Khane,

Below The necropolis of Shah-i Zinda stands in an elevated position, just beyond the ancient city limits of Samarkand.

wife of Timurid ruler Abu Said in 1464. The structure has survived mostly in its original state without renovation. It has a large, beautifully decorated entrance portal and sizeable central chamber beneath a dome raised on overlapping arches, beneath which is the octagonal domed burial chamber.

The palatial mausoleum Aq Saray (*c*.1450) stands close to the Gur-e Amir complex, but all that remains is the central chamber, with corner rooms, and a hall attached on the north side. The surviving interior decoration is beautiful, with the finest tile mosaics and relief work painted in blue and gold below elegant vaults.

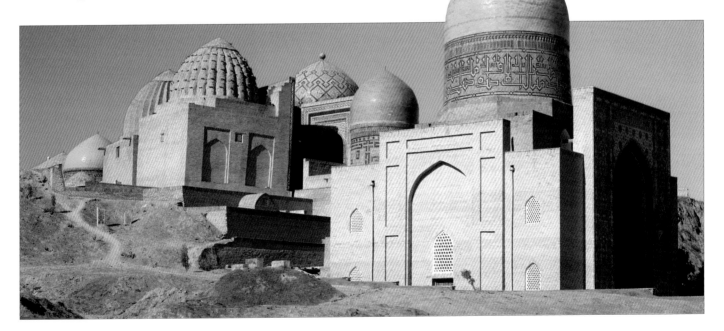

ISLAMIC ASTRONOMY AND ASTROLOGY

EVEN BEFORE THE INTRODUCTION OF ISLAM, ASTRONOMY HAD DEVELOPED THROUGHOUT THE MIDDLE EAST. CELESTIAL IMAGES, THOUGHT TO BE PROTECTIVE, WERE OFTEN USED IN DECORATION.

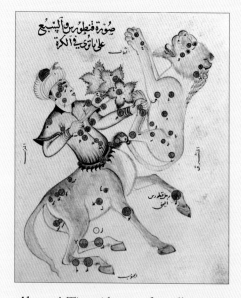

Above A Timurid copy of an illustration from The Book of Constellations, *by Abd al-Rahman al-Sufi, showing the constellations Centaurus and Lupus.*

Thanks to the great efforts of the translation movement in Abbasid Baghdad (8th–10th centuries), a wealth of international scientific literature had been made available for study and research in Arabic. Classical instruments, such as the celestial globe and the astrolabe, were developed further, and ancient texts in Greek, Pahlavi, Sanskrit and Syriac were drawn from and closely analysed. This intellectual culture also influenced the material world: the early 8th-century domed ceiling at the Umayyad palace of Qusayr Amra is decorated with a fresco map of the constellations.

ASTRONOMY AND ISLAM

For Muslims, astronomy held an important role in the service of Islam. The determination of daily prayer times and of the *qibla* (direction for prayer) were essential functions that scientists could address, as was calculating the lunar calendar. The appearance of a new moon, for example, signals the beginning and end of the fasting month of Ramadhan. In the 13th century, the role of the mosque astronomer (*al-muwaqqit*) was established to provide these services.

Astronomy was not restricted to only these religious purposes. Its uses in navigation and timekeeping are singled out for special praise in the Quran: 'He has ordained the night for rest and the sun and moon for reckoning. Such is the ordinance of the Mighty One, the all-knowing. It is He that has created for you

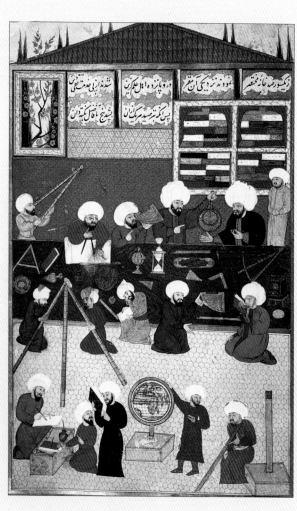

Left Suleyman 'the Magnificent' founded this Istanbul observatory in 1557, and appointed the renowned scientist Taqi al-Din al-Misri as director.

the stars, so that they may guide you in the darkness of land and sea' (6:95–96). This quotation shows that practical astronomy was the norm in 7th-century Arabia, but it also emphasizes that astronomy is gifted by God – and that the stars and planets should not be venerated (as pagan deities) in themselves.

ASTRONOMY V. ASTROLOGY

In Islamic courts, there was a big demand for astronomers, who were employed not only for astronomical work (at times even teaching their patron astronomy), but also to cast horoscopes and advise the ruler of planetary events that were unusual. Because it was thought that the movements of the celestial bodies have an influence on people and objects, major events, such as laying foundations for a new palace, were planned to begin at a certain time, calculated by astronomers. For example, to guarantee a good horoscope for the Abbasids' new capital of Baghdad, two scientists were consulted before building began on 31 July 762, following their precise instructions.

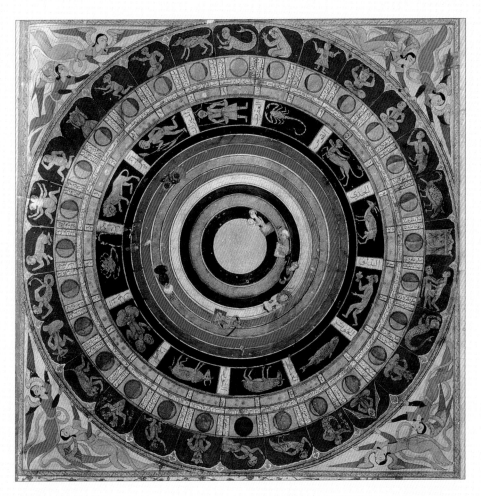

Above Dedicated to Sultan Murad III, this 1583 map of the universe shows the signs of the zodiac, from Zubdet ut-Tevarih *(The Fine Flower of Histories).*

This association of astronomy (the study of celestial bodies) with astrology (the study of how these bodies influence us) was both useful and troublesome. On the one hand, rulers were most likely to sponsor major observatories and to hire astronomers in order to benefit from astrology. Also, the technical requirements of measuring the exact planetary positions in order to cast an accurate horoscope encouraged greater observational accuracy and the development of more precise instruments. On the other hand, astrology could also draw religious censure on to astronomical projects, and was used in retrospect to explain why some dynasties had fallen.

A PRINCELY ASTRONOMER

The Timurid Prince Ulugh Beg (d.1449) was more than a patron of astronomical activity: he was also a scholar, mathematician and astronomer. He built an observatory at Samarkandwhere he worked with a staff of scientists and produced new records from their observations. Ulugh Beg has been credited with designing new astronomical instruments, and a contemporary colleague described him as a proficient scientist: 'the Emperor of Islam is (himself) a learned man and the meaning of this is not said and written by way of polite custom...I venture to state that in this art he has complete mastery, and he produces elegant astronomical proofs and operations'.

Right Ulugh Beg's mural sextant at his observatory at Samarkand was used to measure the angle of celestial bodies.

CELESTIAL IMAGERY

The importance of the stars and planets in astrology guaranteed that their imagery circulated far beyond the instruments and texts of specialists in the field. The evidence found on many centuries of decorative objects, furnishings and architectural detail confirms that certain celestial bodies were widely known and respected. These are the zodiac signs, and the seven 'planets' – sun, moon, Mercury, Venus, Mars, Jupiter and Saturn – along with a 'pseudo-planet' associated with eclipses. Furthermore, astrological imagery was typically applied in an organized way, which shows that the manufacturers and indeed consumers of these luxury objects understood a set of core rules about an astrological system, which they deliberately used for their benefit.

According to astrology, each planet has zodiac constellations, where its influence will be at its most powerful. For example, the planet Mars is strongest when combined with the constellation Scorpio, and the sun when with Leo. These powerful pairings are used as decorative motifs on many luxury items of inlaid metal or overglaze-painted ceramics, as they provide the best protection and good luck to the owner.

TIMURID HERAT

THE TIMURID DYNASTY MOVED ITS CAPITAL TO HERAT IN THE EARLY 15TH CENTURY. THIS ANCIENT CITY ENJOYED A RENAISSANCE, DURING WHICH SEVERAL IMPRESSIVE MONUMENTS WERE BUILT.

The conquests of Timur had established a powerful empire in the East, but this threatened to disintegrate after his death in 1405, as bitter rivalries surfaced. Shah Rukh – Timur's only surviving son – decided against moving to his father's base in Samarkand. Instead, he chose Herat as the new capital and appointed his son, Ulugh Beg, as governor of Samarkand.

AN ESTABLISHED CITY

Herat, in present-day Afghanistan, was an old city with an illustrious past. Pre-Islamic Persian rulers as well as early Muslim dynasties had recognized the city for its military and commercial importance. It also had an impressive cultural reputation and was known in the Islamic world for its high-quality metalwork. Yet, before Shah Rukh's time, the Mongols had demolished the city and, in 1381, Timur had sacked it again.

The accession of Shah Rukh opened a new chapter for Herat. He set about rebuilding the place, transforming his court into a major artistic centre. He is probably best remembered as the patron of a number of outstanding illuminated manuscripts, while the surviving architectural monuments are more closely associated with his wife, Queen Gawhar Shad.

MOSQUE OF GAWHAR SHAD

In nearby Mashhad, Queen Gawhar Shad commissioned a new mosque (1405–19) as part of the renovations around the shrine of Imam Reza, a popular destination for pilgrims. The building is especially famous for its outstanding tile work. Though Islamic architects had for a long time adorned the domes and façades of their build-

Above *The shrine of Abdullah Ansari at Gazargah lies within a* hazira – *an enclosed burial ground – located within a four-*iwan *courtyard.*

ings with colourful glazed tiles, this art form reached its peak during the Timurid period. The mosque at Mashhad is a fine example, featuring extensive sections of mosaic tiles.

MUSALLA COMPLEX

The mosque was designed by Qavam al-Din Shirazi (d.1438), one of the most successful of the Timurid architects. When finished, the queen commissioned him to undertake an even more ambitious project – her Musalla complex in Herat. *Musalla* normally refers to a communal place of prayer, but in this instance it encompassed several buildings, including Gawhar Shad's mausoleum, a *madrasa* (religious college) and a congregational mosque.

The complex must have been spectacular, but only fragments have survived. Much of it was destroyed during military campaigns in the

Left *Gawhar Shad's mausoleum, at the Musalla complex in Herat, has a distinctive ribbed cupola.*

19th century, or by an earthquake in 1932. The best-preserved section is the domed mausoleum, which rests on a 16-sided drum base. Eight Timurid princes were buried here, along with Gawhar Shad herself. Only isolated minarets remain from the *madrasa* and the mosque, but their glazed tiles embellished with floral motifs and Kufic inscriptions are a hint of their former splendour.

OTHER MAJOR PROJECTS

Progress on the Musalla complex was slow, taking almost 20 years to complete. This was because, in 1425, Shah Rukh diverted the architect to the Abdullah Ansari Funerary Shrine at Gazargah, just outside Herat. Ansari was a 12th-century Sufi mystic, revered as the *pir* (wise man and guardian) of Herat. His tomb had long been a place of pilgrimage for Sunnis, and Qavam al-Din's new shrine added to its prestige. The most impressive feature there is a massive *pishtaq*

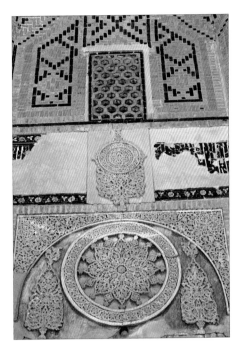

Above The intricate carvings in Ansari's tomb complex at Gazargah are centred on a 16-point star, flanked by stylized depictions of the Tree of Life.

Below At Abu Nasr Parsa's shrine at Balkh, the tile mosaics combine arabesques with Chinese-style blossoms.

(monumental portal), 30m (98ft) high, which soars over the tomb. The decorations include *banna'i* designs, another form of tile work favoured by the Timurids. Here, the technique was to lay the glazed bricks on their ends, to form zigzag patterns or angular inscriptions.

Qavam al-Din's last commission was a *madrasa* at Khargird, which was completed after his death. The structure is now in ruins, but there are enough remains to demonstrate its similarity to the Ansari shrine. This is evident from the panels of glazed-brick decoration and the arrangement of the entrance bays.

Another important Timurid monument in the region is the Funerary Mosque of Abu Nasr Parsa at Balkh, a spiritual leader in Herat who died in 1460. The mosque was begun shortly after his death, but its completion date is unclear. The entrance has a huge *pishtaq*, and the mosaic decoration displays Chinese influences.

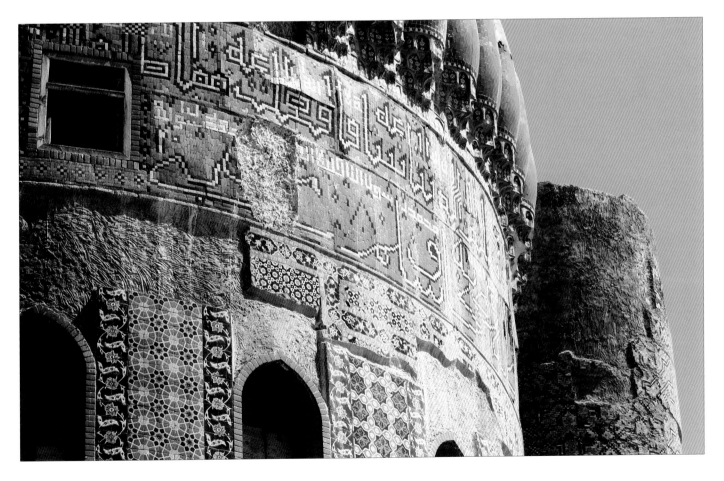

JADE CARVINGS

AS MILITARY CONFLICTS, DIPLOMATIC MISSIONS AND TRADING LINKS SPREAD CHINESE CULTURE THROUGH THE ISLAMIC WORLD, THERE WAS A DEMAND FOR SPECIFIC CHINESE GOODS AND MATERIALS, SUCH AS JADE.

Above A dagger handle made from nephrite jade, set with gold and rubies. It dates from the reign of the Mughal Emperor, Alamgir (reigned 1658–1707), when animal hilts were very popular.

The Chinese, since prehistoric times, have been fascinated with jade, believing that the semi-precious stone possesses a number of magical qualities. Although Muslims do not share the majority of these views, they may have accepted the notion that jade had alexipharmic properties – namely, that it had the power to ward off the effects of poison. This may explain why it was used so often to make drinking vessels.

WORKING WITH JADE
Islamic craftsmen were intrigued by the material itself, which varies in colour from green to brown, yellow or white. Jade is an incredibly hard stone. It is difficult to carve and some artists – most notably, those at the Mughal court – preferred to shape objects out of it by abrading or polishing the material. Ironically, this gave the stone a soft, wax-like appearance, which prompted the craftsmen to portray delicate, perishable objects. For example, it was fashionable to produce cups in the shape of gourds.

TIMURID JADE
The early history of Islamic jade is hard to trace. In medieval sources, there are isolated references to jade objects in Mamluk Egypt and Yemen, but none of these have survived. It is only during the Timurid era (1370–1506) that the desire for high-quality jade appears to have blossomed. The Timurids called it the 'Victory Stone', and believed it had certain talismanic properties.

The material itself was generally obtained from mines in the Kunlun mountains, in Central Asia, but significantly, craftsmen did not make slavish copies of Chinese models. Instead, they tended to adapt existing designs from Islamic metalwork, most notably from objects made out of gold or silver.

The finest surviving pieces from this period bear inscriptions to Timur's grandson, Ulugh Beg, who was killed in 1449. These include a nephrite cup and a remarkable pot-bellied jug, which was made out of white jade and adorned with a sinuous handle in the shape of a dragon.

Some spectacular examples are on display at the Topkapi Palace Museum in Istanbul, although these probably date from a slightly later period. Among the highlights are a green nephrite jug and an eye-catching Safavid box, mounted with various gems and silver-gilt dolphins' heads.

MUGHAL JADE
Although the Safavids produced a certain amount of jade, the true heirs of the Timurid tradition can be found in India, at the Mughal

Left A magnificent wine cup made of milky white jade and belonging to the Mughal ruler, Shah Jahan, dated 1657.

Right A 19th-century jade mirror-back set with precious stones. The floral pattern is reminiscent of designs that can be found in Islamic metalwork, textiles and tiles.

court, where the work was often carried out by expatriate Persian artists. The style appears to have developed during the rule of Jahangir (reigned 1605–27), but it continued through to the 18th century. Some sources pinpoint the start of the trend more specifically, linking it with the visit of Khwaja Mucin, who was the grandfather of one of Akbar's (reigned 1556–1605) generals. He controlled the jade monopoly at Kashgar and is said to have stopped at the Mughal court during a pilgrimage to Makkah, with a selection of his wares.

Mughal patrons commissioned a number of jade vessels that carry echoes of the work produced in the north. In the British Museum in London, for example, there is a fine cup in the shape of a gourd, which was made for Shah Jahan (reigned 1628–58) in 1647. Dating from the same period, there is also a jade box formed into the shape of a mango.

Increasingly, there was a trend to treat jade as a component of fine jewellery. Later Mughal artists displayed less interest in carving the material, preferring instead to combine it with gold or precious gems. There are several outstanding 18th-century examples of swords produced with elaborate jade handles encrusted with jewels.

Right A jade dish, produced in India in the 18th century. Luxury items were in high demand at the Mughal court and the simplest household goods were often fashioned out of jade or crystal.

In a similar vein, Mughal artists produced an extraordinary range of lavish jade plaques. These were used to adorn a variety of objects, from bow cases to belts, and Quran bindings to mirror-backs. Typifying this trend is a sumptuous jade mirror, now housed in the Victoria and Albert Museum in London. The octagonal object, fashioned out of green jade, is decorated with flower-shaped inlays made out of white jade, and is encrusted with gold mounts and rubies.

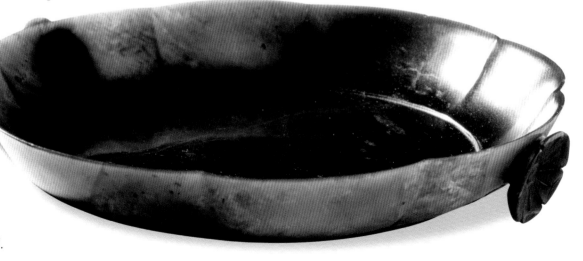

TIMURID MANUSCRIPT PAINTING

DURING THE 15TH CENTURY, THE TIMURID PRINCES OF IRAN SPONSORED THE PRODUCTION OF LUXURY MANUSCRIPTS. CLASSIC WORKS OF PERSIAN LITERATURE WERE MADE BY TEAMS OF ARTISTS.

In the late 14th century, the Asian conqueror Timur sacked many of the great cities of the Middle East, and as he did so, he conscripted the skilled citizens of his conquests into his service at his capital of Samarkand. Centralizing cultural skills was beneficial to Timur's court, because the finest artists, calligraphers, poets, scholars and craftsmen of the day were assembled in one place. Timur's sons and grandsons were educated by an elite selection of masters, and grew up to be connoisseurs of the arts.

After Timur's death in 1405, the empire was subdivided among his male descendants. Timurid princes were posted as regional governors in several Iranian cities, where each

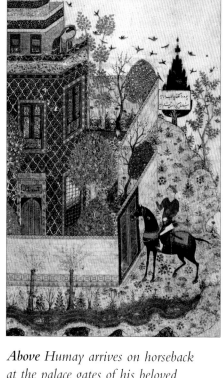

Above Humay arrives on horseback at the palace gates of his beloved Humayan, produced by Khvaju Kirmani in 1396.

had his own atelier, or workshop, of artists and calligraphers to produce illustrated manuscript copies of Persian literary classics. Different schools of Timurid painting style developed in Shiraz, Herat and Samarkand, under these various patrons, whose ambitious military rivalry was also played out in the cultural sphere. At the same time, a commercial industry of manuscript production developed for other wealthy members of society.

PRODUCTION IN HERAT

Baysunghur Mirza (1399–1433), one of Timur's grandsons, was a renowned patron, 'alike in talent and the encouragement of talent', as described by a court biographer. His court welcomed poets and artists. He died young, however, allegedly by falling from his horse while drunk. During his time, the

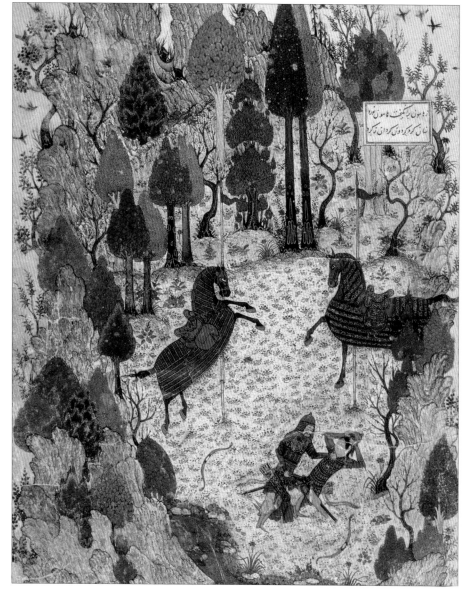

Left Humay recognizes Humayan in this woodland scene, produced by Junaid Sultani at the Timurid school in 1396.

Right Muslim pilgrims perform the Hajj *at Makkah, in this Shiraz manuscript from c.1410–11. It was produced for the Timurid Prince Iskandar Sultan.*

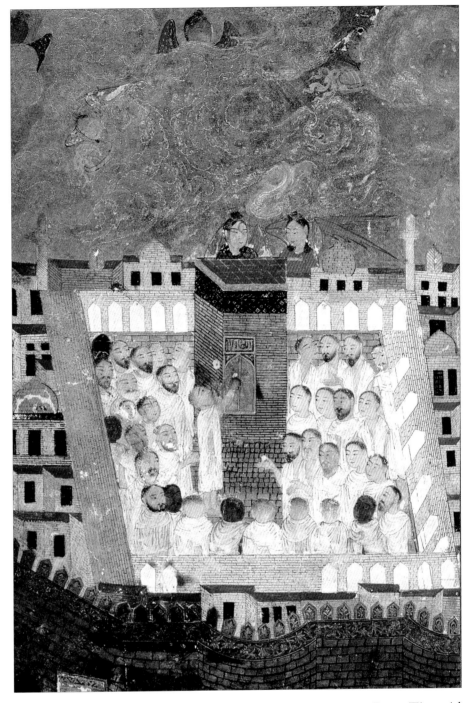

Right Muslim pilgrims perform the Hajj *at Makkah, in this Shiraz manuscript from c.1410–11. It was produced for the Timurid Prince Iskandar Sultan.*

exact workings of an atelier in Herat were recorded in a contemporary document, datable to the late 1420s. Entitled *Arzadasht*, this is a progress report apparently written by the atelier director Jafar al-Tabrizi for his patron, Baysunghur Mirza.

Jafar provided a list of more than 20 craftsmen, describing which project each was engaged with: these are calligraphers, painters, illuminators, gilders, bookbinders and leather workers. As well as the ongoing progress of manuscript production, Jafar described repair work and restoration of damaged manuscripts, preparation of designs to be given to craftsmen to decorate tent poles, saddles and ceramic tiles, and problems with staff illness.

Jafar's account shows how designs were produced centrally in Timurid art, and how they were applied to a range of different media. This systematic process of distribution explains the stylistic unity in Timurid art, in which designs and motifs recur with regularity.

It is also possible to see the level of high specialization practised among artists, and to get a glimpse at how a manuscript painting was created. One note specifies that the painter Amir Khalil had finished applying silver to a seascape in a *Gulistan* manuscript (silver was typically painted to represent water), and would now proceed to paint in the colours. Remarkably, this exact manuscript survives in the Chester Beatty Library in Dublin and, indeed, contains two seascapes.

INFLUENCE FROM BAGHDAD

The style of Timurid court painting was strongly influenced by the late 14th-century art of the Jalayirid dynasty from Baghdad and Tabriz,

and manuscripts that were illustrated at Baysunghur Mirza's court atelier are very similar to the exquisite crystalline style of Jalayirid works. Timurid princes not only admired Jalayirid manuscripts, but in the early 15th century, they employed the same artists: the painter Amir Khalil recorded in Baysunghur Mirza's *Arzadasht* had previously worked for Jalayirid rulers in Baghdad, and presumably, had been conscripted by Timur after he took the city in 1401.

In turn, some Late Timurid artists actually went on to work under the subsequent Safavid dynasty in the early 16th century, and so on. The continuity of the Persian painting style from the 14th century onward was clearly noted by the 16th-century commentator Dust Muhammad: in an album preface dated from 1544, he observed of an early 14th-century painter: '[the style of] depiction which is now current was invented by him'.

LATE TIMURID PAINTING: BIHZAD IN HERAT

THE PAINTER BIHZAD WORKED FOR THE TIMURID COURT IN LATE 15TH-CENTURY HERAT, AND IS CREDITED WITH CREATING A NEW AND INFLUENTIAL STYLE OF PAINTING.

In the second half of the 15th century, Timurid military power began to decline, and the dynasty lost western and southern territory to Turkman tribal confederations. The former empire was eventually reduced to the region of north-eastern Iran, where Sultan Husayn Bayqara (reigned 1469–1506) ruled over the last Timurid court in Herat. He was a legendary patron of cultural activity, and hosted an extraordinary coterie of scholars, poets and artists at his court. This included the calligrapher Sultan Ali Mashhadi, the poet Jami and the painter Bihzad, whose masterpieces were all admired and emulated for centuries. Husayn Bayqara's chief minister, Mir Ali Shir Navai, was also a poet, and the prince himself wrote literary debates.

Above An illustration of Laila and Majnun meeting at school, from Bihzad's Khamsa of Nizami *(1494–95)*.

EVOLVING PAINTING STYLE

In this milieu, there came about a radical development in manuscript painting, which determined the character of Persian painting in both Iran and Mughal India for the following centuries. The style of depicting figures and landscape changed greatly, as did some of the typical subject matter. This has been characterized as a cool, rational and even humanistic approach, rendering figures in more natural poses and expressions, and using a more modulated palette of colour.

Credit for this change has been given to one artist, Kamal al-Din Bihzad (d.1535), but it is unlikely that he was the only artist to work in this new style. He was probably a leading proponent rather than a lone pioneer. His work bridges the end of the Timurid period and beginning of the Safavids, and his transfer from one court to the next ensured the continuity of Persian painting traditions, from Timurid to Safavid patronage.

Left Bihzad's illustration of Harun al-Rashid at the bathhouse, from the Khamsa of Nizami *(1494–95)*.

174

Above A wonderful depiction of Iskandar, or Alexander the Great, as he consults the seven sages, from Bihzad's Khamsa of Nizami *(1494–95).*

As with all respected painters, Bihzad's style was imitated and his compositions were re-drafted by generations of Persian artists as a matter of course. Owing to this renown, 'signatures' of Bihzad may be found widely, inscribed on to paintings, perhaps by later owners making a hopeful attribution, or by painters feeling their work worthy of the great artist's name.

THE *BUSTAN*

The exact corpus of Bihzad's work is not fully agreed, but one of his least disputed works is the *Bustan* (or 'Garden') of the poet Saadi (d.1291), a luxury manuscript dated June 1488, which features five masterpiece paintings: one double frontispiece and four subsequent illustrations. Each illustration is discreetly signed by Bihzad, on a horseman's arrow quiver,

Right The royal herdsman reproaches Shah Dara, signed by Bihzad (1488).

on a hand-held book or placed in the calligraphic frieze around an architectural setting. The double frontispiece is a remarkable scene of feasting, no doubt revealing the world of Husayn Bayqara's famous court. The revellers are drinking heavily from wine cups, while servants are kept busy pouring from vessels of porcelain, glass and precious metal. A still is seen in operation on a hill beyond the courtyard.

By contrast, the dignified ruler kneels beneath an illuminated canopy, conversing with a younger courtier and listening to music. An upstairs window opens to reveal the prince's porcelain collection, giving further evidence of his refinement.

KHAMSA OF NIZAMI

A second manuscript generally agreed to be partly illustrated by Bihzad is a copy of the *Khamsa of Nizami* (1494–95), now in the British Library in London. Typically of late Herati Timurid painting, the new subject matter of the 22 illustrations is a little more realistic than the typical jewel-like canon of earlier 15th-century works. They have added genre scenes of an old beggar woman and a busy building site, as well as a working bathhouse, with active figures engaged in their affairs, however humble they may be. These realistic vignettes contrast with the royal scenes of court society, and challenge their complacent, comfortable privilege.

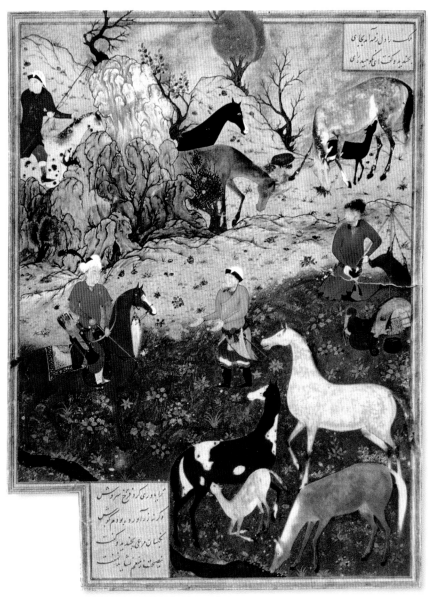

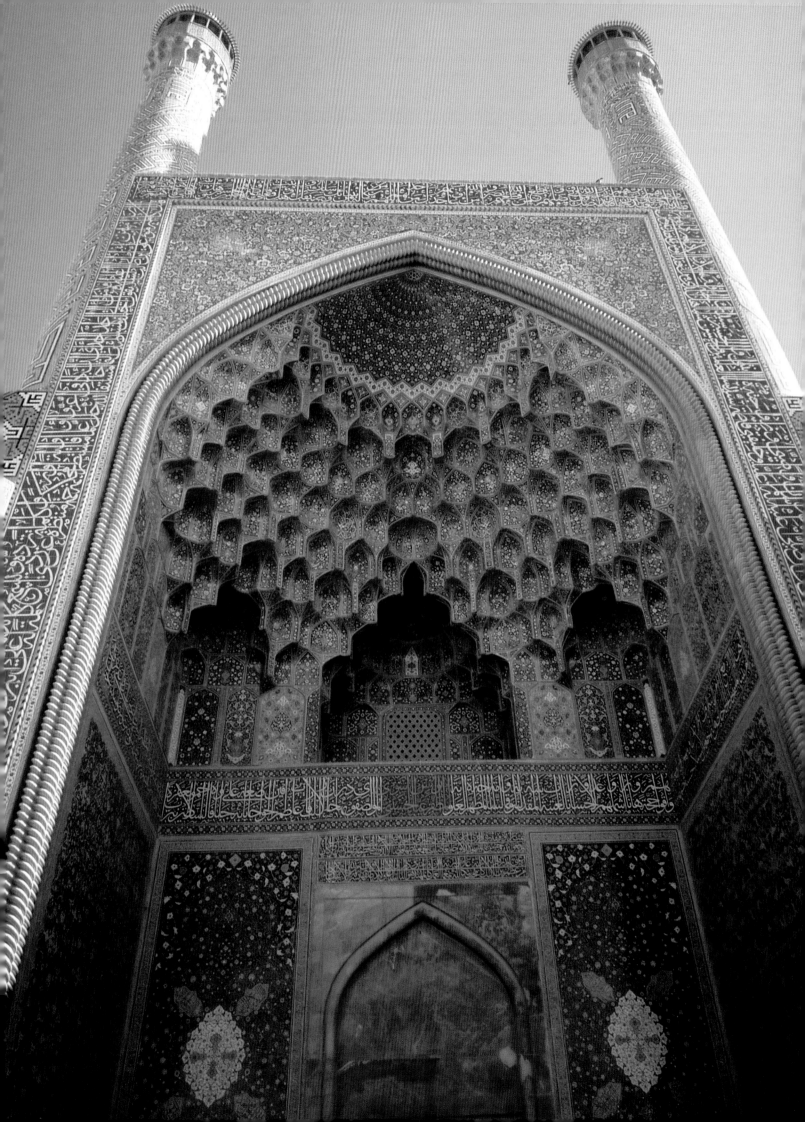

CHAPTER 9

IRAN: THE SAFAVIDS TO THE QAJARS

In 1501, the young Ismail Safawi established Safavid power across Iran, swiftly uniting a vast region. For the first time, Iran became a Shiah state, and the Safavid shahs ruled until 1722. Safavid court art of the early 16th century is regarded as a pinnacle of technical finesse and taste, particularly for the arts of the book. In 1598, Shah Abbas I (reigned 1587–1629) moved the capital to Isfahan, and transformed the profile of Safavid Iran in the eyes of the world's travellers, diplomats and merchants. He added spectacular public and private architecture, much of which remains to this day. Safavid art of this period, particularly the portraits of painter Reza Abbasi, reflects a prosperous society. The Safavid dynasty collapsed in 1722 and the country was beset by political unrest for much of the 18th century. Stability returned with the Qajar dynasty (1794–1925) and Fath Ali Shah brought in a new era of ostentatious imperial imagery. The art of 19th-century Iran combined the archaism in Qajar visual culture with an interest in Western traditions and modern trends.

Opposite One of the most beautiful achievements in Safavid Isfahan is the Masjid-e Imam. It was designed to impress, with a breathtaking entrance portal arch that features a cascade of muqarnas *vaulting decorated with coloured tile mosaic.*

Above A 16th-century 'Kubachi' plate produced in Iran, decorated in black under a green glaze. European travellers named the pottery after the village in Daghestan where this type of ceramic ware was discovered.

SAFAVID ISFAHAN

BUILDING STATELY MOSQUES, PALACES AND A BAZAAR AROUND A NEW CENTRAL *MAIDAN*, OR SQUARE, SAFAVID SHAH ABBAS I TRANSFORMED ISFAHAN INTO A FITTING CAPITAL FOR HIS DYNASTY'S PERSIAN EMPIRE.

The sublime architecture built by Shah Abbas I (reigned 1587–1629), fifth and greatest ruler of the Safavid dynasty, is regarded as the supreme achievement of the Safavid era. Situated on the river Zayandeh Rud in central Iran about 340km (211 miles) south of Tehran, Isfahan had been a town of note as far back as the Parthian Empire (238BCE–226CE), and a capital under the Seljuk Turks (11th–14th centuries CE). It reached a golden age when Shah Abbas made Isfahan the new Safavid capital and began a grand building programme in 1598.

A NEW CITY CENTRE

Abbas I made a new centre by laying out a vast rectangular *maidan*, or square, known as Maidan-e Shah (King's Square), and now renamed Maidan-e Imam, or Imam Square. Covering 8ha (20 acres), the *maidan* was built in 1590–95, initially as a public space for state ceremonial, military and sporting events. In a second building stage, completed by 1602, a double-storey arcade of shops was laid out around the perimeter.

On the north side of the *maidan* the shah oversaw the building of a covered two-storey bazaar entered by a grand portal decorated with a tile mosaic of Sagittarius the archer, because the city was founded under this astrological sign, and frescoes showing Abbas I's military victories over the Uzbek Shaybanid dynasty. The bazaar contained a 140-room royal *caravanserai*, baths, a hospital and the royal mint.

TWO MAJOR MOSQUES

On the east side of the square, the Lutfallah Mosque, named after the scholar Shaykh Lutfallah Maisi al-Amili, was erected in 1603–19. A grand entrance portal on the square gives access to the mosque's prayer hall, a single square-domed room measuring 19m (62ft) on each side, and set at a 45-degree angle to the portal, so that the *mihrab* (niche) and *qibla* wall (indicating the

Above The ceiling in the music room at the Ali Qapu Palace on Maidan-e Imam. The Ali Qapu was originally just a gateway into the royal gardens.

direction of prayer) could be aligned to Makkah. The inner dome is finely decorated with glazed tiles in a sunburst design at the apex and medallions filled with floral designs running down the dome's sides. This was the shah's private oratory.

On the south side of the *maidan* another great entrance portal, finely decorated with tiers of *muqarnas* (stalactite-like decoration) domes and tile mosaic, gives access to the Masjid-e Imam, or Imam's Mosque. Originally known as the Masjid-e Shah (King's Mosque), this large congregational mosque was built in 1611–30 to replace the older Friday Mosque in the Seljuk part of Isfahan.

Its traditional layout consists of a courtyard measuring 70m (230ft) on each side, surrounded by arcades and with an *iwan* (hall) in the centre of each side, with a domed prayer hall behind the *qibla iwan*. As with the Lutfallah Mosque, the entrance *iwan* fronts the square, but the main part of the complex behind is shifted 45 degrees so that the *qibla* wall is aligned to Makkah. The side *iwans* on the courtyard lead into

Left The Safavid Empire reached its peak under Shah Abbas I (reigned 1587–1629). He made Isfahan the capital city.

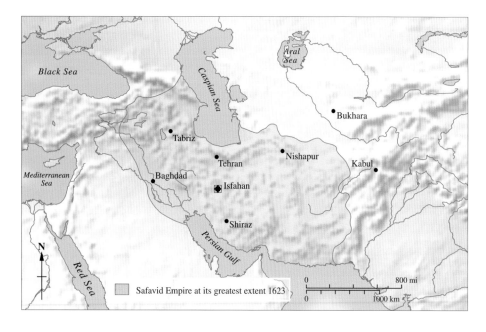

Safavid Empire at its greatest extent 1623

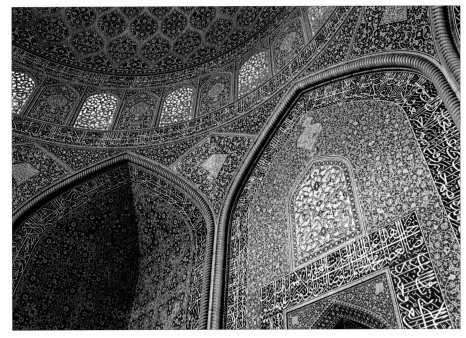

Right The interior of the Lutfallah Mosque in Isfahan is decorated with ceramic tiles on every surface.

domed chambers, while behind the arcading on each side of the main courtyard is another arcaded yard that was used as a *madrasa* (religious college). There are four minarets, but the call to prayer was given from a small building, called *guldasta* in Persian, situated above the west *iwan*. The grand dome above the prayer hall is 52m (170ft) tall; like the Gur-e Amir in Samarkand, it has a double shell, with a bulbous outer dome rising above its inner dome.

GARDENS AND PALACES

On the west side of the *maidan*, Abbas I built the Ali Qapu ('Highest Gate'). Originally an entrance to the royal gardens, this was reworked as a palace with a raised veranda, or *talar*, that was used as a royal viewing platform when displays, parades or sporting events, such as polo matches, were held on the *maidan*.

The Ali Qapu was the entrance to 7ha (17 acres) of royal parkland containing pavilions, garden palaces

Below The view across the square looks south to the Masjid e-Imam which is angled toward Makkah.

and walled gardens. In the park, the Chihil Sutun ('Forty Columns') Palace built by Shah Abbas II (reigned 1642–66) stands beside a rectangular pool. The palace has a flat-roofed *talar* supported by tall pillars of the kind built in pre-Islamic Persia. Despite its name, the palace has only 20 pillars: it appears to have 40 because they are reflected in the pool. The palace contains a large hall and many murals of court life. Also in the gardens is the Hasht Behesht ('Eight Heavens') Palace, built by Shah Sulaiman I (reigned 1666–94).

RIVERSIDE IMPROVEMENTS

Shah Abbas I's redevelopment of Isfahan also included the laying out of the Chahar Bagh esplanade from the *maidan* to the river Zayandeh. This splendid avenue was lined with the palaces of leading nobles. Great bridges were built across the river. The Si-o Se Pol ('Thirty-three Arch Bridge'), constructed in 1602 by Allahvardi Khan, general to Shah Abbas I, is 300m (984ft) long and has pavilions from which pedestrians can take in the view. New Julfa, a quarter for Armenian merchants, was built on the opposite bank.

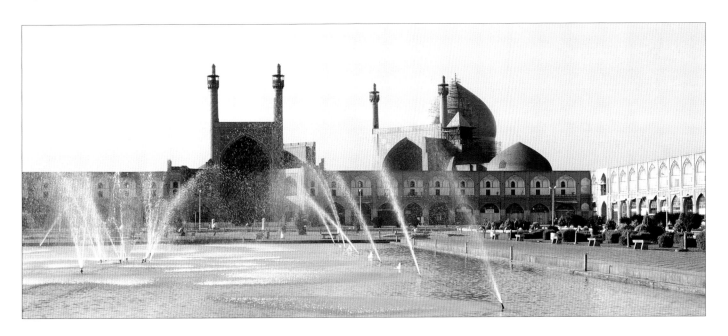

CHINESE-INSPIRED SAFAVID POTTERY

IMPORTED CHINESE POTTERY INFLUENCED THE PRODUCTION OF TIMURID POTTERY IN THE 15TH CENTURY. THE SAFAVIDS FOLLOWED THE TIMURID TRADITIONS IN THE 16TH AND 17TH CENTURIES.

From the 9th century onward, Chinese porcelain was highly valued in the Middle East and was almost continuously imported by land and sea. Blue-and-white wares were made specifically for export at the Jianxi kilns of Jingdezhen in China, and were imported into Syria and Egypt from the late 14th century.

Although imported Chinese porcelain was used as tableware, it was also displayed in specially designed pavilions, known as *chini khaneh*. The Mughal Emperor Babur, who visited the collection of Ulugh Beg (d.1449), one of the amirs during the Timurid dynasty, described a hall lined with porcelain tiles ordered from China. The interior was probably lined with wooden panelling cut into niches of various shapes to house vessels of different forms. This type of display has been found illustrated in manuscript paintings of the Timurid and Safavid periods.

When the Turkic Amir Timur (reigned 1370–1405) conquered Damascus in 1400, he brought its craftsmen back to his capital Samarkand, where the conscripts began producing blue-and-white pottery using the manufacturing techniques they were familiar with. The stonepaste body was made using sand, which was at variance with the traditional Iranian practice of using river pebbles.

After Timur's death in 1405, the Timurid capital moved to Herat, and in 1411 conscripted workmen were allowed to travel home. This resulted in craftsmen settling in a number of areas. Three main pottery centres developed from the late Timurid era into the Safavid period at Nishapur, Mashhad and Tabriz.

Above *This elegant vessel, with Chinese-inspired scenes, was used for smoking tobacco.*

ARCHITECTURAL TILES

Timurid buildings were lavishly decorated with tiles. Tile-makers used a range of techniques: glazed bricks, carved and glazed terracotta, tile mosaic and *cuerda seca*, overglaze enamelled, underglaze painted, relief and occasionally lustre tiles. Tile mosaic was made from slabs of glazed tile that were cut after firing into interlocking shapes. The individual pieces were put together face down on a drawing of the design and plaster was poured over the back and strengthened by canes; when dry, the panel was attached to the wall. This was a labour-intensive process, but a faster alternative, named the *cuerda seca* ('dry rope') technique, developed in Spain. This overcame the technical difficulties of firing several colours together by outlining each area with an oily substance, which burnt off during firing to leave an outline in relief.

When Shah Abbas I (reigned 1587–1629) moved his Safavid capital to Isfahan in 1598, a great

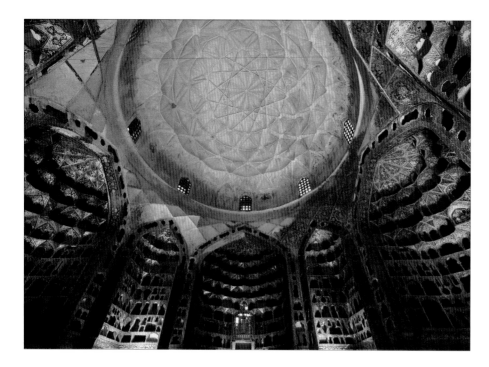

Left *In 1607–8, Shah Abbas I gave the palace collection of Chinese porcelain to his family shrine. This* chini khaneh *(china hall) was built in the shrine with individual niches to house the pieces.*

period of construction began. Palaces and other secular structures were decorated with square tiles individually painted in polychrome glazes. These tiles were then combined to form large pictorial scenes with elegant, languid figures arranged in garden settings in the new style developed by Reza Abbasi, chief painter of the court atelier.

SAFAVID BLUE AND WHITE

In 1607–8, Shah Abbas I donated the imperial collection of Chinese porcelain, some 1,162 mostly blue-and-white pieces, to his ancestral shrine at Ardabil in north-western Iran, where they were displayed in a specially renovated building. Inspired by this and the newly popular Wanli porcelain being imported from China, production of blue-and-white increased to satisfy the local demand.

The East India Company had built up a trading network in Iranian ports and when the fall of the Ming dynasty in 1644 disrupted Chinese exports, the Persian workshops became one of the biggest suppliers of blue-and-white to Europe. Persian and European sources single out Kirman as the centre that was producing the finest blue-and-white wares. Mashhad was also an important centre and potters there revived the use of the lustre technique, producing vessels decorated with delicate landscape and floral designs.

KUBACHI WARE

The term 'Kubachi' ware has been used to describe pottery of both the Timurid and Safavid periods. The name refers to a village in the Caucasus, where 19th-century travellers discovered large quantities of ceramic dishes hanging on the walls of the houses. The dishes were in many different styles – blue-and-white, turquoise-and-black, and polychrome – but were identifiable by the holes drilled in the foot ring for hanging

Above A 17th-century stonepaste dish with coppery lustre, probably from Mashhad, Iran. The design was inspired by marginal decoration on manuscripts.

and a crackling in the glaze. However, it became clear they were never made there and it has only recently been established that they were made in Nishapur, Mashhad, Tabriz and Isfahan.

Below During Abbas I's rebuilding of Isfahan, individually painted square tiles were often combined, as here, to form large pictorial scenes.

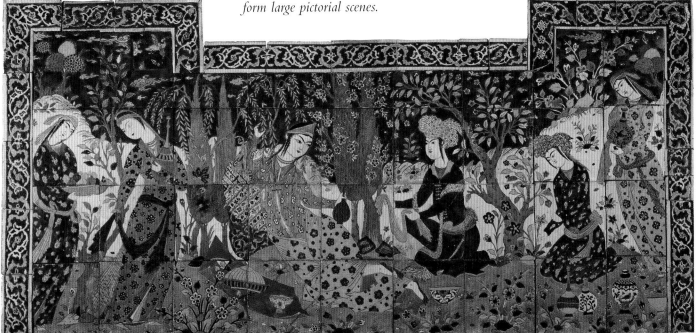

PERSIAN CARPETS

ESPECIALLY IN THE REIGNS OF SAFAVID SHAHS TAHMASP AND ABBAS, CARPETS MADE WITH ABSTRACT SYMMETRICAL DESIGNS CENTRED ON A MEDALLION OR WITH FIGURATIVE SCENES WERE A HUGE INDUSTRY.

The weaving of carpets was an ancient art form in the Islamic world, and fragments of rugs and carpets survive from Mamluk Egypt, Seljuk Anatolia and even earlier. The oldest complete, dated Islamic carpets, however, are from Safavid Iran.

Many carpet designs echoed the composition of contemporary book covers, with an elongated rectangular layout in which the central area was set within borders. Figurative designs were often similar to those in book illustrations, and indeed were designed by the same artists, while others consisted of repeating abstract patterns. The colours typically used in these carpets were blue, yellow, red and white.

THE ARDABIL CARPETS
One common carpet design, which gave rise to the term 'medallion carpets', featured a large central medallion. Two especially large medallion carpets were made on the order of Shah Tahmasp for the Safavid family shrine in Ardabil in 1539–40. These are known as the Ardabil carpets and they are probably the most celebrated of all Persian carpets.

Designed as a matching pair, the carpets consist of a densely knotted wool pile on a white silk warp and weft foundation, and feature an intricate design rendered in ten deep colours. A central yellow medallion is surrounded by a circle of smaller oval shapes, and two lamps are represented as if hanging from the medallion. All are set on a dark blue ground filled with curling scrolls of lotus flowers. A quarter section of the medallion is repeated in each corner, giving the sense of a continuing pattern. The whole design is framed by a border of patterned parallel bands.

Pieces from one carpet have been used to repair the other, altering their sizes. The larger carpet, now in

Above The hunting image on this 16th-century Persian carpet is from a scene in the Khamsa Quintet by Nizami Ganjavi.

the Victoria and Albert Museum in London, measures an immense 10.5m by 5.3m (34ft 6in by 17ft 6in), and contains 33 million woollen knots. The smaller, now in the Los Angeles County Museum of Art, California, measures 7.2m by 4m (23ft 7in by 13ft 1in).

SAFAVID SILKS
French traveller Jean Baptiste Tavernier (1605–89) claimed that more people worked at silk weaving than in any other trade in Safavid Iran. Shah Abbas I (reigned 1587–1629) revived the textile industry in Iran, establishing factories across the empire in Isfahan, Kashan, Kirman, Mashhad, Yazd and elsewhere. Many silks bore figurative images, derived from contemporary manuscript painting, of courtly picnics, lovers, huntsmen, warriors leading prisoners and scenes from the works of the poets Firdawsi (c.935–c.1020) and Nizami Ganjavi (1141–1209). In England, in 1599, the Earl of Leicester gave a set of Safavid silk hangings to Queen Elizabeth I to be hung in an apartment in Hampton Court Palace.

Left This elegant 17th-century Persian silk panel shows a pair of courtiers, in perfect symmetry, at a country picnic.

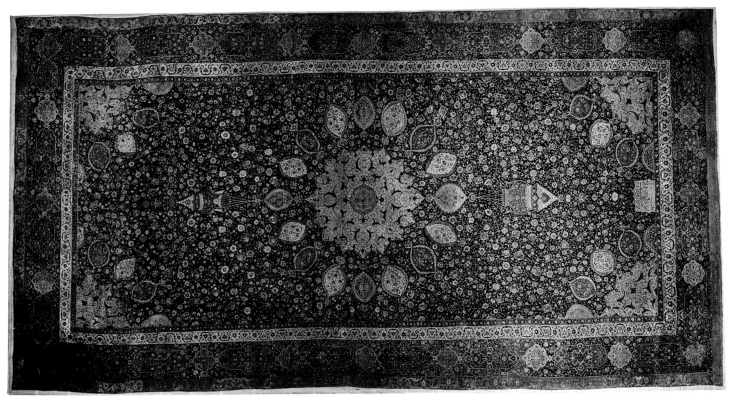

The London carpet also features a text-panel of poetry at one end:

'Except for thy threshold, there is no refuge for me in all the world. Except for this door there is no resting-place for my head. The work of the slave of the portal, Maqsud Kashani. 946.'

The number refers to the year 946 in the Hijra calendar, corresponding to 1539–40CE. Maqsud Kashani may have been the designer of the carpets or the court official who organized their production on behalf of Shah Tahmasp.

FIGURATIVE SCENES

The Ardabil carpets do not feature animals or people in their design because they were made for a religious environment. Safavid carpets designed for a more secular courtly location were frequently decorated with figural motifs.

Pairs of animals were artfully depicted in combat poses, and represented natural enemies: lion against bull, snow leopard against mountain goat, and even falcons against waterbirds. Supernatural animals were also very popular:

Above The two hanging lamps on this Ardabil carpet vary in size – perhaps to correct the perspective effect when this gigantic carpet is viewed from one end.

fighting dragons, phoenixes and chilins, all borrowed from Chinese art – without their associated symbolic meanings.

Another category of Safavid carpet depicted hunting scenes. These carpets were decorated with hunters mounted on horseback pursuing their prey, often set within borders containing kings, courtiers and musicians and, sometimes, angels. A celebrated example is the carpet created by master weaver Ghiyath al-Din Jami in 1542–43, and today held in the Museo Poldi Pezzoli in Milan, Italy. The carpet is made of wool, silk and cotton, and is precisely twice as long as it is wide, measuring 3.4m by 6.8m (11ft by 22ft).

The category known as garden carpets represented flowerbeds and cultivated vegetation; fish and ducks in rivers, waterways and ponds; garden pavilions, terracing and fountains; and animals such as deer,

peacocks, hares and even lions and leopards. Other carpet designs showed vases and flowers.

Some of the garden and hunting carpets also featured medallions in their design. On the Ghiyath al-Din Jami hunting carpet in Milan, for example, the hunting scenes were arranged around a medallion, while in the corners of the design were cranes set amid bands of cloud.

EXPORTS

Many carpets were made for non-Islamic users. Under Shah Abbas I (reigned 1587–1629), a number of carpets were made in the royal workshops in Isfahan and Kashan to be given as gifts to foreign rulers, or were commissioned by patrons in Europe. Examples include a group bought by King Sigismund III Vasa of Poland in 1602, complete with the royal coat of arms, while silk carpets were given to the doges of Venice in 1603 and 1622. Exported Safavid carpets, known as the 'Polonaise' carpets, were discovered in Poland in the 19th century.

SAFAVID MANUSCRIPT PAINTINGS

IN THE FIRST HALF OF THE 16TH CENTURY, A COORDINATED TEAM OF ARTISTS AND CRAFTSMEN AT THE SAFAVID COURT PRODUCED LUXURY MANUSCRIPTS OF EXCEPTIONAL QUALITY.

When the Safavid young crown prince Tahmasp was sent to Herat to be regional governor, his court there included the company of Herati artists from the last Timurid *kitab-khana*, or atelier (workshop), that of Sultan Husayn Bayqara. The renowned master painter Bihzad was head of the *kitab-khana*, and it was the young Tahmasp's privilege to be tutored by him.

When Tahmasp finally returned to the Safavid capital Tabriz in 1522, his taste for metropolitan Timurid painting would have been at odds with the current idiom of the Tabriz court atelier, which was directed by the painter Sultan-Muhammad in the Turkman style. However, Prince Tahmasp then studied under Sultan-Muhammad, while the elderly Bihzad was brought to Tabriz and appointed director. From this amalgamation, the placement of a Herati master at the head of the Tabriz painters, the character of 16th-century Safavid court painting was set, as a stylistic synthesis of taste, under a royal patron who was an able connoisseur of both modes, and a competent artist and calligrapher too. The results were spectacular.

TAHMASP'S *SHAHNAMA*

In 1524, Tahmasp became shah and soon after, from *c*.1524 to 1540, his court painters produced the grandest *Shahnama* (Book of Kings) manuscript ever seen. The manuscript has 258 paintings in its current state, most of which appear toward the beginning. It provides an extraordinary showcase of 16th-century Safavid court art, with recognizably Timurid or Turkman aspects, and a successful fusion of the two styles, where fluid figures are painted in finely detailed compositions, using brilliant rich colours.

Although there are few signatures or dates on the paintings, one – the remarkable *Court of*

Left A Shahnama *work attributed to Sultan Muhammad, showing Faridun striking Zahhak with an ox-headed mace.*

Above This illustration of Adam and Eve (c.1550) is from the Falnama, *a work of bibliomancy attributed to the sixth Shiah Imam, Jafar al-Sadiq.*

Gayumars – has been identified as the work of Sultan-Muhammad from a description in a biography of the Tabriz master. The painting shows a crowded court scene set in a rocky landscape, but look closely and it is possible to see an astonishing array of minuscule faces and figures, barely discernible to the naked eye, concealed in the rocks and clouds. The biographer's description is effusive: '[he] has developed depiction to such a degree that, although it has a thousand eyes, the celestial sphere has not seen his like...With the pen of his fingertips, on the tablet of vision, he has drawn a different version at each and every instant.'

A POLITICAL STATEMENT

Firdawsi's epic poem tells the history of generations of pre-Islamic Iranian kings, from the dawn of time up to the last Sasanian shah. It consists of some 60,000 couplets and is packed with eventful narratives of suspense and derring-do, making it an ideal text for illustration. Being a royal commission, a king's personal copy of the *Shahnama* has political

significance too, as it bestows the glamour of historical Persian kingship upon its owner – perfect for a Safavid shah, or any Iranian ruler.

It has been suggested that Tahmasp may have had additional motives for commissioning such an ostentatious version. In 1514, his father Ismail had been soundly defeated by the Ottomans at the Battle of Chaldiran. The Ottomans went on to sack the Safavid capital, Tabriz, including the royal treasury. As a key theme of the *Shahnama* is the Iranian triumph over their longstanding enemies, the Central Asian Turkic Turanians, this new version may have brought some solace to the Safavids in a post-Chaldiran world by enabling them to relive earlier victories over the Turks. Tahmasp may also have wanted to replace the *kitab-khana*'s losses after the Ottoman sack of the capital by commissioning a major new project.

THE SHAH'S DISAFFECTION

Tahmasp, his brother Bahram Mirza (d.1549) and Bahram's son Ibrahim Mirza (d.1577) were all bibliophile princes, with a connoisseur's eye and personal training in painting, calligraphy and poetry. They commissioned manuscript paintings, collected art and exchanged gifts, such as the precious 1544 album of paintings and drawings given to Bahram Mirza by his brother the Shah. The album is prefaced with an illuminating account of Persian art history as told by a 16th-century compiler named Dust Muhammad.

The history of Safavid painting took an abrupt turn around this time, due entirely to a change of heart on Tahmasp's part. He turned increasingly to religion throughout the 1530s and 1540s, renouncing non-Islamic habits, and gradually abandoned the company of his youth, dismissing from the Safavid court his artists, musicians and poets. They sought employment at

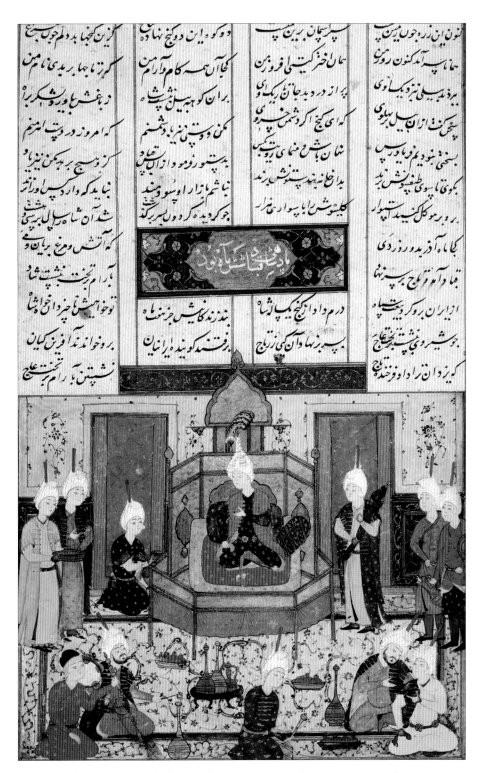

provincial courts and beyond in Mughal India, or simply retired.

In 1567, Tahmasp's monumental copy of the *Shahnama* was one of many spectacular accession presents sent to the new Ottoman ruler, Selim II, in the hope of retaining an important peace treaty agreed with Selim's predecessor Suleyman. In view of this decision, Tahmasp's apparent disaffection shows political

Above This stunning scene from a 1536 Shahnama *depicts Khusrauis ascending the throne.*

maturity. The biographer Qadi Ahmad notes: 'having wearied of the field of calligraphy and painting, [Tahmasp] occupied himself with important affairs of state, with the wellbeing of the country and tranquillity of his subjects.'

THE *KHAMSA* OF NIZAMI

REVERED AS ONE OF THE GREAT MASTERPIECES OF PERSIAN LITERATURE, THE *KHAMSA* (QUINTET) WAS WRITTEN BY THE 12TH-CENTURY POET NIZAMI GANJAVI.

Above A fine example of a scene from the Khamsa *(c. 1550), showing a game of polo between a team of men and a team of women.*

Nizami was the pen name of Ilyas Yusuf Nizami Ganjavi (1141–1209), who was born and spent the great part of his life in the south Caucasian city of Ganja, then part of the Seljuk Empire and now known as Gyandzha, in Azerbaijan. He was orphaned early in life and raised by his uncle, Khwaja Umar.

Nizami lived a simple, quiet life, largely keeping away from court – although he had a number of royal patrons. He was a passionate admirer of the early 11th-century poet Firdawsi's *Shahnama* (Book of Kings) and used it as his source for material in his own epic. In addition to the *Khamsa*, Nizami also wrote many odes and lyrics, but few of these have survived.

Above An illustration of the Ascension of the Prophet Muhammad, as retold in the Khamsa, *dated 1505.*

THE FIVE PARTS

The *Khamsa* is an anthology of five epic poems written between 1171 and 1202 in the *masnavi* style of rhyming couplets (*masnavi* means 'the doubled one'). The poems were dedicated by Nizami to local dynastic lords and Seljuk rulers. Comprising 30,000 couplets in total, the work is known as the *Khamsa* (the Arabic word for 'five').

The first of the five poems, *Makhzan al-Asrar* (Treasury of Mysteries), differs from the rest in that it is not a romantic epic but a collection of 20 parables on religious and ethical themes, such as the benefits of just royal rule and the necessity for all to ready themselves for life after death. Written in 1171, the *Makhzan al-Asrar* acknowledges its debt to an earlier work, the *Hadiqat al-Haqiqa* (Garden of Truths) of the 11th- to 12th-century Persian Sufi poet Sanai.

TWO ROMANTIC POEMS

Khusrau o-Shirin (Khusrau and Shirin), the second of the five poems, was written in 1177–80. This is an epic treatment of the celebrated story, also told in the *Shahnama* and in other sources, of the proud and protracted courtship between the Sasanian King Khusrau II and Princess Shirin of Armenia. The pair fall in love before they have even met: Shirin by seeing Khusrau's portrait, Khusrau by hearing Shirin described by poets. The course of the relationship is not smooth, however, and the two endure quarrels, separation and jealousy until they finally agree to marry.

Layli o-Majnun (Layla and Majnun), completed in 1192, is the third of the five poems, and recounts a legend of tragic love from Arab sources. A poet named Qays falls passionately in love with his cousin Layla at school, but cannot wed her because of a family quarrel and, as a result, is driven into madness. His strange behaviour wins him the name Majnun (from the Arabic for 'mad'). He cuts himself off from normal life, isolating himself in the desert with only wild animals for company and writing love poems about Layla. The star-crossed couple never find union in life, but after death are laid to rest in a single grave.

According to legend, the story was based on real events that took place in 7th-century Umayyad Arabia: a Bedouin poet fell in love with a young woman of his tribe, the Bani Amir, but was refused her hand in marriage by her father and afterward isolated himself in the Najd desert; his family left food in places where they knew he would

find it. This story passed into the Persian tradition, and was recounted by the 9th–10th-century Persian poet, Rudaki.

EXPLOITS OF GREAT RULERS

The *Haft Paykar* (Seven Portraits, or Beauties), the fourth poem in the *Khamsa*, was completed in 1196 and recounts episodes from the life of the Sasanian King Bahram V (reigned 421–38), often known as Bahram Gur. While a prince, Bahram is sent to the court of an Arabian king. There, he discovers a secret room containing paintings of beautiful princesses from China, India, Africa, Russia, Turkistan, Byzantium and Persia, representing the seven regions of the world. Bahram learns that when king he is to take these princesses as his brides.

Once on the throne, Bahram sends out a messenger to find and bring back the seven princesses. Upon their return he has a palace built for each one where they are visited by the king. The central section of the poem is subdivided into seven tales, delivered as the seven stories told to Bahram Gur over seven consecutive nights by each of his seven brides.

Nizami acknowledged his debt to Firdawsi's *Shahnama*, where Bahram's exploits had already been described, but he also presented several adventures from the king's life that were not described by Firdawsi. Literary scholars hail this poem as Nizami's masterpiece.

The final epic in the *Khamsa* is the *Iskander-nameh* (Book of Alexander), written in 1196–1202, celebrating the many legendary and mysterious events from the life of Macedonian general, Alexander the Great (356–323BCE). The poem contains 10,500 couplets arranged in two books: the *Sharaf-Nama* and the *Iqbal-Nameh*. The second book

focuses on Alexander's personal qualities, and his emergence as the ideal worldly ruler.

CLARITY AND LEARNING

The *Khamsa* is celebrated for its originality of expression and clear, colloquial use of language. It also shows Nizami to be a man of great learning, capable of drawing on both Persian and Arabic literary traditions, and of making references to astronomy, astrology, medicine,

Above A duel between two court doctors, a scene from Nizami Ganjavi's Khamsa, *copied in Tabriz c.1539–43.*

Islamic law, music, philosophy, botany, alchemy and mathematics. His work was very influential, and the *Khamsa*, a set of five epics, became a literary form in its own right. The Indian Sufi Amir Khosrow (1253–1325), and the Timurid statesman Mir Ali Shir Navai (d.1501) also wrote *khamsas*.

REZA ABBASI

REGARDED AS THE MOST IMPORTANT AND INFLUENTIAL PERSIAN ARTIST OF THE 17TH CENTURY, REZA ABBASI (D.1635) SPECIALIZED IN PLAYFUL PORTRAITS OF ISFAHAN'S PEOPLE.

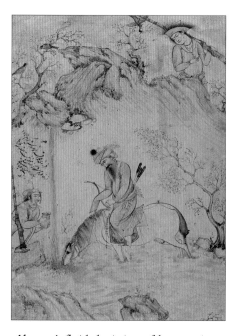

Above A fluid depiction of hunters in the landscape, painted by Reza Abbasi five years after he rejoined the royal workshop in 1610.

Reza's father was the court artist Ali Asghar, who had served successive Safavid shahs and princes in the late 16th century, at the courts in Qazwin and Mashhad. Following custom, he trained his son as a painter too, so Reza grew up in the company of the elite artists of the day, at the royal ateliers (workshops) of Shah Tahmasp, Prince Ibrahim Mirza, Shah Ismail II and Shah Abbas I.

He showed talent at an early stage, and was strongly admired by his contemporaries, as was recorded in a contemporary biographical note: 'it is fitting that the present age should be proud of his existence, for in the flower of his youth, he brought the elegance of his brushwork, portraiture and likeness to such a degree that [the great artists of the past] would praise his hand and brush a hundred times a day. In this age he has no rival; master painters, skilful artists who live in our times regard him as perfect.' Shah Abbas was also appreciative of Reza's talent, awarding him the honorific title 'Abbasi' as a measure of his esteem.

PORTRAIT ARTIST

Reza specialized in the single-page paintings or tinted drawings that were in vogue in Iran in the late 16th century. This romantic genre features slightly windswept lone figures in an idealized natural setting. Reza contributed to at least one manuscript painting project at this period, but then he began his single-page portraiture, with great success. He focused on young courtiers relaxing, but also created powerful images of people in the wider community. His 1598 drawing of a portly official taking his turban off to scratch his head is a masterpiece of observation.

CHANGE IN CHARACTERS

In 1598, the Safavid court moved from Qazwin to Isfahan, which was transformed into a vibrant imperial capital thanks to major architectural and commercial projects initiated by Shah Abbas I. New dynastic palaces and mosques were built in this old city, as well as monumental public spaces, major avenues, garden quarters and bridges. A great part of Reza Abbasi's surviving works reflect the moneyed society of this new capital, with portraits of foppish youths and dallying girls dressed in high fashion and posed in relaxed mood, enjoying romantic picnics of wine and fruit.

However, in the period from about 1603 to 1610, it would seem that Reza tired of this company, for he withdrew from court circles and entered a different sphere of Isfahan life. This is recorded with

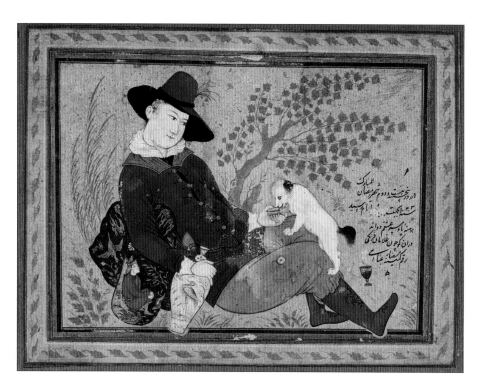

Left Reza Abbasi's satirical depiction of a young Portuguese merchant as he allows his dog to drink from his wine cup, painted in 1634.

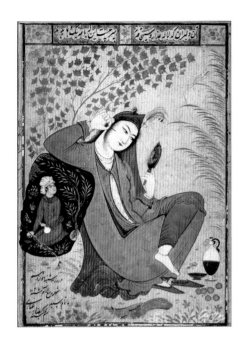

Above *Sitting alone, this young woman adjusts her make-up. A young man woven into the design of her cushion cover seems to spy on her.*

disapproval by biographers of the day. One biographer notes: 'He avoided the society of men of talent and gave himself up to association with low persons', while another comments: 'vicissitudes [of fate] have totally altered Aqa Reza's nature. The company of hapless people and libertines is spoiling his disposition. He is addicted to watching wrestling and to acquiring competence and instruction in this profession.' Sure enough, Reza's portraits from this period typically depict wrestlers, dervishes and other humble characters that belonged to an Isfahan subculture not usually represented in court art.

This period of disaffection may have been triggered by Shah Abbas's departure on a military campaign against the Ottomans in 1603, when Reza was left behind in Isfahan and then wearied of the other remaining courtiers. After about 1610, the artist returned to Abbas's court and resumed his paintings of courtiers, although he also continued to portray older dervishes until his

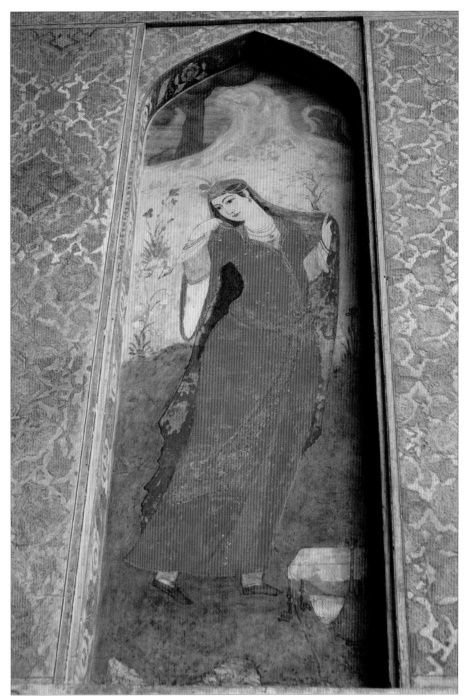

Above *This alcove painting of a young woman, from the Ali Qapu Palace in Isfahan, is in the style of Reza Abbasi.*

death in 1635. The double portrait of a younger court dandy paired with an older, wiser dervish was a recurring theme in Reza's work, emphasizing the contrast in lifestyle and outlook of these two different sections of society.

A LASTING INFLUENCE

Reza's influence on contemporary artists was considerable; it lasted throughout the 17th century and can be seen in paintings, murals, ceramics and textiles. This is evident from the work of Reza's students, such as his son Shafi Abbasi and Muin Musavvir, and many other painters, including Muhammad Qasim and Muhammad Yusuf al-Husayni. In addition, there are a large number of 17th-century paintings that appear to be 'signed' by Reza, but which are in fact tributes made by later painters.

AFSHAR, ZAND AND QAJAR PAINTING

IN THE 17TH CENTURY, EUROPEAN ART STYLES AND TECHNIQUES BEGAN TO INFLUENCE ART IN IRAN. THE PROCESS REACHED ITS PEAK DURING THE 19TH CENTURY UNDER THE QAJAR DYNASTY.

Later 17th-century Safavid art increasingly began to toy with international styles, such as Mughal themes, and European conventions, such as tonal modelling, perspective and the technique of oil painting. The late 17th-century artist Muhammad Zaman produced unsettling illustrations of familiar subjects from the *Shahnama* and *Khamsa* featuring (European) classical architecture rendered in steep perspective. Full-length oil portraits were also produced at this time depicting single figures – not unlike the genre established by Reza Abbasi earlier in the century.

In 1722, an Afghan invasion overturned the Safavid dynasty, and the rest of the century was a dismal period of tribal violence and civil war. In 1736, Nadir Shah Afshar founded the shortlived Afsharid dynasty, which was followed in 1751 by that of the Zands. Karim Khan Zand established his capital in Shiraz. Several full-length portraits have survived from his reign, along with some of the early works of Mirza Baba, who is better known as a Qajar artist.

QAJAR IMPERIAL STYLE

Long-term stability returned when the Qajar dynasty came to power in 1794, led, with some brutality, by Aga Muhammad (d.1797). The Qajar capital was established at Tehran, which remains the capital of modern Iran today.

The distinctive Qajar style emerged during the long reign of Fath Ali Shah (1797–1834), Aga Muhammad's nephew, who commissioned a number of oil portraits of himself and his many sons. He used the portraits, which emphasize his full beard, large eyes and wasp waist and show him wearing heavily jewelled crown and regalia, to cultivate an imposing public image, and he had them

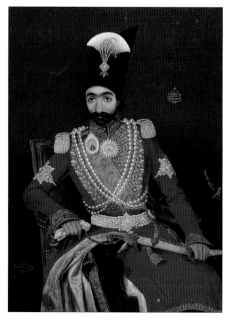

Above This colourful and detailed portrait shows the longest reigning Qajar king, Nasir al-Din Shah. It was painted in oils on copper in 1857.

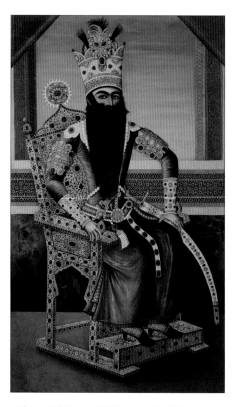

Above This c.1805 portrait of the second Qajar king, Fath Ali Shah, shows the influence of both Western and Islamic painting styles.

Left The Qajar Empire reached its peak early in the reign of Fath Ali Shah (1797–1834). Tehran was its capital.

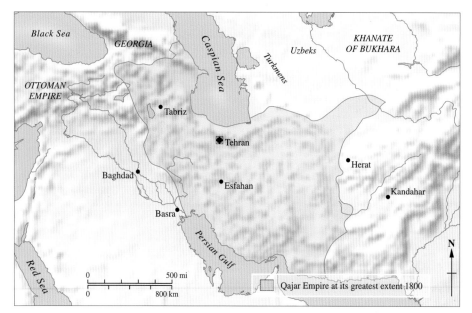

Black Sea
GEORGIA
Caspian Sea
Uzbeks
KHANATE OF BUKHARA
Turkmens
OTTOMAN EMPIRE
Tabriz
Tehran
Herat
Baghdad
Esfahan
Kandahar
Basra
Persian Gulf
Red Sea
0 500 mi
0 800 km
N
☐ Qajar Empire at its greatest extent 1800

Above Qajar artists produced many images of beautiful women – including this oil painting of a dancing girl with a tambourine.

As Iran moved into the modern era under Muhammad Shah (reigned 1834–48), Western-style reforms and fashions crept in. Military uniform became formal dress at court, as can be seen in contemporary imperial portraiture.

The taste for Western art and culture remained strong during the long reign of Nasir al-Din Shah (reigned 1848–96), who made three official tours of the courts of Europe and was keen to present Iran abroad as a similar imperial nation. He was particularly taken with the new invention of photography and took it up as a hobby – building his own studio and taking up to 20,000 photographs of the court, including his mother, wives and children. His albums remain in the collection of the Gulestan Palace.

In 1851, Nasir al-Din Shah set up a European-style technical college in Tehran called Dar al-Funun (House of the Arts) to train military cadets, engineers, musicians, doctors and interpreters. Photography and lithography were also taught, which encouraged their wider use. Painting was added to the curriculum in 1861. In the later Qajar period, the Ghaffari family from Kashan produced generations of important court painters: Abu'l-Hasan Khan Ghaffari (d.c.1866), who had the title Sani al-Mulk (Craftsman of the Kingdom), was sent to Italy by Muhammad Shah to study academic painting and lithography. His nephew Muhammad Ghaffari (d.1940) was a major court portraitist who studied at Dar al-Funun and also spent five years in Paris.

distributed around Iran. He also sent the portraits to a number of foreign rulers. Fath Ali Shah also commissioned an enormous mural for his Negarestan Palace in Tehran. Depicting an imaginary court reception to celebrate *No Ruz* (Persian New Year), it showed the shah surrounded by 12 of his sons, together with retainers and foreign ambassadors from Britain, France, the Ottoman Empire, Sind and Arabia.

THEMES IN QAJAR PAINTING

Qajar artists also produced paintings of beautiful women, including a series made for the Gulestan Palace in Tehran. These ranged from royal women to dancers, musicians and serving girls. The most unusual subjects were the acrobats and tumblers who entertained the royal household, and are depicted upside down, balancing precariously on their hands, elbows and even on the tips of knives.

Right A ceramic tile showing musicians and dancers at the court of Qajar king, Nasir al-Din Shah.

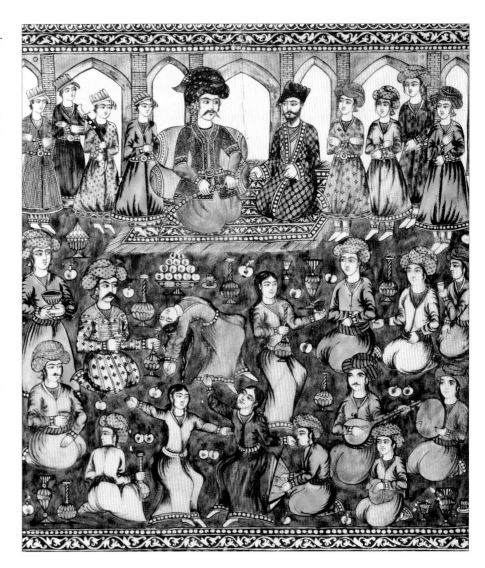

LACQUER PAINTING

CHINESE LACQUER PAINTING HAD LONG IMPRESSED ISLAMIC ARTISTS, AND FROM THE TIMURID DYNASTY THROUGH TO THE QAJAR ERA LACQUER PAINTING BECAME INCREASINGLY POPULAR.

Over the centuries, Islamic artists drew inspiration from their contacts with China. However, this did not mean that they made copies of the objects that came their way. In the case of lacquer, Chinese examples gave them a point of reference, and they soon provided their own, unique slant on the process.

The true lacquer made in China was derived from the sap of the lacquer tree, or *Rhus verniciflua*, which produced a hard and durable surface like plastic, with a glossy sheen. Early Islamic craftsmen lacked this technology, instead using layers of varnish over a painted surface to create a similar effect. It is possible that a breakthrough was achieved during the 15th century by adapting Persian 'bow gloss' (*rawghan-i kaman*), a varnish used by armourers, to produce a surface with the characteristic lacquered glow.

LACQUER BOOKBINDINGS

In Iran, lacquer painting developed in the late 15th century, when it was first adapted for use in Timurid bookbinding in Herat. The technique soon spread to Safavid Tabriz and other cities. Artists painted designs in watercolour on to a prepared surface of papier mâché, or pasteboard, then applied a coat of varnish, thus replacing traditional leather bindings. The varnish could be given an added sheen by mixing it with powdered gold or mother-of-pearl. The immediate stimulus for this activity came from new polychrome lacquers that had recently been imported from the East. The most influential of these was *qiangjin* – incised black lacquer infilled with gold. Islamic artists hurried to copy this gold-and-black palette.

The popularity of lacquer bindings increased under the Safavids and reached a peak in the Qajar era. Over the years, artists developed a varied repertoire of themes. There were simple, ornamental designs,

Left A Qajar box from 1867, which depicts Shaykh Sadi in conversation with Nizami and his attendants.

Above This beautiful blue iris, painted by Muhammad Zaman in 1663–64, appears in a manual on bookbinding and lacquerwork.

composed of arabesques and scroll-work; elegant scenes of courtly entertainments in idyllic gardens; studies of birds and flowers; and, in the 19th century, rolling landscapes, influenced by European painting. Royal portraits were also in demand, and a well-known Qajar binding depicts Fath Ali Shah in a lively hunting scene.

AN EXPANDING ART FORM

From the 17th century, Islamic artists broadened their outlook and began applying lacquer decoration to a wide range of other luxury objects. The most common of these items was, perhaps, the pen case. This simple box carried all the accoutrements of the calligrapher's art: reed pens, inkwells, a small knife for cutting fresh nibs and scissors to trim the paper. In the finest examples, paintings were added to both the interior and the exterior of the lid. Most cases were adorned with a mass of birds, butterflies and

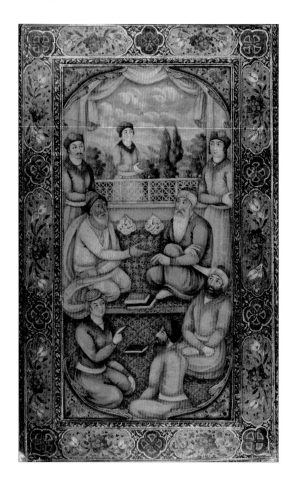

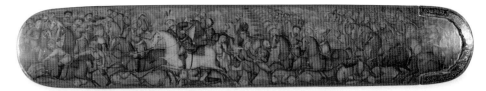

colourful flowers, although by the mid–19th century, narrative subjects were also in vogue, such as the contemporary battle scene on an 1865 lacquer casket depicting Muhammad Shah's siege of Herat.

There was a considerable range of lacquer-painted objects by the Qajar period, including fans, mirror cases, musical instruments, playing cards and backgammon boards. One of the most spectacular items is an ornate chest from 1840, now in the British Museum in London. The box contains a collection of instruments for weighing jewellery, and its lid is adorned with a scene of an enthroned King Solomon surrounded by an array of *jinns*, *peris* and demons.

BEHIND THE CHANGES

It has been suggested that the rise of lacquer painting during the Qajar period was the result of changes in the Islamic art world. For centuries, the most prestigious form of painting had been manuscript painting, but its status was undermined by the growing taste for larger, Western-style paintings and

Below These lacquer bookbindings, painted in 16th-century Persia, show a hunting scene (left) and a prince, under the awning, enjoying courtly life (right).

Above This Qajar lacquered papier-mâché pen case, from c.1880, shows Safavid ruler Shah Ismail defeating the Uzbeks in 1510.

the use of printed illustrations. This encouraged many painters to turn to lacquer decoration, where there was a market for small-scale, exquisitely detailed artworks. The subject matter could yet be strongly European, such as in the lacquer work of Nadir Shah's chief artist, Muhammad Ismail, whose nickname was *farangi-saz* – 'the Europeanizer'.

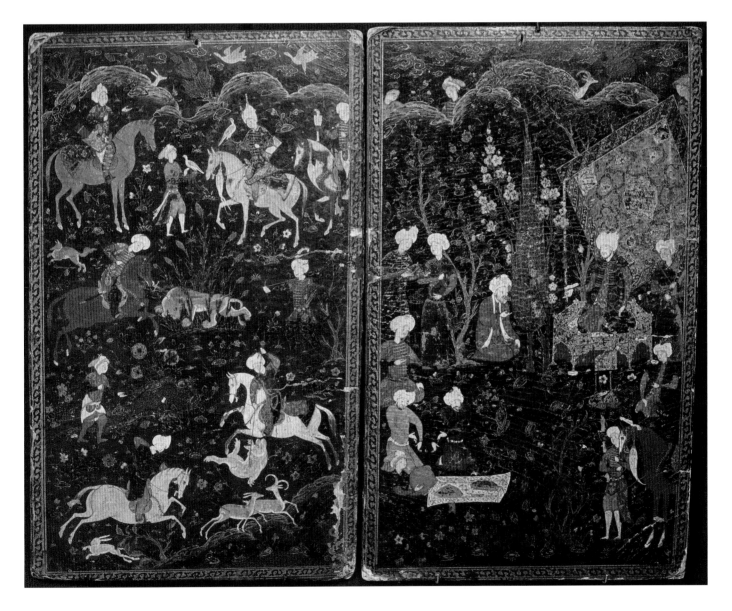

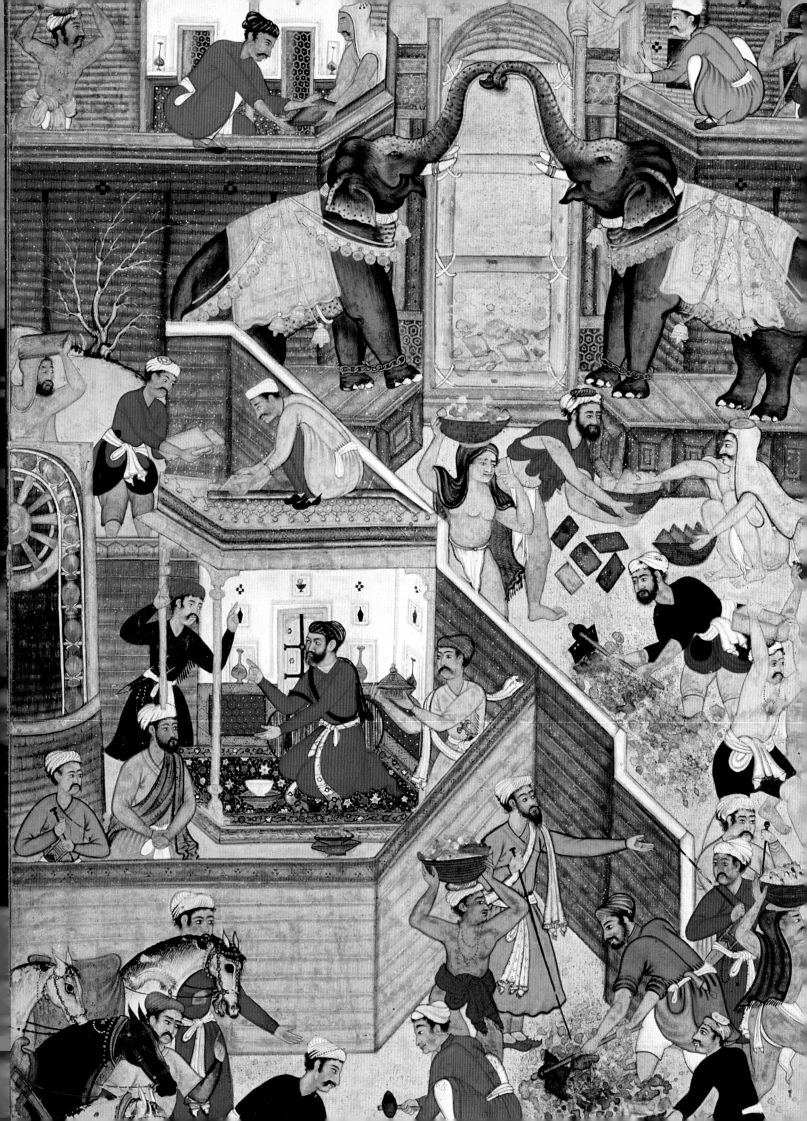

ISLAMIC ART IN MUGHAL INDIA

Babur, the first Mughal ruler, invaded India from his Central Asian homeland in 1526 and eventually established a great empire that lasted into the 19th century. Descended from both Genghis Khan and Timur, the Mughals were one of four superpower states in Western Asia at the time, all with Turco-Mongol roots, the others being the Safavids, Uzbeks and Ottomans. Babur's son Humayun was a less effective ruler, and sought political asylum with the Safavid Shah Tahmasp for a time – which proved very formative for Mughal court art as Humayun was much taken by the sophistication of Safavid painting. By the time he returned to India, Humayun had persuaded Persian artists to join his court, and their contributions in the royal atelier combined with Indian art traditions to great effect. The three greatest Mughal emperors were Akbar (reigned 1556–1605), Jahangir (reigned 1605–27) and Shah Jahan (reigned 1628–58), who presided over a period of enormous wealth and power with great creativity and exuberance in art and architecture.

Opposite Seated in the centre of the picture, Akbar inspects the building of his new imperial city, Fatehpur Sikri. Its pavilions and palaces were made of red sandstone and carved with intricate motifs.

Above The decorative art of Pietra Dura, an intricate technique for inlaying semi-precious stone, was a major design element of Mughal architectural decoration.

MUGHAL TOMBS

ARCHITECTURE UNDER THE MUGHALS ACHIEVED A WONDERFUL BLEND OF HINDU AND PERSIAN STYLES. THE MOST SPECTACULAR EXAMPLES ARE MONUMENTAL TOMBS, OFTEN IN A GARDEN SETTING.

Though the glorification of the dead is alien to the spirit of Islam, there are many outstanding tombs built in Islamic lands. 'The most beautiful tomb,' according to the Prophet Muhammad, 'is one that vanishes from the face of the earth.' Yet magnificent tombs were built by rulers to perpetuate and glorify their names or at the desire of a community of believers to honour their saints. The tombs of

Below The red sandstone exterior of Humayun's imposing tomb in Delhi is picked out in relief with white marble.

rulers were often built by the rulers themselves, whereas those of saints were the gift of their disciples.

Sher Shah (reigned 1540–45), the Afghan ruler who seized the throne and forced Humayun into exile, built his own monumental mausoleum at Sasaram. At the time it was completed, in 1545, it was the largest tomb ever built in India. Its setting in the middle of an artificial lake and its octagonal shape are both allusions to the Islamic notion of paradise. The tomb rises in three tiers of diminishing size and is crowned by a painted white dome.

Above The shadowed interior of the Tomb of Salim Chishti at Fatehpur Sikri is lit by intricately carved marble latticework windows, or jalis.

Akbar (reigned 1556–1605) ordered the construction of a tomb at Fatehpur Sikri to honour Shaykh Salim Chishti, the saint who had predicted the birth of his son, Jahangir. Built of luminous white marble, the tiny tomb lies at the feet of the red sandstone walls of the city's great mosque. The tomb's canopy is inlaid with ebony and mother-of-pearl. Jahangir (reigned 1605–27) added exquisite marble screens, mosaic flooring and a walkway paved in marble.

TOMB OF HUMAYUN

Humayun's mausoleum in Delhi was, and remains, a fine example of Indo-Islamic architecture and was one of the first of many garden tombs built during the Mughal period. It was probably built my Humayun's son Akbar. Construction began in 1562 and continued for nine years. Set on a wide, high platform, the mausoleum has four double-storey pavilions set in a square, creating a central space between them. The space is crowned by a white

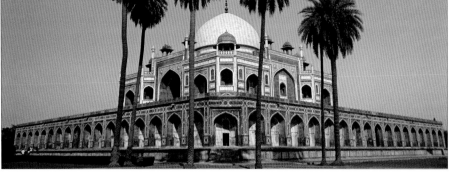

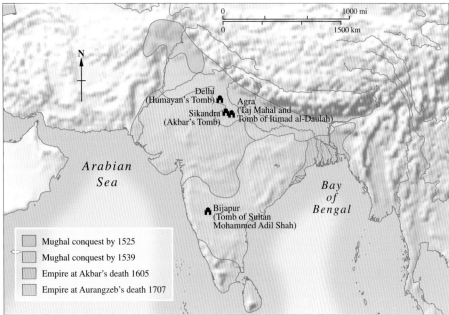

Left The growth of the Mughal Empire across the subcontinent and the sites of the major Mughal tombs.

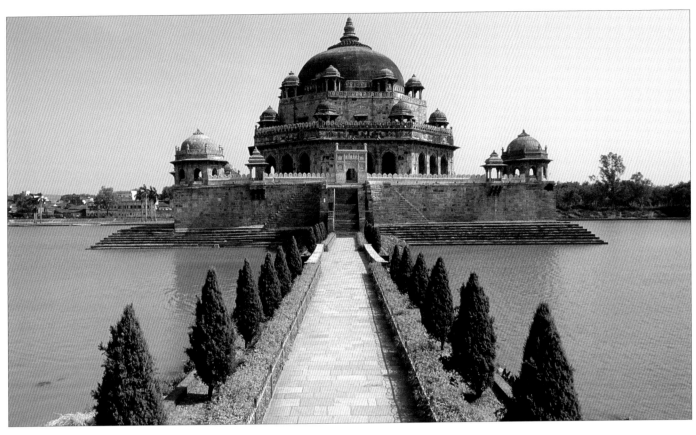

Above Rising in three tiers of diminishing size, the Tomb of Sher Shah at Sasaram is crowned by a dome.

marble dome mounted on a high drum. The red sandstone exterior is picked out in relief with white Makrana marble. Inside the tomb, a system of corridors allows for the circumambulation of the central cenotaph (a monument for a person whose remains are elsewhere). High walls surrounding the garden are intersected by four gates.

GARDEN TOMBS IN AGRA

The garden setting of Akbar's own tomb at Sikandra, near Agra, follows the same basic design as Humayun's tomb. Set in a *chahar bagh*, or four-part garden of Persian origin, the tomb consists of five storeys, surmounted by red domed kiosks supported on pillars. The tomb's upper storey is open to the sky, and in the centre is Akbar's white marble cenotaph. His actual grave lies in a domed hall at ground level, reached

through a portico. The tomb complex is entered by an imposing gateway. At its four corners rise white marble minarets.

OTHER IMPORTANT TOMBS

The tomb of Itimad al-Daulah in Agra was built in 1622–28 by Nur Jahan, the wife of Jahangir, for her parents. The mausoleum, set in a garden, is entirely clad in white marble with subtle inlays in yellow and green stone, differing from earlier use of red sandstone. A small pavilion on the roof is surmounted by a square dome. Here lie the two cenotaphs, surrounded by marble screens. Every inch of the whole mausoleum, inside and out, is decorated with geometrical patterns, floral designs in marble mosaic and *parchin kari* inlay, using semi-precious stones, such as topaz, onyx and lapis lazuli.

Right This detail of the Tomb of Itimad al-Daulah at Agra shows the magnificently crafted marble of the vaulted chamber on the roof.

At Bijapur in the Deccan lies another noteworthy mausoleum, the Tomb of Muhammad Adil Shah (reigned 1627–57). Known as Gol Gumbaz, this mausoleum boasts one of the largest domed spaces in the world – 4.9m (16ft) larger than the dome of St Paul's in London. At each corner of the building is an impressive domed octagonal tower.

The Taj Mahal

ONE OF THE MOST FAMOUS MAUSOLEA IN THE WORLD, THE TAJ MAHAL AT AGRA MARKS THE MOMENT WHEN INDO-ISLAMIC ARCHITECTURE REACHED A PEAK OF PERFECTION.

The future Shah Jahan (reigned 1628–58), Prince Khurram, was the favourite of his grandfather Akbar and of his own father, Jahangir. A fine soldier, it was Prince Khurram who was responsible for the military successes of Jahangir's reign. To honour his son's victories, his father bestowed on him the title Shah Jahan, or 'King of the World'. While still a prince, he had already demonstrated a passion for architecture and gardens and had carried out a number of building projects, including the Shahi Bagh (Princely Garden) at Ahmadabad and the wonderful Shalimar Gardens in Lahore.

On Shah Jahan's accession to the throne, the prodigious wealth at his command enabled him to carry out

Below Often considered the finest example of Mughal architecture, the Taj Mahal sits at the end of a 300m (980ft) square chahar bagh *garden.*

not only an extravagant building programme but to maintain a court whose magnificence was the envy of all. The sums he expended on his tombs, hunting pavilions, palaces and gardens, even entire planned cities, such as Shahjahanabad in Delhi, would seem astonishing even today. The emperor took a close personal interest in all these undertakings. His pride in his magnificent buildings is reflected in the famous couplet inscribed on the Diwan-i-Khas in the Red Fort at Delhi: 'If there be a paradise on earth, it is this, it is this, it is this!'

THE EMPEROR'S WIFE

The peak of the ruler's architectural achievements is the Taj Mahal, built as a tomb for his favourite wife, Mumtaz Mahal, who was a niece of Jahangir's formidable queen Nur Jahan. Mumtaz Mahal played a discreet but important role in Shah Jahan's government. She was, wrote

Above The decoration on the Taj Mahal includes Hindu-influenced design elements, such as this lotus flower, beautifully carved in white marble.

a Mughal chronicler, the emperor's 'intimate companion, colleague, close confidante in distress and comfort, joy and grief'. He was utterly devoted to her and although he had other wives, he had children only by her. When she died in 1631 while giving birth to his 14th child, he was devastated. It is said that he shut himself up in his private

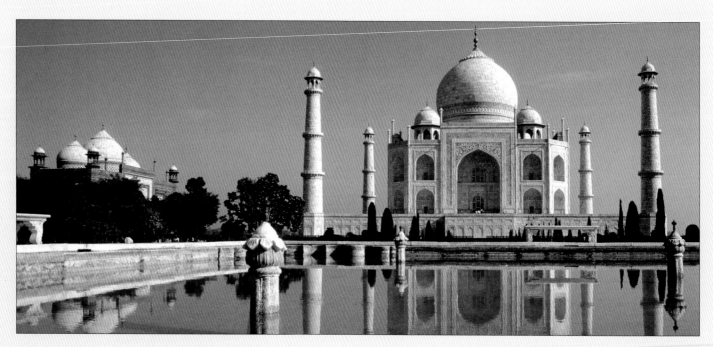

quarters and refused to eat. When he emerged eight days later, his hair and beard had turned white.

OUTSIDE THE TOMB

The grief-stricken emperor chose a site for his wife's tomb on a bend in the river Jumna at Agra. Instead of following the usual practice of positioning the tomb at the centre of a garden, he placed it at the end overlooking the river, so it is visible at the horizon. The tomb, built by some 20,000 workers over 20 years, is set on a marble terrace, which in turn stands on a wide platform, flanked by two red sandstone buildings. At each corner, at a distance from the tomb, are four marble minarets, 42m (138ft) high.

All four sides of the tomb are identical, but it can only be entered from the garden side. The garden is bisected by a broad, straight canal that stretches from the tomb to the main gateway, an elegant two-storey building of red sandstone. In the centre of the canal lies a square pool in which the inverted reflection of the Taj seems to hang suspended. The huge dome, shaped like a lotus bud – a typically Hindu motif – culminates in a gilded bronze finial. The entire building is faced with pure white Makrana marble decorated with *parchin kari*, a type of inlay stonework that characterizes many of Shah Jahan's buildings.

INSIDE THE TAJ MAHAL

The interior of the tomb consists of a central octagonal chamber, which contains the cenotaphs of Shah Jahan and his wife. Linked to each other, and to the central chamber, are four side chambers. A white marble trelliswork screen surrounds the cenotaph, filtering the light entering the tomb chamber. For the Mughals, light served as a metaphor for divine light, symbolizing the true presence of God.

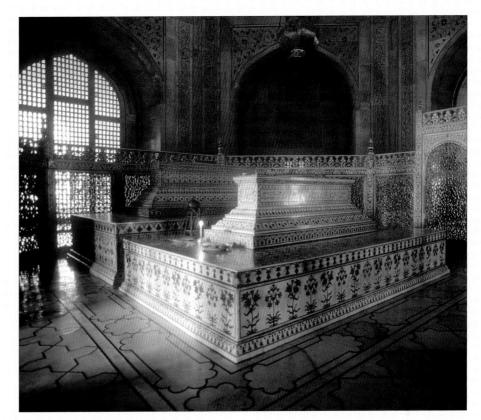

Shah Jahan's severe illness in 1657 led to a rivalry between his four sons, in which the third son, Aurangzeb, killed his brothers, declared his father unfit to rule and seized the throne. Shah Jahan lived for another seven years, imprisoned inside the Agra fort in one of his own palaces, overlooking his most sublime creation.

Above The cenotaphs of Shah Jahan and his wife Mumtaz Mahal lie at the heart of the Taj Mahal. An exquisite octagonal marble screen, or jali, surrounds the cenotaphs.

Below Extensive stone inlay decoration on the exterior of the Taj Mahal includes calligraphy, abstract forms and designs based on plant forms.

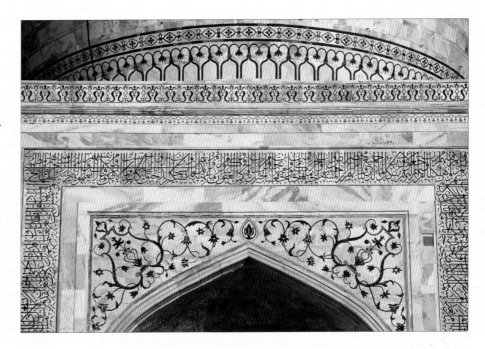

RED FORT

AT THE HEART OF SHAH JAHAN'S NEW CITY STOOD THE RED FORT, A VAST WALLED COMPLEX OF PALACES AND ASSEMBLY HALLS FROM WHICH HE RULED WITH UNRIVALLED POMP AND CEREMONY.

In 1639, Shah Jahan founded a new city at Delhi. He named it Shahjahanabad, meaning 'the abode of Shah Jahan'. The city of 2,590ha (6,400 acres) supported a population of 400,000. The Friday Mosque, the largest mosque in India at that time, was built on a hillock. Shahjahanabad became the new capital of the Mughal Empire.

According to the emperor's librarian: 'It first occurred to the omniscient mind that he should select on the banks of the [Jumna] river some pleasant site, distinguished by its genial climate, where he might found a splendid fort and

Below One of the two imposing entrances to the Red Fort. The fort was a city within a city, housing a bazaar, many workshops and 50,000 people.

delightful edifices…through which streams of water should be made to flow, and the terraces of which should overlook the river.'

A NEW PALACE-FORTRESS

As the emperor had desired, a structure was sited on the banks of the Jumna. Known today as the Red Fort, the complex was situated on Shahjahanabad's eastern edge, dominating the new imperial city but separated from it by walls of red sandstone over 1.8km (1 mile) in circumference. With its palaces, audience halls, bazaars, gardens, mansions for the nobility and an estimated population of 57,000, the Red Fort was a city within a city.

In 1648, nine years after work on the complex began, the Red Fort was dedicated in a magnificent

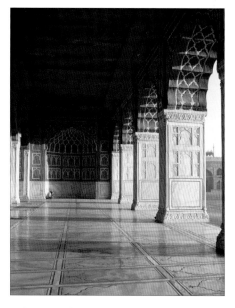

Above Red sandstone, pillars with intricate low-relief carving and marble flooring are used to decorate this building in the Red Fort.

ceremony. The buildings were decorated with impressive textiles embroidered with gold, silver and pearls, and costly gifts, such as jewelled swords and elephants, were distributed to members of the imperial family and nobility.

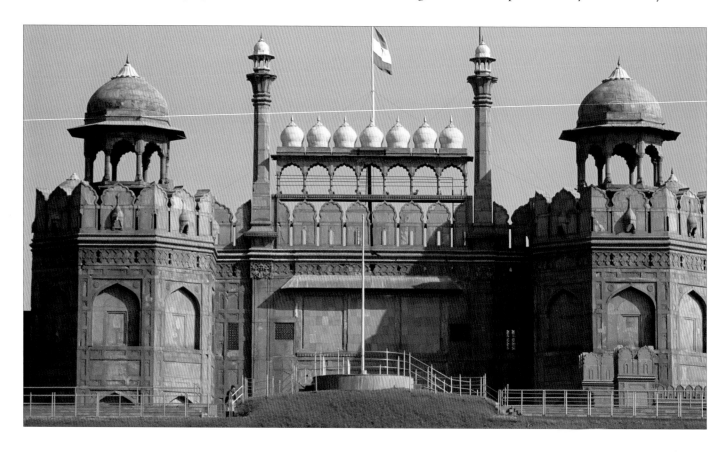

CANAL OF PARADISE

The great palace-fortress could be entered by two gates, the massive red sandstone Lahore Gate and the Delhi Gate. The Lahore Gate led to a long covered bazaar street, the Chatta Chowk, whose walls were lined with shops. The principal buildings and the emperor's private quarters were sited along the river side of the fort on a terrace some 600m (2,000ft) long.

A shallow marble watercourse, known as the Canal of Paradise, ran through the centre of all these exquisite marble pavilions. Water for the Mughals was just as vital an element in their architecture as it was in their gardens. 'There is almost no chamber,' reported a 17th-century visitor, 'but it hath at its door a storehouse of running water; that 'tis full of parterres, pleasant walks, shady places, rivulets, fountains, jets of water, grottoes, great caves against the heat of the day, and great terraces raised high, and very airy, to sleep upon in the cool: in a word, you know not there what 'tis to be hot.' This Mughal love of water is particularly evident in the Shah Burj ('King's Tower') pavilion, where the water ripples down a marble *chador*, or water chute, into a lotus-shaped pool, and from there flows into the Canal of Paradise.

COURTLY QUARTERS

In a commanding position at the centre of the fortress-palace was the Diwan-i-Am ('Hall of Public Audience'), which contained the marble throne from which Shah Jahan presented himself to his court. The Diwan-i-Khas ('Hall of Private Audience'), the most richly decorated of all the fort's buildings, was where Shah Jahan, seated on a gem-encrusted peacock throne, held the equivalent of cabinet meetings. Built of white marble, the pavilion's interior was richly

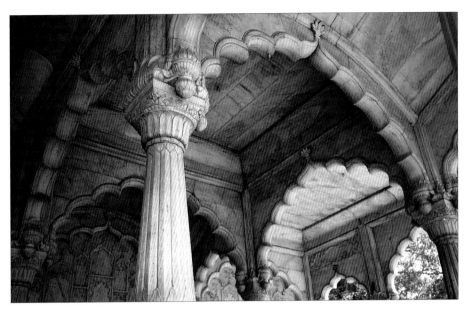

embellished with floral *parchin kari* stone inlays, precious stones and a ceiling made of silver and gold.

Next to the Diwan-i-Khas lay the Khwabagh, or emperor's private quarters (now called the Khass Mahal). Every day at dawn the emperor presented himself to his people from the balcony of an octagonal tower, which overlooked the river bank. Here too were staged fabulous spectacles, such as elephant fights and military reviews. Also along the riverside were the *zenanas*, or women's quarters, and the *hammam*, or bathhouse. Cool in summer and heated in winter, the *hammam* was ideal for discussing affairs of state in private.

Above Beautiful cusped arches enliven the Sawan Pavilion, named after a month in the rainy season. It is one of two pavilions in the Red Fort's garden.

There were two major gardens, the Moonlight Garden and the Lifegiving Garden, where the hyacinths 'made the earth the envy of the sky' and 281 fountains played. The fort's other areas held numerous workshops that supplied the vast court with everything it needed from slippers to daggers.

Below The Diwan-i-Khasr was used to hold meetings. It held Shah Jahan's peacock throne, before it was plundered by Iranian invader Nadir Shah in 1739.

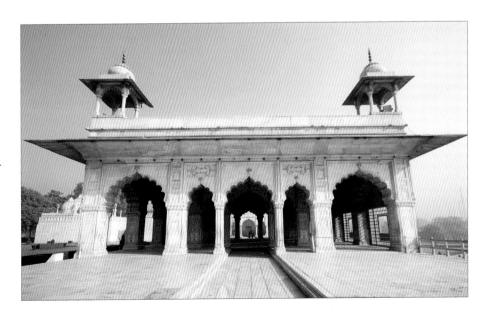

LAHORE

THE CITY OF LAHORE IN NORTHERN INDIA REACHED A PEAK OF ARCHITECTURAL GLORY DURING THE RULE OF THE MUGHALS. FROM 1584 TO 1598, IT SERVED AS THE IMPERIAL CITY.

During most of the Mughal dynasty, the imperial capital was moved to different cities. When the emperor and his army set off on campaign, his entire establishment went with him, from the ladies of the harem to the treasury and from the court artists to the menagerie. However, several cities did become – and remained for a while – the official Mughal capital.

Akbar (reigned 1556–1605) used Agra as his capital until 1571, when he moved it to his newly built city, Fatehpur Sikri. Within 15 years, he had transferred his capital to Lahore in the Punjab. Lahore remained the capital until 1598, when Akbar moved it back to Agra. However, Lahore, which was strategically situated along the routes to Afghanistan, Multan and Kashmir, continued to be one of the most important Mughal cities after Agra until 1648, when Shah Jahan built his new capital at Delhi.

MUGHAL FORT

During his residence at Lahore, Akbar constructed a fortified palace on the edge of the city overlooking the river Ravi, on the site of an earlier fort. The walls of Akbar's fort were brick, a traditional building material of the region. Under Jahangir (reigned 1605–27), Lahore gained increasing prominence – the city was described by Europeans as one of the greatest in the East. The fort was substantially remodelled, and several audience halls and residential pavilions, with private courtyards and gardens, were added.

The fort's exterior walls were decorated with hundreds of brilliantly coloured tiles, a material common in Lahore, arranged in complex geometric patterns. Other tiled mosaics depicted elephant fights, camels, the Virgin Mary and Jesus, while the emperor's bed chamber had friezes of angels around the ceilings.

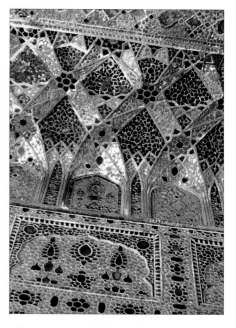

Above In the Shish Mahal, tiny pieces of mirror on the walls and ceilings create shimmering, reflective surfaces.

AFTER JAHANGIR

In 1627, Jahangir died on the way to Kashmir. His queen, Nur Jahan, constructed his mausoleum at Shadera near Lahore. Set in a large square garden, the tomb's exterior is decorated with marble inlay and the cenotaph inlaid with semi-precious stones representing tulips and cyclamen. Nur Jahan's own tomb in Lahore bears a moving epitaph: 'On the grave of this poor stranger, let there be neither lamp nor rose. Let neither butterfly's wing burn nor nightingale sing.'

Jahangir's succeeding son, Shah Jahan (reigned 1628–58), was born in Lahore. Like his father, he extended the fort and built several other structures in the city. Here, as elsewhere, he was closely involved in the design of his buildings. His love for white marble is evident in the Shah Burj, built inside the fort for his exclusive use. Within the Shah Burj he built the Shish Mahal

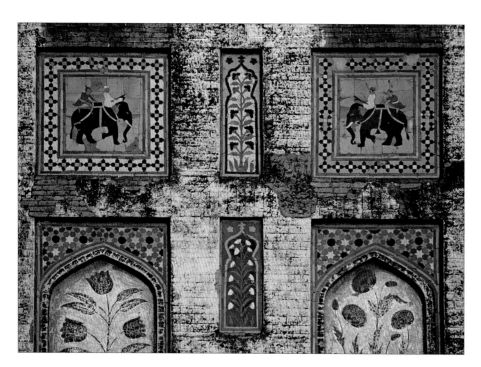

Left The exterior walls of Lahore's fort are made of brick and profusely decorated with tile mosaics depicting a myriad of subjects.

('Glass Palace'), so-called because its walls and ceilings were inlaid with a mosaic of mirrors, which created a shimmering effect, that was especially noticeable at night when the interior was lit by lamps.

One of the most beautiful tiled buildings in Lahore is the Wazir Khan Mosque, built in 1634 by Wazir Khan, Shah Jahan's governor of the Punjab. Four towering minarets dominate the building, which is set on a plinth and entered through a high portal. Every inch of the walls is faced with coloured tile mosaics depicting floral sprays, arabesques and calligraphy.

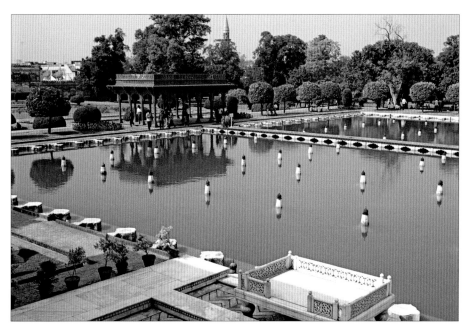

SHALIMAR GARDENS

Shah Jahan's most spectacular addition to Lahore was the Shalimar Gardens, the greatest of the Mughal water gardens. Constructed in 1641–42, the garden is rectangular in shape and has numerous marble pavilions of intricate design and exquisite workmanship. The garden has three terraces, with two changes of level. At the centre of the middle terrace lies a square pool, said to have contained 152 fountains. Looking out across the pool is the emperor's marble throne.

BADSHAHI MOSQUE

Set in a vast courtyard, the Badshahi Mosque was built in 1674 by Aurangzeb (reigned 1658–1707). With its trio of white domes, octagonal minarets and imposing arched portal, the mosque is the largest place of prayer constructed during the Mughal era. Some walls are covered with intricate geometric patterns, others with a mass of tiny flowers and floral sprays springing from vases. Moulded plaster lattices adorn the vaults and domes, taking on an almost textile

Above Lahore's Shalimar Gardens, the greatest of all Mughal water designs, were laid out by Shah Jahan.

quality. Although responsible for the construction of this great mosque, Aurangzeb seldom visited Lahore. Probably because the city lacked an imperial presence, by the second half of the 17th century it was in a state of rapid decay.

***Below** The courtyard of Aurangzeb's Badshahi Mosque in Lahore can hold tens of thousands of believers for prayers.*

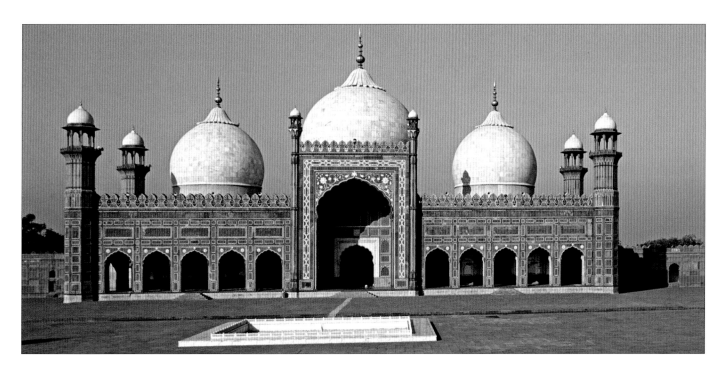

DECORATIVE OBJECTS

UNDER THE PATRONAGE OF THE MUGHALS, THE DECORATIVE ARTS
REACHED UNPRECEDENTED HEIGHTS. ARTICLES OF EVERYDAY USE,
SUCH AS INKWELLS, WERE OBJECTS OF OPULENCE AND BEAUTY.

Influenced by the arts of the wider Islamic world, yet firmly rooted in Indian traditions, Mughal style permeated every element of the Mughal courts. In the vast network of *karkhanas*, or imperial workshops, expert artists, artisans and craftsmen produced luxurious furnishings and objects for the Mughal palaces. Even practical objects, such as *huqqas* (water pipes), ewers and back scratchers, were fashioned from costly materials, such as jade and rock crystal.

The decorative themes echoed those found in architecture. Under Jahangir (reigned 1605–27), images of plants, animals and people appeared in a naturalistic style, and by Shah Jahan's reign (1628–58), the plant motif was at its peak.

JADE

The Mughal rulers were patrons of jade carving. The techniques of hardstone carving had been employed in India from historical times, but the carving of jade reached a peak of excellence under the Mughals. The colours varied from milky white nephrite jade to an opaque, deep green. Jahangir owned several jade pieces, including an inkwell, pen box and a cup in the form of a poppy flower, from which he took an opium mixture.

The finest jade pieces date from Shah Jahan's reign when the organic style of jade carving achieved perfection. One of the most exquisite pieces to survive is Shah Jahan's wine cup, dated to 1657. Made of pearly white jade, the cup is of a lobed half-gourd shape, tapering into a curving handle in the shape of the head of an ibex. The base is shaped like open lotus petals with radiating leaves. Other objects of everyday use were the *huqqas,* through which smoke was passed in order to cool and purify it.

Above *This flower pattern from the tomb of Itimad-al-Daulah shows the first use of the Mughal stone inlay technique of* parchin kari.

However, those made of jade, often inlaid with precious stones, were too precious to have been used by anyone except the emperor. Jade, often encrusted with gems, was also used for the hilts of swords and daggers, though such weapons would have been too fine to be used in battle. Because they were seen as symbols of honour, carved, bejewelled daggers were presented as gifts to persons of high rank.

STONE INLAY

Mughal craftsmen were masters of the art of stone inlay, also known as *parchin kari*, where marble or soapstone, for example, was carved and thin pieces of shaped and polished semi-precious stones were glued in place to form a design. Geometrical patterns, floral arabesques and calligraphy embellish the great Mughal

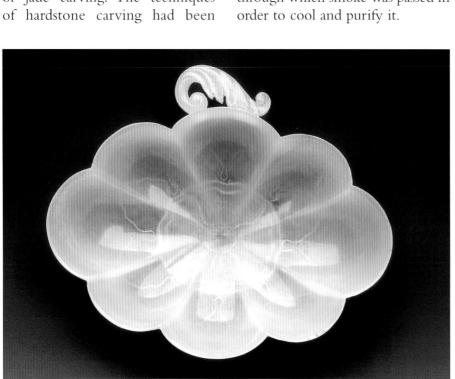

Left *Jade objects were among the Mughal emperors' most prized possessions. This white jade wine cup is carved with such skill that it appears translucent.*

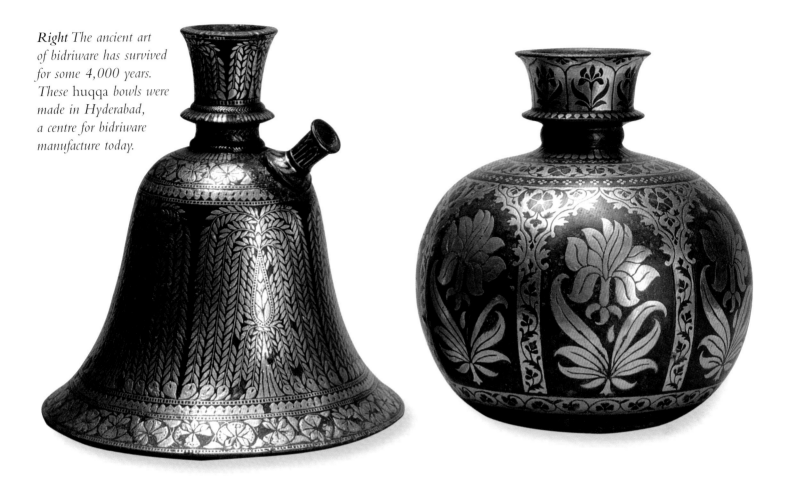

Right The ancient art
of bidriware has survived
for some 4,000 years.
These huqqa *bowls were
made in Hyderabad,
a centre for bidriware
manufacture today.*

tombs with astonishing complexity
and profusion. Mughal craftsmen
also produced smaller objects in
stone inlay, such as table tops, pen
stands, trinket boxes and coasters.

BIDRIWARE
Some of the most important metal
articles that have survived from the
Mughal period are bidriware, a
uniquely Indian kind of metalware
that takes its name from Bidar in
the Deccan, where it is thought to
have originated. The base metal of
bidriware is an alloy of zinc, copper,
lead and tin, which is richly inlaid
with silver. Many of the pieces
made before 1700 are also inlaid
with copper and brass.

The colour contrast beween the
often elaborate floral and abstract
silver patterns and the background
is enhanced by using a chemical to
turn the base metal a rich, lustrous
black. *Huqqa* bowls, ewers, basins
and trays were the objects most
frequently made of bidriware.

ROCK CRYSTAL AND GLASS
The clear, ice-like appearance
of rock crystal had a great
appeal for the Mughals and
Mughal examples, inlaid with
gems, survive from the
mid-17th century onward,
although the techniques of the
inlay process were already
known during Akbar's reign.
Vessels, such as cups and bowls,
were deeply engraved with
floral patterns, others inlaid with
gold and set with precious stones.

Long-necked glass decanters had
long been produced in India, but
there is no evidence of large-scale
glass production until the Mughal
period. Manuscript paintings show
bottles of every shape and size
arranged in wall niches or placed
on the floor beside the emperor.

Right This Mughal wine cup, made of
emerald, gold and enamel, was recently
sold at auction for £1.8 million, the
highest price ever realized for a wine cup.

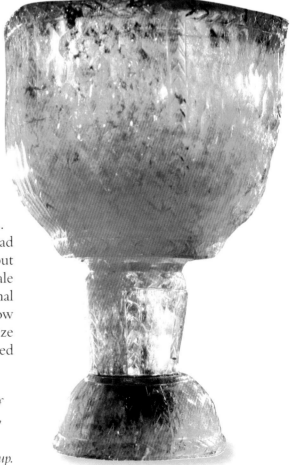

MUGHAL PAINTING

UNDER AKBAR'S LIBERAL PATRONAGE OF PERSIAN AND INDIAN PAINTERS, THE ART OF THE MUGHAL MINATURE EVOLVED, REACHING PERFECTION AT THE COURT OF JAHANGIR.

From the 16th to 19th centuries, artists found almost continuous employment at the Mughal court. They even accompanied the rulers on their hunting expeditions and military campaigns. Akbar (reigned 1556–1605), although reportedly illiterate, had a passion for books, particularly illustrated ones. He had also been taught to paint as a child. Early in his reign, he established a large studio of talented indigenous artists, who worked under the direction of the two great Persian masters, Mir Sayyid 'Ali and Abd as-Samad, who had been brought back from Iran by Akbar's father, Humayun.

Artists learned their trade as apprentices, often from their fathers or uncles as the craft was frequently a family occupation. They were taught how to make paintbrushes from bird quills set with fine hairs, how to grind their pigments and how to prepare the aqueous binding medium of gum arabic or glue. Seated on the ground, with one knee bent to support the drawing board, they painted with opaque watercolour on paper or occasionally on cotton cloth.

NATURALISM

Under Akbar's close supervision, a style of manuscript illustration evolved that combined native Indian traditions – he particularly admired Hindu painters – with Persian technical refinement. These manuscripts were full of vivid representations of plants, flowers, animals and people, despite orthodox religious objections to figurative painting. As Akbar's official historian, Abul Fazl, had commented: 'Bigoted followers of the letter of the law are hostile to the art of painting, but their eyes now see the truth.' This naturalism was also influenced by European prints and pictures brought to the Mughal court by merchants and Jesuit missionaries.

***Above** Beautiful mounts were a feature of Mughal painting. This example contains a portrait of Emperor Aurangzeb.*

AKBAR'S MANUSCRIPTS

In about 1567, Akbar ordered his artists to prepare an illustrated copy of the *Hamzanama*, the story of the mythical adventures of the uncle of the Prophet Muhammad. A team of 100 painters, gilders and binders were assembled for the task. The multivolume work contained no less than 1,400 paintings and took 15 years to complete.

One of the most outstanding examples of the Akbari style was the *Akbarnama*, the official history of Akbar's reign written by Abul Fazl. The vivid, naturalistic paintings illustrate scenes from the emperor's daily life and events from his military campaigns. At his death, Akbar's library contained some 24,000 volumes, including works in Persian, Arabic and Greek, many of which had been copied during his reign to the highest standards of book production.

***Left** A study of a zebra painted by the artist Mansur in 1621 for the famous 'Minto Album' begun by Jahangir. Exotic animals were commonly presented as diplomatic gifts.*

JAHANGIR'S ARTISTS

Akbar's achievement as a patron of artists was refined under Jahangir (reigned 1605–27), who was a great connoisseur of the arts and claimed that he could distinguish the work of each of his painters at a glance. Preferring quality to quantity, and lacking his father's fondness for grand projects, he greatly reduced the staff of the royal studio, concentrating instead on a few favourite masters. As a result, fewer illustrated manuscripts were produced and more individual pictures, usually portraits or animal and flower studies, were created.

During this time, artists were encouraged to paint with increased realism and subtlety, softer colours and more harmonious designs. Much of this work shows the influence of European painting, such as the use of perspective and shading. The individual paintings were often mounted in exquisitely decorated borders and bound together in albums.

Some of these artists also painted under Shah Jahan (reigned 1628–58). Detailed studies of flowering plants continued and one of the last great Mughal illustrated manuscripts, the *Padshahnama*, was painted. This was a history of the emperor's reign, with pictures recording military victories and court ceremonials. Their style is more formal and lacks the exuberance and dynamism of the paintings produced under Akbar and Jahangir.

Left Emperor Babur and his architect are shown planning the Bagh-i-Wafa near Jalalabad (1589–90).

ROYAL PORTRAITS

A large number of portraits were produced under Akbar. 'His Majesty himself sat for his likeness,' reported his chronicler, 'and also ordered to have the likenesses taken of all the grandees of the realm.' Jahangir's preference for individual pictures, rather than the historical manuscripts of Akbar's reign, also encouraged portraiture. His admiration of English manuscript paintings saw the beginning of a more naturalistic style of portrait and the use of symbolic imagery. Toward the end of his reign, his portraits contained Islamic, Hindu and European imagery, such as the halo, to affirm his continuing glory. Under Shah Jahan and his successors, portraiture became more stiffly official in character.

Above A likeness of Emperor Akbar (1542–1605), painted in gouache shortly after his death. He encouraged the artist to paint 'individual' works.

Above A portrait of Emperor Jahangir (1569–1627) holding a portrait of his father, Emperor Akbar (reigned 1556–1605).

INDIAN CARPETS

INDIAN CARPETS REACHED THE HEIGHT OF SPLENDOUR UNDER MUGHAL EMPERORS, WHOSE TASTE FOR LUXURY CREATED A FLOURISHING ENVIRONMENT FOR COMMERCE AND THE ARTS.

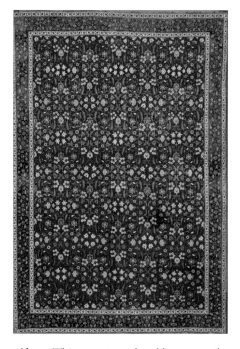

Above This carpet, with a blossom and lattice design, is made of pashmina, *the delicate Kashmiri wool, which was considered the best material for the knots of luxury carpets.*

The art of weaving carpets is not native to India: the hot damp climate makes warm floor coverings both impractical and unneccesary. It was through Babur, the founder of the Mughal dynasty, that the art of the carpet was first implanted in India. The earliest documentary evidence that carpets were being manufactured in India appears in the chronicles of Akbar's reign (1556–1605), the *Ain-i Akbari*. His chronicler, Abul Fazl, relates that the emperor: '…has caused carpets to be made of wonderful varieties and charming textures; he has appointed experienced workmen, who have produced many masterpieces…All kinds of carpet weavers have settled here, and drive a flourishing trade.' Some of the carpet weavers, especially the weavers of floral carpets, were of Persian origin.

EARLY MUGHAL CARPETS

The carpets made in Akbar's imperial workshops in Fatehpur Sikri, Agra, Delhi and Lahore set a standard for subsequent carpet weaving in India, which resulted in carpets of jewel-like beauty. They were densely knotted, with woollen piles and cotton or silk warps and wefts (the woven threads that form the base of the carpet). Their subjects were often taken from Mughal manuscript paintings. Alongside accurately depicted real animals are fabulous beasts drawn from mythological subjects. Hunting scenes showing hunters pursuing a fleeing deer remain among the most famous scenes on Mughal carpets. Some designs have swirling foliate scrolls, while others are semipictorial, depicting various animals locked in savage combat.

Most of the finest Mughal carpets date from Jahangir's reign (1605–27). The designs on the carpets show animals, human figures and plants,

Left This 16th-century red silk carpet shows the thick silver arabesque designs common in the most luxurious Mughal designs of the period.

which tend to be represented with remarkable realism. It was under Jahangir that trade with the English was initiated and huge sums of money were invested in the carpet-weaving industry. Many of the carpets exported to Europe were elongated because they were used to cover tables. Sir Thomas Roe, the English ambassador to Jahangir's court, is known to have returned from India with 'a great carpet with my arms thereon'.

FLORAL CARPETS

Many examples of fine floral carpets also date from this period, and on into Shah Jahan's reign (1628–58). The Lahore floral rugs date from the mid-17th century and echo the architectural decoration in buildings such as the Taj Mahal. Also from Shah Jahan's reign are prayer rugs that show a large flowering plant flanked by smaller plants within a *mihrab* (niche). These are perhaps the most typically Mughal of all carpet

Right Made of silk interwoven with silver, this carpet shows hunters killing a deer. Hunting scenes are among the most famous subjects used by Mughal weavers.

designs. Another distinctive group shows flowering plants arranged in rows. The naturalism of the flowers is a characteristic of these carpets, as is the use of a deep red background. A variation on this scheme, which frames plants in a golden lattice, was probably developed in the time of Aurangzeb (reigned 1658–1707). Lattice is a characteristic motif of architectural decoration in his reign.

THE USES OF CARPETS

Illustrated manuscripts reveal that carpets were not just laid on the floors of palaces, but in tombs and imperial tents. On special festive occasions even the streets of Akbar's imperial city, Fatehpur Sikri, were strewn with carpets. So highly regarded were they that visitors to the Mughal court were required to remove their shoes before walking on them. When Shah Jahan received important visitors in his Hall of Private Audience, every surface of the room was covered with silk carpets. All Akbar's most valuable carpets and textiles were stored in the *farrashkhana* (private storehouse) at Fatehpur Sikri. Akbar considered this one of the most important areas of his household for it was these textiles that were used to display the power and wealth of his court.

After the fall of the Mughals, the East India Company encouraged the production of carpets that would suit the European market, but they were not as sumptuous or so skilfully made.

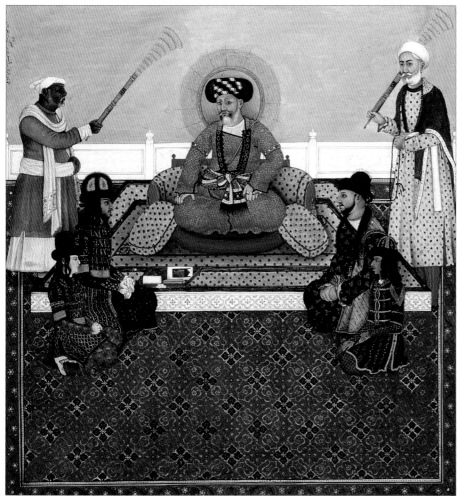

Left Emperor Akbar Shah II sits on a dais with his sons. To preserve the luxurious carpet, they have removed their shoes.

JEWELLERY

WORN BY BOTH MEN AND WOMEN, MUGHAL JEWELLERY WAS THE MOST OPULENT IN THE ISLAMIC WORLD. PRECIOUS STONES WERE ALSO USED IN THE ORNAMENTATION OF OTHER OBJECTS.

An Italian visitor to India in the second half of the 17th century was astonished by the conspicuous consumption and display at the Mughal court. 'In the Mughal kingdom,' he wrote, 'the nobles, and above all the king, live with such ostentation that the most sumptuous European courts cannot compare in richness and magnificence with the lustre beheld in the Indian court.'

The splendour of the court was enhanced by the custom of giving and receiving presents. When the emperor received honoured guests, he presented them with gifts, such as robes of honour, gold, silver and richly decorated swords and daggers. Sir Thomas Roe, the English ambassador at Jahangir's court, received a gold cup from the emperor, which was 'set all over with small turquoises and rubies, the cover the same set with great turquoises, rubies and emeralds…'

However, the custom also worked in reverse: to gain an audience with the emperor, it was obligatory for the visitor to present him with some precious object. 'For no man,' wrote a visiting French jeweller, 'must come into his presence empty-handed, though it be an honour dearly purchased.' Courtiers, too, were required to give expensive gifts to the emperor and to important members of the imperial household.

SUPPLYING THE DEMAND

This constant demand for jewelled objects was met by the imperial workshops, or *karkhanas*, which employed thousands of skilled craftsmen, many of them foreigners who had been attracted to India by the enormous wealth of the Mughal court. According to an account by one of Akbar's courtiers, gems could be purchased in the town markets. After a visit to Bijapur, he wrote: 'In the jewellers' shops were jewels of all sorts, wrought into a variety of articles, such as daggers, knives, mirrors, necklaces, and also in the form of birds…all studded with valuable jewels, and arranged upon shelves, rising one above the other.'

Left A naturalistic floral design is carved into this dark green, hexagonal Mughal emerald – a decoration reflecting their love of nature.

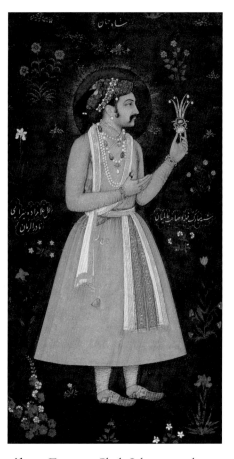

Above Emperor Shah Jahan was the most extravagant of all the Mughal emperors. He regularly wore diamonds weighing over 50 carats.

MALE JEWELLERY

All the Mughal emperors, especially Jahangir (reigned 1605–27) and Shah Jahan (reigned 1628–58), were festooned with jewels. 'For the Mughals, though his clothing be not so rich and costly, yet I believe that there is never a monarch in the whole world that is daily adorned with so many jewels as he himself,' reported an English clergyman at Jahangir's court. Akbar's jewels were all given names, while Jahangir had his arranged in such a way that he could wear a different set each day.

Pearls played an especially important role. By the time of Akbar (reigned 1556–1605), double and triple strands of pearls were symbols of nobility. Portraits of the emperors also show them wearing enamelled gold armlets, jewelled turban ornaments, pearl earrings,

gold bracelets inset with diamonds and rubies, archer's rings on their thumbs and pendants with rubies and emeralds.

FEMALE JEWELLERY

The imperial ladies wore earrings, armlets, forehead ornaments, rings, bracelets, gem-studded necklaces and several ropes of pearls, which hung down to below their waists. In the harem, the concubines were similarly bedecked: according to one French visitor, they wore the sleeves of their thin dresses short so that 'they may have liberty to adorn the rest of their arm with carcanets (chains) and bracelets of gold, silver and ivory, or set with precious stones…'

OTHER BEJEWELLED ITEMS

The goldsmith's art was even applied to weapons: dagger and sword hilts, which were often made of hard stones, such as jade and rock crystal, were carved and encrusted with gold and precious stones.

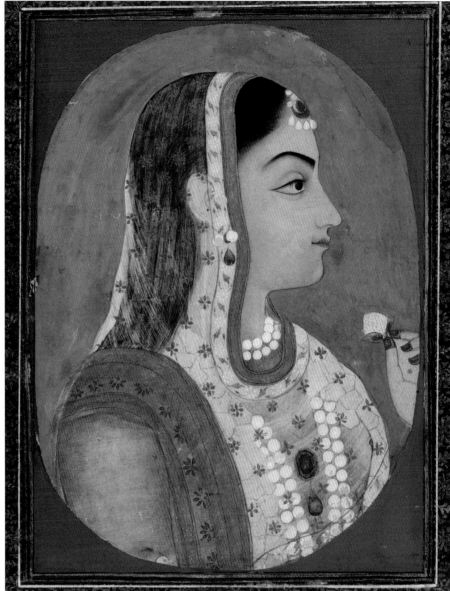

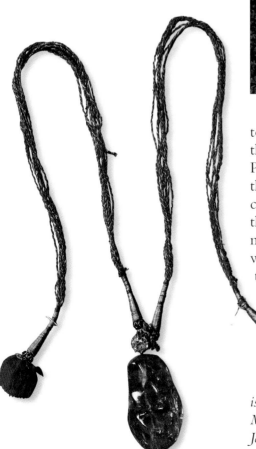

However, the object that came to symbolize the splendour of the Mughal court was Shah Jahan's Peacock Throne. This celebrated throne, which took seven years to construct, was commissioned by the emperor at his coronation as a means of displaying the incredible wealth of jewels in the royal treasury. Contemporary accounts give conflicting descriptions, but paintings show Shah Jahan seated cross-

Left Known as 'The Carew Spinel', this gemstone is inscribed with the names of three Mughal emperors – Jahangir, Shah Jahan and Aurangzeb.

Above This early 18th-century Mughal miniature painting depicts a noblewoman wearing earrings and a necklace made from pearls, emeralds and spinel stones.

legged on a four-legged dais, with four columns supporting a domed canopy. Above the canopy was a peacock, its raised tail studded with sapphires and other precious stones. In the centre of its breast lay a great ruby, given by Shah Abbas, the Safavid emperor, to Jahangir. Every surface of the throne was encrusted with diamonds, pearls, emeralds and rubies. In 1739, it was looted by Nadir Shah and carried off to Iran, and a decade later it was destroyed.

COMPANY PAINTINGS

AS THE MUGHAL EMPIRE BEGAN TO DECLINE, THE EMPEROR'S PATRONAGE OF ARTISTS WAS TAKEN UP BY OFFICERS OF THE EAST INDIA COMPANY. THESE WORKS ARE KNOWN AS COMPANY PAINTINGS.

The Mughal emperors were receptive to Western artistic ideas and both Akbar (reigned 1556–1605) and his successor Jahangir (reigned 1605–27) had collected European prints and other works of art. Mughal artists copied these imported pictures and began to paint nature with greater realism, adding shading and perspective to their own work.

EARLY COMMISSIONS

Both the Mughal love of nature and their penchant for portraits were shared by many Britons and Europeans based in India. The British were also familiar with the technique of Indian artists – opaque watercolour or gouache on paper – because it was identical to that used by artists in Britain. Having seen and admired the work of Mughal artists, in the mid-18th century officers of the East India Company began to commission their own paintings from them.

The initial commissions were for miniature paintings, executed in the traditional Indian manner but showing scenes with European figures. These portraits often depict a portly European gentleman, sometimes wearing Indian dress, seated awkwardly on a cushion and drawing on a *huqqa*, a type of smoking pipe. With their propensity for documenting everything, the British commissioned pictures of native crafts, castes, festivals and pastimes – indeed, exactly the kind of subjects that are photographed today. The depiction of natural history subjects and topographical views of famous Mughal monuments followed.

One of the earliest and most important collections of natural history subjects was commissioned in Calcutta between 1777 and 1783 by Lady Mary Impey, wife of the Chief Justice of Bengal. While the drawings show a mastery of the subject, they have a power and

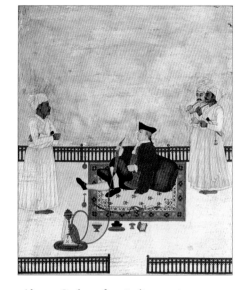

Above Only a few Indian artists were known by name, but Dip Chand signed this charming picture of Dr William Fullarton on his terrace, puffing a huqqa.

character all their own. Their distinctive quality perhaps indicates that the artists were given complete freedom to express their talents as they wished.

THE FRASER ALBUMS

A remarkable collection of more than 90 watercolours by Indian artists was commissioned between 1815 and 1819 by two brothers, James and William Baillie Fraser. Known as the Fraser Albums, this collection is now generally accepted as one of the finest groups of Company pictures ever painted by Indian artists. They record a broad range of Indian life in Delhi and its surroundings and depict some of the colourful Indian characters encountered by William Fraser in the course of his civil and military employment. One of the most arresting drawings is of a young Indian trooper who had saved his life when he was attacked by a would-be assassin.

Left These two women and a buffalo were painted by the Indian artist who accompanied William Fraser on his travels for the East India Company.

Because the Indian artists were regarded by their patrons as no more than employees, few of their names were recorded. Most Indian painters were artists because they had been born into a family whose men followed the caste profession. Although the identity of the artists who worked on the Fraser Albums is uncertain, they are thought to be the work of a single family, that of Ghulam Ali Khan. He is probably also the artist responsible for the illustrations in the Skinner Album, commissioned by Colonel James Skinner, the Anglo-Indian Colonel of the famous Irregular Cavalry Corps, Skinner's Horse.

TOPOGRAPHICAL PAINTINGS

The first purely topographical artist known from late Mughal Delhi was Mazhar 'Ali Khan. It seems likely that he was commissioned by Thomas Metcalfe, the Agent representing British power at Delhi, to produce 125 paintings of Mughal monuments in the city and surrounding area. One of the most impressive of his pictures, painted in 1846, is a large-scale panorama of Delhi, nearly 5m (16ft) wide. It is a valuable record of the Red Fort and the outlying city before much of it was destroyed in 1858.

One well-known name among Indian artists working for the British in Calcutta was Shaykh Muhammad Amir of Karraya. His paintings depict the British way of life in and around the city: their large, palatial mansions, favourite dogs, horses and carriages. One picture, painted in 1845, shows a little girl on a pony attended by no less than three servants. Her face is entirely hidden by a blue bonnet and her isolation from reality seems to symbolize the colonial position of the British in India before the Mutiny that occurred in 1857.

Above The British often employed local Indian artists to paint their houses or favourite animals. This racehorse, jockey and groom are shown on the racecourse.

Above This bird of prey was one of 44 paintings, bound together in a volume, which were executed by an Indian artist for an East India Company botanist.

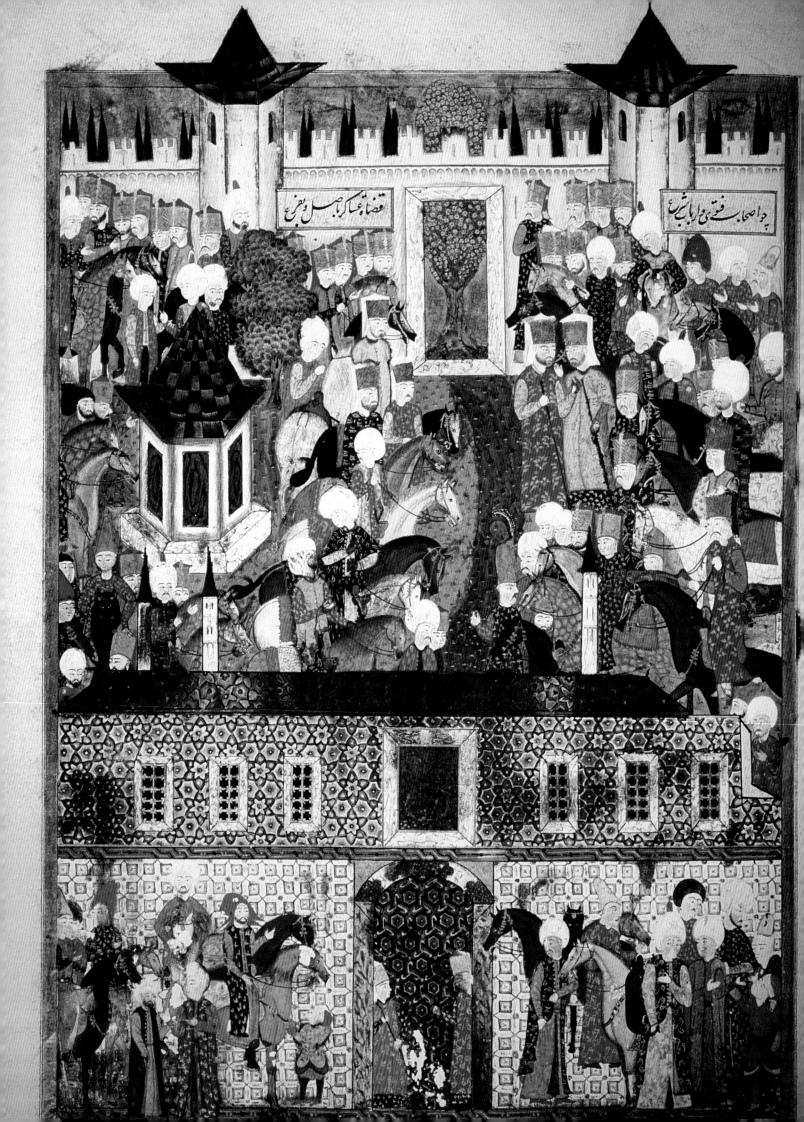

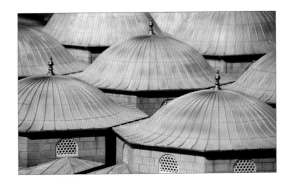

THE OTTOMAN EMPIRE

O f Central Asian tribal descent, the Ottoman Turks first formed a small *beylik* (principality) close to the Byzantine frontier in Anatolia in the 13th century. In 1453, the Ottoman Sultan Mehmet II ('the Conqueror') captured Constantinople (Istanbul) from the failing Byzantine Empire, and the imperial city became the heart of Ottoman power, ruling a massive land empire that lasted until 1924. At its greatest extent, Ottoman territory extended from North Africa to Iraq and from Arabia into the Balkans, pressing to the walls of Hapsburg Vienna on two separate occasions. The golden age for imperial Ottoman culture was the 16th century, particularly the long and glorious reign of Sultan Suleyman 'the Magnificent' (1520–66). The architect Sinan transformed the urban landscape of Istanbul and other Ottoman cities with formidable mosque complexes, while the luxury arts promoted an elegant floral style. The Ottoman sultans were great patrons of the arts and attracted the most talented artists and craftsmen, from calligraphers and metalworkers to the renowned potters of Iznik.

Opposite The Topkapi palace courtyards are filled with soldiers and courtiers in this 1558 painting.

Above Domes are clustered together at the Bayezid I Mosque complex (1390–95) in Bursa. The foundation includes a dervish lodge, hospital, hammam, madrasa and mausoleum for the sultan.

EARLY OTTOMAN ARCHITECTURE

IN THE 14TH AND EARLY 15TH CENTURIES, THE OTTOMANS BECAME POWERFUL IN THE EASTERN MEDITERRANEAN. THEIR ARCHITECTURAL STYLE WAS INFLUENCED BY BYZANTINE ORIGINALS.

A succession of victories against the weakened Byzantine Empire allowed the Ottomans to expand their dominion at a fast rate. In 1326, Orhan Gazi (reigned 1324–62) conquered Bursa, a town near the southern coast of the Sea of Marmara that became his capital. The crossing into Europe in 1349 shifted the weight of conquest west, and Edirne was declared the new capital after its capture by Murad I (reigned 1362–89) in 1365.

MERGING TRADITIONS

Both early Ottoman capitals alongside Iznik, a town near Bursa conquered in 1331, preserve a large number of early Ottoman buildings. These modest in scale but ambitious structures can be viewed as Ottoman variations on traditional themes. However, their experimental plans and novel ideas cannot be explained without taking into account the main outside influence on the Ottomans, which was Byzantium.

While adopting the fiscal and administrative structures of the fading empire for practical reasons, the Turkish sultans also tried to emulate the splendour and continue the legacy of an ancient Mediterranean imperial tradition. They aspired to the conquest of Constantinople, the ultimate imperial Roman city of the East. Ottoman builders made use of the Byzantine repertoire of architectural forms and techniques that were drawn from buildings within their conquered lands.

DOMED SPACES

The predominance of domes found within Ottoman architecture has been attributed to both an Islamic

Above A band of calligraphy forms part of the ornate decoration on this 1396 column from the western portal of the Ulu Cami in Bursa.

tradition developed by the Seljuks and a Byzantine influence. However, it is in the treatment of space under the dome and in the techniques adopted in order to support it that Ottoman originality and Byzantine inheritance are better demonstrated. The earliest surviving Ottoman mosques were cubic buildings crowned with relatively large domes resting on pendentives or squinches that bridged the triangular spaces between the corners of the walls and the perimeter of the domes. However, it was their builders' constant concern to expand the space under the dome without breaking up its unity with bulky supports or blind walls. An easy solution was to increase the number of domes and place them on arches resting on columns or pillars.

Left The Ottoman Empire was formed by Turkish tribes from Anatolia. The expanding state included Bursa to the east and Edirne to the west.

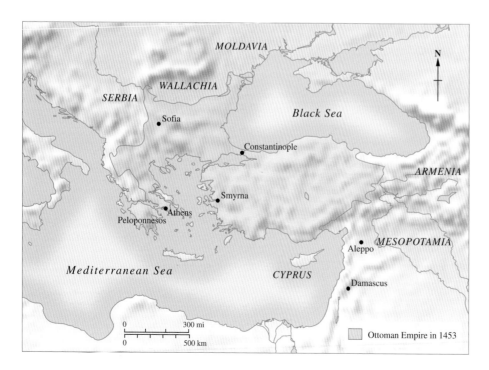

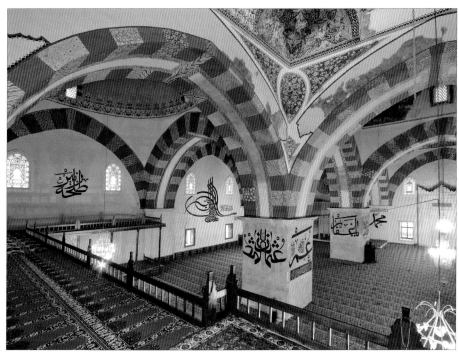

Above Huge pillars inside the late 14th-century Eski Cami, decorated with 19th-century calligraphy, support arches and domes above.

EARLY EXPERIMENTATION

The Ulu Cami (Great Mosque) in Bursa, built in 1396–1400 for Sultan Bayezid I (reigned 1389–1402), is the most representative example of this multidomed type. Despite its significant ground area, the forest of 12 columns necessary to support 20 domes marred the desired feeling of expansiveness. The same problem had been faced a thousand years earlier by the builders of the Early Christian period, and several solutions had been proposed, most popular being the domed cross-in-square plan, in which a central domed square space is surrounded by eight square spaces of equal or similar proportions. The Eski Cami Mosque in Edirne (1403–14) can be viewed either as a concentrated version of the Ulu Cami, with only nine domes

Right The impressive 15th-century Uc Serefeli Mosque (1438–47) was the first in Edirne to have a large courtyard adjoining the prayer hall.

supported by four pillars, or as a version of the nine-bay solution, a plan not unknown to Islamic architecture but better developed within the Byzantine world.

Further proof of the Byzantine origin of this idea is the late 14th-century Didymoteicho Mosque, in which the central bay is wider and crowned with a dome, whereas the surrounding eight bays are smaller and covered with barrel or cross vaults. This arrangement appears frequently in Byzantine buildings that were scattered within the newly conquered Balkans, for example at the 1028 church of Panagia 'ton Chalkeon', in the administrative and trade centre of Thessaloniki, conquered in 1430.

Given the conscious adoption of a Byzantine prototype for most Ottoman mosques after the conquest of Constantinople in 1453, it would be reasonable to assume that a similar desire to include Byzantine, and ultimately Roman, imperial elements within the designs of early Ottoman architecture had encouraged these experimental plans, although they proved to be short-lived.

Nevertheless, the century that predated the 1453 conquest has offered innovative buildings. An elegant example is the Uc Serefeli Mosque (1438–47) in Edirne, built for Murad II (reigned 1421–44, 1445–51) and featuring a 24-m (79-ft) wide dome resting unusually on a hexagon instead of a square or octagon. The side pillars prevent unimpeded views of the four side bays, but the effect is novel and challenging, and is unique within the Ottoman architectural canon.

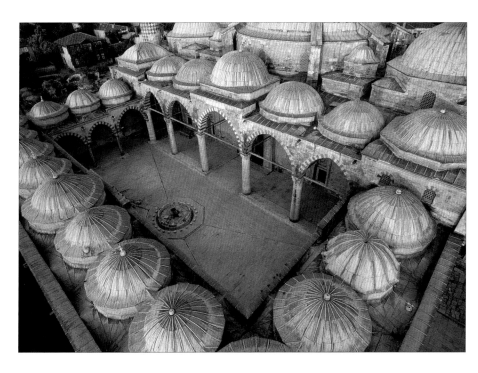

CONSTANTINOPLE (ISTANBUL)

THE OTTOMANS GAINED A NEW PRESTIGIOUS CAPITAL WHEN THEY
TOOK CONSTANTINOPLE IN 1453. THE CITY ALSO PROVIDED THEIR
BUILDERS WITH THE PROTOTYPE FOR THEIR GREAT MOSQUES.

Istanbul, the Turkish version of the Greek words *eis ten polin*, or 'to the City', became the official name of the city on the Bosphorus only as late as 1930. Until that date, it was still called Constantinople, 'the city of Constantine', a name reflecting its Roman and Byzantine imperial past. The grandeur of this capital of three successive empires inspired several sieges by Muslim rulers, but the prize of conquest was reserved for Sultan Mehmet II (reigned 1444–46, 1451–81), who consequently assumed the epithet of Fatih, 'the Conqueror.'

THE FATIH MOSQUE

The first mosque to be built in the soon-to-be-regenerated capital still bears the same name, Fatih Mosque (1462–70), and despite collapsing and being reconstructed in 1771, it retains its original plan. Like the pre-1453 mosques of Bursa, Edirne and Didymoteicho, it has a large central domed roof and some lateral bays, but it also presents the first occurrence of a feature that later would develop into the main characteristic of classical Ottoman mosques: a large semidome that supports the main dome on the *qibla* (toward the direction of prayer) side over a long and narrow bay, unlike the square side bays to the left and right. Significantly, this bay is separated from the domed central bay by an arch supported by pillars that recede to the sides, creating the illusion of a unified roof consisting of the central dome and the semidome.

THE HAGIA SOPHIA PLAN

This effect was undoubtedly inspired by the patriarchal church of Byzantine Constantinople and eventually mosque of the Ottomans, Hagia Sophia (Ayasofya),

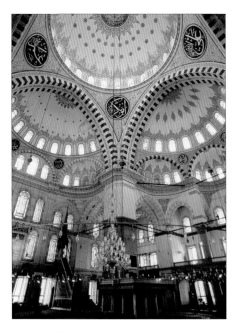

Above *The interior decoration of the reconstructed Fatih Mosque follows the Baroque style of 18th-century Ottoman architecture.*

a building laden with imperial connotations. Built between 532 and 537, it was an inventive and short-lived answer to the problem of a large floor area sheltered by a domed roof. The 'Hagia Sophia plan' was popular with Ottoman builders and characterized 16th-century mosque architecture.

The original 'Hagia Sophia plan,' as in the 6th-century cathedral, was finished with a second semidome opposite, creating an elongated oval shell. The complete version first appeared in the Sultan Bayezid Mosque in Istanbul, built for Bayezid II (reigned 1481–1512) around the turn of the century, in which the central core (semidome-dome-semidome) was flanked to the right and left by eight domes arranged over eight bays.

The most faithful Ottoman version of the plan was erected between 1550 and 1557 by Sinan

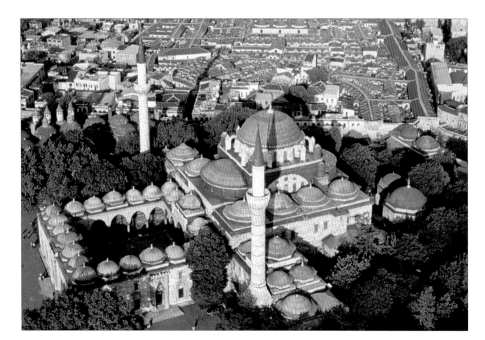

Left *This aerial view of the Sultan Bayezid Mosque (1501–6) gives some idea of its relatively small scale, compared with the Suleymaniye complex.*

(1489–1588), the principal architect of the Ottoman Empire, for Sultan Suleyman 'the Magnificent' (reigned 1520–66). The Suleymaniye Mosque, the high point of classical Istanbul architecture, bears a striking resemblance to the Byzantine cathedral in both proportions and ground plan, although the lofty arches opening to the right and left toward the side bays represent a step forward by alleviating the restricting effect of the church's side walls.

BEYOND THE PROTOTYPE

While little innovation can be seen in the floor plans of sultanic mosques because they adhere to a venerated prototype, the architectural designs of smaller buildings are often more original. The graceful Sehzade Mosque, built by Sinan in 1543 to commemorate the son of Suleyman I, was a symmetrical departure from the Hagia Sophia plan. Two lateral semidomes balancing the ones on and opposite the *qibla* side create a strong central focus complementing the single large dome. The pillars carrying the main arches are pushed toward the outside walls to allow the play of curved surfaces on the top half of the building's interior to counterbalance the strong vertical lines of the supports. By this stage, walls are simple screens bridging the gaps between load-bearing elements and they are profusely pierced with stained-glass windows in symmetrical arrangements.

Buildings other than mosques, erected around the Ottoman Empire in great numbers, were built within the traditions of earlier Islamic architecture. Surrounding mosques and supporting them financially were complexes of shops and *hammams* (bathhouses), creating income to cover the running costs of mosques and charitable institutions complementing their social role, such as *imarets* (public kitchens) and *madrasas* (religious colleges).

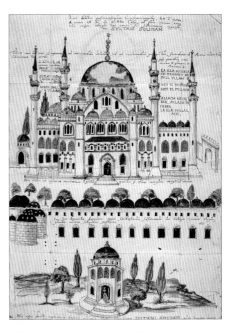

Above A drawing of the Suleymaniye Mosque shows the domed roof based on the Hagia Sophia plan. The grand scale of the complex symbolizes the sultan's power.

Below The Hagia Sophia's domed structure inspired Ottoman architects. The giant Arabic calligraphy panels were added to the interior in the 16th century.

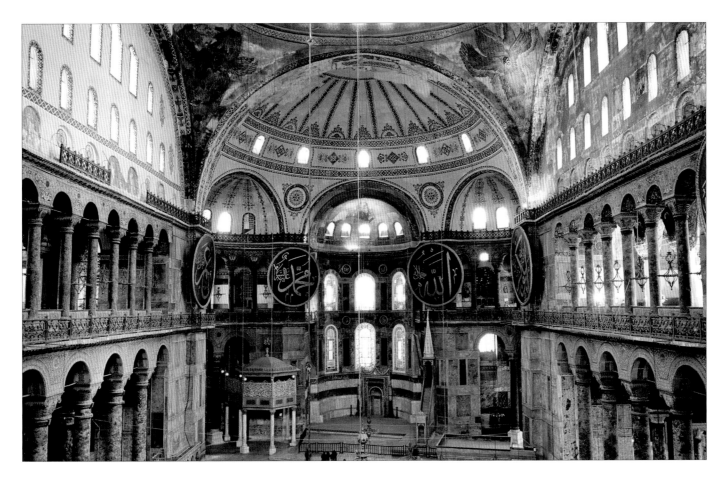

THE CLASSICAL ERA

CLAD WITH IZNIK TILES AND DRESSED STONE, AND EMBELLISHED WITH STAINED GLASS AND FURNITURE, 16TH-CENTURY OTTOMAN MOSQUES ARE AMONG THE GLORIES OF ISLAMIC ARCHITECTURE.

The grandeur of the classical Ottoman mosques is not only due to their vast size, ground plan and height but also to their interior decoration. The balance between light and dark, straight and curved lines, empty space and decorative excess reaches its pinnacle in the works of the master builder Sinan.

INTERIOR DECORATION

The striking colours of the tiles that adorn the buildings, commissioned from workshops in Istanbul and the town of Iznik not far from the capital, have preserved the splendour of decorative schemes from the 16th century. This is often not true of other decorative materials: few stained-glass windows have survived and the wall paintings have often been renewed several times since first executed. Contrary to current practice, it is possible that the polished marble floors were uncovered in hot summer months, to reflect light streaming in from the windows. However, bitter Istanbul winters called for warmer coverings, and the few period carpets still extant testify to the opulent, colourful woven fields of flowers and elaborate geometry added to the mosque interiors.

Sinan's Rüstem Pasha Mosque (1561–63) in Istanbul, commissioned by the Grand Wazir and son-in-law of Suleyman 'the Magnificent', is an architecturally unassuming edifice with an ornate interior featuring a profusion of tiles arranged in panels on the walls both inside and under the front porch. The splendour and expense of the decorations enhanced the visual impact of the building.

Even more impressive is the tile cladding of the Sokollu Mehmet Pasha Mosque (1571–72), again by Sinan, for the successor of Rustem

Above The floral pattern on the tiles in the Rustem Pasha Mosque includes an innovative red glaze.

Pasha. In this simple domed space with four semidomes over the side bays, the stone surfaces of the walls and bearing elements are only selectively embellished with tiles, custom-made to fit specific spaces. The beautiful effect achieved, despite the unremarkable architecture must have been worthy compensation for the time and effort needed. The survival in more-or-less original form of the stained-glass windows completes the image of a restrained yet elegant interior.

BUILDING DONORS

The relation between the donors who funded the building of both of these mosques and the sultan emphasizes the social and political dimension of such religous foundations. The ruler's family and high officials of the empire erected extravagant public structures as status symbols advertising their donors' munificence and power to the capital's citizens. Women of the imperial family were also great

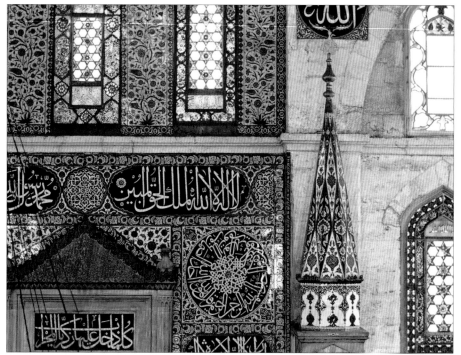

Left Calligraphy and floral patterns are among the design elements in the blue, green, red and white tiles that adorn the Sokollu Mehmet Pasha Mosque.

builders. Mihrimah Sultana, daughter of Suleyman 'the Magnificent' and wife of Rüstem Pasha, erected a mosque near the Edirne Gate of Istanbul's walls between 1562 and 1565. The choice of architect was unsurprising: Sinan's dense fenestration of the elevated cube under the dome dematerializes the Mihrimah Sultana Mosque's structure; he would fully deploy this decorative device a decade later in Edirne's Selimiye Mosque. The comparatively modest scale of non-sultanic buildings was a testing ground for ideas that were blended into an elegantly varied yet homogeneous body of work.

THE ARCHITECT SINAN

Sinan was the most important *mimar* (architect) in Istanbul and his long career spanning the reigns of three sultans, from the early 16th century to his death in 1588, marks the classical period of Ottoman architecture. A cross between a civil engineer, an architect and a minister of public works with a portfolio of hundreds of monuments across the Ottoman dominion, Sinan was revered even in his own lifetime.

His masterpiece is the light-filled, delicately detailed Selimiye Mosque, built in Edirne (1569–75) for Selim II (reigned 1566–74). With this mosque he claimed to have surpassed Hagia Sophia in building a larger dome. However, his real achievement is the distribution of interior space under the vast dome, which rests on eight arches supported alternately by semidomes and window-pierced walls. The arches spring from capital-free pillars that recede toward the outside of the building, creating a huge unified space unobstructed by structural elements. The multitude of glazed windows admits abundant daylight, forming an open-air, ethereal illusion. In the Selimiye Mosque, Ottoman architecture had truly surpassed its prototype, pushing the capacity of building materials and geometry to their limits.

The architecture of the late 16th and 17th centuries added few variations to the themes already introduced by Sinan and his predecessors, and there was a decline in the standards of both construction and decoration.

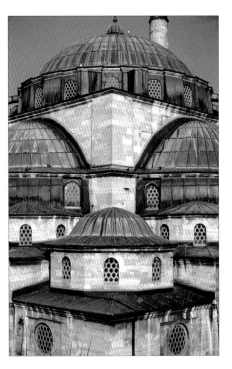

Above A main dome on a cubed structure forms the base of the Mihrimah Sultana Mosque. It was the first time Sinan used semidomes flanking a central dome.

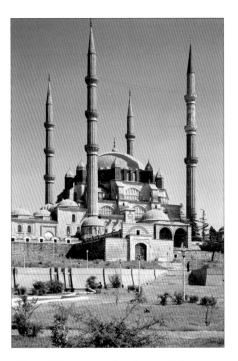

Above The impressive dome of the Selimiye Mosque stands 42m (138ft) tall. The slender towering minarets reach a tapered point at about 71m (233ft).

Left Pillars arranged in an octagon shape support the massive dome of the Selimiye Mosque, creating a huge area illuminated by natural daylight.

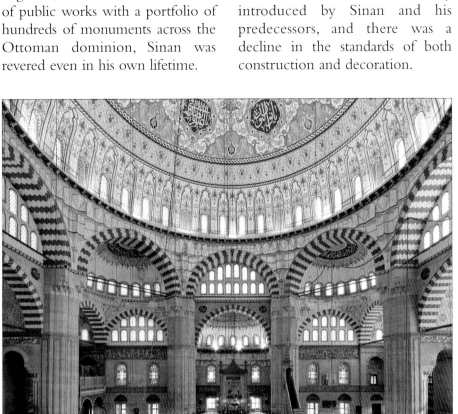

TOPKAPI PALACE

THE LEGENDARY TOPKAPI PALACE PRESERVES MOST OF ITS ORIGINAL
PLANS, ALONG WITH EXQUISITE ARTEFACTS. ITS HISTORY EPITOMIZES
THE OTTOMAN EMPIRE, AN AMALGAM OF GRANDEUR AND TERROR.

Founded by Mehmet II in the 1450s, Topkapi Palace is one of the best-known of the Islamic world. Built on the acropolis of ancient Constantinople, it overlooks the Golden Horn, the Sea of Marmara and the Bosphorus, and was an ideal location for the new centre of Ottoman power. It is difficult to envisage its original setting of hunting grounds and gardens, but its nucleus – a series of courts and buildings – survives.

AN ORDERED UNIVERSE
Today's experience of walking through the palace is chaotic; the labyrinthine ground plan evolved in an organic way from the complex's original foundation to the late 16th century and even later, thanks to additions and alterations that continued until 1855, when the court moved to the Dolmabahçe Palace. Although the main areas have kept their principal use unaltered for centuries, other functions have changed between apartments, adding to the confusion.

However, there was an exacting order that permeated everyday life within the enclosure. Specific groups were admitted at particular areas during determined times to perform prescribed duties. Some quarters were altogether out-of-bounds, except to a few: famously, the only non-eunuch adult male to be allowed in the harem, the female quarters, was the sultan himself. Even access to the successive courts was progressively restricted as one approached the fourth court – the sultan's private domain.

A HIERARCHICAL LAYOUT
The Gate of Majesty leads into the first court, where the Imperial Mint and the 8th-century church of Hagia Irene, used in Ottoman times as a warehouse and armoury, still stand. Upon arriving at the Gate of Salutation or Middle Gate, everyone but the sultan had to dismount in order to proceed into the second court, the main gathering place for courtiers, the location of the grandest audiences

Above The Throne Room, where the sultan received ladies from the harem, was in the third courtyard – restricted quarters entered from the Gate of Felicity.

with the sultan and the point of access to various areas of the palace: the kitchens, rebuilt by Sinan after a fire in 1574, the Outer Treasury, the Divan Hall, seat of the government council, the Tower of Justice and the harem, among others. From here, and through the Gate of Felicity, or of the White Eunuchs, the few that were granted access by the sultan could enter the third court, surrounded by the Chamber of Petitions, or Throne Room, the Library of Ahmet III (reigned 1703–30), the Mosque of the Aghas, the Kiosk of the Conqueror (housing the Inner Treasury), the Dormitory of the 39 Senior Pages (the sultan himself being the 40th 'page') and the sultan's apartments.

From here the sultan accessed the harem, a complex of palatial proportions in itself; apartments featured several smaller or larger mosques, ancillary rooms, *hammams* (bathhouses) and warehouses. Finally, in the innermost fourth court, visitors can nowadays enjoy the views and lofty quarters once reserved for the sultan, among them

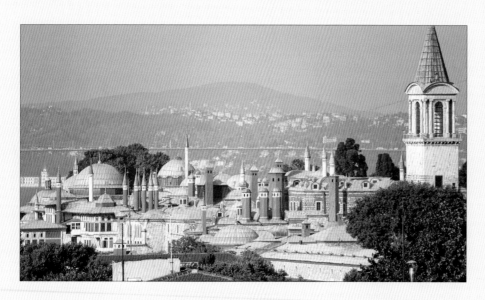

Left A dense array of buildings form the Topkapi Palace, originally called the Yeni Saray, or 'New Palace'. The Tower of Justice can be seen here (right).

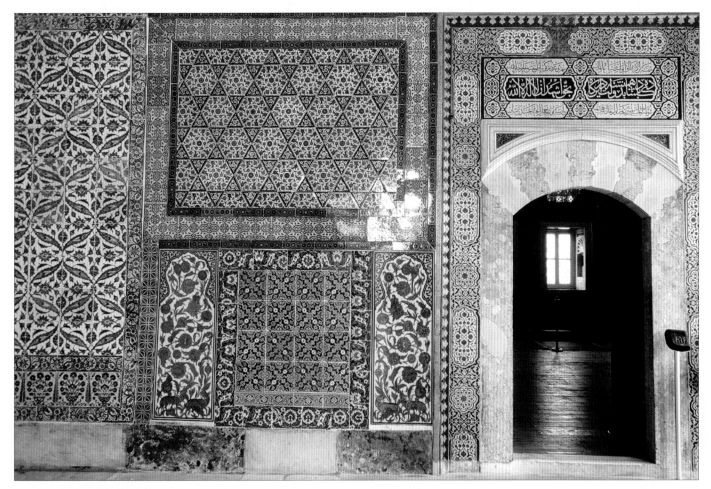

the superbly decorated Baghdad Kiosk and Circumcision Chamber, standing between pools. The slopes leading down to the sea are still planted and give a flavour of the gardens that surrounded the palace.

DRAMA AND TEDIUM
The inaccessibility of the palace and secrecy surrounding life within its walls allowed the creation and propagation of stories about it that are a mixture of truth and myth. Erotic fantasies focusing on the harem, in reality more of a school for ladies than a den of lust, have been combined with stories of brutality. It is hard to envisage within the splendidly tiled walls of the Circumcision Chamber the execution of a new sultan's brothers so that no competitors could appear from within the bloodline. The rooms of the harem witnessed the rule of more than one imperious

valide sultan (sultan's mother) and the suffering of several weak sultans who preferred a 'golden cage' to the military tent. However, the short exciting spells simply interrupted years of repetitive official duties performed by myriads of officials, workers and slaves supporting the government of the vast empire.

Above The Circumcision Chamber was clad with the finest tiles manufactured during the peak of Iznik production.

Below The love of flowers is apparent in the 18th-century Fruit Room, where painted wooden panels of fruit and flowers decorate the walls and ceiling.

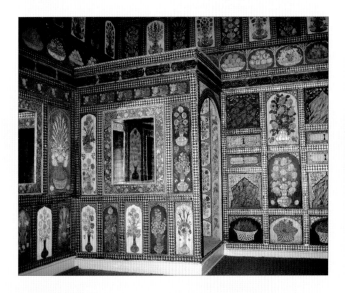

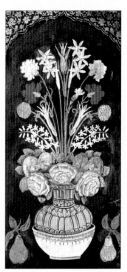

DAMASCUS, ALEPPO AND IZNIK

AS THEY EXTENDED THEIR TERRITORIES, THE OTTOMANS BUILT NOTABLE STRUCTURES IN OTHER CITIES, SUCH AS THE ANCIENT SYRIAN CENTRES OF DAMASCUS AND ALEPPO AND IN IZNIK.

The highly attractive Dervish Pasha Mosque in Damascus was built in 1574 by the Ottoman governor of the city, Dervish Pasha. The use of the traditional Syrian architectural feature of *ablaq* (bands of alternating black-and-white stone) gives the main façade a distinctive look. The entrance consists of an arched doorway with an Arabic inscription naming patron and date and a polygonal minaret with conical roof above. Within, there is a rectangular open-air courtyard with polychrome paving and at its centre a 16-sided fountain; on the yard's south side stands the prayer hall's five-bay portico with five small domes supported by white stone columns. From the courtyard a spiral staircase climbs to the minaret.

The prayer hall is a typically Ottoman square-domed space, with side aisles, each with three smaller domes. The main dome has 16 arched windows. To the south, the *qibla* wall (facing the direction of prayer) is covered with geometric patterns in multicoloured marble; its *mihrab* (niche) arch has a rectangular frame with diamond-and-star decoration made of coloured stones, and is flanked by marble columns. The niche has vertical stripes of white and black marble, and the semidome above it contains white, red and black marble laid in a zigzag decoration. The *minbar* (pulpit) is also marble.

The other walls of the prayer hall are covered with panels of Persian-style Kashani tiles and also contain coloured-glass windows. The mosque also has a *madrasa* (religious college) and the shrine of the governor, who died in 1579.

Another fine 16th-century Ottoman mosque in Damascus is the al-Sinanieh Mosque, built on

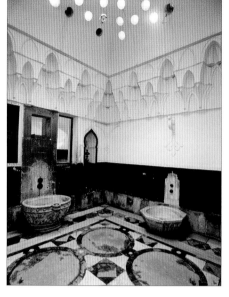

Above The Azem Palace baths, built in imitation of the main city baths, are now dilapidated, but visitors can see that they were once beautifully decorated.

the Bab al-Jabieh Square just outside the city wall by Governor Sinan Pasha in 1590–91. Like the Dervish Pasha Mosque, the al-Sinanieh also has a striking *ablaq* façade, a rectangular open-air court and a seven-dome prayer hall. It is particularly celebrated for its beautiful cylindrical minaret covered with green and blue tiles.

AZEM PALACE

Near the citadel and south of the Umayyad Mosque in the Old City of Damascus, the splendid Azem Palace was built in 1749 as the residence of Asad Pasha al-Azem, Ottoman governor of Damascus. It comprises several buildings arranged in three wings. The first, the *haremlik*, is a private residential area for the governor and his family, containing baths and kitchens as well as lavish accommodation. An interesting touch is that the baths are an exact replica, scaled down in

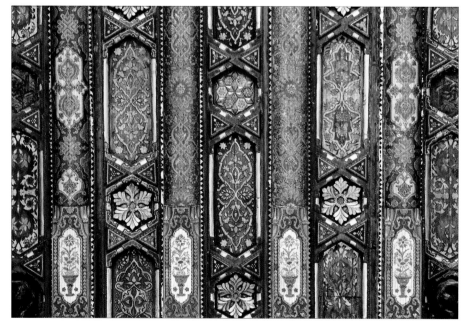

Left This ornate wooden ceiling is typical of the elegant and carefully restored interior decoration of much of the Azem Palace.

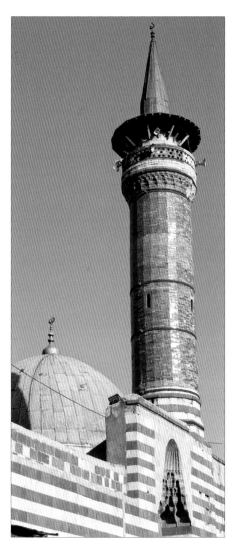

Above The minaret of the Ottoman-era al-Sinanieh Mosque in Damascus rises above the façade decorated in black-and-white ablaq *stonework.*

the architects used the *ablaq* technique, creating a pleasing decorative effect in their combination of marble, basalt, limestone and sandstone in the walls; within, the bedroom ceilings were fitted wooden panels bearing paintings of natural scenes, and there were marble mosaics and *muqarnas* (stalactite-like decoration) corners. The palace was damaged in 1925 during the Syrian revolt against French control in the region, but has since been carefully restored and today is a Museum of Arts and Popular Traditions.

ASAD PASHA KHAN
In 1751–52, Governor Asad Pasha al-Azem also built a magnificent *khan* (lodging place) on Suq al-Buzuriyyah in Damascus' Old City. Covering 2,500sq m (27,000sq ft), the *khan* is laid out in traditional style over two floors around a central courtyard: the ground floor contains shops, while on the upper level 80 rooms are arranged as accommodation for merchants.

The courtyard is divided into 9 equal areas, each covered with a dome standing on a drum containing 20 windows; an octagonal fountain stands beneath

its own dome in the centre of the courtyard. It has a magnificent monumental entrance portal with carved stone decoration as well as a beautiful *muqarnas* semidome.

IN ALEPPO AND IZNIK
The Ottomans left a proud architectural legacy in other cities of the empire, notably Aleppo in Syria and Iznik (now in Turkey). Of particular note in Aleppo is the Khan al-Wazir, probably the city's most beautiful *khan*, constructed in 1678–82 on the traditional pattern with buildings arranged around a courtyard, with shops and storage on the ground floor and merchants' accommodation on the upper floor. It has splendid ornamented window frames and a black-and-white marble *ablaq* façade with an arched entrance door.

Among the many Ottoman buildings in Iznik is the Nilufer Hatun Imareti, a soup kitchen built by Sultan Murad I (reigned 1362–89) in 1388 and named after his mother Nilufer Hatun. A five-bay entrance portico leads into a domed central court, and beyond it a raised vaulted building that contains a *mihrab* indicates that it may have been used as a prayer hall.

size, of the main baths in Damascus. The second, the *khadamlik*, or servants' quarters, is attached to the family quarters. The third, the *salamlik*, is a guest wing, and contains grand reception areas, including a hall with a beautiful internal fountain, and superb courtyards with water features; the grounds were kept lush by waters diverted from the river Barada. The palace combines opulent interiors with serene exteriors: once again,

Right In Iznik, the Nilufer Hatun Imareti of 1388, once a soup kitchen, was restored in 1955 and is now the city's principal museum.

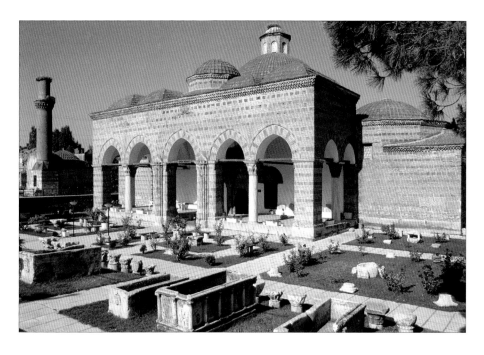

IZNIK POTTERY

THE SKILLED CRAFTSMEN OF IZNIK WERE RENOWNED FOR THEIR CERAMIC POTTERY AND TILES, AND THEIR PRODUCTION REACHED ITS PEAK DURING THE 16TH CENTURY.

The production of glazed earthenware at Iznik, formerly Nicaea, went back to the 13th century. In the 15th century, potters from Iran introduced the technology for making stonepaste, a hard ceramic material. The tile work of the mosque of Sultan Mehmet in Bursa, dated 1419–24, is signed by 'the masters of Tabriz' (a city in north-western Iran). The typical Iznik pottery body is hard and white, coated in a white slip (liquid clay) made of the same raw materials as the body but ground more finely. The transparent glaze is particularly brilliant and glossy.

EARLY PRODUCTION

The late 15th century was the beginning of large-scale production. The imperial workshops in Istanbul were responsible for many of the designs that were applied to the pottery vessels using stencils. Entire compositions or individual motifs were drawn on wax paper, the outlines were pricked and the design was laid over a tile or vessel and charcoal dust sprinkled though the holes. The first phase of design, inspired by both Chinese porcelain and the radial designs of Ottoman metalwork, consisted of tightly drawn arabesques reserved in white on dense, often

Above The walls of Rüstem Pasha Mosque are covered in tiles. Designs include a repetition of serrated saz leaves, Chinese-style cloud bands, plus tulips and carnations.

blackish cobalt ground. By the beginning of the 16th century, the blue had become paler, there was a greater use of white and the decoration had become looser.

TABRIZ INFLUENCE

In 1514, Sultan Selim I captured Tabriz and brought back 38 master craftsmen, including 2 tile cutters and at least 16 painters; one of these was Shahquli, who became head of the workshop in 1526 and initiated a new, more Persian style typified by the 'saz leaf and rosette' style, a harmonious combination of serrated leaves and large, many-petalled flowers.

One of the most impressive commissions of this period is a series of five massive tiles (each one

Left The floral spray on this late 16th-century dish includes tulip, rose and saz leaf – a classic combination. Red was applied thickly to survive the firing.

Right The distinctive pattern of tight foliated spirals on this mid-16th-century tondino – a small bowl with broad rim – was derived from manuscript paintings, particularly the tughra, or imperial monogram.

125cm/50in high), made for the walls of the Sunnet Odasi, or Circumcision Chamber, in the Topkapi Palace. These tiles were decorated with imaginary beasts grazing in a landscape of swirling leaves and flowers in various shades of blue and turquoise.

A new style was developed during the reign of Suleyman 'the Magnificent' (1520–66), in which the motifs were outlined in dark green or black for better definition, and new colours, such as purple and olive green, were introduced. A mosque lamp in this style is signed by its maker Musli.

ARCHITECTURAL TILES
Suleyman was a great patron of architecture, particularly religious buildings, and from 1550 tile making became the pre-eminent concern of the pottery workshops. The palette of soft colours used in vessel decoration needed to be altered, because when viewed from a distance these tones were muddy and indistinct. The colour red was introduced for better impact and visibility but had to be applied thickly to survive the firing. The red colouring was made from Armenian bole, a powerful astringent that the Ottomans used to heal circumcision wounds.

Sinan was made chief architect in 1538 and put in charge of all ceramics and architectural industries. He needed to have a close

relationship with the Iznik potteries to ensure that the tiles were made to the correct dimensions to fit his building plans.

The new palette was so successful on tiles, it was eventually applied also to vessel production. The potters were inventive and developed many new shapes, some of which were based on metal and leather items, and many new designs. The floral style was still the most popular, particularly a spray of carnations, tulips and hyacinths springing from a central tuft, but there were also figural designs with animals and ships.

DECLINING INDUSTRY
In the 17th century, the industry started to decline. This was closely linked with

Right This 1549 mosque lamp is signed on the base by its maker, 'the poor and humble Musli', and the inscription around the base is dedicated to Esrefzade, a local saint of Iznik.

the decline of Ottoman rule but also with the construction of the Sultan Ahmet Mosque, which while employing many tile makers during the peak of its ten-year construction period, eventually put them out of business. Sultan Ahmet was obsessed with tiles and ordered over 20,000 from Iznik. Extra clay had to be imported from Kutahya, and the tile makers were forbidden to do other work in the meantime. When work was completed, many potters must have gone bankrupt because they had been forced to neglect other production.

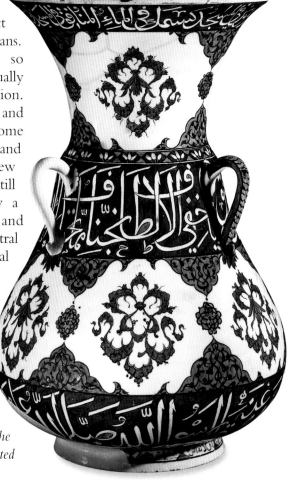

OTTOMAN CARPETS

FROM THE 15TH CENTURY ONWARD, MANY FINE CARPETS WERE PRODUCED FOR THE IMPERIAL COURT IN ISTANBUL OR FOR EXPORT TO EUROPE. PRAYER RUGS WERE ALSO MADE FOR THE FAITHFUL.

The finest Ottoman carpets were produced in Ushak, in western Anatolia. Carpets from this region, now known as Ushak carpets, were commissioned by the Ottoman court under sultans Mehmet II (reigned 1444–46, 1451–81) and Bayezid II (reigned 1481–1512). The Ottomans held a strong, central control over the artistic production of the carpets, and the designs reflected their tastes.

The carpets are conservative, but they have very fine designs, in part inspired by calligraphy and the highly prestigious 'arts of the book', which were often created in Istanbul and provided for carpet makers to follow. Some of the Ushak carpets were manufactured in a large format, up to 10m (33ft) in length, and they were produced in beautiful blue and red tones.

Below This 17th-century Star Ushak rug is the only surviving complete example of a design that uses quatrefoil (four-leaved) medallions with smaller diamonds.

Ushak carpets have been divided into groups based on design. One major group is known as the 'Star Ushaks' because these carpets bear an endlessly repeating design of an eight-pointed star alternating with a smaller lozenge. Another group is known as the 'Medallion Ushaks' because they were decorated with a medallion design. Designs such as these remained in use for long periods under the Ottomans.

EXPORTS FOR EUROPE

Many fine Ottoman carpets were exported to Europe, especially Italy, from the 15th century onward. Members of the nobility and church authorities were frequent buyers; the rugs were prestigious possessions, and were represented by leading artists in portraits and in sacred paintings intended for churches (*see* Holbeins and Lottos, opposite). Henry VIII had extensive collections of Turkish and Egyptian carpets: by his death in 1547, there were 500 such carpets in Tudor palaces.

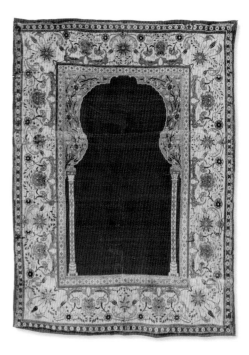

Above The Ottomans added floral designs to the prayer rugs they commissioned. This rug was woven from wool and cotton in c.1600.

PRAYER RUGS

Another category of carpet was the prayer rug. These were intended for use by the Muslim faithful in mosques. They carried an image of the *mihrab* (niche) and were laid on the floor pointing toward Makkah when, during prayers, worshippers prostrated themselves in this direction. Many of the rugs were double-ended.

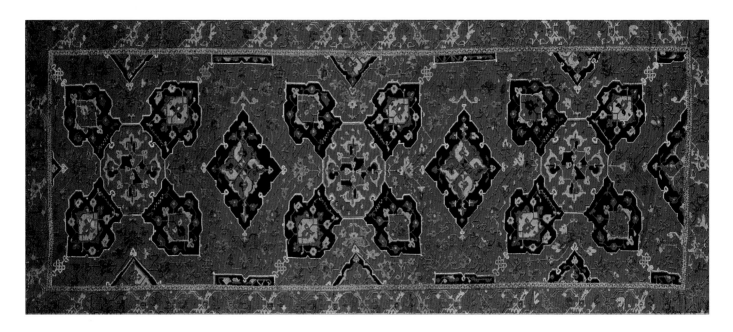

There were both single prayer rugs for individual use, and longer ones with several woven niches aligned either horizontally or vertically on the rug, designed to be shared by a number of worshippers at prayer. Few of these carpets have survived because they were in daily use during worship, but there are some surviving fragments of communal prayer rugs: some now held in the Museum of Islamic and Turkish Art in Istanbul are badly damaged but are still 8m (26ft) long, giving an idea of how long they once must have been. Ushak prayer rugs often used a cloud-bank border adopted from Persian designs; some represented a pendant to indicate a mosque lamp.

An Ottoman prayer rug in the collection of the Textile Museum in Washington, DC, is a good example of another common design featuring three prayer arches. It dates to the 1600s, and is very similar to rugs represented in 17th-century Dutch paintings, such as *Still Life* by Nicolaes van Gelder (1664), now in the Rijksmuseum, Amsterdam.

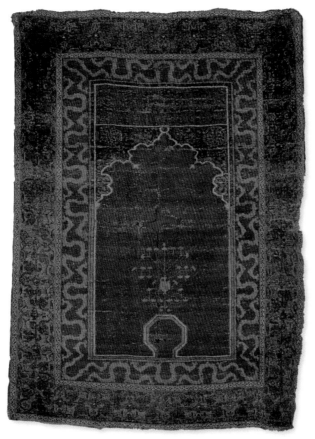

Above A prayer rug of c.1500, woven from wool in Cairo, provides ample evidence of the Mamluk artisans' skill that was so admired by the Ottomans.

MAMLUK INFLUENCE

After the Ottomans conquered Egypt in 1517 under Sultan Selim I (reigned 1512–20), they had access to the highly skilled carpet makers of Mamluk Cairo. The Mamluks used finer wool than their Turkish contemporaries and so could make tighter knots to create even more elegant flowing designs; they also used cotton for some of the white areas of a design and silk for the main weave. Before the Ottoman conquest, they had typically woven carpets with kaleidoscopic designs and patterns of octagons with stars, in blues, green and wine-red colours. The Ottomans dispatched detailed designs for floral patterns featuring hyacinths, carnations and tulips from Istanbul to be followed by the Mamluk weavers.

In 1585, Sultan Murad III (reigned 1574–95) called 11 master carpet makers from Cairo to Istanbul, with a large consignment of Egyptian wool; at this point there were 16 master carpet makers in the Ottoman capital, but the demand for carpets was so high that they could not meet it. As a result of Egyptian influence, some carpets and rugs made in Turkey began to show Egyptian elements: for example, a rug from the mausoleum of Sultan Selim II (d. 1574) used typically Egyptian green and cherry-red colours.

HOLBEINS AND LOTTOS

Certain designs of Ottoman carpets exported from Ushak became known as 'Holbeins' and 'Lottos', after the European artists Hans Holbein the Younger (1497/8–1543) and Lorenzo Lotto (c.1480–1556), in whose paintings the carpets were represented as luxury objects. The artists carefully copied the delicate patterns and rich colours of the carpets. Both designs appeared also in the works of other artists. The Holbein design, which featured octagons interlaced with cross-shaped elements, appeared in European art from 1451 onward; the first appearance of the similar Lotto design was in a 1516 portrait by Sebastiano del Piombo (c.1485–1547).

Right An Ottoman carpet takes pride of place in this portrait, Husband and Wife *(c.1523), by Italian artist Lorenzo Lotto.*

SAZ STUDIES AND THE ARTIST SHAHQULI

DURING THE 16TH CENTURY, EXQUISITE DESIGNS WERE PRODUCED BY SKILLED ARTISTS, PARTICULARLY THE 'SAZ' STYLE CREATED BY SHAHQULI, AND THESE INSPIRED CRAFTSMEN IN OTHER MEDIA.

Ottoman art was characterized by the central production of designs on paper at the imperial atelier (artist workshop), and the dissemination of these designs to the other art forms. The drawings of these designs were generally regarded as artworks in themselves. Like single-page specimens of calligraphy, tinted drawings were collected by connoisseurs at courts all across the Islamic world. They assembled the drawings in albums, known as *muraqqa*.

The collected images might be studies based on figural compositions familiar from illustrated works of literature, themes of fighting animals, collectable older works by previous masters or even drawings from foreign countries, such as a European print or a Chinese painting. The owner of the album (or his librarian) might

then inscribe attributions to an artist, or even place the image in an illuminated frame.

THE SAZ COMPOSITION

More abstract studies were also collected in the *muraqqa*, including stylized patterns based on natural or geometric forms. A typical theme was the 'saz' drawing, a foliate composition that mainly features stylized convoluted leaves inhabited by chinoiserie (Chinese-style) animals or birds. Its name refers to the *saz qalami*, or 'reed pen', and the broader genre of tinted drawings is known as *siyah qalami*, or 'black pen'. Both of these were drawn with brush and black ink, with only occasional details being made with a reed pen.

A saz leaf itself is long and thin with feathery edges, and typical saz compositions are elegant arrangements of leaves, twisting around other elements, such as beautiful winged angels, wild creatures fighting, including mythical dragons and phoenixes, and large rosette flowers.

PERSIAN LINKS

As well as being kept in albums, the designs drawn on paper were sent to craftsmen, who used them to transfer the designs on to other

Above In this 16th-century saz manuscript painting, a dragon is entwined in stylized leaves, drawing attention to the second dragon above it.

media, such as leatherwork, metal or ceramics. This was certainly the case in 15th-century Iranian art, which had a strong influence on taste in the Ottoman world.

This preference in taste changed in the early 16th century, when the Persian vogue was superseded by a new self-confidence in Ottoman visual culture. Before this shift in taste, the Ottomans achieved a major coup in 1514, when Sultan Selim I, 'the Grim', defeated the Safavid Shah Ismail in battle at Chaldiran (north-western Iran), and the Safavid treasury in Tabriz was looted. Along with material booty, many Persian artists moved to the Ottoman court in Istanbul.

The designer Shahquli Baghdadi was among this number, and he soon rose to the highest rank in the palace atelier, remaining there until his death in about 1556. The saz design is particularly associated with him. His Persian art training was no doubt central to this success, and he is personally

Left The floral composition that forms the highlight of this 16th-century Iznik dish includes the typical saz leaf, with its long feathery edges.

associated with bringing the saz leaf genre into Ottoman art. A designer rather than a painter of manuscript illustrations, Shahquli is credited with decorating works on paper, papier mâché, mother-of-pearl, leather and ceramics.

According to one 16th-century account, Sultan Suleyman 'the Magnificent' particularly enjoyed Shahquli's work, and even visited the artist in the atelier. A record also survives of his exceptional salary (100 akce, or silver coins, per day), and of the gifts received from the sultan, as reward for his work-manship: large cash gifts, and kaftans of brocade and velvet.

SAZ LEAF IN OTHER MEDIA
In Ottoman art, the distinctive saz leaf is recognizable across the media in the first half of the 16th century. It spread to other art forms, from armour and weapons to textiles and ceramics. This tallies with the period of Shahquli's role as imperial designer, when he provided patterns for craftsmen to apply.

In approximately 1530, Shahquli designed for Suleyman a series of large rectangular blue-and-white ceramic tiles, for a small pavilion in

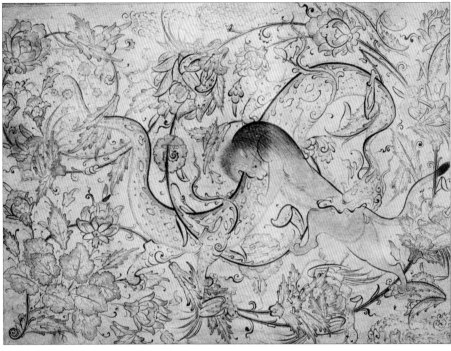

Above A lion embraced in combat with a dragon is shown against a background of stylized foliate pattern in this 16th-century Turkish drawing.

the Topkapi Palace, which are now remounted on the exterior wall of the 17th-century Sunnet Odasi, or Circumcision Chamber, within the palace. These tiles are considered to be the pinnacle of the saz style: each bears a lyrical composition of twirling saz leaves, among which are long-tailed birds and outsized flowers. Along the base line, mythical creatures from Chinese art, quadrupeds known as chilins, are stalking. The ceramic under-

glaze decoration deliberately copies the look of ink-wash drawings on paper: the cobalt blue is applied in dark colour along the leaf spines, and as a paler wash across the larger forms. This subtle style was not continued in Iznik ceramics, which went on to use a range of strong opaque colours effectively.

Saz leaves and rosette flowers were used effectively in Ottoman textiles and in Iznik ceramic objects and tile complexes – though the animals and birds were generally omitted. As the century progressed, the imperial decorative repertoire expanded to a wider floral range, associated with Shahquli's successor and pupil Kara Memi. This featured identifiable specimens of flowers, including tulip, rose and hyacinth, with the occasional saz leaf still intertwined.

Left The pattern on this 16th-century tile panel from the Circumcision Chamber in the Topkapi Palace shows mythical Chinese creatures amid saz leaves.

OTTOMAN MANUSCRIPT PAINTING

INTRICATELY DETAILED OTTOMAN MANUSCRIPT PAINTINGS ARE VALUABLE NOT ONLY AS EXQUISITE WORKS OF ART, BUT FOR THE INSIGHT THEY PROVIDE INTO OTTOMAN CULTURE AND HISTORY.

The artistic tradition of the Ottoman Empire absorbed diverse influences from conquered and neighbouring states to create new artistic styles, and nowhere was this more apparent or innovative than in manuscript painting. The earliest surviving examples of Ottoman manuscript paintings date from the reign of Mehmet the Conqueror (1444–46 and 1451–81). After he captured Constantinople

Below A portrait of Sultan Selim II (r. 1566–74) firing an arrow was painted by Nigari, one of the artists working at the Topkapi Palace in Instanbul.

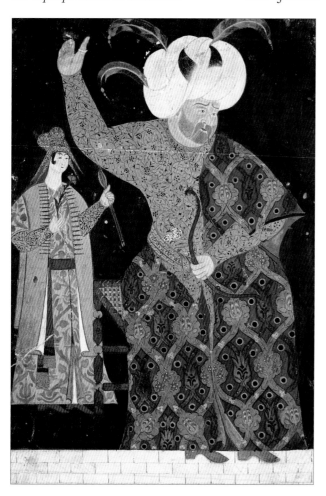

in 1453, the Ottomans envisioned themselves as the political and cultural heirs of the Byzantine and Roman empires. Early Ottoman miniature paintings show clear influence from this heritage.

Conquest of lands to the east brought a new dimension to the development of Ottoman manuscript painting, when an influx of artists and Persian works of art followed the capture of the Safavid capital, Tabriz, by Selim I in 1514. Numerous artists and craftsmen of the Safavid court were transported to the Topkapi Palace in Istanbul and joined the Ottoman court atelier. Their influence had a profound impact on the later development of Ottoman art.

PATRONS OF THE ARTS

A golden age of artistic achievements followed during the reign of Suleyman 'the Magnificent' (1520–66) and his immediate successors, when the political power of the empire was at its height. Patronage of the arts was of enormous importance to the sultans, because it demonstrated their wealth, nobility and power, and artists from across the empire were attracted

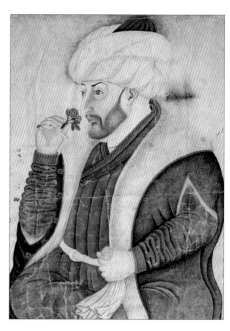

Above A painting (c. 1475) of Mehmet the Conqueror at the height of his power, possibly by Sinan Bey.

to Istanbul by the Ottoman court. By 1525, the state departments Ehl-i Hiref ('Communities of the Talented') were formed, in which companies of artists and artisans progressed through an apprenticeship system. Book arts – comprising calligraphy, painting, illumination and bookbinding – were highly regarded artistic forms, and the imperial painting studio was influential and pioneering within the Ehl-i Hiref.

Miniature paintings – many of which remain unsigned – were produced through a collaborative effort, with the master drawing out the composition and his pupils adding colour. Miniatures depicting scenes and portraits were used to illustrate a wide variety of books from works of literature, history and science to religious volumes.

IMPERIAL HISTORIES

Like the rulers of Iran, the Ottomans were keen to claim an important place in history. They commissioned many history projects to record their own achievements and genealogies.

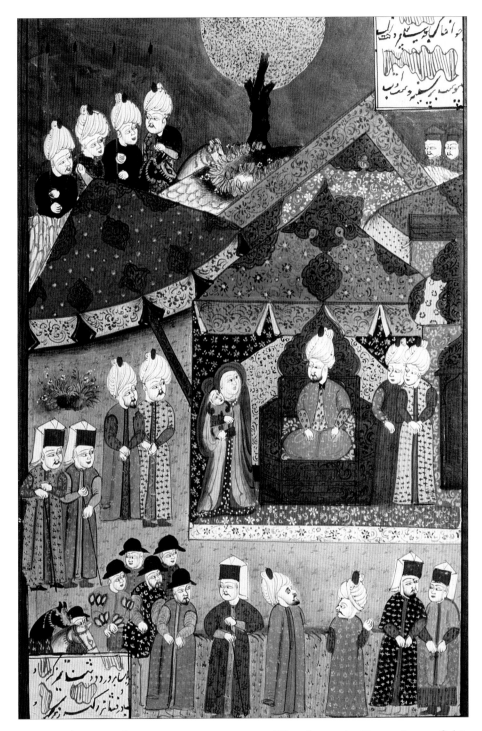

Left The 1541 reception of Hungarian Queen Isabella and infant King Stephen in the 1558 Suleymanname manuscript.

This series includes scenes of the sultan's death, funeral procession and burial at his Suleymaniye complex in Istanbul.

LATER HISTORY

In the 17th and 18th centuries, the classical Ottoman style of manuscript painting continued, and was influenced by European art. By the end of the 17th century, economic conditions led to a decline in the quantity and quality of imperial art.

A resurgence influenced by Western styles occurred in the reign of Ahmet III (1703–30), known as the 'Tulip' period due to the popularity of this flower as a motif. A major project of this time was the 1720 *Surnama*, or Book of Festivals. Written by the poet Vehbi, with Levni as master illustrator, the work details the festivities celebrating the circumcision of Ahmed's four sons, and depicts a grand street procession where every city guild was represented on parade.

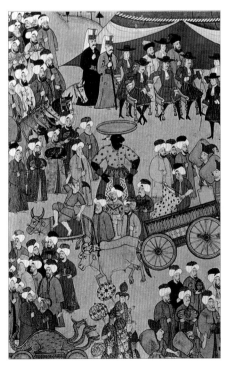

Grand historical accounts were densely illustrated and provide exciting views of 16th-century Ottoman life at court and at war. One notable example is the Suleymanname, which details the reign of Suleyman 'the Magnificent' until 1556, ten years before he died. Arifi, the first official Ottoman biographer, had written a five-volume history of the Ottoman rulers, of which Suleymanname was the final volume.

The dynamic illustrations of this multivolume work follow the highlights of Suleyman's rule from the battles and sieges of conquest, to accession ceremonies and the reception of foreign dignitaries. A further two works, illustrated by the court painter Nakkash Osman, detail the remainder of Suleyman's reign.

Right The Procession of the Trade Corporations was illustrated in Vehbi's Surnama, *1720.*

233

OTTOMAN CALLIGRAPHY

DURING THE OTTOMAN PERIOD, SHAYKH HAMDULLAH AND OTHER OUTSTANDING CALLIGRAPHERS REFINED SEVERAL CALLIGRAPHIC SCRIPTS, EVEN CREATING A NEW OFFICIAL SCRIPT CALLED *DIWANI*.

Above Some fine Ottoman calligraphy is displayed on the water fountain just outside the Topkapi Palace.

Over the centuries, calligraphy became the foremost Islamic art form, a way of giving physical and visible form to the words of Allah as revealed to the Prophet Muhammad and recorded in the Quran. Calligraphers were highly honoured at the Ottoman court: the foremost Ottoman calligrapher, Shaykh Hamdullah (1436–1520), was befriended by the future Sultan Bayezid II when Bayezid was a prince in Amasya, and on Bayezid becoming sultan in 1512, he was summoned to Istanbul. According to tradition, Bayezid was happy to see himself as a pupil of Hamdullah, and willingly held the *hokka* (ink pot) while his master wrote.

SHAYKH HAMDULLAH

While at Bayezid's court, Shaykh Hamdullah created a new character and style for the *thuluth, naskhi* and *muhaqqaq* styles of calligraphy, in particular succeeding in making *naskhi* script unambiguous to read.

According to a tradition originating with Ibn Muqla, 10th-century wazir in Abbasid Baghdad, there were six 'hands', or canonical scripts: *naskhi, muhaqqaq, rayhani,* Tawqi, Riqa and *thuluth*. Shaykh Hamdullah's work in Istanbul was based on a close study of the writings and calligraphy of a 13th-century follower of Ibn Muqla named Yaqut al-Mustasimi (d. 1295), who was revered in the Ottoman era as a master of calligraphy. Shaykh Hamdullah was hailed as Kibletul Kuttab ('Highest of scribes') and founded his own school of calligraphic artists in Istanbul. His followers greatly developed the *naskhi* script for use in copying books.

In the late 17th century, Hafiz Osman (d. 1698) worked in the same traditions. He made further improvements to the *naskhi* script by drawing together the works of Yaqut al-Mustasimi and Shaykh Hamdullah. Such was the stature of this calligrapher that he was hailed as Sayhi Sani ('the second Shaykh', a reference to Shaykh Hamdullah). His work had a great influence on later calligraphers.

A SCRIPT FOR DOCUMENTS

Ottoman calligraphers developed a new calligraphic style known as *diwani*, which was used for decrees, resolutions, endowments and other official documents. It was named *diwani* because it was used for the official documents of the sultan's *diwan*, or council of ministers. Only a few official calligraphers were instructed in the secrets of the script. The style was developed in the 16th century and was known to Shaykh Hamdullah – an album of his calligraphy preserved in the Topkapi

Left This elegant calligraphic line above a doorway at the Topkapi Palace reads: 'There is no god but God, and Muhammad is his Prophet.'

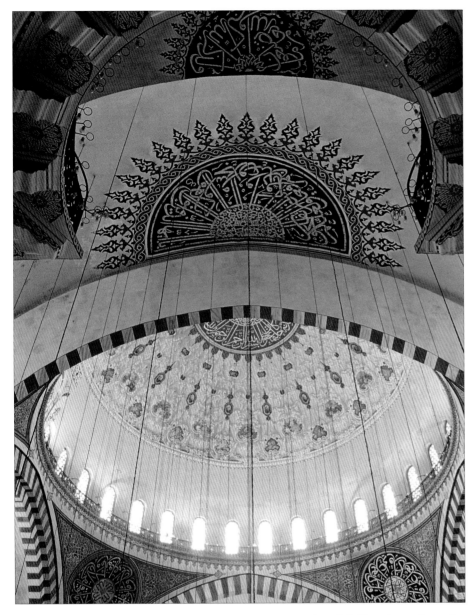

Above Verses from the Quran, inscribed in magnificent calligraphy, sanctify the walls and dome of the Suleymaniye Mosque in Istanbul.

Palace contains writing in the *diwani* script as well as in *naskhi, thuluth, muhaqqaq,* Riqa and Tawqi.

Ahmet Karahisari (1468–1556) was another leading calligrapher of the 16th century, a contemporary of Shaykh Hamdullah and a favoured artist at the court of Suleyman I 'the Magnificent' (reigned 1520–66). Karahisari was celebrated for his calligraphic representation of the *bismallah* formula in praise of Allah, which could be inscribed without lifting the pen from the paper.

Two splendid illuminated copies of the Quran largely composed by his hand are kept in the Topkapi Palace. One of these is very large, measuring approximately 61cm by 43cm (24in by 17in), bound in black leather with gilded ornament, and has 300 pages. It is written in the *naskhi, thuluth, muhaqqaq* and *rayhani* styles. The calligraphy, illumination and binding of this Quran are all of the highest quality, and it is viewed as an absolute masterpiece. However, this Quran was not signed by Karahisari, which is unusual. For this reason, textual historians believe that when Karahisari died in 1556 the work was unfinished, and that it was probably completed by his adoptive son Hasan Celebi, who was another fine calligrapher.

DECORATIVE CALLIGRAPHY

Leading calligraphers also played an important role in other arts, providing designs for textiles, metalwork and ceramics, and notably sacred architecture. Ahmet Karahisari designed the grand calligraphic inscription in the dome of the Suleymaniye Mosque in Istanbul, built in 1550–57. In the same building, Hasan Celebi made a calligraphic piece above the harem door; the same artists produced fine work in the Selimiye Mosque in Edirne, built by Sinan in 1568–74 for Selim II.

THE SULTAN'S SEAL

Each Ottoman sultan had his own *tughra*, a calligraphic form of his name and title, with the words *al-muzaffar daiman* ('ever victorious') used as a signature and seal on official documents and on all coins issued in a sultan's reign. The calligraphy was increasingly embellished with infilled illumination, such as the delicate foliate style, known as *tughrakesh*.

Above The tughra *of Sultan Murad III (reigned 1574–95) also appears over the Imperial Gate of the Topkapi Palace.*

OTTOMAN METALWORK

THE OTTOMANS PRODUCED OPULENT, HIGH-QUALITY METALWORK.
SKILLED CRAFTSMEN MADE AN IMPRESSIVE RANGE OF WARES USING
PRECIOUS METALS AND JEWELS.

Ottoman metalwork has roots going deep into the history of the Turkish people, who were producing artworks in metal as early as the 3rd century BCE in Central Asia. In particular, the Ottomans inherited metalworking traditions from the Seljuks: early in the Ottoman era, in the 14th century, artisans produced metal objects decorated with the repoussé technique (where an object is hammered to create the decoration) favoured by the Seljuks.

The wave of Ottoman military conquests in the 15th century brought new lands into the empire, and as a result a wide range of traditions and techniques had an influence on imperial metalwork in Istanbul. The conquest of the Balkans, with their rich deposits of gold and silver and resident artisans expert in the long local tradition of work in precious metals, was particularly important.

IMPERIAL PATRON

At the end of the century, Bayezid II (reigned 1481–1512) was a great patron of artists including metalworkers. In his reign, the state departments Ehl-i Hiref ('Communities of the Talented') were first established in Istanbul. Their members included *zergeran* (goldsmiths), *hakkakan* (jewellers), *kuftgeran* (gold inlayers), *kazganciyan* (coppersmiths) and *zernisani* (gold repoussé workers). The greatest workers in their field included Armenians, Jews, Iranians, Greeks, Slavs and Arabs. These craftsmen all came to the imperial capital to make their fortunes.

After the conquest of Egypt in 1517 by Selim I (reigned 1512–20), the influence of the highly skilful

Left A patron of metalworkers, Suleyman I commissioned this fine pendant made of gold with pearls and emeralds for the Topkapi Palace.

Above This parade helmet, decorated with gold, turquoise and rubies, was made for Sultan Suleyman I 'the Magnificent' (reigned 1520–66).

Mamluk metalworkers was felt on Ottoman work in metal. Although few signed pieces of metalwork survive from the period, one celebrated jeweller of the age, Mehmet Usta, is known from his signed pieces.

OTTOMAN STYLE

A distinctive, ostentatious Ottoman style developed in metalworking by the mid-16th century, at the height of the empire under Suleyman 'the Magnificent' (reigned 1520–66). This style was seen in a range of decorative techniques, in particular *murassa*, in which the artisans set precious stones, such as the ruby, emerald or garnet, into the surface of a metal object. Ceremonial swords, daggers and the covers of books were sumptuously decorated in this way. Artisans also continued to use repoussé and other techniques, including chasing (making a decoration by hammering from the front side of the piece), filigree (decoration using twisted threads of gold or silver), niello (black metallic inlay on engraved designs) and embossing.

As princes, future sultans Selim I and Suleyman 'the Magnificent' were trained in the art of making jewellery. Once in power, they maintained workshops for jewellers in the imperial palace at Istanbul, where work of the highest quality was produced. Both sultans were keen patrons.

Istanbul was the great centre for Ottoman metalwork, but artisans were also producing fine metal pieces in Damascus and Aleppo in Syria; in Anatolia, metalworking centres included Diyarbakir, Sivas, Kayseri, Erzincan and Erzurum. A school of metalwork was associated with Damascus, and Syrian artisans in Istanbul created Damascus work.

Metalworkers began to use floral decorative motifs in the 17th century. They favoured naturalistic designs of pomegranate blossoms, roses, carnations, hyacinths and tulips, especially on silver objects. In later periods, the artisans and their patrons increasingly followed Western influences, and began to use Baroque and Rococo decorative motifs.

TYPES OF WORK

Craftsmen made magnificent helmets, swords, daggers, armour and firearms for ceremonial use by sultans, princes and leading members of the military: the blades were inlaid with gold arabesques or calligraphy, while the hilts were often adorned with jade or precious stones. They also made practical weapons, including swords and battle-axes, often with jewelled scabbards, sheaths and hilts.

A superb engraved helmet made for Sultan Bayezid II has survived and is kept in the Army Museum in the Hôtel National des Invalides

Above These daggers with decorated sheaths date from c.1600, in the reign of Mehmet III. He had 19 siblings murdered to consolidate his position.

in Paris. Measuring about 33cm (13in) in height, the helmet is made of steel and decorated with gold wire using the technique of *kuft-gari*, in which the steel surface is roughened with a chisel and a design in gold wire is hammered into it. The inscription reads: 'Allah, I am the helmet for the head of the brave imam, the fearless Sultan, the world-Emperor, the bringer of victory to Islam, the leader blessed with Allah's support and aid, al-Malik al-Nasir Sultan Bayezid,

son of Sultan Muhammad Khan, may his followers and supporters be granted greatness by Allah.'

An example of a 15th- to 16th-century Ottoman ceremonial dagger with a steel blade, about 20cm (8in) in length, has survived and is today held in the Royal Scottish Museum in Edinburgh. It bears decoration of arabesque foliage and a calligraphic inscription inlaid in gold, from a poem by Ottoman poet Necati (d. 1509). The hilt is made from grey-green jade.

Another category of work included candlesticks, oil lamps and censers. A good number of lamps decorated with repoussé, intaglio (carved stones) and openwork, and using well-established *hatayi* and *rumi* decorative motifs, survive from 1450–1500.

Among domestic items, metal bath bowls, ewers and basins were popular. Table-ware included beautifully engraved jugs, bowls and trays. Craftsmen often made canteens for holding water or sherbet in highly decorated gold, bronze or tombac (copper or bronze coated in a mixture of gold and mercury). They also made coffee pots, braziers, ashtrays and other metal accessories for smoking *huqqas*.

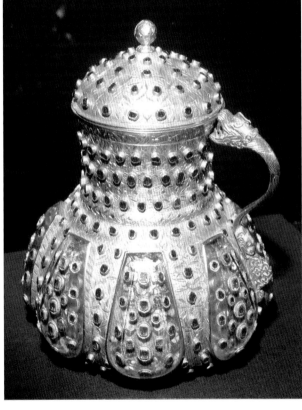

Left The handle of this 16th-century golden jug, commissioned by Suleyman I, represents a dragon. The jug is encrusted with rubies and emeralds.

OTTOMAN COSTUME

THE OTTOMAN COURT WAS CELEBRATED FOR ITS THEATRICAL CEREMONIAL. MEMBERS OF THE COURT, FROM RULER TO SLAVE, WORE CLOTHING MADE FROM BEAUTIFULLY EMBROIDERED FABRICS.

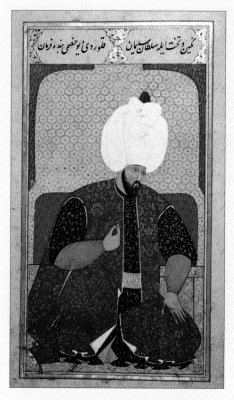

The knowledge of royal and court costume in the Ottoman era has been boosted by the survival of several complete outfits in the Treasury of the Topkapi Palace in Istanbul. More than 2,500 textiles survive in storage, including no fewer than 1,000 kaftans.

On Friday, the Ottoman sultan went in public procession to attend noon prayers at a mosque outside the palace. On formal occasions such as this, he typically wore decorated gold and silver cloth, called *seraser* in Turkish, and a brooch with precious stones in his turban. Foreign dignitaries visiting the Ottoman court were invited to watch the procession, and were impressed by the wealth on display.

A decorative motif of 'tiger stripes' and three spots was often used on royal garments. The design was already centuries old by the time of the Ottoman era, and its constituent elements were reputedly based on the stripes and spots on tiger and leopard skins. It appears on a fragment of a kaftan that belonged to Sultan Mehmet 'the Conqueror' (reigned 1444–46, 1451–81) held in the Topkapi Palace Museum in Istanbul.

On some occasions, however, sultans wore plain materials. At funerals, for example, the sultans dressed in plain purple, dark blue or black kaftans of pure silk or mohair; for accession ceremonies, the new sultan wore white. Beneath the luxury of silk kaftans, they would wear more humble material – to avoid directly contravening the Quranic ban on wearing silk.

The sultan generally changed his silk robes after wearing them once, and afterward they were cared for by the wardrobe master in the treasury. After the death of a sultan his clothes were labelled and placed in the treasury; one of his kaftans, a turban, a belt and a dagger were laid on his tomb for the funeral.

Above *Floral designs decorate the robes worn by Sultan Suleyman 'the Magnificent' in this portrait. He wears a jewelled brooch in his turban.*

ROBES OF HONOUR

Many fine textiles and kaftans were given as 'robes of honour' by the sultan to leading officials or to visiting dignitaries. Called *hilat*, these robes were of varying quality according to the degree of honour bestowed. This ancient system therefore expressed a strict and subtle social code. The robes given to the Grand Wazir were usually made of gold or silver cloth and given in pairs: one lined with sable fur, one without. Religious scholars would only wear fine wool or mohair, but never silk.

A group of court tailors called *hayyatin-i hassa* were detailed to produce the *hilat* robes. A fine silk kaftan with elongated ornamental

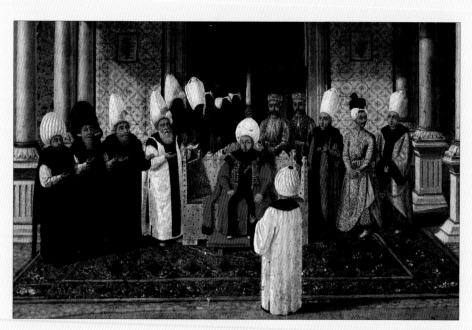

Left *Courtiers gather for a reception at the court of Selim III (reigned 1789–1807). Splendid costumes added to the Ottoman court's projected image of power.*

sleeves and a large pattern of leaves embroidered in gold on a silver ground, dated to *c.*1760, was given to and worn by an envoy of Frederick the Great of Prussia (reigned 1740–86) to the court of Ottoman Sultan Mustafa III (reigned 1757–74). It survives in good condition and is held in the Staatliche Museen zu Berlin in Germany.

STATUS AND CLOTHES

Clothes played an important role in Ottoman society, displaying the social status and allegiances of the wearer. Only courtiers and the wealthy elite wore kaftans and fine embroidered clothing, while poorer people wore more practical clothes. In the era of Suleyman 'the Magnificent' (reigned 1520–66), clothing regulations were issued. Poorer men and women often wore *salvar* (trousers) or *potur* (breeches) with *mintan* (jackets) and *cizme* (boots). Strict rules

Right This silk robe, which belonged to Sultan Bayezid II (reigned 1481–1512), is in the collection at the Treasury of Topkapi Palace, Istanbul.

were laid down covering the clothes that state officials, members of the military and Christian and Jewish religious leaders could wear.

In a reform known as the *Tanzimet* (Reordering) Period in the mid-19th century, Western-style clothing, such as the waistcoat, necktie and high-heeled shoes, became fashionable among the wealthy; poorer people still wore traditional clothing.

HEADWEAR

Garments worn on the head were highly significant in Ottoman visual culture: in the 16th–18th centuries people wore either the *sarik* (turban) or a cone-shaped headdress called *bashlyk*. The *sarik* was made out of particularly fine material, often more expensive than the rest of the wearer's outfit. In 1826, under Sultan Mahmud II, the short cone-shaped felt hat called the fez replaced the *sarik*. Then in 1925, after the foundation of the Republic of Turkey, Mustafa Kemal Ataturk outlawed the fez as part of his series of modernizing and secularizing reforms. People began to wear Western-style hats.

OTTOMAN SILK AND VELVET WORK

The Ottomans ran a thriving industry in silks and velvet, with production based at Bursa. Weavers used patterns based on crescents, leopard spots and tiger stripes, and a lattice enclosing flowers, such as tulips. Patterns were often in gold on a crimson ground. Weavers used silk for court kaftans and covers to be laid on the tombs of sultans and great officials; the tomb covers were embroidered with Quranic verses and invocations to Allah. A beautiful 18th-century red silk tomb cover of this kind is held in the Victoria and Albert Museum, London. Craftsmen used velvet for divan cushion covers, large hangings and saddle covers. A fine velvet saddle cloth embroidered in silver and gilt wire with flowers and foliage was given to King Gustavus Adolphus of Sweden in 1626 and is kept in the Royal Armoury, Stockholm.

Right A warrior horseman is shown wearing a wonderful silk robe in this battle scene from the Suleymanname.

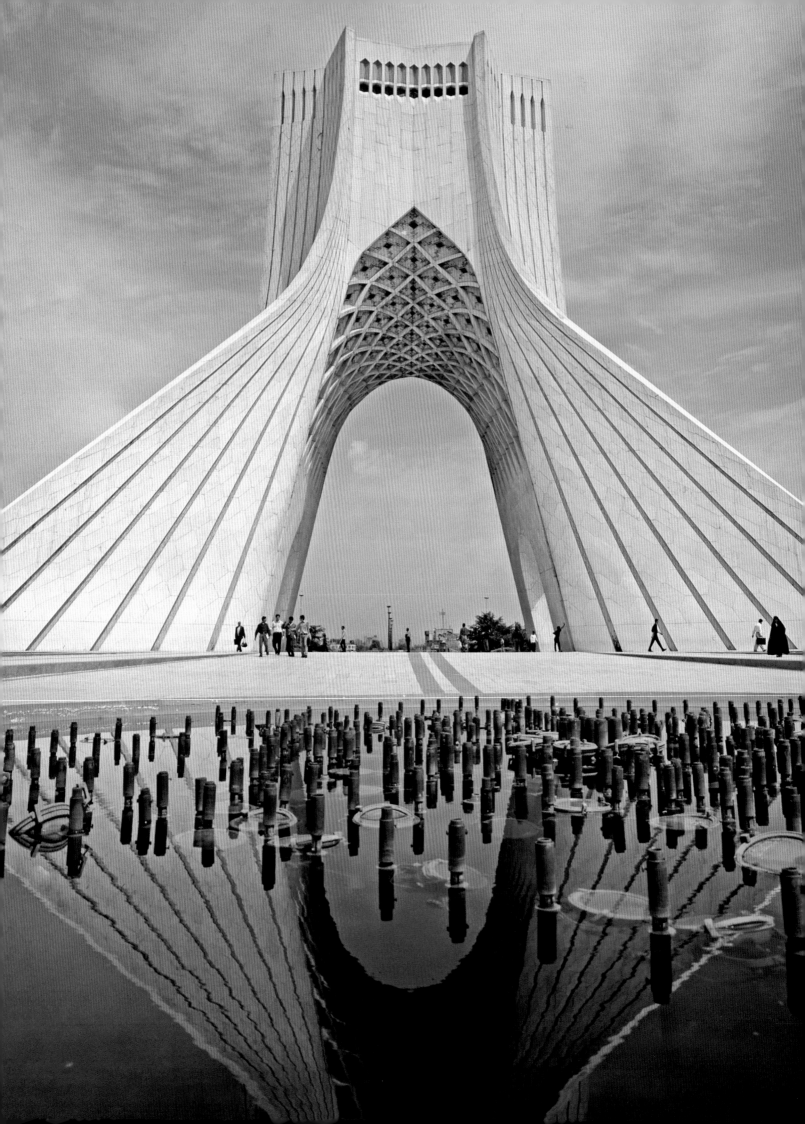

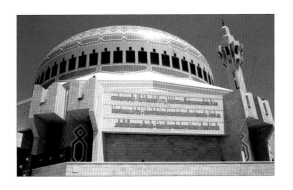

MODERN ISLAMIC ART AND ARCHITECTURE

From the late 18th century, European interests in Western Asia became increasingly dominant, and many Muslim countries began programmes of modernization and reform. This discrepancy of power and influence was reflected in the art and architecture of the times, by the adoption of certain European media and models, including oil painting, printing, photography, costume, academic training and even urban planning. There was also a new interest in reviving the grand styles of the past, with deliberate archaism. Meanwhile, European Orientalist artists were engaging with the Islamic world with an altogether different agenda, portraying a mysterious and even seductive 'East' for the curiosity of Western audiences.

Come the 20th and 21st centuries, both traditional revivalism and global assimilation have continued to characterize modern art and architecture in Western Asia as a whole. To this day, world-famous icons of modern architecture continue to be built in Muslim countries, particularly the Arabian peninsula.

Opposite The Azadi Tower sits at the centre of one of Tehran's main avenues. The architect Hossein Amanat (b.1942) won the state-sponsored competition to build the tower in 1971.

Above The blue-domed King Abdullah Mosque in Amman, by Jordanian architect Rasem Badran (b.1945), is typical of much of Islamic archítecture in the 20th–21st century.

REVIVALIST TRENDS

MANY ARTISTS OF THE MODERN AGE – BOTH EUROPEANS VISUALIZING MUSLIM CULTURE AND THOSE FROM WITHIN THE MUSLIM WORLD – HAVE BEEN INSPIRED BY THE HERITAGE OF THE ISLAMIC MIDDLE EAST.

In the 19th century, a number of important Western European artists celebrated the achievements of the Islamic artistic past and revived these traditional methods in their own work. Prominent among these was English tile designer and potter William de Morgan (1839–1917), a friend of and collaborator with the artist, writer and designer William Morris (1834–96). Both men were notable figures in the Arts and Crafts aesthetic movement, which in the wake of the Industrial Revolution turned away from mass production, instead celebrating individual craftsmanship.

William de Morgan began to work in ceramics in 1863. He was a great experimenter and in *c.*1873 rediscovered the technique used by craftsmen in al-Andalus to make lustreware and by later Italian artisans to make maiolica. He also began to use a colour palette (including turquoise, dark blue and green) and imagery (including fabulous creatures and repeating geometric motifs) derived from Iznik ware made by craftsmen in the Ottoman Empire during the 16th century.

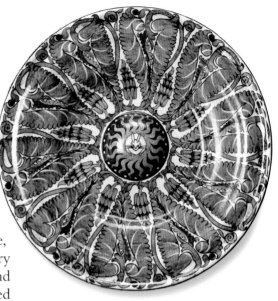

Above English craftsman William de Morgan's Persian-style charger (display plate) draws inspiration from the designs of Ottoman-era Iznik ceramics.

LEIGHTON'S 'ARAB HALL'

In the 1870s, English artist and sculptor Lord Frederic Leighton (1830–96) built a magnificent 'Arab Hall' as part of an extension to his house in Holland Park in London. The hall was intended to house and display Lord Leighton's large collection of Iznik and other Islamic tiles, and the interior was a tribute to the banqueting hall of the summer palace of La Zisa, which was built in Palermo, Sicily, by Egyptian Fatimid and other Islamic craftsmen working for the Norman rulers of Sicily in 1166.

The hall's grand decoration includes an epigraphic frieze of tiles with an inscription quoting from Surat 54, verses 1–6, beginning 'In the name of the long-suffering Allah, ever merciful, who has taught me the Quran…'. Richard Burton may have acquired this for Lord Leighton in Sind, Pakistan: he certainly sourced tiles for Leighton in Jerusalem. Upstairs is a 17th-century wooden *zenana*, a box-like construction designed for segregating women from men during worship, which Lord Leighton transported to London from a mosque in Cairo, along with a 17th-century stained-glass window from a Damascus mosque.

IRANIAN PAINTERS

The revival of miniature painting in early 20th-century Iran is a notable instance of the attempt to resurrect historic artistic traditions in Islamic countries. A key figure in the renewal was Mirza Hadi-Khan Tajvidi, who in 1929 established the Madraseh-i Sanaye'-i Qadimeh ('School of Traditional Arts') in Tehran. He taught many artists there who formed the School of Tehran.

Other notable painters in this revival included Mohammad Ali Zavieh, Shayesteh Shirazi and Hossein Behzad. Born in Tehran, Behzad produced paintings in the

Left Leighton House's Arab Hall contains an indoor fountain as well as beautiful tiling, slender columns and muqarnas vaulting.

style of traditional Timurid and Safavid manuscript paintings. He won international renown as a miniaturist, beginning with his illustrations to works by the Persian poet Nizami (1141–1209), completed in 1915, and continuing with illustrations to the *Rubáiyát of Omar Khayyám* (1048–1123), finished in 1936. He received several international awards, and many of his works were collected and housed in the Behzad Museum in the Saad Abad Palace in Tehran.

In the wake of these artists came a generation of Iranian painters who were both inspired by the great Persian miniature tradition and introduced modern techniques from other areas of the arts. Among these, Mahmoud Farshchian has achieved great prominence. Born in Isfahan and educated in the fine arts both in Iran and in Europe, Farshchian has won wide acclaim with works inspired by the Iranian epic the *Shahnameh* (Book of Kings) and the works of the Sufi mystical poet Rumi (1207–73). Other artists in this generation include Mohammad Bagher Aghamiri, Majid Mehregan and Ardshir Mojarrad-Takestani.

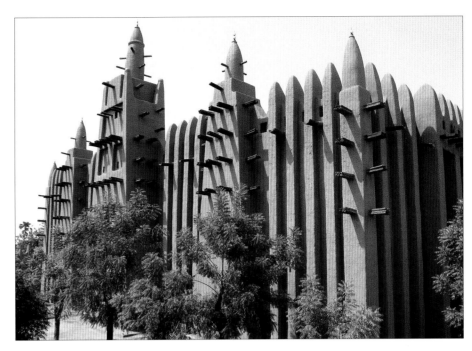

TRADITIONAL BUILDINGS

Particularly in Africa, some modern architects have maintained traditional forms when constructing mosques. For example, the Great Mosque of Niono in Mali, completed by master mason Lassina Minta with local workmen in 1973, was built in line with centuries-old local Islamic building traditions with wooden beams and walls of clay bricks and roofs made from matting and earth. A number of the historic mosques of the region,

Above The Grand Mosque of Djénné, Mali (1906), is one of several 20th-century West African mosques built from clay and wood in the traditional style.

such as the Great Mosque of Djénné, were rebuilt in the 20th century using similar materials and craftsmanship. The Great Mosque of Niono has a vast prayer hall covering approximately 726sq m (7,815sq ft). The Niono Mosque won an Aga Khan Award for Architecture in 1981–83.

Above John Frederick Lewis drew on memories of life in Cairo for his Orientalist work, An Intercepted Correspondence *(1869).*

IMAGINING THE EAST: 'ORIENTALIST PAINTERS'

From the late 18th century and throughout the 19th century in Britain, many Western artists were drawn to scenes of life in the Orient – which often meant the Mediterranean coastline of Egypt, Syria, Turkey and Palestine. These artists represented harem, bazaar or city scenes, especially in the cities of Istanbul, Damascus, Cairo and Jerusalem, at this time all part of the declining Ottoman Empire. One of the leading Orientalist painters was John Frederick Lewis, who had lived for ten years in Cairo, and later made his name in England with images such as *Harem Life, Constantinople* (1857), *Edfu, Upper Egypt* (1860) and *The Seraff: A Doubtful Coin* (1869). The exotic appeal of Orientalist art lay in authentic reportage of foreign landscape and architecture, as well as in the sexual mores of the harem. Artists made close study of Islamic domestic architecture, and painstakingly reproduced latticework screens, as in *An Arab Interior* (1881) by Arthur Melville, but their actual knowledge of local genre situations was extremely restricted.

THE MODERN AGE

AFTER THE 18TH CENTURY, ART AND ARCHITECTURE WERE INFLUENCED BY EUROPEAN STYLES, AND IN CAIRO AND ELSEWHERE URBAN DESIGNERS ADOPTED STRAIGHT-BOULEVARD CITY PLANNING.

By the 1800s, the Ottoman Empire was in decline, and the balance of political and financial power swung westward. Former Ottoman territories, such as Greece and Serbia, won independence; North Africa came under varying degrees of Western colonial control.

In many Islamic countries, political and social reforms brought government and administration closer to Western models: in the Tanzimet Period (from the Arabic word for 'Reordering') in 1839–76, Ottoman sultans Abdulmecid I (reigned 1839–61) and Abdulaziz (reigned 1861–76) introduced reforms of the army, administration, judiciary and education systems; in 1861, Tunisia was the first Islamic country to adopt a constitution and established itself as a Western-style constitutional monarchy. In line with this, architecture and the arts turned to Western models.

THE BALYAN ARCHITECTS

In Istanbul from the 1820s onward, the architects of the Armenian Balyan family produced mosques in a style influenced by Western Baroque and Empire styles. Krikor Balyan designed the Nusretiye Mosque, built in 1823–36 for Sultan Mahmud II (reigned 1808–39). The mosque was called the Victory Mosque to celebrate the abolition by Mahmud II of the janissary troops who had been behind many revolts, and their replacement with a Western-style military.

Garabet Amira Balyan and Nigogayos Balyan, Krikor's son and grandson, were responsible for several mosques: the Dolmabahçe Mosque (1853–55), the Ortakoy Mosque (1854–56) and the Buyuk Mecidiye Mosque, finished in 1855. These have a Western European look, using marble and grand paintings in place of tiles as decoration.

Above Three Western styles of architecture – Baroque, Rococo and Neoclassical – combine in the Dolmabahçe Palace. Its ceilings are covered with 14 tonnes of gold.

These two men also designed the Dolmabahçe Palace, built in 1844–55, for Sultan Abdulmecid I. The palace stands in what was once a harbour on the Bosphorus, indeed where Mehmet II had once anchored 70 ships. The harbour was later reclaimed for use as royal gardens and the name of the palace means 'filled garden'. Its white marble façade, 284m (932ft) long, faces on to a quay 600m (1,968ft) in length. The Dolmabahçe was the first European-style palace in Istanbul: its interior was beautifully designed by the French decorator Charles Séchan (designer of the Paris Opera) and was lavishly appointed, with the world's largest chandelier, weighing 4.5 tonnes and con-taining 750 lights, in the Exhibition Hall and a celebrated staircase with banisters made from Baccarat crystal.

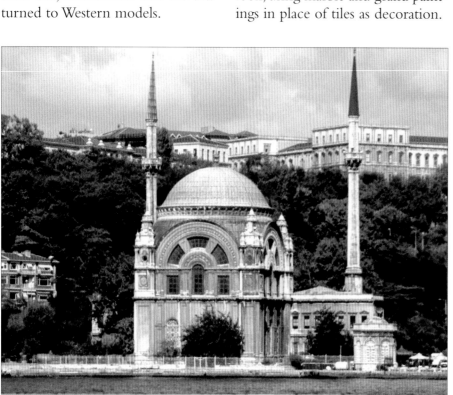

Left The Dolmabahçe Mosque stands on a site measuring 25sq m (269sq ft) close to the Dolmabahçe Palace beside the waters of the Bosphorus.

MUHAMMAD ALI MOSQUE

In this period, Egypt was ruled by the Khedives, descendants of Muhammad Ali Pasha (1769–1849). He was an Albanian officer, sent to the country as part of an Ottoman force following the invasion of Egypt by French general Napoleon Bonaparte. Muhammad Ali had taken power and established himself as Wali (Ottoman governor) in 1805, and founded a dynasty that ruled until 1952. In the Cairo Citadel, he built a Grand Mosque in the Ottoman style in 1824–48.

The Muhammad Ali Mosque was at first planned in the local Mamluk style by a French architect named Pascal Coste, but the designs of Greek architect Yusuf Bushnaq were preferred. The mosque has a large main dome and four half-domes with Ottoman spindle minarets, modelled on the 1599 Yeni Valide Mosque in Istanbul.

The Muhammad Ali Mosque was the largest mosque built in the first half of the 19th century, and superseded the nearby Mamluk Mosque of al-Nasir Muhammad as the state mosque of Egypt. It was built on the grounds once occupied by Mamluk palaces, which were destroyed on Muhammad Ali's order. In choosing the Ottoman instead of the Mamluk mosque style, Muhammad Ali made it clear that Egypt was aligned with the Ottomans. At the same time, the decorative style used displayed a strong European influence and harmonized with that used in the contemporary Empire and neo-Baroque mosques of Istanbul, designed by the Balyans.

Muhammad Ali's grandson, Ismail Pasha (reigned 1863–79), was pro-Western. He added a new area on Cairo's western edge in the style of Paris, as remodelled by Baron Georges-Eugène Haussmann, and built a rail network in Egypt. He declared in 1879, 'My country is no

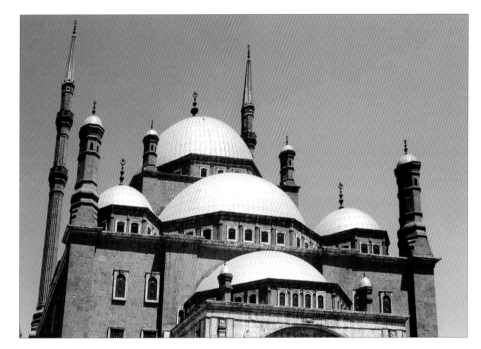

Above The main dome of the grand Muhammad Ali Mosque (1824–48) in Cairo is 21m (69ft) in diameter, and is flanked by Ottoman-style minarets.

longer part of Africa; now we are in Europe. It is natural, therefore, for us to set aside our former ways and to take on a new organization suitable to our social conditions.'

EFFECTS ON OTHER ARTS

These changes had varied effects in other arts. In metalwork, for example, Western influence was felt from the 18th century onward by the elite craftsmen of Istanbul, who produced Baroque and Rococo decorative designs. The craftsmen made mirrors, trays, ewers and coffee sets with intaglio (stone-carved) decoration. Floral decoration became more expansive, with engravings of bouquets and baskets of flowers, bows and ribbons.

In the 19th century, the severe Ottoman decline had dispiriting effects on metalwork and the arts.

Right This clock from the Dolmabahçe Palace clearly shows how Western styles – particularly Baroque – influenced late Ottoman metalwork.

Except for those that were donated to mosques or mausolea, many gold and silver pieces held in the imperial palace were melted down. However, Western influence had little effect on calligraphy, the Islamic art form par excellence.

MODERN ARCHITECTURE

SOME OF THE MOST DYNAMIC ARCHITECTURE OF THE LATE 20TH AND EARLY 21ST CENTURIES WAS CREATED IN THE ISLAMIC WORLD, USING MODERN DESIGNS THAT HONOUR THE ISLAMIC TRADITION.

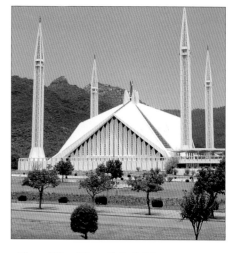

The vast King Faisal Mosque in Islamabad is a symbol of modern Pakistan. Built in 1976–86 under the supervision of Turkish architect Vedat Delakoy, it combines the modern and the traditional: it is based on the design of a central dome with spindle minarets used over centuries by the Ottomans, but here the main dome is opened out into a great folded roof resembling a tent. It is made of concrete without external decoration. The scale is vast: the mosque is part of a complex covering 5,000sq m (53,820sq ft) that can hold 300,000 members of the faithful.

The prayer hall contains a large chandelier, calligraphy by Pakistani artist Sadeqain Naqqash and tiles by Turkish artist Menga Ertel. On the west wall the *kalimah* (the affirmation of faith) is written in Kufic script set in mosaic.

The King Faisal Mosque is the state mosque of Pakistan, and one of the world's largest mosques; it was named after King Faisal of Saudi Arabia, who suggested its construction in 1966 and afterward funded the building.

OTHER MOSQUES

There are several other modern mosques of note, including the Freedom Mosque (or Istiqlal Mosque) in Jakarta, Indonesia, built in 1955–84 by architect Frederick Silaban, using concrete and steel. The large prayer hall covers an area of 36,980sq m (398,050sq ft) and the mosque can hold 250,000 people. It is the state mosque of Indonesia.

Abdel-Wahed el-Wakil built the King Saud Mosque in Jeddah, Saudi Arabia, completed in 1989. It covers 9,700sq m (104,410sq ft) and has a minaret 60m (197ft) tall. It pays tribute to both Iranian and Mamluk architecture, celebrating the four-*iwan* (hall) design of Iranian tradition in that it contains a rectangular courtyard and four *iwan*-like openings in the surrounding wall, and honouring Mamluk architecture in Cairo in the pointed dome shape and the minaret style. The main dome is 42m (138ft) tall and 20m (66ft) across.

Above The King Faisal Mosque (1966–86) stands at the northern edge of Islamabad, where the city gives way to the foothills of the Himalayas.

COMMERCIAL BUILDINGS

In this same period, the vast scale of secular architecture built in Islamic countries is a good representation of their wealth and status. Hotels, apartment blocks and offices have been built in a dynamic, glamorous style.

In Tehran, Iran, the distinctive Azadi Tower was designed in 1971 by architect Hossein Amanat. Initially called the Shayad Tower ('Memorial of Kings'), it was renamed the Azadi (Freedom) Tower after the 1979 Iranian Revolution. The tower contains 8,000 blocks of white marble stone from the region of Isfahan, and was built by the pre-eminent Iranian stonemason Ghaffar Davarpanah Varnosfaderani. It stands at the centre of a great square that was the setting for many of the demonstrations

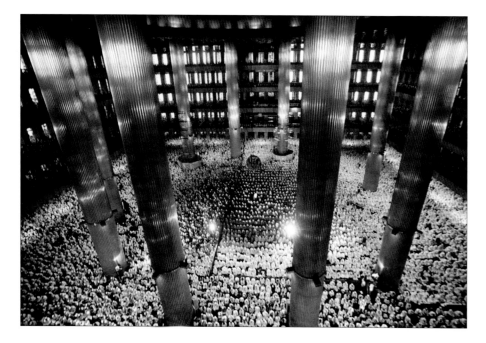

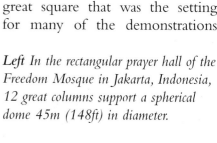

Left In the rectangular prayer hall of the Freedom Mosque in Jakarta, Indonesia, 12 great columns support a spherical dome 45m (148ft) in diameter.

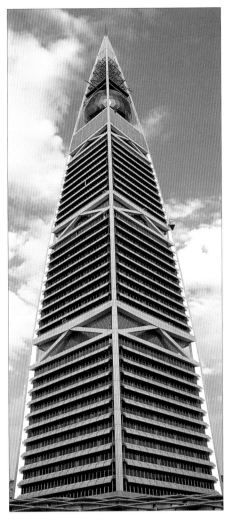

Above A luxury restaurant within the golden sphere atop the Al Faisaliyah building revolves so that diners have a changing view of Riyadh, Saudi Arabia.

and rallies of the Iranian Revolution, and it continues to be a focal point for protest.

Many modern buildings that set new standards for size have been built in Saudi Arabia and the countries of the United Arab Emirates. In Riyadh, the twin towers of the Al Faisaliyah Centre and the Kingdom Centre are the two tallest buildings in Saudi Arabia. The Kingdom Tower, 311m (1,020ft) tall with 43 floors, was completed in 1999. It contains

Right The iconic Burj al-Arab hotel in Dubai, United Arab Emirates, mimics the shape of the sail used in the traditional Arab sailing vessel, the dhow.

offices, a hotel, private apartments, restaurants, fitness clubs and shopping floors; there are also three mosques, including the world's highest, the King Abdullah Mosque, on the 77th floor and a public viewing platform at the top at a height of 270m (886ft). The Kingdom Centre was designed by Ellerbe Becket/Omrania. The Al Faisaliyah Centre, completed in 2000 and 267m (876ft) tall with 30 floors, contains offices and shopping areas. The four main corner beams of the centre bend in to join at the tip and beneath them is a great golden ball containing a restaurant. It was designed by UK architects Foster and Partners.

Dramatic skyscraper hotels were built in Dubai, United Arab Emirates, in the late 20th and early 21st centuries. The highly distinctive Burj al-Arab ('Tower of the Arabs') was built in 1994–99 to designs by architect Tom Wright in the shape of a boat's sail on a man-made island 280m (919ft)

offshore from Jumeirah Beach. It has 60 floors and stands 321m (1,053ft) tall, making it the second tallest hotel in the world, outdone only by the Rose Tower, 333m (1,093ft) tall, on Shaykh Zayed Road, also in Dubai. The Rose Tower has 72 floors and was built in 2004–7.

INSPIRATIONAL AIRPORT

A notable building complex in Saudi Arabia is the Dhahran International Airport, built in 1961 and designed by American architect Minoru Yamasaki (1912–86). The airport's blend of traditional Islamic architectural forms with modern elements was highly influential. Its flight control tower has the appearance of a minaret, and the distinctive terminal featured for some time on Saudi banknotes. In 1999, after the building of the King Fahd International Aiport, the Dhahran International Airport was made into a air base of the Royal Saudi Air Force.

WHERE TO SEE ISLAMIC ART

THE ISLAMIC WORLD

Museum of Islamic Art, Doha, Qatar

This museum opened its doors in 2008. The building, inspired by Islamic architecture, was designed by the architect I.M. Pei. It houses Islamic artworks from the 7th to 19th centuries, including textiles, ceramics, manuscripts, metal, glass, ivory and precious stones. www.mia.org.qa/english

Iran Bastan Museum, Tehran

This national museum now incorporates two original museums that together cover ancient archaeology and many pre-Islamic artefacts and post-Islamic period artefacts. www.nationalmuseumofiran.ir

Islamic Arts Museum, Kuala Lumpur

This collection of more than 7,000 artefacts aims to be representative of the arts of the Islamic world. An emphasis is placed on works from India, China and South-east Asia. www.iamm.org.my

Museum of Islamic Art, Cairo

The renovated Museum of Islamic Art holds a collection of more than 100,000 objects of mainly Egyptian origin produced from the 7th to 19th centuries. www.islamicmuseum.gov.eg

L.A. Mayer Museum of Islamic Art, Jerusalem

Dedicated to the memory of Leo Arie Mayer, a professor of Islamic Art and Archaeology at the Hebrew University of Jerusalem, this museum aims to cultivate a mutual understanding between Jewish and Arab cultures. www.islamicart.co.il/default-eng.asp

Turkish and Islamic Arts Museum, Istanbul

The Ibrahim Pasha Palace is now home to a 40,000-strong collection of Islamic arts, and is particularly famed for its world-class selection of carpets. www.greatistanbul.com/ibrahim_pasa_palace.htm

Below Museum of Islamic Art, Doha.

Above Entry gate to the Topkapi Palace Museum, Istanbul.

Topkapi Palace Museum, Istanbul

Built in the 15th century and once the imperial residence of the Ottoman sultans, Topkapi Palace is now the setting for one of the foremost museums of Islamic art in the world. It holds first-rate collections of manuscript painting, ceramics, clothing and jewellery. www.topkapisarayi.gov.tr/eng

Tareq Rajab Museum, Hawelli, Kuwait

The private collection of the Rajab family, the museum has around 10,000 objects on permanent display. The collection managed to survive the Iraqi invasion of 1990, and the attached Museum of Islamic Calligraphy was opened in 2007. www.trmkt.com

EUROPE

British Museum, London

Concentrated in the John Addis Gallery, the Islamic collection includes artworks from the full range of Islamic history. The museum is actively collecting contemporary Islamic art. www.britishmuseum.org

Right London's Victoria and Albert Museum.

Victoria and Albert Museum, London

The Jameel Gallery at the V&A contains more than 400 objects out of a collection of 10,000 from across the Islamic world. The star piece of this magnificent collection is the Ardabil carpet, the oldest dated carpet in existence. www.vam.ac.uk

Chester Beatty Library, Dublin

Established by the American collector and magnate, this collection was gifted to the Irish Republic on Chester Beatty's death in 1968. The Islamic section is particularly strong in Mamluk Qurans, as well as Ottoman, Persian and Indian paintings. www.cbl.ie

Musée du Louvre, Paris

As of 2010, the objects from the Islamic Department of the Louvre can be found in an exhibition space in the Cour Visconti. The new building can display 3,000 objects. www.louvre.fr

Museum für Islamische Kunst (Museum of Islamic Art), Berlin

Islamic architectural decoration features strongly in this collection, housed in the south wing of the Pergamonmuseum. Its highlights include the façade of the Mshatta Palace, 13th-century *mihrabs* (niches to indicate the direction of prayer) from Konya and Kashan, and the Aleppo Room. www.smb.spk-berlin.de

The David Collection, Copenhagen

Founded by Danish lawyer Ludvig David in his ancestral home, since his death in 1960 the David Collection has concentrated on acquiring Islamic artworks of outstanding quality, resulting in a superb collection of 2,500 objects. www.davidmus.dk

RUSSIA

State Hermitage Museum, St Petersburg

The Islamic art collection holds pieces from Iran, Egypt, Syria and Turkey. The collection includes more than 700 Iranian bronzes as well as Islamic textiles, ceramics, manuscript paintings, glassware and weaponry. www.hermitagemuseum.org

USA

Freer and Sackler Galleries at the Smithsonian, Washington, DC

The Smithsonian is one of the best places to see Islamic art in the United States. The collection of more than 2,200 objects is strong in the areas of ceramics and illustrated manuscripts. www.asia.si.edu/collections/islamicHome.htm

Metropolitan Museum of Art, New York

The Met's Islamic galleries display pieces from its prized collection of 12,000 objects, including ceramics, calligraphy and metalwork. www.metmuseum.org/Works_of_Art/islamic_art

Los Angeles County Museum of Art

There are more than 1,700 Islamic objects in the museum, making it a significant collection of Islamic art in the country. Areas of note include Iranian pottery and tiles, and the Turkish arts of the book. www.lacma.org/islamic_art/islamic.htm

ONLINE

Museum With No Frontiers (MWNF)

The largest transnational museum on the web, the MWNF's flagship project, Discover Islamic Art, contains Islamic art and monuments from around the Mediterranean, organized by country. www.discoverislamicart.org

The Khalili Collection

With more than 20,000 Islamic artworks, the Khalili Collection is one of the most comprehensive private collections ever assembled. More than 30 museums worldwide have exhibited pieces from the collection and slideshows are available on the website. www.khalili.org

GLOSSARY

ABLAQ Typically Syrian use of alternating dark and light masonry, often marble.

ARABESQUE Decorative geometric ornament based on stylized vegetal forms, such as tendrils and creepers.

ARCH A curved area in a building used to spread the weight of the structure above it to the walls, pillars or columns below; important in Islamic architecture, especially for supporting large domes.

ASHLAR Dressed stone blocks.

AZULEJO Tin-glazed ceramic tiles produced in Islamic Spain.

BAB Gate.

BAZAAR Covered marketplace and business centre in Islamic towns and cities, also known as *souk*.

CALLIGRAPHY The art of beautiful writing; in Islam stylized written Arabic is revered as the highest art because it gives visible form to the words of the holy Quran.

CAMI Congregational mosque used for Friday prayers (Turkish; called *jami* in Arabic).

CARAVANSERAI Secure and often fortified lodging for merchants and travellers, their animals and goods, usually on a trade route, also known as *han* (in Turkish).

CASBAH See citadel.

CHAHAR BAGH Persian-style, four-part garden layout.

CITADEL Enclosed, fortified section of a city or town, known as *casbah* (from Arabic *qasaba*) in North Africa.

CLOUD BAND Decorative motif of curling clouds in Chinese art, used throughout Islamic art from the 14th century onward.

CUERDA SECA (in English, 'dry cord') Use of lines of a greasy black substance to mark out and contain areas of glaze applied to tiles, enabling artists to achieve greater sureness of line.

DRESSED STONE Building stone that has been shaped or 'finished' prior to use.

FAIENCE Type of tin-glazed pottery with exquisite painted decoration.

GUNBAD Tomb tower.

HAMMAM Bathhouse.

HAN See caravanserai.

HYPOSTYLE Hall with flat roof supported by columns; type of mosque in which the flat roof of the prayer hall is supported by rows of columns.

INLAYING The technique of inserting one material into another to create a decorative effect, often used in metalwork to add a precious metal, such as gold or silver, to decorate a less expensive metal body, such as bronze or brass.

IWAN Hall with one side left open, giving on to the courtyard of a mosque or *madrasa*.

JAMI Or *masjid-i-jami*, congregational mosque used for Friday prayers (Arabic; *cami* in Turkish).

KAABAH Islam's most sacred shrine, a cube-shaped building in the Masjid al-Haram (Holy Mosque) at Makkah; Muslims must face toward the *Kaabah* when praying.

KHAMSA Five in Arabic; in Persian, a *khamsa* is a group of five books; in Islamic Africa a *hamsa* (sometimes *khamsa*) is a hand-shaped, good-luck symbol used in jewellery.

KHAN See caravanserai.

KHANQA A monastery for Sufis.

KITAB Book; Al-Kitab or kitab Allah (Book of God) are sometimes used as terms for the Quran.

KUFIC Early Arabic script, named after city of Kufa in Iraq.

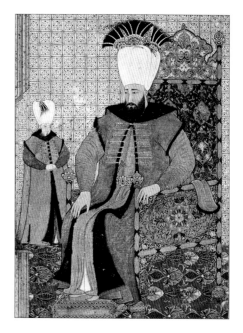

Above Like other Ottoman sultans, Ahmet III (reigned 1703–10) was a great patron of the arts.

KULLIYE Complex of religious buildings centred on a mosque with other establishments, such as *madrasa, caravanserai, hammam,* kitchens and sometimes hospitals, typically built by wealthy subjects of the Ottoman sultans.

LUSTREWARE Ceramics finished with metallic glazes that produce a shining effect. Developed in Abbasid Iraq in the 8th century and used throughout the Islamic world.

MADRASA Islamic educational establishment, often associated with a mosque, where students studied the Quran, law and sciences.

MAGHRIBI Cursive form of Arabic script; developed in western Islamic lands.

MAIDAN Open square, usually in centre of town or city.

MAQSURA Private area in a congregational mosque used by a ruler or governor, often lavishly decorated.

MASHHAD Shrine; tomb of martyr or Sufi saint.

MASHRABIYA Turned-wood openwork screen.

MASJID *See* mosque.

MIHRAB Wall niche in form of arch indicating the correct direction of prayer (toward Makkah).

MINAI Type of 12th–14th-century Persian ceramic pottery with enamel-painted designs on a light-coloured ground.

MINARET Tower on a mosque, once used as a watchtower but now the place from which the Muslim faithful are called to prayer.

MINBAR Pulpit in mosque from which the *khutbah* prayer or sermon is pronounced.

MOSQUE Muslim place of gathering and prayer. In Arabic, *masjid* ('place of prostration').

MUEZZIN Anglicized form of Arabic *muadhdhin*, individual who calls faithful to prayer, traditionally from the minaret of a mosque.

MUHAQQAQ Cursive script used in calligraphy; one of the 'six hands' of calligraphy identified in the 10th century by Ibn Muqla (d. 940).

MUQARNAS Small, concave stalactite vaults, often painted or tiled, used widely in Islamic architecture.

MUSALLA Enclosed area with *qibla* wall, where large numbers can gather to worship; known as *Namazgah* in Persian.

NASKH Style of Arabic script.

NASTALIQ Calligraphic script, used mainly for Persian rather than Arabic.

PISHTAQ Large arched portal leading into an *iwan* at the entrance of a mosque, *madrasa* or *caravanserai*.

QASR Palace or castle.

QIBLA The direction of prayer, toward the *Kaabah* at Makkah, in which Muslims face when praying.

QUBBAH Dome or domed tomb.

Right Islamic architects developed the use of the pointed rather than semicircular arch. The first may have been at the Al-Aqsa Mosque (780).

QURAN The word of Allah as revealed to the Prophet Muhammad in 610–32; the main source of guidance and authority for Muslims.

RIBAT Fortified monastery, a base for *jihad*, or religious war.

RIWAQ Arcades running around the four sides of the courtyard in an Arabic-style courtyard mosque.

SAHN Courtyard of mosque.

SHADIRWAN Fountain in a palace room or the courtyard of a mosque.

SHEREFE Balcony on minaret used by the *muezzin* when issuing a call to prayer.

SOUK *See* bazaar.

SURAH A chapter in the Quran (plural *suwar*).

TALAR Columned hall (Persian).

THULUTH Large and elegant cursive calligraphic script.

TIRAZ Robes given as mark of honour, embroidered with Quranic verses and/or the name of the donor.

TUGHRA Stylized monogram-signature incorporating the name of an Ottoman sultan.

TURBE Mausoleum.

ULAMA Islamic legal/religious scholars (Arabic, singular *alim*).

WAQF A pious endowment supporting a *bimaristan* (hospital), *madrasa*, or other secular Islamic institution.

WAZIR Administrators; ministers (Arabic; plural *vizier).*

YURT Round tent used by Central Asian nomads.

ZIYADA The enclosure or courtyard between mosque precincts and outer walls.

INDEX

A

Below Detail of the floral tile work in the Savar Garden, Shiraz, Iran.

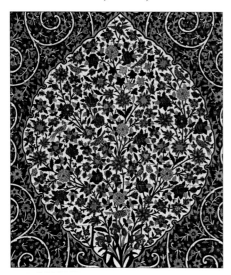

Below Detail of ornate inlay work at Emperor Akbar the Great's tomb at Sikandra, Agra, India.

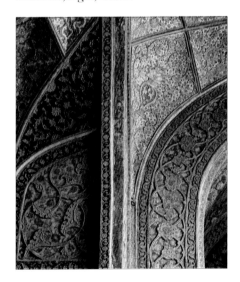

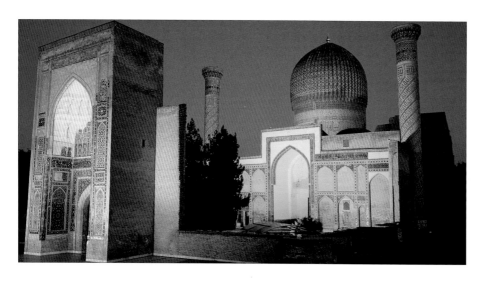

Above Entrance portal and mausoleum at the remains of the Gur-e Amir complex, Samarkand.

Below Blue dome interior at the Sah-i-Zinda necropolis, Samarkand.

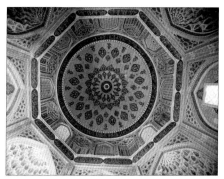

This edition is published
by Hermes House
Hermes House is an imprint
of Anness Publishing Ltd
Hermes House, 88–89 Blackfriars
Road, London SE1 8HA
tel 020 7401 2077; fax 020 7633 9499
www.hermeshouse.com;
www.annesspublishing.com

© Anness Publishing Ltd 2010

Anness Publishing has a new picture
agency outlet for images for publishing,
promotions or advertising. Please visit
our website www.practicalpictures.com
for more information.

ETHICAL TRADING POLICY

Because of our ongoing ecological
investment programme, you, as our
customer, can have the pleasure and
reassurance of knowing that a tree
is being cultivated on your behalf to
naturally replace the materials used to
make the book you are holding. For
further information about this scheme,
go to www.annesspublishing.com/trees

PUBLISHER'S NOTE

Although the advice and information
in this book are believed to be accurate
and true at the time of going to press,
neither the authors nor the publisher
can accept any legal responsibility for
any errors or omisions that may have
been made.

For Anness Publishing Ltd:
Publisher: Joanna Lorenz
Editorial Director: Helen Sudell
Proofreading Manager: Lindsay Zamponi
Production Controller: Wendy Lawson

Produced for Lorenz Books by
 Toucan Books:
Managing Editor: Ellen Dupont
Editor: Theresa Bebbington
Designer: Ralph Pitchford
Picture Researcher: Marian Pullen
Proofreader: Marion Dent
Indexer: Michael Dent
Cartography by Cosmographics, UK

PICTURE CREDITS

The publishers have made every effort
to trace the photograph copyright
owners. Anyone we have failed to
reach is invited to contact Toucan
Books, 89 Charterhouse Street,
London EC1M 6HR, United
Kingdom.

akg-images 16, 17, 18t, 25b, 38t, 39b,
46, 61t, 62b, 64t, 65t, 68t, 77b, 102t,
104, 111t, 114b, 115tr, 115b, 121t,
122b, 134b, 153t, 155bl, 172, 175b,
182t, 185, 190t, 199t, 216tr, 225b, 227b,
230t, 231t, 235t.
Alamy 4bml, mr, 10tm, 11bm, 12tm,
24b, 29b, 38b, 44, 55t, 55, 73, 76b, 80t,
80, 81t, 84t, 92b, 94b, 107t, 110bl, 112,
113br, 116, 117, 118, 133b, 153b, 182t,
186b, 189tr, 196t, 201b, 204t, 217t,
218t, 220b, 221t, bl, 223br, 224b, 225t,
234, 237tr, 242b, 244, 248t, 253.
**Ancient Art & Architecture
Collection** 5bml, 47t, 48, 78t, 87t, 93t,
102b, 237b, 239b.
Art Directors/ArkReligion.com 4bl,
br, 5bl, 20b, 21tl, 26b, 30t, 31t, 59t, 68t,
90t, 95t, 127, 162b, 202t.
The Art Archive *Back Cover* tmr,

Spine b, 7, 13br, 14tm, 20t, 21r, 22t,
23b, 24t, 26t, 27b, 32, 34tr, 35br, 39t,
42t, 51b, 52t, 53b, 58t, 66t, 75b, 76t,
78b, 79b, 85b, 96t, 98b, 101b, 103t,
105, 107b, 108b, 114t, 119b, 120,
121b, 123t, 125b, 147, 154t, 160b,
167t, 170b, 173, 174t, 175t, 183,
190br, 193b, 209b, 219t, 226b, 232t,
233, 235b, 236, 238b, 239t.
The Bridgeman Art Library *Front
Cover* tl, tm, tmr, ml, *Back Cover* tr, bl,
bm, bmr, *Spine* t, 1t, 3b, 5bmr, 8b, 22b,
36t, 37b, 40, 41, 43tr, 43cl, 49b, 57,
59b, 61b, 62t, 63, 66b, 67, 71, 74, 75t,
81b, 86, 87b, 101t, 108t, 124, 125, 128b,
132t, 143t, 144, 150, 155r, 156b, 157,
158, 160t, 161, 166, 170t, 171, 174b,
177, 180t, 181, 182b, 186t, 187, 188,
189tl, 191, 192, 193t, 194, 195, 206,
207, 208t, 210, 211b, 212, 213, 214,
221br, 226t, 227t, 228t, 229, 230b,
232b, 238t, 242t, 243b, 250.
Corbis *Front Cover* tr, *Back Cover* br,
Inside Flap 6, 8t, 9, 11bl, br, 19tl, tr, 28t,
29t, 33, 50, 51t, 52b, 68b, 69b, 88b, 91t,
95b, 97t, 100, 106t, 111b, 119t, 122t,
123b, 136t, 141b, 143b, 146b, 147t,
152t, 156t, 159, 169b, 180b, 184, 197t,
205t, 211t, 217b, 218b, 228b, 231b,
246b, 251, 252, 255, 256.
Getty Images 35tr, 129b.

Heritage-Images 15, 204b.
iStockphoto.com 215t.
Peter Sanders Photography 19b,
129tl, 130tr.
Photoshot 94t, 99b, 109t, 249.
Photolibrary *Front Cover* bl, br, *Inside
Flap, Back Cover* tl, tml, tm, 2, 3t, 5br,
12tl, 14tl, tr, 23t, 25t, 30b, 31b, 47b,
60t, 64b, 70, 82, 85t, 91b, 98t, 110t,
113t, 126, 128t, 130b, 131, 134t, 135t,
137t, 138t, 139, 141t, 142, 148t, 162t,
163b, 164, 165, 178t, 179, 196cl, 198,
199b, 202b, 203, 219b, 220t, 222b, 223t,
bc, 224t, 240, 243t, 245t, 246t, 247,
248b, 254.
Paul Harris Photography 201tr.
Rex Features 84b, 103b, 109b, 205b.
Robert Harding 10tr, 12tr, 13bl, bm,
27tr, 45t, 53t, 54t, 56, 83, 88tr, 89b, 93b,
99t, 106b, 138b, 146t, 148b, 151, 154b,
163t, 167b, 168t, bl, 169t, 176, 197b,
200b, 222t, 241, 245b.
Shutterstock 28b.
Sonia Halliday Photographs 54br.
Werner Forman Archive *Front Cover*
tml, *Back Cover* bml, 36b, 37t, 42–43b,
65b, 72t, 77t, 79r, 92t, 97b, 132b, 133t,
135b, 136b, 137b, 140t, 145, 149b, 200t,
208b, 209t.
**Maps produced by Cosmographics,
UK.**